GUIDE TO GRAPHIC DESIGN

GUIDE TO GRAPHIC DESIGN

Scott W. Santoro

WITH CONTRIBUTIONS
AND EDITING BY JOAN LEVINSON
AND MARY GAWLIK

PEARSON

Boston Columbus Indianapolis New York San Francisco Upper Saddle River
Amsterdam Cape Town Dubai London Madrid Milan Munich Paris Montréal Toronto
Delhi Mexico City São Paulo Sydney Hong Kong Seoul Singapore Taipei Tokyo

Dedicated to my sons, Ellis and Lowell Santoro—and to future generations of graphic designers.

Editorial Director: Craig Campanella

Editor in Chief: Sarah Touborg

Acquisitions Editor: Billy Grieco

Assistant Editor: David Nitti

Editorial Assistant: Laura Carlson

Editor-in-Chief, Development: Rochelle Diogenes

Development Editor: Mary Gawlik

Media Director: Brian Hyland

Senior Media Editor: David Alick

Media Project Manager: Rich Barnes

Vice President of Marketing: Brandy Dawson

Executive Marketing Manager: Kate Stewart

Senior Managing Editor: Melissa Feimer

Senior Project Manager: Lynne Breitfeller

Senior Manufacturing Manager: Mary Fisher

Senior Operations Specialist: Diane Peirano

Senior Art Director: Pat Smythe

Interior Design: Scott W. Santoro

Cover Designer: Scott W. Santoro

Manager, Rights and Permissions: Paul Sarkis

Manager, Visual Research: Ben Ferrini

Project Management: PreMediaGlobal

Printer/Binder: LSC Communications

Cover Printer: LSC Communications

*Typefaces: Adobe Minion Pro by Robert Slimbach
and Adobe Myriad Pro by Robert Slimbach
and Carol Twombly.*

Credits and acknowledgments borrowed from other sources and reproduced, with permission, in this textbook appear on the appropriate page within text and on pages 339–342.

Use of the trademark(s) or company name(s) implies (imply) no relationship, sponsorship, endorsement, sale, or promotion on the part of Pearson Education, Inc. or its affiliates.

Many of the designations by manufacturers and sellers to distinguish their products are claimed as trademarks. Where those designations appear in this book, and the publisher was aware of a trademark claim, the designations have been printed in initial caps or all caps.

Library of Congress Cataloging-in-Publication Data

Santoro, Scott W.
 Guide to graphic design / Scott W. Santoro. — 1st ed.
 pages cm
 ISBN 978-0-13-230070-4 (pbk.)
 1. Graphic arts — Textbooks. 2. Commercial art — Textbooks. I. Title.
 NC997.S265 2012
 741.6 — dc23

 2012035445

KV 04.03 2019 0824

ISBN 10: 0-13-230070-2

ISBN 13: 978-0-13-230070-4

BRIEF CONTENTS

Watch the Video on **myartslab.com**

Chapter 1: Scott W. Santoro

Chapter 2: Steven Heller

Chapter 3: George Tscherny

Chapter 4: Somi Kim

Chapter 5: Luba Lukova

Chapter 6: Paul Sahre

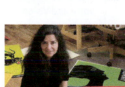
Chapter 7: Paul Shaw

Chapter 8: Barbara Glauber

Chapter 9: Hillman Curtis

Chapter 10: Greenblatt-Wexler

Chapter 11: Agnieszka Gasparska

Chapter 12: Scott Stowell

Graphic Design Concepts

This chapter explores ways in which designers bring design ideas to a visual solution, emphasizing the importance of cohesive integration of concept and form. Students will learn the difference between ideas and concepts as well as how one can lead to the other. Then, students will explore ways to develop ideas and methods for using them as the building blocks of strong design.

◉—[**myartslab.com**] Video: George Tscherny

Researching a Graphic Design Project

Proper research is vital to the design process. Through research, students can infuse their projects with meaningful content and understand what they are doing within a clear context. This chapter explains how to apply focused analysis and problem-solving skills. Students will learn the importance of knowing about their clients, audience, and subject matter. All the basic tools needed for good research are discussed, including best practices for using research wisely.

◉—[**myartslab.com**] Video: Somi Kim

▶ **Chapter 5**

Generating Ideas

Creativity is frequently perceived as being abstract or random. This chapter brings an active and applied approach to the creative process with a discussion of techniques such as sketching, montaging, word play, and benefitting from accidents or chance. Many ideas for exploring and recording ideas are presented, including tips for expanding one's thinking process beyond the commonplace.

👁 **myartslab.com** Video: Luba Lukova

▶ **Chapter 6**

The Elements and Principles of Form

The elements and principles of form are basic aesthetic components that all artists must master to turn ideas into compelling graphic designs. The form an idea takes will draw the viewer into a work and keep that viewer there long enough to comprehend the message being conveyed. As this chapter explains, when form and an intellectual idea unite, they create a solid communication. In effect, form becomes as much a part of the content as the information being presented.

👁 **myartslab.com** Video: Paul Sahre

VIRTUAL CRIT WALL

➡ Follow *Guide to Graphic Design* on Instagram @guide2graphicdesign to see some of the best student work currently on the critique wall in Scott Santoro's classroom, plus his encounters with great graphic design in his hometown of New York City.

Join the design conversation by using the hashtag #mycritwall to submit your own work, your class's critique wall, or examples of great design in your neighborhood.

DEAR READER

Years ago I took a week-long workshop with famed graphic designer Paul Rand. I was in such awe of Rand that when he assigned his first project I felt creatively immobilized. He came over to give me a one-on-one desk critique, but I had nothing to show him, confessing that I didn't know where to begin. Rand looked me straight in the eyes, put his hand under my chin, and with a thick Brooklynese accent said, "Think."

Guide to Graphic Design emphasizes what Rand stated so genuinely—that no matter what the context or problem, one starts any graphic design project by thinking. This fundamental is why graphic design is so "cool" (sorry, I just don't know how else to say it). There's hardly a better job than one that pays you to think (to go through an intellectual process) and then to play (to work ideas out in aesthetically inventive ways). As my mentor Charlie Goslin used to say, "An idea is the hat rack that everything hangs on." My own design practice and simultaneous teaching is based on this approach. The result is an integration of meaning and form. It's the way to go.

The eclectic spirit of *Guide to Graphic Design* is no accident. Designers throughout the book have contributed short essays on their work styles, their studio habits, and their inspirations. Each designer offers a new perspective and approach to possible working methods. At the same time, they all show a passion for design and communication.

Guide to Graphic Design is supplemented by videos of talented graphic designers—in other words, great thinkers (see myartslab.com). Every student who reads this book has the same core talent that they began with. Do something with your talent as these designers did; learn the mechanisms used to convey information, integrate ideas and form into full concepts, but most important, learn how to think like a graphic designer. When you do, the identities you create for companies and organizations will define your own personal identity. You will care more about the work you make, and that care will make your work better.

Scott W. Santoro

ABOUT THE AUTHOR

Photo: Robert A. Ripps

Scott W. Santoro is principal of Worksight, a graphic design studio in New York City. He holds graphic design degrees from Pratt Institute (BFA) and Cranbrook Academy of Art (MFA). He is also an adjunct professor of graphic design at Pratt Institute in Brooklyn, New York. As an active speaker on graphic design, he has lectured around the world including Australia and the Czech Republic. Scott has served as vice president of the New York Chapter of the American Institute of Design (AIGA) and as a national screening committee member for the Fulbright program.

Worksight has been a noticeable entity within the design community for more than twenty years and is well known for its "design for the everyday" approach to graphic communication. Its work connects with diverse audiences: an annual report for the Brooklyn Public Library; a series of brand logos for Steelcase Furniture; an alumni magazine for Purchase College; a book jacket and interior design for *The Sea Around Us,* Rachel Carson's environmental classic; a website design and maintenance for a New Jersey textile manufacturer—Absecon Mills; and now, with *Guide to Graphic Design,* a textbook for college students. The studio has won awards from the AIGA, NY Bookbinders Guild, and *Print Magazine,* and was a grant recipient for Sappi Paper's annual Ideas that Matter program that brings design to charitable organizations.

↓

FEATURES OF THE BOOK

Why study graphic design—after all, isn't it just moving type and image around the page?

Guide to Graphic Design presents design as a layered and evolving profession. Each feature of the book is focused on that principle and seeks to guide students toward a successful and fulfilling career as a graphic designer. To do this, it highlights step-by-step design processes and how to build good work habits. It illustrates and supports each chapter with work from top design firms and design school programs. It guides and motivates students with thoughts from AIGA Medalists Katherine McCoy, Steven Heller, April Greiman, Michael Bierut, Rick Valicenti, and many others.

All of these features are meant to inspire, encourage, and steer students through the contents of this book.

Specifically, each chapter contains:

- **Designer Vignettes** feature interviews from well-known designers intended to inspire students and pique their interest in the material being discussed.

- **Chapter Objectives** list key learning goals that readers can work to achieve in each chapter.

- **In Practice** provides tips that offer a real-world perspective to the specific design problems being discussed.

- **Steps in the Design Process** gives readers step-by-step instructions on how to approach solving a specific design task.

- **Worklist** offers sets of checkpoints and practicalities that students can use throughout the design process.

- **Speakout** features personal accounts and experiences from designers and educators, intended to expose students to unique and varied perspectives on the field of graphic design.

EXERCISES AND PROJECTS

With each exercise and project students will get better at making decisions and understanding the connection between an idea and its execution. Any book on graphic design should be considered as nothing more than a guide to an exciting and unique field that continually focuses on solving communication problems with creative and skillful solutions. With mindful reflection, research, and practice, each student can start designing, turning his or her creative thoughts into forms that communicate and developing a graphic design career.

Each chapter presents quick, in-class exercises and longer, more complicated projects. Successful solutions to these practice opportunities will be determined by the level of commitment a student brings to them. The idea is for students to practice creating effective designs by:

- keeping up with currents events and culture, which can influence their effectiveness as a designer,

- using the design skills they have learned,

- reflecting on the design work of others, and

- researching history, issues, and expectations related to a project.

A great portfolio of intelligent work goes a long way. The text encourages students to approach these exercises and projects as potential pieces for their portfolios, watching for breakthrough points in their work—times when they really took a chance and did something out of the ordinary—and then adding that work to an evolving portfolio. Students will get the best results and opportunities to practice professional skills if they approach their work as if they were "on the job":

1 Complete the assignment (expected of professionals).

2 Do all necessary research (required for creative, professional approaches).

3 Make preliminary sketches (allows exploration and refinement).

4 Follow the specifications in each design brief (good practice for meeting a client's expectations).

5 Consider your audience (required for a design to be effective).

6 Choose imagery that is symbolic and evocative of your message (pushes practice in research to reach an effective solution).

7 Try to provoke a thoughtful response from the viewer (combines research with design knowledge).

8 Use typography to enhance your design (pushes practice using an important tool in a sophisticated way).

9 Make every presentation neat and clean (good professional practice that enhances a portfolio).

10 Meet all deadlines given by your instructor (another opportunity to practice a professional expectation).

MyArtsLab™

MYARTSLAB

This program will provide a better teaching and learning experience for you and your students. Here's how:

The new MyArtsLab delivers proven results in helping individual students succeed. Its automatically graded assessments, personalized study plan, and interactive eText provide engaging experiences that personalize, stimulate, and measure learning for each student. And, it comes from a trusted partner with educational expertise and a deep commitment to helping students, instructors, and departments achieve their goals.

The **Pearson eText** lets students access their textbook anytime, anywhere, and any way they want, including downloading the text to an iPad®.

- A **personalized study plan**—written by Dahn Hiuni, a graphic design instructor at SUNY Old Westbury—for each student promotes critical-thinking skills. Assessment tied to the book enables both instructors and students to track progress and get immediate feedback.

- **Closer Look tours**—interactive walkthroughs featuring the author's narration—offer in-depth looks at designs from the text, enabling students to zoom in on details they couldn't otherwise see.

- **12 Designer Profile** videos, recorded by the late Hillman Curtis, are intimate portraits of designers in their studios talking about their approaches, ideas, and love for the field of graphic design.

- **Chapter Audio,** read by Scott W. Santoro, allows students to listen to the entire text—a key feature for allowing design students to focus on each example.

- **MediaShare**—a new digital drop box and portfolio tool—can help students submit their work to instructors and facilitate online peer critiques.

- Henry Sayre's *Writing About Art* 6th edition is now available online in its entirety as an eText within MyArtsLab. This straightforward guide prepares students to describe, interpret, and write about works of art and design in meaningful and lasting terms. This skill strengthens their ability to support their own design work, too.

VIDEO SERIES

This special interview series, filmed by the late Hillman Curtis, introduces students to twelve working graphic designers. Each designer is a featured voice in the book, contributing their work and thoughts in a *Designer Vignette* within each chapter.

These short films are an intimate look into the daily life of each designer as they offer their thoughts, guidance, and passion for the field of graphic design.

Featuring designers both established and new, young and old, and from all walks of life and areas of the world, this series will be a revealing perspective for students who want to understand the life of a designer.

Each video is accessible through each chapter of your **Pearson eText.**

PEARSON CHOICES AND RESOURCES

Give your students choices.

Pearson arts titles are available in the following formats to give you and your students more choices—and more ways to save.

The CourseSmart eTextbook offers the same content as the printed text in a convenient online format—with highlighting, online search, and printing capabilities. www.coursesmart.com

The Books à la Carte edition offers a convenient, three-hole-punched, loose-leaf version of the traditional text at a discounted price—allowing students to take only what they need to class. Books à la Carte editions are available both with and without access to MyArtsLab.

Build your own Pearson Custom course material.

Work with a dedicated Pearson Custom editor to create your ideal textbook and web material—publishing your own original content or mixing and matching Pearson content. Contact your Pearson representative to get started.

ACKNOWLEDGMENTS AND REVIEWS

First and foremost, thank you **Billy Grieco,** acquisitions editor at Pearson Education who fully understood and supported *Guide to Graphic Design.*

Thank you editors. Without your thorough effort this book would not have been completed: **Joan Levinson** for tying the text together so elegantly; and **Mary Gawlik** for making pragmatic changes and comments that refined this book.

Thank you to the many design instructors, professionals, and students who submitted their work and added to the many Speakouts, Excerpts, and Worklists. The breadth and depth of ideas from around the world demonstrate how expressive and intellectual graphic design can be.

And finally, a thank you to the following professors listed below who have reviewed this book and made their voices heard. Your devotion to teaching and your mentoring of the next generation of graphic designers enriches all our lives.

Trudy Abadie, Savannah College of Art and Design

Scott Anderson, Cape Cod Community College

Stephanie Bacon, Boise State University

Louis Baker, Savannah College of Art and Design

Tobias Brauer, Northern Kentucky University

Michele Bazemore, Prince George

Leslie Becker, California College of the Arts

David Begley, University of North Florida

Zoran Belic, Savannah College of Art and Design

Tim Birch, KCTCS

Sherry Blankenship, Ohio University

Henry Brimmer, Michigan State University

Robyn Brooks, Tunxis Community College

Mike Brown, Northeastern State University

Robert Canger, Brevard Community College

Lloyd Carr, New York City College of Technology

Karen Cheng, University of Washington

Eric Chimenti, Chapman University

Randy Clark, South Dakota State University

Sharon Covington, Tarrant County College Southeast

Lori Crawford, Delaware State University

Beckham Dossett, University of Houston

Thomas Elder, Boise State University

Eve Faulkes, West Virginia University

Ricardo Febre, Humboldt State University

Tom Fillebrown, Sierra College

Grace Fowler, Palomar College

Lynne Fleury, Western Iowa Tech CC

David Gilbert, Pellissippi State Community College

Mary Grassell, Marshall University

Jamie Gray, Kansas City Art Institute

Sabrina Habib, University of Florida

Kevin Hagan, University of Louisiana at Lafayette

James Haizlett, West Liberty State College

Alma Hale, Southwest Minnesota State University

John Harkins, Savannah College of Art and Design

Mary Hart, Middlesex Community College

Mariah Hausman, University of Miami

Nathaniel Hein, Delta State University

Merrick Henry, Savannah College of Art and Design

Pete Herzfeld, Frostburg State University

Dahn Hiuni, SUNY—Old Westbury

Brockett Horne, Maryland Institute College of Art

Jason W. Howell, Oral Roberts University

Jacqueline Irwin, Cowley College

Claudine Jaenichen, Chapman University

Courtney Kimball, Central Piedmont Community College

Kathleen Klos, Anne Arundel Community College

Joel Knueven, Cincinnati State

David Koeth, Bakersfield College

Cathy Latourelle, Northern Essex Community College

Joe Litow, SUNY Orange County Community College

Bobby Martin, Northeastern State University

Lynda Mcintyre, University of Vermont

Brenda McManus, Pratt Institute

Sean McNaughton, S.I. Newhouse School of Public Communications

Jon Mehlferber, North Georgia College & State University

Jerry Nevins, Albertus Magnus College

Laura Osterweis, Framingham State University

Myung Park, California State University, Sacramento

Mookesh Patel, Herberger Institute for Design and the Arts

Dan Paulus, University of Wisconsin-River Falls

Tamara Powell, Louisiana Tech University

Mat Rappaport, Columbia College

Elizabeth Resnick, Massachusetts College of Art and Design

Louise Sandhaus, California Institute of the Arts

Adel Shafik, Bakersfield College

Shawn Simmons, Kent State University

Kenneth Smith, Radford University

Kelly Statum, Lenoir Community College

Keith Tam, School of Design, Hong Kong Polytechnic University

Norman Taber, SUNY Plattsburgh

James Thorpe, University of Maryland

Michael Toti, Manchester Community College

Gwen Wagner-Amos, CSU, Sacraemento

Jonathan Walsh, South Carolina State University

Joyce Walsh, Boston University

Diane Webster, Mercer County Community College

David Weintraub, University of South Carolina

Eleanor Willard, Pitt Community College

Michael Williams, University of Kansas

Jennifer E. Wood, Boise State University

Bruce Younger, Monroe Community College

Dana Zurzolo, Pepperdine University

Un**veil**ing the revelation

Can one exist behind a face that is not theirs?

If so, can they remain sane as the reflection of their reality blinds them to what they see; while their eyes are closed, causing them to mistake nightmares for sought after dreams?

2

CHAPTER 1: ABOUT GRAPHIC DESIGN

About Graphic Design

1

→ **CHAPTER OBJECTIVES**

AFTER READING THIS CHAPTER, YOU SHOULD BE ABLE TO:

- Sequence the heritage of graphic design, beginning with early cave paintings, noting the first use of the term, and continuing through to present times.

- Summarize the many categories of graphic design.

- Describe what it means to be a graphic designer.

- Distinguish art forms and theories that have influenced the development of graphic design.

- Sequence the steps of the design process, from the first contact with a client to the finished work.

- Characterize the basic components of a graphic design solution.

- **Exercises and Projects**

Research categories of graphic design; critique graphic designs; design a T-shirt using text and image; visually document and present a business through the eyes of a graphic designer.

Graphic design is so much a part of our lives that at times it goes unnoticed. The layout of type and imagery on the page you're reading right now is a key aspect of graphic design. This book was designed by organizing all the visual and textual information into a communicable message, an object bound between two covers. But if organizing were the only job of graphic designers, the computer would have replaced us by now.

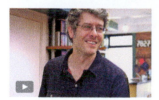

I think design in essence has to have an authentic honesty built into it. The main goal is to convey something that makes a difference in other people's lives. —Scott W. Santoro

◉—[**Watch** the Video on **myartslab.com**

Opposite page: KAREEM COLLIE. Opening page (detail) for *Man behind the Curtain* (full image, see Figure 1.31).

The field uses the two words *graphic* and *design* because of the dual nature of its process. Successful design solutions stimulate viewers intellectually and move them emotionally by including both familiar and surprising elements. As a result, a design communication can not only explain something to an audience but also affect that group on another level.

If you apply this complex thinking to your design process, the results will reflect your intentions, and your messages will be clear. A website is user friendly when its pages are attractive and its navigation simple; a book's content might be more accessible when its cover presents an expressive visual metaphor; a building is easier to navigate when the architect has applied a logical system of signage to its passageways. Each of these situations presents a unique communication problem, solved with specific design approaches.

Being a designer also involves finding ways to reveal the beauty in something that others may not see and expressing a thought in an

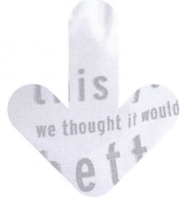

unexpected way—a mission through which blending the useful with the aesthetically appealing has one primary goal—to communicate. For example, Rafael Esquer embraced the notion of giving instead of receiving by transforming a clothing collection bag into a typographic call to action (Figure 1.1). The fresh approach was also a declaration that read visually as "This idea is so clever, I want to help." According to the designer, most people liked the design so much that they kept it as a laundry bag and sent their clothing donations in plain bags and boxes.

In another example, Pierre Bernard transformed the scaffolding for an architectural renovation into a sidewalk spectacle for the Centre Pompidou in Paris (Figure 1.2). A giant program listed the museum's monthly events, and, after each event was over, it was manually crossed out by mountaineers hoisting themselves down on ropes. This creative idea made a simple calendar into a continually dramatic and entertaining performance. The designer found an idea and pushed it further than anyone would have expected. A graphic designer needs to be part artist, scientist, researcher, psychologist, and businessperson.

Design work incorporates aesthetics (to achieve notions of beauty) structure (to organize and arrange), emotion (to accentuate feelings), and

1.1 RAFAEL ESQUER. Clothing donation bag sent to clients for the holidays as a way to help people in need.

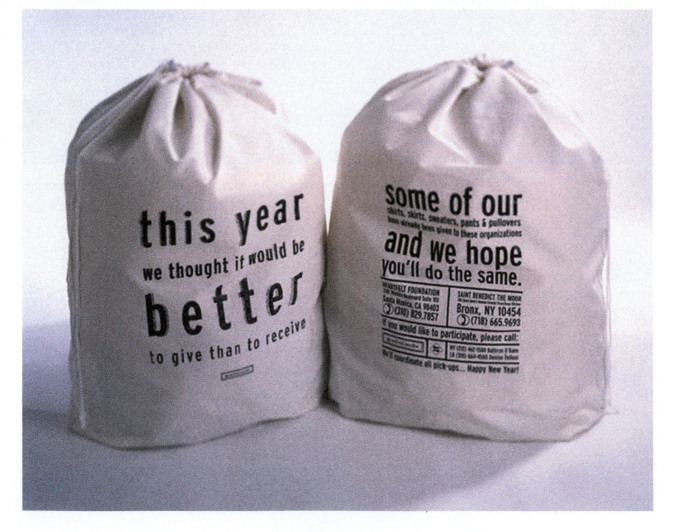

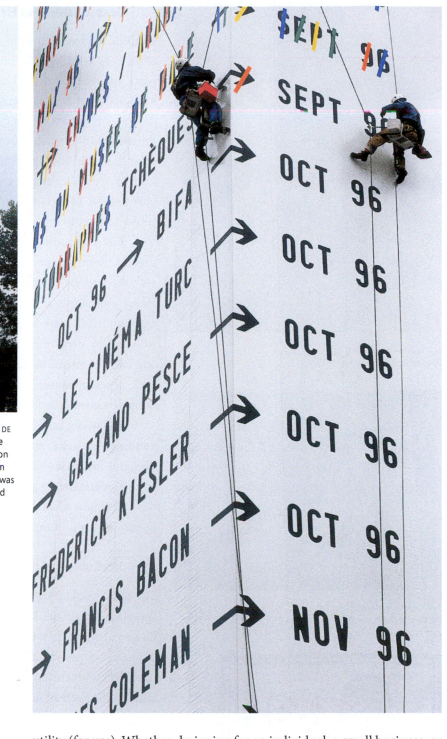

1.2 PIERRE BERNARD, ATELIER DE CRÉATION GRAPHIQUE. For the Centre Pompidou renovation in Paris, a temporary system of signs was devised. Type was hoisted up, crossed out, and ultimately removed.

Everything is design. Everything!
—Paul Rand

utility (for use). Whether designing for an individual, a small business, or a large corporation, the designer brings a degree of art, craft, intelligence, and intuition to every project.

Graphic designers often collaborate with writers, illustrators, photographers, and printers, making for an energizing work environment. Clients sometimes invest large sums of money, and an audience of millions just might see the designer's work, but the most exciting aspect of the graphic designer's job—and the most admirable one—is saying something that matters, and saying it with both grace and intelligence.

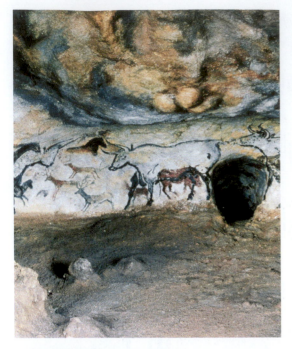

1.3 Lascaux cave paintings, Dordogne, France.

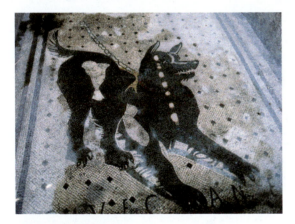

1.4 *Cave canem* (beware of the dog) mosaic, Pompeii, Italy. Late first century AD.

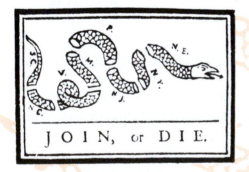

1.5 Benjamin Franklin's political cartoon that appeared in the *Pennsylvania Gazette*, his American newspaper from 1754. In Franklin's time, a superstition existed that a snake cut to pieces could be brought back to life if the pieces were put back together before sunset.

Graphic Design's Heritage

Graphic design (the art of conveying messages) has always been a part of us, even as far back as the early cave paintings of approximately 16,000 years ago. Scenes of the hunt—like the ones pictured at Lascaux—may have been more than merely decorative, possibly serving a number of purposes (Figure 1.3). One purpose may have been to literally describe the animals as an instruction manual might, picturing what to chase and what to avoid. Another likely purpose may have been to bring good fortune by symbolically capturing the animals on the wall. Made with only burnt sticks and colored pigments, these beautifully executed designs could have motivated the hunting group and helped it to survive.

Fast-forwarding 14,000 years, a stone mosaic from Pompeii was used to communicate an important message: "Beware of the dog" (Figure 1.4). A ferocious dog perfectly translated into the black and white mosaic along with words of caution made its point clearly to visitors. Forward another 1,700 years to America's first political cartoon, *Join or Die*, a woodcut by Benjamin Franklin (1706–1790) (Figure 1.5). Franklin's wit and conviction can be seen in the design of a snake severed into eighths, each segment representing a British American colony or region. The design inspired colonial unity in a yet-to-be-born country.

Today, digital printing and electronic media have replaced cave wall paintings, mosaics, and woodcuts. But the functional aspect of graphic design is the same—to educate, symbolize, and even compel us to action.

Understanding graphic design in the context of its history is essential to being a good designer. In Chapter 2, A Brief History of Graphic Design, you will come to see why this context is so important.

The Coining of the Term

The great book designer W. A. Dwiggins (1880–1956) coined the term "graphic design" in 1922. Since then, graphic design has grown into its own, legitimate profession. Dwiggins had it right in two ways. First by blending the words *graphic* and *design*, he better explained the process—graphic sensibility fused with planning and organizing. Second, by naming the profession, he categorized it as its own, legitimate activity.

Although graphic design had an association with commerce, just as printing, lettering, and the advertising trades did, it was no longer considered a subcategory of those trades but a valid field in its own right. Dwiggins's term was just abstract enough to encompass many kinds of design. (See the upcoming Excerpt from "The Name Game," by Michael Worthington.) The categories of graphic design, as described in this chapter, all have their own particular practices, and what unites them is the process graphic designers go through to communicate a concept.

As you continue reading this book, you will see just how that concept of process applies to the art of graphic design. The field is as much

Graphics Design

1.6 The *s* in *graphics* was eventually dropped by the media at the insistence of the profession.

▶ *In Practice: Oddly enough, it wasn't until the late 1970s that the media began to refer to the profession as "graphic design." Until then it was mistakenly called "graphics design," describing only the end product (the design of graphics), and neglecting the idea that there was an approach to the process, which the term graphic design more accurately describes. The media dropped the "s" (Figure 1.6).*

about problem solving, clear thinking, and creativity as it is about the end result, the final design.

The Expanding Field of Design

One of the wonderful things about the graphic design field is that it encourages creative people to develop personally challenging goals. Pushing further, beyond the most obvious design solution, is integral to being a good designer. This effort includes pushing how we develop concepts, how computer technology enables us to complete our tasks, and how new media can help expand graphic design language itself.

And we have academic support. In the last few decades, an increasing number of students have been pursuing master's degrees in graphic design and contributing to the rich mixture of ideas and culture. As a result, the field has grown and become a more sophisticated, serious field of study. Even a doctoral degree, the highest degree awarded in most disciplines, is now attainable as a course of study in graphic design, advancing research and enriching scholarship within the field. Books, journals, and magazines on the subject of design flourish, acknowledging the field's history, theory, methods, and influence. Graphic designers work in countless industries and throughout the world. And yet, design is still a bit of a subculture. Its professionals need to be constantly self-critical to ensure that the field expands beyond the mere styling of information. Graphic design reflects and shapes the culture in which it exists.

🖋 **EXCERPT: The Name Game** by Michael Worthington
(*AIGA Journal*, Vol. 16, No. 2, p. 37)

Eventually I realized it is the vagueness of the term "graphic design" that makes it so appropriate. The same reason my grandmother initially couldn't understand that term is the very reason it works. It can cover myriad skills, cope with technological innovations and changes in the profession, but still refer to the larger concerns of visual communication, representation, and issues of creating meaning through content. This flexibility allows me to take on the role of an interface designer, website designer, or motion typographer, and add that knowledge to the variety of skills that currently fall under the title "graphic designer," a term that itself is as unfinished and malleable as any digital piece of work.

A child is not a target.

Stop the cycle of domestic violence.

TurnAround, a nonprofit agency serving victims of sexual assault and domestic violence, provides counseling, community outreach, emergency shelter and hospital accompaniment to more than 10,000 women, children and men each year.

TurnAround can help: (410) 377-8111
The cycle of violence ends here.

Baltimore & Carroll Counties: Sexual Assault/Domestic Violence 24-hour crisis hotline: (410) 828-6390

1.7 DAVID PLUNKERT, SPUR DESIGN. Posters for TurnAround, a nonprofit agency serving victims of sexual assault and domestic violence.

Graphic Design Categories

To varying degrees, the intent of design is to persuade, identify, or inform. A book jacket informs the viewer of the book's content, persuades the reader to buy, and identifies the writer. The same is true in food packaging where persuasion, identity on the shelf, and information all matter. Even a geographical map's organization and clarity requires the designer to decide on what to include and exclude as well as how to present the information. A clear map is more likely to be purchased and used than a confusing map.

A designer's clients can range from a small, nonprofit organization in need of a few hundred educational posters (Figure 1.7) to a major corporation requiring a set of streamlined, easy-to-read forms that are printed in the millions (Figure 1.8). Take the time to get to know your clients as well as you can. It can help tremendously in producing a design that fits their needs. Each of the specialized areas of graphic design has its own particular problems to solve. The job of a publication design is not the same as that of a package design, for example. But with each project, it is you, the designer, who will bring a graphic sensibility to the final product.

Corporate Design

Corporations have large, internal design departments, hire independent design consultants, and devote relatively large amounts of money for their graphic design projects. Corporations need to project a consistent visual identity—one that brands a corporation into the minds (and hearts) of the general public.

1.8 LANDOR ASSOCIATES. FedEx Express airbill.
FedEx servicemark used by permission.

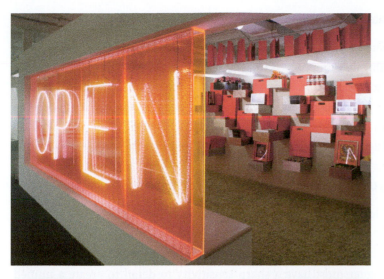

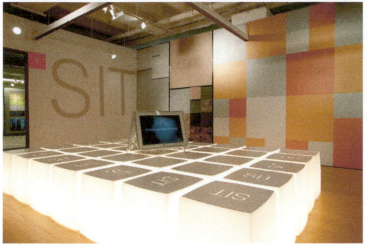

1.9 KUHLMANN LEAVITT, INC.
Design for Formica Group Neocon
exhibition space.

Environmental Design

Creating a three-dimensional experience for the visitor is the goal of an environmental designer (Figure 1.9). The category includes the design of museum exhibits, trade shows, and convention booths. Environmental design overlaps with signage design in the sense that both types of designers work closely with architects as well as interior and landscape designers and must have an understanding of structural materials. In addition, environmental designers must know audio/visual media, including lighting and sound techniques, and interaction design. Environmental design usually includes the display of signs, information designs, and other types of promotional materials. The overall design must remain in keeping with the objects or designs it contains.

Motion Design

This evolving field of design involves adding sound, motion, and time sequencing to pictures and words. Filmmaking, animation, and visual effects converge to tell a story or visually articulate a concept. Motion design projects include film title sequences, trailers, animations, and broadcast identifications (a short spot that confirms the channel being watched). The finished projects are displayed on television, in the cinema, on computer screens, and even through cell phones (Figure 1.10). (See the Speakout by Barry Deck on page 10.)

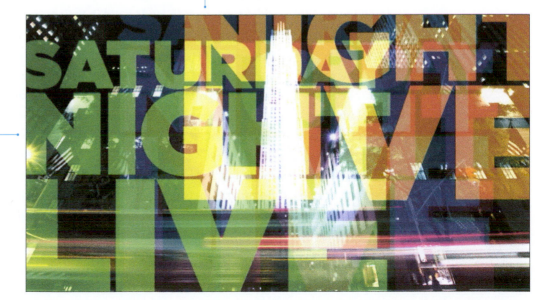

1.10 NUMBER 17, NYC; EMILY OBERMAN, art direction; NAZ SAHIN AND JESSICA ZADNIK, design; MARY ELLEN MATTHEWS, live action. Opening titles for Saturday Night Live.

1.11 MODE. Website design for Mellow Mushroom restaurant.

1.12 JONATHAN HOEFLER. Hoefler & Frere-Jones cover for specimens of type, 8th edition.

Interaction Design

Designers involved in this computer-based medium create user experiences through Internet browsers and touch-screen devices. Software allows for interaction through body movement and speech. This field is a quickly evolving one, and designers need to stay current with the latest software and hardware advancements. The field requires a working knowledge of programming languages (Figure 1.11).

Type Design

A type designer creates new letterforms and **fonts** (variations such as italic and bold) to develop a complete typeface family. The elements include letters, numerals, **ligatures** (where two letters are joined), and punctuation. The designer must have a sharp sensitivity to detail to create a unified feeling within a typeface. It is important to have a strong knowledge of the history of type and an understanding of the theoretical issues involved. As with all design fields, good skills in the latest computer technology will simplify your task. Type design involves a great deal of effort and the results may not be obvious to the general public, but designers understand how expressive a typeface can be and how it can subtly influence those who read it (Figure 1.12).

SPEAKOUT: Motion Design's Evolving Role by Barry Deck, BarryDeckGroup

Although the practice of graphic design began with print, designers are being asked with increasing frequency to consider time, motion, and sound in their work. This is part of a general trend in communication, which may have started with cave paintings and could lead to the making of full-on virtual reality experiences. Most of the messages that were conveyed in print only a century ago have now shifted to onscreen media, like movies, television, software, games, and the Internet. In El Lissitzky's 1923 manifesto, *Topography of Typography,* (which appeared in Kurt Schwitters's Dadaist magazine *Merz*), he wrote exuberantly, "The printed sheet overcomes space and time. The printed sheet, the infinity of the book, has to be overcome. THE ELECTRO-LIBRARY." That future is here, and technology continues to evolve. As the possibilities of the technology change, the designer's role begins to overlap with other disciplines. The difference between design and art has always been a subject of debate. Boundaries between graphic design and writing, software design, behavioral science, film directing, and editing do indeed blur. The graphic designers of the future will have more responsibilities and collaborators than ever, but there will always be a role for people skilled in telling stories visually.

1.13 ANDREA FELLA. *PAPER* MAGAZINE. Layout spread for this New York City-based independent magazine focusing on fashion, pop-culture, nightlife, music, art, and film.

Publication Design

Magazines, newspapers, newsletters, and other periodicals all fall within the umbrella of publication design. Thousands of periodicals are published each year in the United States alone, and other countries are equally invested in their own periodicals. Categories include news, business, travel, retail, entertainment, and fashion, and these publications are distributed weekly, monthly, quarterly, or annually. Each periodical strives for a unique identity, and the elements that provide this uniqueness are a blend of photography, typography, and continuity from page to page. In terms of design, a newspaper or newsletter might stress utility of reading, whereas a magazine will stress creative interpretation of each story (Figure 1.13). Now that most publications have both a print and online presence, designers have to consider how their designs will function in both platforms. A particular printed font may not work well online, or a sequence of images in print may not present themselves in the same way on the screen. Do you design for print and adapt it for the Web or vice versa? Or do you design with both formats in mind from the beginning? These decisions challenge publication designers every day. As online technology advances, such design decisions become not only more complex but also more important for the publication.

Book Design

Book publishers give the final, edited text to designers for layout. It is important that the designer understand the content when making decisions about the font, headers, and all other design elements. The style decisions need to be consistent with the subject matter (Figure 1.14). Illustrated books present a whole different set of design challenges.

1.14 MUCCA DESIGN. Layout spread for a dictionary of words that are a single letter in length. Initial letters were also designed specifically for the book, here a large letter *M*.

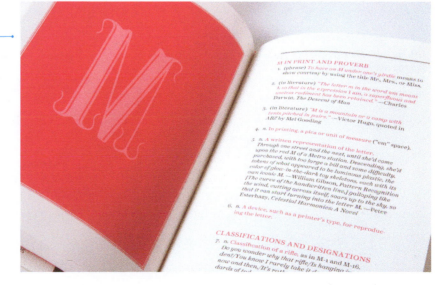

Book Jacket Design

The success of a book, or a series of books, may be dependent on the cover design. The cover relays a great deal of nonverbal information about the content. The ultimate test is the bookshelf—either at actual book stores or on a website where a book becomes a miniposter. The designer's job is to attract notice and provide a point of entry for the book (Figure 1.15).

Signage Design

Helping people find their way through stores, airports, highways, and buildings is the main goal of signage design. A strong understanding of typography is essential in this area of design, as is an understanding of building plans, floor plans, construction, and exit procedures. Signage designers work with interior and landscape designers as well as architects to create **signage**—a sign, or system of signs, that will be highly visible but also will integrate with the space for which they are planned (Figure 1.16).

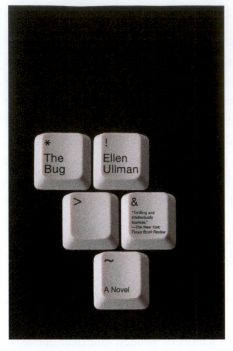

1.15 KEENAN. Book jacket for *The Bug,* Vintage Books. The image of computer keys illustrates this novel about the fate between a software programmer and the bug she sets out to eliminate.

> ❝❞ *A book is a container to save things permanently; better than a picture frame or filing cabinet.*
> —Alvin Eisenman

1.16 MICHAEL GERICKE/PENTAGRAM. Signage and wayfinding for Terminal 1 at Lester B. Pearson International Airport, Toronto.

1.17 DUFFY & PARTNERS. Logo for Tall Tales Restaurant. The handcrafted illustration brings warmth and charm to this Gander Mountain restaurant.

1.18 WORKSIGHT. Pocket folder and capability brochure for Automatic Data Processing (ADP). Computerized transaction processing is abstracted as a cover image for ADP's pocket folder. Inside, the brochure literally translates the end result of the cover—a mailed piece.

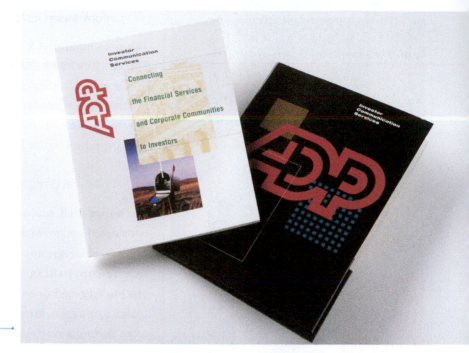

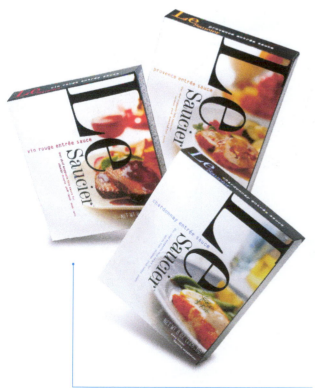

Brand and Identity Design

For any company to succeed, it must establish its own, unique **brand** (an identifying personality) that is burnt into the mind of its audience. A **logo** (a graphic or symbolic representation) can accomplish this function by presenting a face for the viewer to see—a visual identity (Figure 1.17). A logo also differentiates one company from another, becoming quite valuable if used consistently in advertising, print collateral, websites, and broadcast media.

Graphic designers who work at corporations create a wide array of materials. Style manuals help coordinate how a corporate identity is applied to various communications from the annual report and websites, to business cards, advertising layouts, and environmental signage. The goal is to create a comfort zone for the general public by consistently presenting a familiar, instantly recognizable face (Figure 1.18).

Package Design

Package design must function three-dimensionally and often utilizes texture as well as text and image. Industrial packaging is a major field, but it's the consumer category that holds the most presence for industry, including food and beverages, cosmetics, household products, pharmaceuticals, and smaller groups. Decisions about size and shape are often impacted by government regulations, and decisions about the overall personality and approach are often determined based on focus groups and consumer feedback (Figure 1.19).

1.19 LARSEN. Photography Lars Hansen. *Le Saucier* package design using contemporary typography and photography to bring a distinctive look and feel to this product.

Information Design

The presentation of information and data is both an art and a science. The designer must make data understandable and easy to use in a way that is effective, efficient, and attractive. Typical examples might include instructions for product use, signs, public information systems, computer interfaces, websites, forms, educational materials, maps, charts, graphs, and diagrams (Figure 1.20).

Collateral Design

Promotion that supports or reinforces an identity, service, or event is considered collateral material. This type of material includes brochures, mailers, catalogs, announcements, and so on. These materials usually require **copywriting** (composing the words), photography, and **illustration** (stylized drawing/painting). While advertising agencies handle major campaigns for promoting a brand's product or service, they will often commission designers to produce collateral pieces (Figure 1.21).

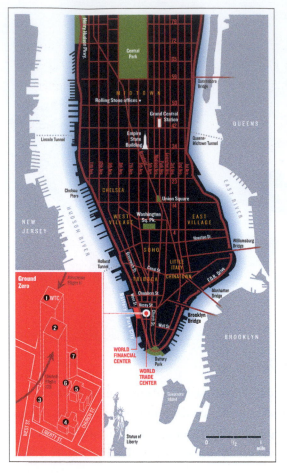

1.20 NIGEL HOLMES. A map of Manhattan/World Trade Center for *Rolling Stone* magazine that helped readers locate the specific 9/11 site known as "Ground Zero."

1.21 JASON ACKLEY, MORNINGSTAR. *Morningstar FundInvestor* and *StockInvestor* newsletters that project a clarity and vibrancy to complicated financial information.

Advertising Design

Graphic designers working within advertising media fuse their understanding of visual identity with campaign marketing strategies. Magazine advertising and direct mail are two potential directions for designers to take in this category. Designers can bring a graphic sensibility to traditional campaigns and help integrate type and image to strengthen advertising concepts. Advertising designers usually have a strong background in marketing (Figure 1.22).

1.22 SCOTT STOWELL, OPEN. The "Between" campaign, developed in collaboration with ad agency Wieden + Kennedy advertising agency, tries to make Coca-Cola more a part of everyday Japanese life. Each print ad defines a moment (and chance to drink Coke) by what came before and what comes after. In this example, the theme was "between heartbreaks."

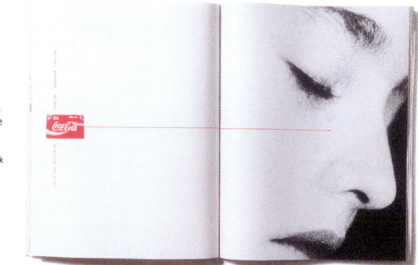

Self-Publishing

A digitally interactive performance is an example of how new media and activities can be incorporated into a self-published project. In the example shown here, the designer Elliot Earls combines elements of music, poetry, typography, design criticism, and performance into a piece that enters territory traditionally defined as fine art (Figure 1.23).

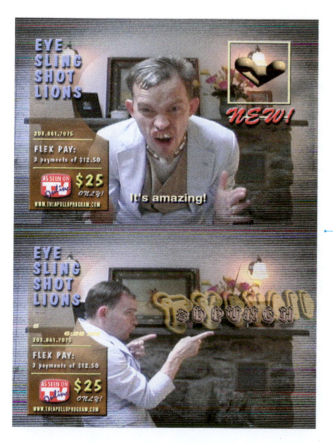

1.23 ELIOT EARLS. Video still. Eye Sling Shot incorporates a mélange of typography, sound, video fragments, interactive digital video, simulated live performance, short films, and pop music—all controlled by means of midi (musical instrument digital instrument).

Being a Graphic Designer

The field of graphic design is always changing and advancing. Keeping up with these changes means the life of a designer is continually exciting. The software applications used to create and assemble designs are making production effortless, digital printing technology is advancing every day, and critical writing on design has gained respect as a legitimate field. The general public seems to be more aware of the design world and of the huge impact graphic design has on daily life.

The design field can be so much more than a straightforward job. Designers are paid to be creative and expressive—something so few people in other occupations can claim. But the field also offers the chance to contribute to the community in a positive way. From social to political to environmental causes, each project offers an opportunity to make a difference in the world.

Contributing to the community in which you live begins with an awareness of that community. A conscious observation of how information is presented and how meaning is read must become your path of study. To be an informed designer, you need to be continually aware of current events as well as political, economic, and social issues. In other words, you need to take responsibility for your place in the world by reading newspapers, books, and magazines and by listening to the news. You should also keep up with what is happening in your community culturally—by going to museums, galleries, concerts, and theater. If you can present yourself to a client as a person who is intelligent and worldly, the client will trust your judgment ever so much more than if you appear to be uninformed. All this knowledge will help with your design work on a very practical level. The abilities we use to interpret culture and social issues are the same ones we exercise to solve design problems.

As a case in point, consider the Poetry Slam logo by Travis Olson and Carmichael Lynch Thorburn (Figure 1.24). Here the designers have created a humorous character to convey the organization's spirit; the starburst inside the voice bubble evokes a sense of passion about poetry readings. These events are not the tame readings you might have gone to in college. A poetry slam is a raucous, exciting, and creative affair. The simple colors of black and red further reflect the emotional charge of slamming. When form and content blend as well as they do here (with bold and simple lines and shapes), they achieve an effective whole, giving the design vitality through its consistency. The designers have been to poetry slams and know what they're about. They use that knowledge to create meaningful designs.

1.24 TRAVIS OLSON, CARMICHAEL LYNCH THORBURN. Logo design for Poetry Slam, Inc.

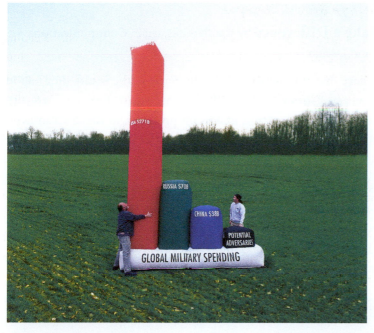

1.25 STEFAN SAGMEISTER AND HJALTI KARLSSON. "Move Our Money" charts as part of a traveling road show.

Voice and Vision

Acknowledging your individual point of view in your own work also has significant value. The places you've been, the things you've seen, felt, or heard, all feed into your ability to approach a design project in a unique way. Your life experiences, as well as your education, will have a profound impact on your designs. Because of these influences, your work will have a distinct identity and will be a contribution to the field and to the community. (See the Speakout by Kali Nikitas and Figure 1.27.)

So many charts are a mundane representation of data, but the "Move Our Money" chart is anything but dull (Figure 1.25). The designers blended creativity with politics through an unusual medium—an inflatable balloon. Part of a traveling road show, the sculpture dramatized extreme military spending, creating a spectacle wherever it went. The designers' voice and vision made an otherwise dull set of statistics become very much alive. The light-hearted approach brought a disarming aspect to the information, adding to the message by presenting horrifying data in a ridiculous way. The piece spoke effectively because there was an informed opinion to begin with.

In the context of a business-oriented problem, Cheryl Heller used a similar approach to create the package identity for LouisBoston (Figure 1.26). She used a witty voice and adept vision to promote the store's expanded offering for women and younger customers. A light-hearted presentation with an approachable style, the shopping bag design is humorous as well as engaging and intelligently communicates "young and fresh" at the same time. Its success derives from the insightful blend of form and content into a meaningful concept.

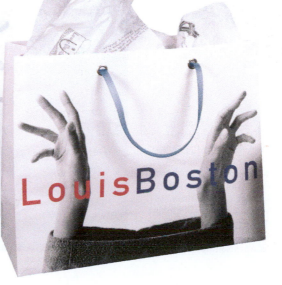

1.26 CHERYL HELLER. Package identity for LouisBoston.

SPEAKOUT: Design Can Make a Difference by Kali Nikitas, chair, Communications Department, Otis College of Art and Design (Figure 1.27)

In the past, kids were raised to believe that in order to make a difference in the world, they had to study to be lawyers, doctors, or engineers. However, graphic design has recently been credited with playing a significant role in society. Through word and image, on products, in the environment, on the web, in publications, and in advertising, graphic design has become a viable career path for instigating change.

Design students and practitioners can shift and alter ways of thinking and enrich the way we experience our everyday life. As image-makers and idea generators, we contribute to what people buy, how people vote, and the ways in which individuals live as citizens. Once students realize the profound potential of their major, they tend to develop a sense of responsibility and urgency towards contributing to the profession and the world socially, economically, politically, and environmentally.

Steal ideas—just not from other graphic designers.
—Ed Fella

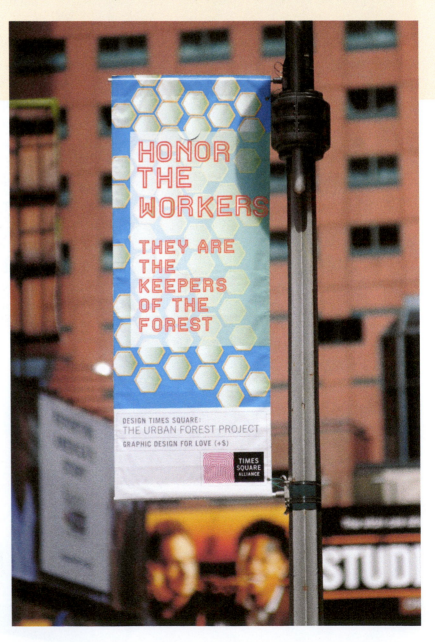

1.27 KALI NIKITAS AND RICH SHELTON. Graphic Design for Love(+$). "Honor the Workers" was one of 200 banners designed for "The Urban Forest Project," an outdoor banner exhibit created for the Times Square Alliance. Profits from the sale of the banner designs went to help the Worldstudio AIGA Scholarships program.

In Janet Froelich's cover for *The New York Times Magazine* (Figure 1.28), she created a mathematical equation comprising images of objects, the sum of which was inspiration. The article itself answers the question as to where inspiration comes from, while the cover poses the question in a way that suggests that the answer is direct and concrete. Of course readers will want to find out why the particular images were chosen. Froelich knew how to make the most of the elements supplied to draw the viewer in and to give the form meaning. Design like this example doesn't happen unless there is someone behind the work who has a voice to verbalize the idea and the vision to carry it out through graphic form.

The computer has given almost everyone the ability to move type and images around the page into pleasing arrangements. But the computer can't translate the spirit of the times or bring a personal touch to a communication. Simply put, the voice and vision that designers give to their projects make the communication more human and more effective. Good designers have the ability to create meaning and create change. (See the Speakout by Maya Drozdz.)

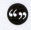

The creative process is not performed by the skilled hand alone, or by the intellect alone, but must be a unified process in which head, heart, and hand play a simultaneous role.

—Herbert Bayer

1.28 JANET FROELICH. Cover for *The New York Times Magazine*.

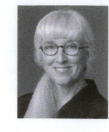

Katherine McCoy was cochair of the design department at Cranbrook Academy of Art for twenty-four years, a distinguished visiting professor at London's Royal College of Art, and a senior lecturer at Illinois Institute of Technology's Institute of Design. Her graphic design practice and teaching have garnered her a medal from the American Institute of Design (AIGA), election to the Alliance Graphique International, and an honorary Ph.D. from the Kansas City Art Institute. She served as national vice president of AIGA and is a past president of both the Industrial Designers Society of America and the American Center for Design. She writes frequently on design criticism and history, has coproduced a television documentary on Japanese design, and chaired the first Living Surfaces Conference on interactive communications design. Currently the Hall Distinguished Professor at Kansas City Art Institute, she is also a partner, with her husband Michael McCoy, of High Ground, a design workshop and studio based in Colorado.

▶ How do you define graphic design—what does it mean to you?

Graphic design is both a process and an artifact—software and hardware. Communications design involves serious cerebral activity, including research, analysis, conceptualizing, and planning. All this rational activity must be translated through the designer's personal talent, intuition, experience, and a scientifically indescribable connection between body and brain. In that mysterious mix, original expressions are born which bring the design brief to life and resonate with the audience. These expressions take eloquent form in the tangible artifacts that we see in museums and design exhibitions, including posters, books, brochures, and many other graphic media, and also in nonphysical communications in the digital realm. At the end of the day, it is the audience's interaction with the graphic message, and their response, that really counts.

How do you see design evolving? Is it morphing into something designers won't recognize in 100 years or are there staples that hold true?

The staples hold true, but rapidly changing media challenge designers to develop new conceptual theories, processes, and skills. Interactive electronic communications require far more education to understand how audiences navigate and make meaning out of nonphysical communications spaces. Electronic communications design now involves sound, motion, and interactivity.

What advice or insight can you give to students studying graphic design?

Passion is the largest requirement. This is a challenging, competitive, and rapidly evolving field, so it is essential that prospective designers feel a real love of the conceptual and form-giving elements.

"Passion is the largest requirement."

Vignette 1.1 Cranbrook Crane symbol, Cranbrook Educational Community.

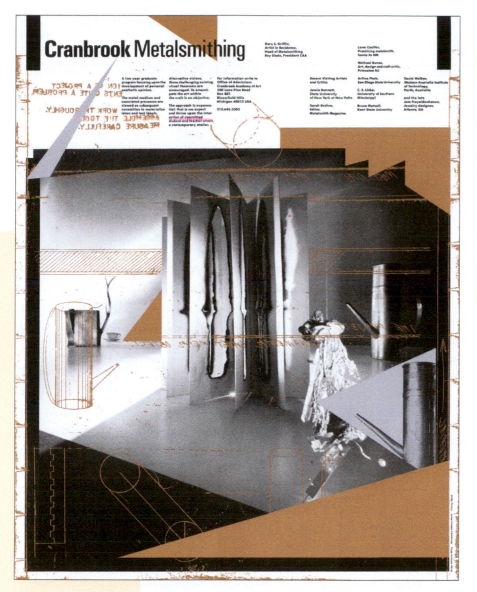

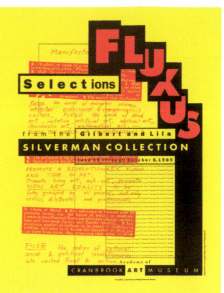

Vignette 1.3 Fluxus exhibit catalog cover. This cover's structure refers to a diagram of the history of Fluxus by the movement's founder, George Maciunas. The bright colors of cheap printing paper are in the provocative spirit of Fluxus.

Vignette 1.2 *Cranbrook Metalsmithing* poster. A staged photograph makes a landscape of recent student work. Here, a schematic plan for the pitcher is superimposed and metallic forms of silver and copper cut into the photograph.

Vignette 1.4 KATHERINE MCCOY & DANIEL LIBESKIND. Architecture *Symbol and Interpretation* exhibition poster. An announcement for an exhibition refers to the rational and irrational in architecture. A reconstruction of a De Chirico painting includes an early Renaissance perspective drawing and diagrammatic notations from an Edgar Allan Poe short story.

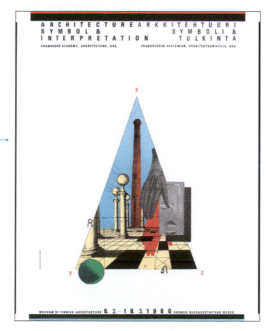

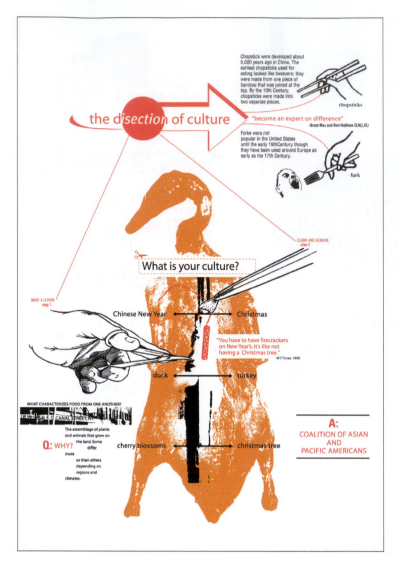

Chopstick were developed about 5,000 years ago in China. The earliest chopsticks used for eating looked like tweezers; they were made from one piece of bamboo that was joined at the top. By the 10th Century, chopsticks were made into two seperate pieces.

the disection of culture

chopsticks

"become an expert on difference"
-Bruce Mau and Rem Koolhaas (S,M,L,XL)

Forks were not popular in the United States until the early 19thCentury though they have been used around Europe as early as the 17th Century.

fork

CLAMP AND REMOVE
step 2

What is your culture?

MAKE A LESION
step 1

Chinese New Year Christmas

"You have to have firecrackers on New Year's. It's like not having a Christmas tree."
-NY Times 1998

duck turkey

WHAT CHARACTERIZES FOOD FROM ONE ANOTHER?

CANAL STREET, NY

Q: WHY?

The assemblage of plants and animals that grew on the land. Some differ more so than others depending on regions and climates.

cherry blossoms christmas tree

A:
COALITION OF ASIAN
AND
PACIFIC AMERICANS

1.29 LOAN LAM. Design for a flier titled *What Is Your Culture?* questioning a law banning the use of fireworks in New York City's Chinatown.

Addressing the Personal and the Public

There is both a personal and a public side to graphic design. In other words, the same communication tools that designers use in service to the business community can also be redirected in service to the social community. Graphic designers have that potential, and they work in both arenas. The emotionally charged thought is easily expressed when words and images are at our fingertips.

The flier *What Is Your Culture?* by Loan Lam does just that (Figure 1.29). After noticing a newspaper article about a law banning the use of fireworks being enforced in Chinatown, especially during the Chinese New Year, Lam felt the need to speak out. After researching the subject, she used her design to make the point that banning fireworks during the Chinese New Year was as culturally insensitive as banning turkey during Thanksgiving or a decorated tree during Christmas. She used an image of a cooked duck—a classic icon of Chinese culture seen hanging in most Chinatown restaurant windows. In a surreal twist, a firecracker is being removed from the duck's dissected body. It is an emotional translation as much as a literal one. The ban on fireworks rips something vital out of Chinese culture. The image is confrontational and creates the kind of public dialogue the designer wanted.

▶ *In Practice: A cooked duck is used as a cultural icon to represent Chinese culture. The dominance of the image draws the specific audience in, while smaller images and text explain the social issue being challenged.*

Another equally passionate student project is a design titled *Man behind the Curtain* (Figures 1.30 and 1.31) by Kareem Collie. The piece

SPEAKOUT: **Intuitive Knowledge** by Maya Drozdz, visualingual. wordpress.com

Design is something to which you have been exposed your entire life. You take your cues from design as you make even the most mundane choices, including shopping for groceries or interpreting road signs. If you ever feel overwhelmed by how much you don't yet know about design, consider and draw on the wealth of design knowledge you already have. You may lack the specialized vocabulary to articulate what you know, but you already have an intuitive knowledge about the subject.

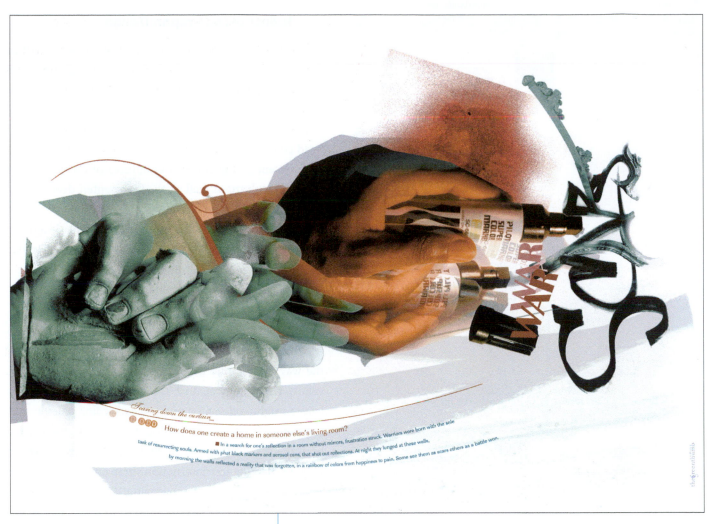

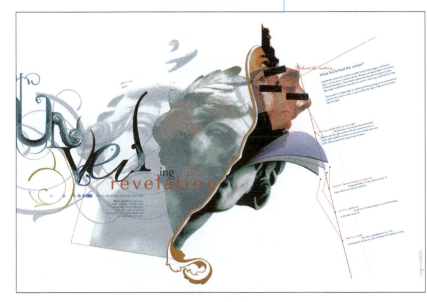

1.30 KAREEM COLLIE. Design project (series) on revealing a neighborhood's cultural icon discrepencies; titled *Man behind the Curtain*.

1.31 KAREEM COLLIE. Opening page to *Man behind the Curtain*.

notes that in Crown Heights, a neighborhood in Brooklyn whose population is primarily of African descent, there are many bronze statues commemorating civic leaders, but not one of them is black. The student asks: "How can I create a home in a place that feels like someone else's living room?" His answer is expressed in the design. A bronze hand transforms into the designer's own hand. The "tag" is a graffiti signature that takes some representation away from the past and moves it into the present day. In both projects, the designers use personal convictions, a strong connection with their heritage, and awareness of their surroundings to make a social concern more public. *What Is Your Culture?* deals with the conflict between Chinese culture and Western law. *Man behind the Curtain* explains neighborhood graffiti as a proud expression of black presence. In this sense, the personal, expressed publicly, makes for what we might call a citizen designer, an important role in the field.

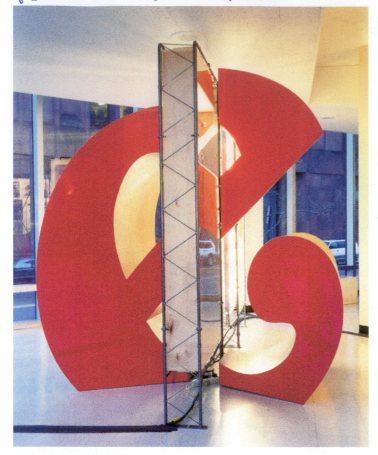

1.32 ABBOTT MILLER/PENTAGRAM. Exhibition design for "The 30th Anniversary Covers Tour" for *Rolling Stone* magazine.

1.33 THEO VAN DOESBURG. *Contra-Composition of Dissonances, XVI.* 1925.

1.34 RICKY CASTRO AND BROOKE MACKAY. Vancouver Culture Guide.

Influences on Graphic Design

Graphic design is affected by many other fields within the visual arts. We see the influence of sculpture and architecture in the exhibition design by Abbott Miller for *Rolling Stone* magazine in which a giant, fractured, three-dimensional letter *e* from the rock magazine's own masthead emerges (Figure 1.32). There is a definite sensibility reminiscent of the colossal sculptures of Swedish artist Claes Oldenburg as well as the fragmented deconstructivism of contemporary architect Frank Gehry. These keen references are pulled into the box of the designer's own problem. The result is a design solution that has visual impact and cultural significance.

Designers can also embrace literature for its storytelling, philosophy for its ethics, science for its objectiveness, linguistics for its syntax, and so on. Noticing the nonlinear storyline of a movie you saw could inspire the way you handle the type in your design; the warm yellow street sign against the backdrop of cool green leaves might influence your project's color palette; and the step-by-step process you went through to build your bookshelves (easy at first, then more complex, finishing with a satisfying last instruction) may possibly affect the way you sequence pages in the layout of a magazine. The pure, utilitarian compositions of Theo van Doesburg help us to realize how affected we are by the concept of abstraction (Figure 1.33). The Vancouver Culture Guide by Ricky Castro and Brooke Mackay was clearly influenced by this type of stark abstraction. The clear structure and playful grid further interprets this abstract yet useful sensibility (Figure 1.34).

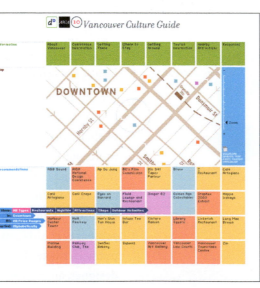

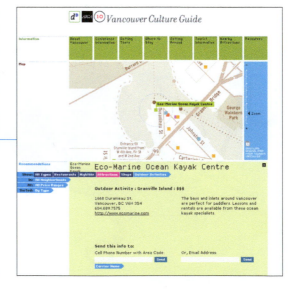

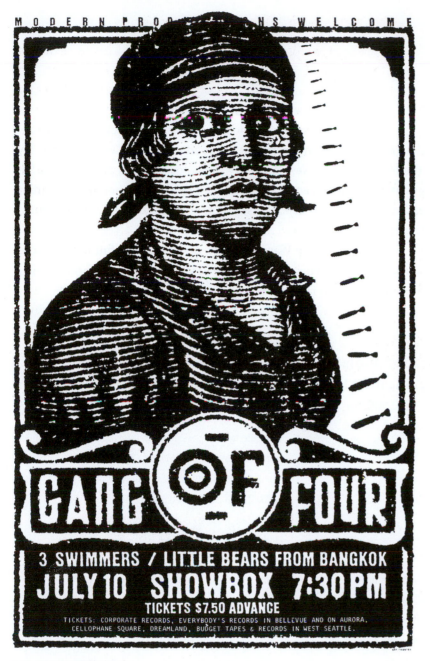

Music also has a large influence. A reoccurring melody in a piece of classical music from 300 years ago may help a designer understand how to bring unity and rhythm to a series of printed pages with a repeating graphic element. Or, similarly, a designer's work may be energized by the influence of the punk rock movement of the late 1970s and early 1980s. The structure, the beat, and the melody of music can all have an impact on a design. Some of the designers profiled in this book talk directly about their influences. In all the work presented here, you will learn to discern the influences, and more important, you will learn to look to outside sources to inform your own design work.

The fliers by Art Chantry take an unusual approach to punk rock (Figure 1.35). Their tough photocopier aesthetic complemented the "street" environment of the fliers—taped and stapled to telephone poles and sides of buildings. The visual language also worked backwards: distressed graphics became an alternative language to counter the bland aesthetic conventions toward which design seemed to be heading during that time period, for example, uninventive grids and overuse of the typeface Helvetica.

1.35 ART CHANTRY. Black and white offset poster for the music band Gang of Four.

► *In Practice: László Moholy-Nagy (1895–1946), believed that a strong interrelationship exists between the fine and applied arts. In his 1947 book* Vision in Motion, *Moholy-Nagy wrote of design's broad scope: "There is design in organization of emotional experiences, in family life, in labor relations, in city planning, in working together as civilized human beings." A very basic, reductive approach was a way to connect the various fields. Architecture, painting, photography, industrial and graphic design, and so forth, all shared an aesthetic based on a simple but inventive use of materials and production. A refinement of this approach translated into the clean, organized Swiss style of the 1950s.*

 Designing is not a profession but an attitude.

—László Moholy-Nagy

THE NEW SCHOOL

1.36 SIEGEL & GALE. The New School visual identity.

The agitated, expressive spontaneity of punk rock still influences design today, an example of which is even seen in the visual identity for The New School in New York City by the design firm Siegel & Gale. Its graffiti aesthetic has an unexpected edge that reflects not only the urban environment of the school itself but also its socialist underpinnings (Figure 1.36).

In the excerpt by Warren Lehrer, many of the definitions, associations, and contradictions of design are fleshed out in poetic form. Its most poignant line is his last: graphic design can be the life you make it.

EXCERPT: Emptying the Spoon, Enlarging the Plate; Some Thoughts on Graphic Design Education by Warren Lehrer, *The Education of a Graphic Designer, Second Edition,* Allworth Press, 2005

graphic design is an art

graphic design is a business

graphic design is a profession

graphic design is next week's garbage

graphic design gives shape to culture

graphic design gives shape to ideas

graphic design gives shape to information

graphic design gives shape to misinformation

graphic design gives shape to feelings

graphic design gives shape to stories

graphic design gives shape to dreams and experiments

graphic design gives shape to experience

graphic design creates experience

graphic design is the visualization of language

graphic design facilitates dialogue

graphic design boils things down like poetry

graphic design diagrams teeming complexities

graphic design grows out of local traditions

graphic design drains local traditions

graphic design is manifest through invention

graphic design can help save lives

graphic design can destroy lives

graphic design can pose questions and illuminate ambiguities

graphic design can help transform consciousness

graphic design can make the ordinary sacred

graphic design can be used as a weapon

graphic design can be cool, slick, objective

graphic design can be personal, idiosyncratic, hot, deep, strange, lovely

graphic design can be playful, funny, ironic, or biting

graphic design can make the useless mandatory

graphic design can make the unseen visible

graphic design can make the incomprehensible clear

graphic design can be condescending, misinformed, and insulting

graphic design can be a flower blooming on a rainy day

graphic design can help perpetuate stereotypes or dispel them

graphic design can help facilitate democracy

graphic design can help fake democracy and enable fascism

graphic design is a powerful gift/responsibility

graphic design can be a one- or a two-trick pony

graphic design reveals the society that produces it

graphic design can be the life you make it

The SCI-Arc lecture series poster demonstrates the production value of a design idea (Figure 1.37). The event hosts cross-disciplinary speakers that push the technological boundaries of architecture. In this spirit, the piece twists the idea of a traditional announcement. It is created with a **silkscreen,** a common printing method used to make posters, but one printed onto a clear, inflatable plastic poster. It must be pumped up to be read and, in so doing, transforms into a three-dimensional, toy-like object.

Knowledge of every possible medium is quite valuable to the graphic designer. How something looks in its texture and feel is built into the images a designer uses, but texture and feel also become part of the printing of a brochure or the functioning links on a website. These subtle finishes can make or break a design. A crisply folded brochure or a website's seamless flow through efficient coding all become part of the design process, too. Knowing what the possibilities are can greatly expand your creativity.

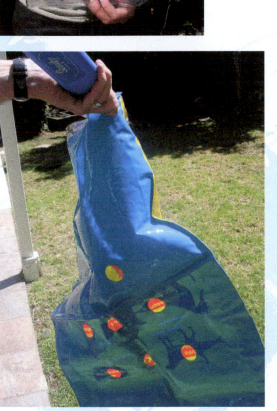

1.37 MICHAEL WORTHINGTON. SCI-Arc lecture series poster using an inflatable poster to draw attention.

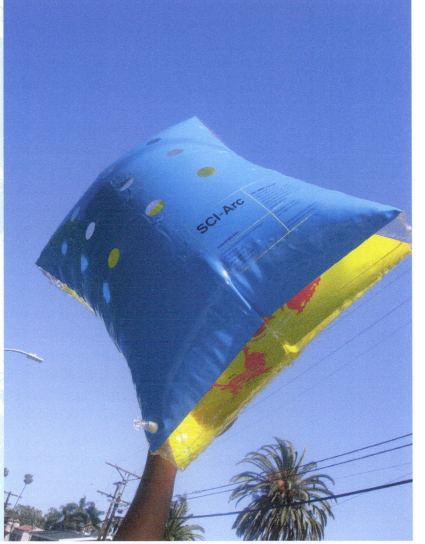

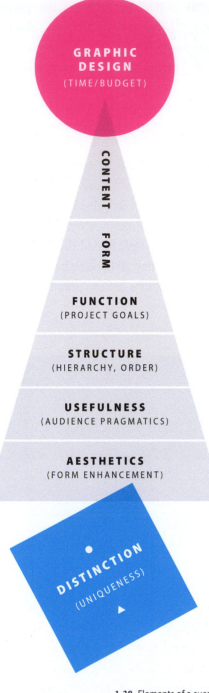

GRAPHIC DESIGN
(TIME/BUDGET)

CONTENT

FORM

FUNCTION
(PROJECT GOALS)

STRUCTURE
(HIERARCHY, ORDER)

USEFULNESS
(AUDIENCE PRAGMATICS)

AESTHETICS
(FORM ENHANCEMENT)

DISTINCTION
(UNIQUENESS)

1.38 Elements of a successful design solution.

> *Everything should be made as simple as possible, but not simpler.*
> —Albert Einstein

The Nuts and Bolts of Graphic Design

The design process is typically linear. Steps include the initial brief, research, roughs, and so on. Along the way are basic components (or elements) that designers must consider and factor into every distinctive design solution (Figure 1.38).

Components of a Successful Design Solution

Time/Budget: The most concrete of graphic design components, making graphic design an applied art with constraints.

Content: What needs to be included in the communication being made.

Form: The shape a design takes based on the content it needs to convey.

Function: The basic determination of a project's goals. For example, a promotion for an event will have, as its main objective, to convince people to attend. Function defines the direction a design will take.

Structure: A hierarchy to the audience: what to see and read first, then second, third, and so on. Every design benefits from some kind of structure or planned order to convey information.

Usefulness: A practical consideration to make the design useful for the audience. Usefulness can include many aspects. For example, an edgy aesthetic with distressed type might be useful for a music magazine, but not for instructions on a medicine bottle, which must be in a clear, easily readable typeface.

Aesthetics: The way a design looks, which can attract or repel the audience. Aesthetics is tied to usefulness in this way. An environmentally friendly product that is packaged with a cold, industrial aesthetic isn't going to connect as logically as one that is packaged using earth tones and organic shapes. A design that is tough or sweet, mundane or exciting, should be made with the subject and audience in mind. Remember, though, that aesthetics can be a matter of taste and are influenced by cultural norms. You need to know your audience and the context in which your work will be seen.

Distinction: The ways a design can be different from all that is around it. We are bombarded with all sorts of messages and images. Your design must somehow stand out. If a wall full of posters shouts, a unique quality might be achieved by one that whispers. The ephemeral nature of graphic design offers the possibility for distinction to be made by what a design does (it is functional, structured, useful, and aesthetic), but also by what it doesn't do.

▶ *In Practice: There is a joke within the profession in which a typical client is always presented with three options—a kind of a triangle, as it were. The options are as follows: a project can be done quickly, well, and cheaply, but the client can pick only two of those options. The combinations are as follows: (1) design made quickly and at a high quality, but at a cost that will not be cheap, (2) design made quickly and cheaply, but not of high quality, and(3) design with high quality and made cheaply, but done slowly.*

1.39 Client brief outlining project goals, coordinates, and suggestions.

1.40 Schedule notating what is due, and when.

1.41 Thumbnail sketches indicating ideas, in this case, creating a map of company locations as a three-dimensional construction that can be photographed.

The Graphic Design Process

Getting a **design brief** from a client is generally the first step in the design process (Figure 1.39). A brief might include a rough outline about the company initiating the project, its history and mission, the goals of the company's communication, a target audience (age, sex, and social levels), and the general requirements (media, budget, and time frame).

Once the client has submitted the brief, the designer creates a schedule (Figure 1.40). If no brief exists, then the designers might want to create one. This information becomes part of the project's research (for more details on research, see Chapter 4). **Research** helps determine what the project is really about and where it can go. A company's competitors—along with any of their solutions designed along the same terms—help a designer get started. Knowing design history, how past designers have approached similar communication problems, becomes very valuable at this early stage of the process.

When a designer has done enough research and starts to feel comfortable with the knowledge attained, she begins developing ideas. Designers record these ideas as small drawings, known as **thumbnails,** on paper or on a computer screen. Here the designer begins to indicate words and images with the simplest lines and shapes (Figure 1.41). The point is to generate as many thumbnails as possible and to do it as quickly as they occur so they aren't forgotten. Many idea-generating techniques come into play during this phase of the process (see Chapter 5 for a discussion of such techniques).

Selecting from the thumbnails, designers then enlarge a few of the best ideas into rough approximations of the design (Figure 1.42). These **roughs** help determine how the design ideas can be better visualized and further refined. Designers present these roughs to their colleagues in a session called a **critique.** A critique is an evaluation in which a professor, classmates, and, when you're working at a design firm, your manager

1.42 A "rough" example of an actual map sketched in against the corner of a wall.

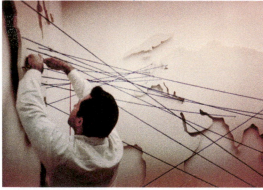

1.43 A studio setup where the map construction is made ready for photographing.

1.44 MICHAEL BRALEY. Final design as it appears in the printed brochure.

and coworkers, review the solutions you have created. Critiques also help you to clarify ideas; asking questions about your own work can begin the process. For example: Is the objective being met? Is the concept communicating? How is the design being packaged and does the solution work within the company's brand image and strategy? Is the form creative and eye-catching? Is the overall design pushed as far as it can go, or is there another level that the concept can step toward? The answers and the discussion that follow these kinds of questions will help you move forward. Ultimately, the critique will help you clarify ideas and recharge your creativity. (See the Worklist: How to Be Critiqued by Randall Hoyt.)

Final **comprehensives,** or **comps** as they're called, are the polished and finished versions of roughs. Comps are prepared for the client and, therefore, typography, imagery, and layout are more refined. For example, a poster should be scaled to 100 percent to realize its full effect, a website presented in the context of a computer screen, a package's label wrapped around its container—all with the intention of bringing the comp as close to the real thing as possible.

At the **presentation,** the designer shows the finished comp to the client, explaining the ideas behind the solution and going over the entire concept. Designers do their best to make sure the client feels that the primary goals are being met, with the design balancing creativity, integrity, clear communication, and budget.

If approved, the design goes into actual **production** in whatever media it is intended. At this point, the designer or design team needs to prepare the final artwork (Figure 1.43), shoot the photographs, edit the text, and assemble all the parts into the design's composition (Figure 1.44).

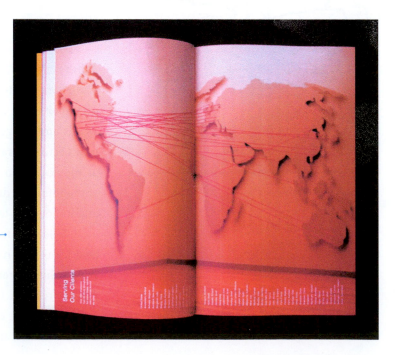

How to Be Critiqued by Randall Hoyt, associate professor of communication design, University of Connecticut

The critique process is essential in graphic design education, but we forget how much of a skill it actually is. Design students must be prepared to take advantage of the experience. Following are twelve steps to a healthy and memorable critique:

1 Get some sleep: Preferably a good night's sleep, but no fewer than three hours.

2 Look sharp: Engage in the rituals of hygiene. Take a shower and put on clean clothes free of tears and stains. How your ideas are perceived is in direct relation to how you are perceived. Dress accordingly.

3 Bring some work: If you don't have work, then come anyway and listen. When it is your turn, respectfully decline.

4 Shut up and listen: Give a brief introduction to your work, and then hear what others have to say.

5 Rehearse your introduction: Write it down, but don't read it. Spend no more than 2–4 minutes explaining it.

6 Present your work well: Work should be well crafted, clean, and neat. Keep process materials well preserved and organized.

7 Know your issues: Facilitate your critique by asking for commentary on specific issues in your introduction. But don't direct it—allow for a fresh response from your reviewers.

8 Don't critique yourself or your work: Give yourself a break and let everyone else do what they came to do.

9 Don't be defensive: You can explain confusing aspects of the work when necessary, but do not try to convince people that your way is correct. Let the discussion run its course—listen to all sides.

10 Take notes (or have someone take them for you): Critiques go quickly, so record what happens. They are an invaluable resource.

11 Don't take it personally: Try to remain detached while your work is discussed. If you think your critique was too personal, talk about it with your instructor outside of class.

12 Thank everyone: Appreciate the effort of those involved and thank everyone for their time in discussing your work.

In Perspective

There are many areas of graphic design, but whatever the final form, the designer's job includes assembling words, numbers, and images into a coherent whole. Thinking is required in all the processes of design. This discipline is not an intuitive art; it is an art of rationality combined with creativity. The designer combines all the elements into a cohesive whole, giving a unique identity to a product, service, or company, just as one's manner of speech, facial features, or the clothes one wears shout THIS IS ME!

As ideas, aesthetics, and digital technology merge more cohesively, the understanding of graphic design as an applied art will change, too. This energized path is just starting to emerge in this early part of the twenty-first century. It includes design solutions that are printed, yet animate, that are projected, but interact with the user. As you will see in the following chapter on the history of graphic design, design has been vital to our culture and to the world. Its goal for the future remains the same—to create communications that are meaningful.

EXERCISES AND PROJECTS

✓ ● ─ **Review** additional Exercises and Projects on **myartslab.com**

Exercise 1 (Categories of Design): Research two categories of graphic design, for example, package design and motion design. Then find at least two design firms that specialize in those areas. Use the Internet, magazines, books, and design competition annuals in your search. Create a five-minute presentation reviewing the two categories, the two firms, their locations, and how they approach their projects. Include the skills you think are especially necessary for each of the two design categories.

Exercise 2 (Design Ideas): Find an example of graphic design that you think is terrible. It can take any form—an advertisement, website, motion design, package, and so on. What is the basis for your choice? What is the design lacking? Next, choose an example of graphic design that you think is fabulous. What makes it so successful? Present both to the class and give the reasons for your choices.

Project 1 GENELLE SALAZAR. T-shirt design with the statement: GRAPHIC DESIGN IS ALL WORK & NO PLAY.

Project 1 (T-Shirt Design): Design a T-shirt using both text and image that together define graphic design for you. The text must include the words "graphic design is." Begin by researching at libraries, bookstores, and the Internet. Consider the audience and the context in which the shirt will exist. When you're ready, begin sketching until you have two or three ideas that you can refine further. Think in terms of symbols—not illustration. Reach beyond the most obvious and try bringing a related activity or subject to help paraphrase what design is, for example: "Graphic design is like a…." "Creating graphics is just like…." Consider iconography, various typefaces, typography, scale, and punctuation. There are no restrictions

on color or style of shirt. Use the back of the shirt only if it works with your idea. For the finished piece, either present a flat 11" × 17" laser print-out with the design located within a shirt, or use a real shirt (instructor's preference).

Things to Consider: *Be sure to consider the social aspect of a T-shirt. It has to be something wearable, but also fun to look at. Also think about how the design might be produced—screen printing or heat press.*

Project 2 (Design Emergency): Find a business or organization and visually document as much as you can about it: its visual identity, location, advertising, collateral materials, and web presence. Consider something fun and treat your response as a kind of design emergency in how you believe design can help them succeed. Make your presentation on two full-color poster-sized sheets (18" × 24"). Include as much supplemental information as you feel necessary, including charts, categories, a list of their products or services, their context in a store, their competition, and anything else that seems relevant.

Things to Consider: *Be as outrageous as you can be in your choice of subject and in the presentation design you make.*

Project 2 ABBY HIRSH. Student project using data to create a visual document that promotes a bagel store's many variations.

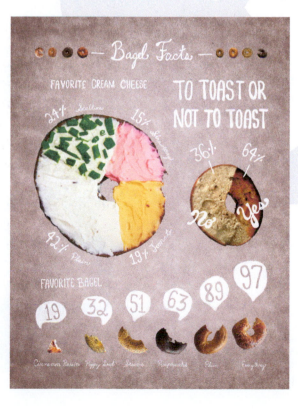

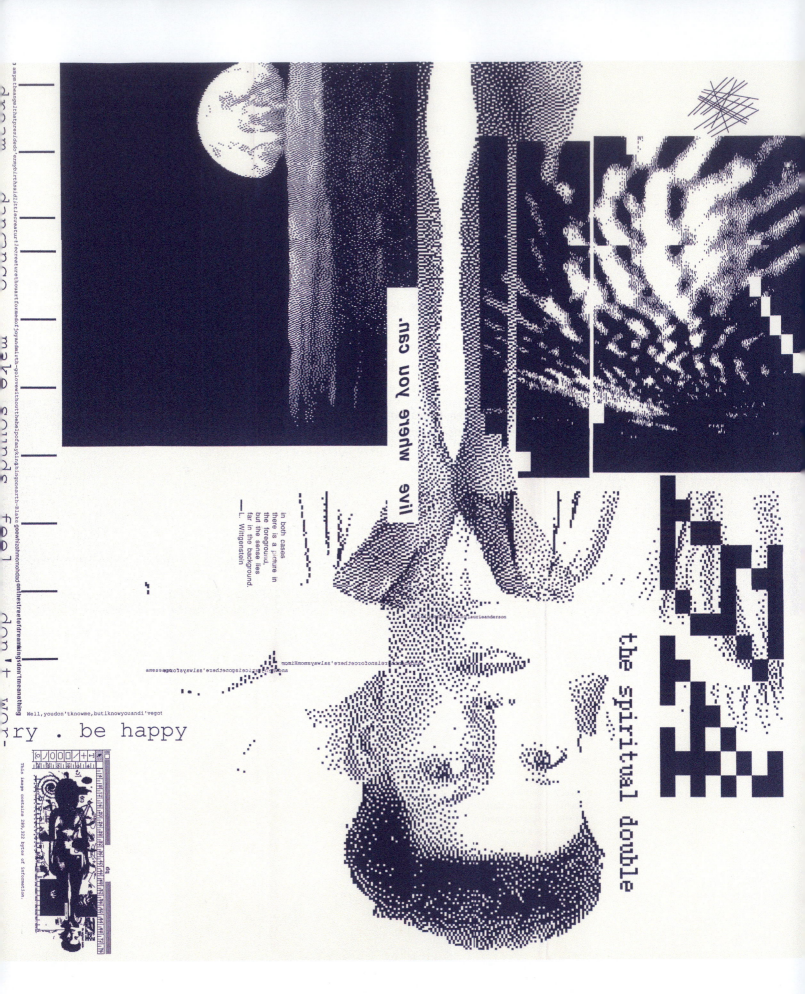

A Brief History of Graphic Design

CHAPTER OBJECTIVES

AFTER READING THIS CHAPTER, YOU SHOULD BE ABLE TO:

- Discuss how the Industrial Revolution led to graphic design as a distinct profession.
- Summarize how the Arts and Crafts, Aestheticism, and Art Nouveau movements evolved in response to industrialization.
- Explain how the trend toward abstraction enabled artists, designers, and architects to convey ideas with more complexity.
- Analyze how Modernist movements were expressed in graphic design.
- Describe how political and social changes were expressed through art, design, and architecture.
- Explain how utopian concepts led to the New Typography.
- Compare the styles of graphic design inspired by Modernist ideas from Europe.
- Describe the New York School's approach to design.
- Explain how graphic designers pushed Modernist thought further by taking a more conceptual approach.

2

Graphic design has been shaped by social, cultural, political, and technological circumstances throughout its evolution. Egyptian hieroglyphs were created to record history, chiseled into stone to last an eternity (Figure 2.1). Chinese woodblock printing, which began in the third century as a method of printing on cloth, made the reproduction of both text and image economically possible (Figure 2.2).

- Analyze Postmodernism's origins and growth in the digital age.

Exercises and Projects

Research and write about a graphic designer; match a designer with a musical genre; pair examples of architecture with graphic designs; research a twentieth-century graphic designer and create a poster on him or her.

I feel that any course of study that fosters visual literacy is extremely valuable, particularly now when our attention levels are reduced considerably.
—Steven Heller

▶ Watch the Video on **myartslab.com**

Opposite page: APRIL GREIMAN. Poster (detail) from *Design Quarterly*, no. 133, 1987 (full image, see Figure 2.83).

Photograph © 2012 Museum of Fine Arts, Boston

2.1 Ancient Egyptian carving of offerings being made to the sacred barque of Amun at the great temple of Amun at Karnak, Luxor in Egypt.

2.2 Chinese woodblock print of Wenshu, Bodhisattva of Supreme Wisdom. ca. 950 A.D.

2.3 Page with self-portrait of the nun Guda. *Book of Homilies.* Early 12th century.

Paper, invented in China as a substitute for printing on cloth, later became a substitute for parchment skins in the West in the eighth century. The first bound books made entirely of paper soon followed in the Middle East, their pages protected from humidity by flattening against one another. Although the Chinese had started printing processes, European Bibles continued to be scribed with quill pens for centuries. The exhaustive, time-consuming process was a religious rite for monks serving as copyists, editors, and teachers (Figure 2.3), until Johannes Gutenberg printed a Bible using movable type (see Chapter 7). Each innovation reflected the cultural and economic needs of the society that produced it.

Today is no different. The imagination of graphic designers is guided by the innovations and needs of contemporary society; their designs are a reflection of the social, cultural, and political worlds in which they live. In looking back at the history of their art, graphic designers can better understand their own work within a broad context. As with any field, knowing the history gives one the knowledge and freedom to innovate and grow.

Industrial Expansion

An acceleration of technology began to take hold in Europe in the late 1700s as economies shifted from manual labor to machine-based manufacture. Inventions such as the steam engine, perfected by James Watt (1736–1819) helped drive this Industrial Revolution, especially in England. By the 1850s, England's national economy was dominated by manufacturing, and its power structure shifted from landowners to industrialists. As people began filling cities to work in factories, their purchasing power grew. Products offered to them kept pace, as did advertising. Newspapers, magazines, and posters thrived.

For European inventors, England was an outlet. Nicholas Robert (1761–1828) of France devised his first machine for making paper by the roll in 1799, leading to patents and further development in England by the Fourdrinier Brothers. Steam-powered printing soon followed, brought to the *Times of London* in 1814 by a German, Friedrich Koenig (1774–1833) (Figure 2.4). Paper manufacturing and press speed reduced the cost of printed promotions, making them more available to the public. As a result, the design of advertisements and fliers became a specialized activity, which was considered a separate task from printing and production. Commercial and artistic possibilities developed as the technology available to designers advanced.

The first permanent photograph was made in 1826 by the French inventor Joseph Nicéphore Niépce (1765–1833). Niépce's partner Louis-Jacques-Mandé Daguerre (1787–1851) refined the invention further by speeding up the developing process from eight hours to thirty minutes and by inventing a way to fix the image on the exposed silvered plate. In 1839, the invention of daguerreotype, the term for this type of early

2.4 The first steam-powered cylinder press. 1814.

photograph, was formally announced, and a New York magazine, *The Knickerbocker,* wrote: "Their exquisite perfection almost transcends the bounds of sober belief." Photographs seemed at first unreal to a general public more comfortable with handmade illustrations of products and events. Soon, however, newspaper companies and advertisers began to rely on published photographs to sell their newspapers and products. Consumers not only could see actual images of the corsets, hats, and carriages that were being sold but also could view them in an indisputable and immediate way.

Another early developer of the photographic process, English scientist William Henry Fox Talbot (1800–1877), created a negative image from which an unlimited number of paper prints (called *calotypes*) could be made. A brilliant scientist, writer, and photographer, Talbot was also a graphic designer. His publication *The Pencil of Nature* was the first photographically illustrated book, and Plate 6, called *The Open Door,* is an example of meaningful communication created through this new medium (Figure 2.5). Composed much like a sixteenth-century Dutch genre painting (popular in England at the time), everyday objects are loaded with symbolism and meaning: a handmade broom, as a metaphor of the old agrarian world (drawing and painting), leans outside of an aging cottage. The broom aligns with the opened door's shadow—they both point to the darkened interior. At the back of the cottage, light comes through a window. Talbot tried to portray a world beyond the frame and a future for the new, mechanically based medium of photography.

Typesetting was changing, too. Until the nineteenth century, printing was primarily limited to books. The Industrial Revolution brought a demand for printed brochures, product ads, and advertising posters. A variety of wooden display typefaces came into existence along with type-specimen catalogs. Up to that point, handbills looked similar to title pages

2.5 WILLIAM HENRY FOX TALBOT. *The Open Door.* 1843. Science Museum, London. Fox Talbot Collection.

🖊 **EXCERPT: The Pencil of Nature,** 1844, by Fox Talbot

It frequently happens, moreover—and this is one of the charms of photography—that the operator himself discovers on examination, perhaps long afterwards, that he has depicted many things that he had no notion of at the time. Sometimes inscriptions and dates are found upon the buildings, or printed placards most irrelevant, are discovered upon their walls: sometimes a distant dial-plate is seen, and upon it—unconsciously recorded—the hour of the day at which the view was taken.

2.6 BENJAMIN FRANKLIN. Title page using Caslon type. 1744.

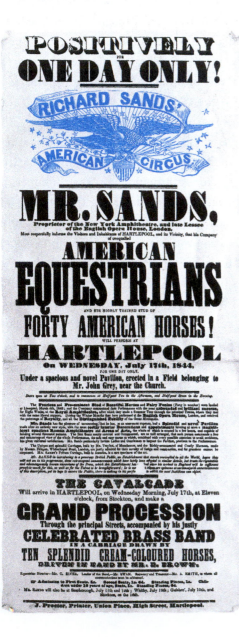

of books, the book types merely enlarged (Figure 2.6). Two eighteenth-century English founders of typefaces include William Caslon (1692–1766), whose typeface of 1724 was so distinct and legible it was used to set the Declaration of Independence, and the printer John Baskerville (1706–1775), whose typefaces were adopted by the U.S. government for its publishing.

In advertising, new display typefaces were being introduced. Slab Serif types from Britain were designed to help information stand out noticeably. These typefaces were used on pamphlets, posters, and anything that had short lengths of text. British type designer Robert Thorne (d. 1820) coined the term Egyptian serifs to describe these thick Slab Serifs because the letterforms resembled the weight and bluntness of hieroglyphs. In 1803, Thorne developed what he called Fat Face typefaces, which had an even bolder look and weight than the Egyptians. Fat Faces appealed to advertisers because of the impact they created on the page (Figure 2.7). Many variations of the Fat Faces soon followed, including forward and backward sloping italics, inline, shadow, and three-dimensional relief letters.

Book typesetting also kept pace with the growing demand as literacy increased, and in 1886, the German inventor Ottmar Mergenthaler (1854–1899; Figure 2.8) perfected what he called his "Linotype machine" (Figure 2.9). The mechanical process of composing type transformed the industry. The slow hand-setting of type, letter by letter, was replaced with type composed from a keyboard and transmitted to a series of matrices that held brass letterforms, which cast slugs of raised lead lines of type ("line o' type").

2.7 Woodtype poster using Fat Face types. 1844.

2.8 Ottmar Mergenthaler.

2.9 The Model 5 Linotype machine. Courtesy of the Mergenthaler Linotype Company, Melville, NY.

2.10 JOHN AUGUSTUS ROEBLING. Brooklyn Bridge, New York City. 1867–1883.

> 🗨️ *Industry without art is brutality.*
>
> —John Ruskin, 1870

A Turn-of-the-Century Response to Industrialization

As the Industrial Revolution advanced, artists, writers, and social critics began to object to the dehumanizing effects of mechanization. The most vocal critic, the British writer and painter John Ruskin (1819–1896), believed that the handcrafted Gothic style of the late Middle Ages, with all its imperfections, was worth reviving as a way to offset the mechanical ordinary nature of modern mass production. Ruskin's chapter, "the Nature of Gothic," in *The Stones of Venice,* Vol. II (1851–1853) explains that we should find a kind of pleasure in an object that was made with pleasure.

Ruskin's writings inspired a **Gothic revival** in England and across the Atlantic to America. The Gothic style (which in architecture included the pointed arch, the ribbed vault, and the flying buttress) permeated art and design. The Brooklyn Bridge (1883), designed by German immigrant John Augustus Roebling (1806–1869), is a grand example of the Gothic style, its pointed arches contrasting with the steel-wire suspension system, the first of its kind and the leading construction technology of its day (Figure 2.10).

Steven Heller is cochair of the MFA The Designer as Author + Entrepreneur program at the School of Visual Arts, New York. He is also cofounder of the following programs: MFA Products of Design, MFA in Design Criticism, MFA in Interaction Design, and MPS in Branding. His websites include imprint.printmag.com/daily-heller and hellerbooks.com. He is a columnist for The New York Times Book Review, New York Times T-Style, The Atlantic, *and he writes regularly for* PRINT, EYE, Baseline, *and other magazines. He is the author or editor of more than 140 books, including* Graphic: Sketchbooks of Designers and Illustrators *(with coauthor Lita Talarico) and* I Heart Design and Scripts: Elegant Lettering from Design's Golden Age *(with coauthor Louise Fili). He is the recipient of the 1996 Special Educators Award, The New York Art Director's Club Hall of Fame; 1999 AIGA Medal for Lifetime Achievement; 2000 Pratt Institute Hershel Levit Award; 2000 Walter Hortens Award/Graphic Artists Guild; 2006 Gangel Award, Society of Illustrators; 2008 School of Visual Arts Masters Series Award; and 2011 Smithsonian National Design "Design Mind" Award.*

▶ What is the value of learning and understanding graphic design history?

What's the value of learning about any field? Some say then we're not doomed to repeat the mistakes. That's one way of looking at history. Another is as a primer for current practice. Graphic design has not changed all that much from the early days of commercial advertising—the late nineteenth century. Styles have come and gone and returned, but the basic formal issues and practical concerns are the same. So history puts this into perspective. We can still invent things, but we don't have to reinvent things. Now that the web has become a design venue, new paradigms are being created, but even in this new digital world many of the old conventions are relevant. Studying design history places these conventions in context, but also reveals how new ideas (and ideals) were introduced. Historic graphic design also serves as a primer for current practice. History is not some musty notion but rather a living link to many traditions.

What role does design history play in "everyday" problem solving?

The most practical use of history in problem-solving is the practice of borrowing. Pastiche [imitation of older styles] is a large component of graphic design, and where else does one acquire the raw material other than from

history lessons? Aside from this, history offers a blueprint for problem-solving. Can you tell me that a designer can compartmentalize historical knowledge from contemporary practice? No. Since little has changed, other than technology, from the "good-old-days" to today one is still able to use historical lessons as textbook examples of how to make design, if not overtly, then subconsciously.

To what degree do outside influences such as technology, politics, and pop culture affect graphic design?

If you don't practice design by rote—if it has more meaning than sweeping a floor—then outside influences will affect the way graphic design is created. Technology often determines how design will look (and be made); politics is often the theme of design. And pop culture? Well, graphic design is pop culture, as well as influenced by it (music, art, film, video, and so on, all have been tapped for graphic designs). To be a well-rounded designer means to have knowledge about all these things. To be a hack, means to ignore them.

Opposite page: Exhibition of Steven Heller books at the School of Visual Arts in NYC.

2.11 WILLIAM MORRIS. Kelmscott Press trademark. 1892.

2.12 WILLIAM MORRIS. Page from *The Canterbury Tales*. 1896.

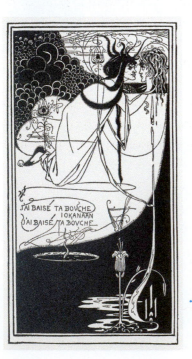

Arts and Crafts Movement (1880–1910)

The first full-scale **art movement,** or focus on a particular approach to art, that surfaced from Ruskin's theories was the **Arts and Crafts movement.** William Morris (1834–1896) led the way, prolifically devoting himself to a philosophy of art that advocated looking back to the Middle Ages and, in particular, to the natural forms that were embraced in that era. "The past is not dead, it is living in us, and will be alive in the future which we are now helping to make."

Morris's trademark for his Kelmscott Press is a beautifully crafted example of a commitment to recapturing the handcrafted art forms of the past (Figure 2.11). Some of the greatest examples of the art of the printed book came out of the Kelmscott Press. In the page design for *The Canterbury Tales,* Morris also designed the three typefaces used (Golden, Troy, and Chaucer), each modeled on fifteenth-century type styles (Figure 2.12). The philosophy of the Arts and Crafts movement was that handcrafted forms brought physical and spiritual pleasure to one's work. Morris led by example, with a repertoire that included furniture and cabinet making, wallpaper, ceramics, as well as textile and stained glass design—an entire man-made, yet organic, environment.

Aestheticism (1870–1914)

The Aesthetic movement took the issue of the purpose of art further than the Arts and Crafts movement, advocating a complete separation of art from morality and utility. **Aestheticism** began as early as 1818 when the French philosopher Victor Cousin (1792–1867) coined the phrase "art for art's sake." Based on a search for ideal beauty, the Aesthetic movement's ideology wanted to remove art completely from commerce and industry and form a more direct relationship between art and life. Two of its greatest proponents were the writer Oscar Wilde (1854–1900) and the illustrator Aubrey Beardsley (1872–1898). In fact, Beardsley won widespread notoriety in 1894 with his illustrations for Oscar Wilde's play *Salomé* (Figure 2.13). By blending the curvilinear style of **Art Nouveau** with contrasting forms found in Japanese woodblock prints, he created drawings that were new, elegant, and sensual.

Art Nouveau (1890–1910)

The Arts and Crafts and Aestheticism movements directly inspired Art Nouveau, which quickly became the most encompassing of the turn-of-the-century art movements. In addition, Japan began trading with the West after 1853, and Japanese woodblock prints and ornamentation

2.13 AUBREY BEARDSLEY. *Salomé.* 1892.

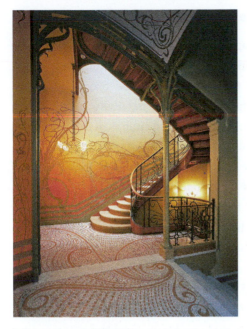

2.14 VICTOR HORTA. Stairway, Tassel House, Brussels. 1892.

2.15 Trademark for General Electric. ca. 1890 (left) and current mark (right).

2.16 HENRI DE TOULOUSE-LAUTREC. *La Goulue (with enlarged detail).* 1891.

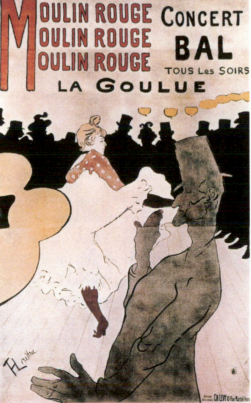

View a Closer Look for La Goulue on **myartslab.com**

influenced a generation of Western artists. Art Nouveau's vocabulary of natural forms included birds, flowers, and vines, which were translated into high-contrast shapes and patterns. The impact and energy of these forms were appealing but also reflected the West's break from traditional dependence on history and the classics for its subject matter.

The style began with the architectural work of Belgian architect Victor Horta (1861–1947). The centerpiece of his work for his Tassel House project was a stairway (Figure 2.14). Its integration of pattern with space moved architecture away from the rigid box and brought an organic flow to both exteriors and interiors. As Art Nouveau developed, nearly everything painted, manufactured, or designed was affected—from teapots to subway entrances. The General Electric (Figure 2.15) and Coca-Cola trademarks designed in this period have been in continuous use ever since with only slight modifications.

Art Nouveau's most exuberant expression was in the work of French artist Henri de Toulouse-Lautrec (1864–1901). Commercial printing was at a point where graphics and color could be reproduced without much loss of quality, and this development inspired artists like Lautrec to work in the medium. The inspiration from Japanese woodblocks is seen in Toulouse-Lautrec's *La Goulue* through his use of flat color and line (Figure 2.16). Those elements create visual impact, as does the contrast of the cancan dancer against the solid black crowd in the background. Her undergarments go completely white, the paper itself becoming part of the drawing. Repeating the words "Moulin Rouge" in the poster, Toulouse-Lautrec also made typographic strides as he mimicked the bouncing rhythm of the dance hall. Rather than sit as a separate title, the words integrate into the poster's space.

Look closely and you will see something else not seen before in poster design— Toulouse-Lautrec's personal observation. The face of the dancer is psychologically distanced from the setting, with an almost sad expression. That sadness, contrasted against the joyous setting, was a personal nod to the budding feminist movement that was gaining acceptance in Europe. Toulouse-Lautrec was dedicated to depicting the social life in Parisian cafés, theaters, dance halls, and brothels, and his inclusion of this subtle suggestion of unhappiness shown in the work, signaled new and expressive possibilities for graphic design. A very public medium suddenly had room for a personal voice.

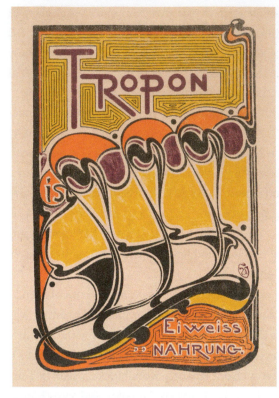

2.17 HENRI VAN DE VELDE. Poster for Tropon food concentrate. 1899.

Moving Toward a Modern Sensibility

As the twentieth century began, the everyday lives of people became much more complex. Innovations in all fields of human study were beginning to be driven by concepts that could be expressed only abstractly. Albert Einstein's (1879–1955) special theory of relativity (published in 1905) changed our understanding of space and time, just as Karl Marx's (1818–1983) writings changed our understanding of politics and government. In the arts, photography offered realistic visual representation of our world, prompting painters to shift to other modes of gesture and expression. Artists increasingly focused on the intrinsic qualities of their media—line, form, and color. The process of distilling information down to basic elements or qualities became known as **abstraction.** Under its banner, artists and designers were free to shed the limitations of literal representation. Architects could abandon past styles in favor of a form of architecture based on essential functional concerns. All of the visual arts were significantly transformed by these revolutionary changes.

Henri van de Velde (1863–1957) brought a modern sensibility, a heightened awareness and responsiveness, to graphic design. Trained as a painter in Belgium, van de Velde was strongly influential in the birth of Art Nouveau in that country. A disciple of William Morris and the Arts and Crafts movement, he believed in the concept of total design—a union between the fine and applied arts. In contrast to Morris, van de Velde adopted a contemporary attitude in his work by looking toward the future rather than the past. A poster for Tropon food concentrate illustrates the modern idea he was striving for (Figure 2.17). It has the look of Art Nouveau, but the form of the poster is not simply decorative. Tropon's manufacturing process becomes part of the poster's content—the fluid center shapes are abstracted interpretations of eggs being separated from yolks. The intricate spiral designs are directly determined by the shapes of the letters in the word "Tropon." In this sense, the poster was a precursor to functional **Modernism**—the dynamic expression of abstract form with practicality and purpose. In fact, van de Velde, in his later years, reorganized the Kunstgewerbeschule (School of Arts and Crafts) in Weimar, Germany, laying the foundations for the Bauhaus to follow (see page 53).

Architecture and graphic design were beginning to share modern sensibilities of abstraction. Each affected the other. The work of architects Charles Rennie Mackintosh (1868–1928) and Frank Lloyd Wright (1867–1959) showed signs of this new geometry. The grid and linear patterning of Mackintosh's Salon de Luxe is a refined and almost eccentric example of geometry and abstraction (Figure 2.18). There are still hints of Art Nouveau in the linear patterns, but the interior charted new territory. Wright's living room of the Francis Little House also reflected the spiritual and organic feel of Art Nouveau, but the geometry and integration of the space, furniture, and windows, edges even closer toward the

> ❝❞ *I wish to replace the old symbolic elements, which have lost their effectiveness for us today, with a new, imperishable beauty…in which ornament has no life of its own but depends on the forms and lines of the object itself, from which it receives its proper organic place.*
>
> —Henri van de Velde, 1901

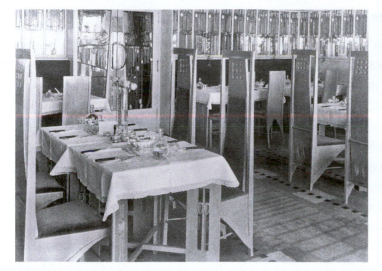

2.18 CHARLES RENNIE MACKINTOSH. Salon de Luxe, Willow Tearoom, Sauchiehall Street, Glasgow. 1904.

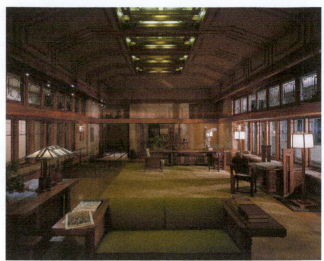

2.19 FRANK LLOYD WRIGHT. Living room of the Francis W. Little House, Wayzata, Minnesota, designed 1912–1914.

2.20 PETER BEHRENS. Trademark for the Allgemeine Elektricitäts-Gesellschaft. 1908.

2.21 PETER BEHRENS. Poster for AEG electric lamps. 1910.

clean lines and simple forms that were more in keeping with Modernism (Figure 2.19). The architect Peter Behrens (1868–1940) brought this same thinking into graphic design.

Like many artists of his era, Behrens was influenced by the design ideals of the Arts and Crafts movement. In 1907 he was hired as artistic adviser of the world's largest electrical manufacturing company, Allgemeine Elektricitäts-Gesellschaft (AEG) in Berlin. Behrens's job was to determine and manage AEG's visual image, from architecture to industrial and graphic design. His turbine factory (1909–1910) in Berlin for AEG was his most successful display as an architect, but as a graphic designer, he set a completely new standard and modern tone for the field by unifying art and industry. The logotype for AEG reflects the bridge he was creating, the letters interconnected by a geometric honeycomb (Figure 2.20). Behrens developed an entire typeface for AEG, unifying all of its publicity. In a poster promotion, the entire arrangement of the page has the structure of the AEG logotype, with tiny circles not only set linearly to create the grid lines but also spaced together to create an abstract image of light (Figure 2.21). Behrens also designed AEG's industrial products, making him the first industrial designer. He stripped all ornamentation out of his designs in the belief that utility had a beauty of its own. In fact, a new mode was being found for modern times that included proportion, geometry, and abstraction. His approach would help lead the architecture and design world fully into the twentieth century, and his staff, architects Walter Gropius (1883–1969), Ludwig Mies van der Rohe (1886–1969), and Le Corbusier (1887–1965), would go on to refine this logical and systematic thinking well into the century to come.

2.22 LUCIAN BERNHARD. Poster for Priester matches. 1905.

2.23 PABLO PICASSO. *Les Demoiselles d'Avignon.* 1907.

The Modern World

The work and writings of the artist Paul Cézanne (1839–1906) helped determine the direction that visual abstraction would take. His emphasis on basic forms—the cylinder, sphere, and cone—had a huge impact in the art world. Graphic designers, influenced by Cezanne, absorbed the principles of abstraction and return to basic forms, bringing this new design thinking to book jackets, postage stamps, posters, packaging, trademarks, and signage.

The poster art of the young designer Lucian Bernhard had wide-reaching effects on graphic design's reductionist approach. Bernhard's submission for a competition by Priester matches eliminated parts of a larger picture that he had created (Figure 2.22). The table, cigar, ashtray, tablecloth, and dancing girls were blackened out until all that was left was the product being advertised, matchsticks, and the name, Priester. The jury reviewing this design initially rejected it, but one of the jurors, a printer named Ernst Growald, saw the genius in the design. He convinced fellow jurors that it should take first prize, and thus the modern poster was born. An "economy of means" attitude was established, and such an approach would continue to flourish, impacted by political and cultural influences, throughout the rest of the century.

Cubism (1907–1921)

The artist Pablo Picasso (1882–1973) was greatly influenced by the work and words of Cezanne. Picasso combined Cezanne's philosophy with his own interest in the raw, abstract qualities of traditional African art. Picasso's paintings and sculpture led to the development of **Cubism,** one of the most influential art movements of the twentieth century. His milestone painting *Les Demoiselles d'Avignon* (Figure 2.23) involved figures that were broken up into semi-abstracted forms. Picasso showed these figural forms from multiple points of view simultaneously, thus questioning established notions of viewpoint, reality, time, and space. This painting was completed just after Einstein's special theory of relativity was published, which explored completely new theories of space and time. Gertrude Stein (1874–1946), a close friend of Picasso's, used the same theories of simultaneous space and time in her writing. Composer Erik Satie (1866–1925) also embraced similar concepts in his music, revisiting the same musical themes from different angles. He collaborated with Picasso on the ballet *Parade.* The visual arts, literature, music, and science were all evolving and influencing one another.

Another fellow artist and friend Georges Braque (1882–1963) especially appreciated how Cubism discarded all the techniques of the past (perspective, foreshortening, modeling, and chiaroscuro, or representation through light/dark contrasts) and helped Picasso envision an entirely new movement in art. Together, Braque and Picasso painted a new reality

2.24 FILIPPO MARINETTI.
Les mots en liberté. 1919.

2.25 E. MCKNIGHT KAUFFER.
Poster for the *Daily Herald.*
1918.

2.26 A.M. CASSANDRE. Poster
for the French daily newspaper
L'Intrans. 1925.

that left the previous time-honored theories of art by the wayside. Cubism didn't imitate nature. Its new approach could be applied to all the arts, both fine and applied, giving them the freedom to interpret form and space in a new way. It was a complete break from the past and offered an opportunity to explore creativity in a way artists had never experienced before.

Futurism (1910–1918)

Artists, graphic designers, and typographers also found new freedom in an art movement known as **Futurism.** Poet and writer Filippo Marinetti (1876–1944) established the movement in 1909 with a manifesto that claimed, "Motion and light destroy the materiality of bodies." Marinetti's visual language was based on science rather than on classical forms. In his 1919 poem *Les mots en liberté (the words to freedom),* the chaos of war, noise, and speed were embedded in the visual poetry of the page. Gone were the horizontal and vertical alignments of typography. Letters were used as expressive objects, the printed page as a work of art (Figure 2.24).

The work of two graphic designers, E. McKnight Kauffer (1890–1954) and A.M. Cassandre (1901–1968), exemplify the influence of Futurism on the applied arts. Kauffer, an American expatriate who was one of Europe's most influential poster designers in the 1920s and 1930s, used the dynamics of motion to create a poster for the progressive English newspaper the *Daily Herald* (Figure 2.25). Fragmented birds, clearly influenced by Cubism, soar off the top of the page, filled with energy, especially in contrast to the large expanse of empty space in the center of the poster. Cassandre, an acclaimed French poster designer, integrated typography and image in an energized composition for *L'Intransigeant,* where telegraph wires lead straight to the ear of an abstracted face (Figure 2.26). Again, the Futurist attributes of motion and speed are fused with Cubist abstraction. The result is a hybrid of styles in service to the applied art of promotion.

2.27 KAZIMIR MALEVICH. *Suprematist Painting (Eight Red Rectangles)*. 1915.

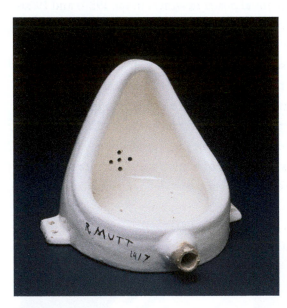

2.28 MARCEL DUCHAMP. A flipped urinal that Duchamp titled *Fountain*.

❝❞ *I am interested in ideas, not merely in visual products.*
—Marcel Duchamp

Suprematism (1915–1934)

In Russia, artist Kazimir Malevich (1878–1935) referred to the blend of Cubism with Futurism as *Cubo-Futurism*. Both fractured and energized, its distillation led to Malevich's *Suprematist Painting (Eight Red Rectangles)* (Figure 2.27). **Suprematism,** a movement in art conceived by Malevich, was short for "the supremacy of pure feeling in creative art." His movement launched an art form that completely eliminated objects and representation. Composition became a pure geometrical abstraction and hinted at a kind of metaphysical spirituality—a quest for a greater truth. Reducing everything to the basics was a way to start over in the visual arts, just as the Bolshevik Revolution of 1917 sought to start over by leveling society into a classless, stateless, social organization. Suprematism, with its belief in pure form and pure concept, continues to influence the visual arts today.

Dada (1916–1923)

World War I (1914–1918) was fought with machine guns, tanks, airplanes, and poison gas. This mechanization unleashed a level of killing the world had never seen before. The **Dada** movement was a reaction by artists to what they perceived as a world gone mad. Alternate perspectives, including irony, irrationality, and even anarchy, seemed better choices than the logic and reason that led to such unspeakable horrors. The Dadaists rejected all traditions and standards in art; its publications and manifestoes, all written by Tristan Tzara (1896–1963), claimed that whatever art stood for, Dada stood for the opposite. This nonsensical spirit began in a small cabaret in Switzerland, but spread, establishing footholds in Germany, France, and America.

In New York, Marcel Duchamp's (1887–1968) approach to art making was ironic, shocking, funny, and, at the time, highly intellectual. By elevating mundane, everyday objects into new gallery contexts, Duchamp simultaneously proved that everything could be art, and, by default, art was dead. His urinal, submitted in 1917 to the Society of Independent Artists, of which he himself was director, was an ordinary plumbing fixture (Figure 2.28). Flipped upside down, titled *Fountain,* and signed "R. Mutt," it was promptly rejected by the committee but succeeded in turning the understanding of art on its head. It inspired a whole school of art known as "readymades," or found art, and remains one of the most famous works of art of the twentieth century. After *Fountain,* anything was possible.

In Germany, the Dadaist artist Hannah Höch (1889–1978) brought a feminist perspective to the work she created. She was one of the pioneers of photomontage, a new technique where multiple photos were joined together to create a seamless whole. In her photomontages, Höch ironically portrayed the culture of beauty in fashion photography by contrasting images of female perfection with photos of real women. In her work

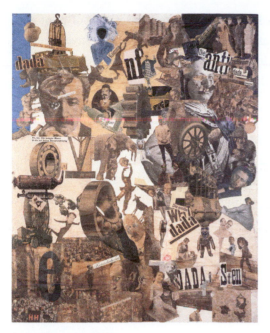

2.29 HANNAH HÖCH. Collage titled *Cut with the Kitchen Knife Dada through the Last Weimar Beer Belly Cultural Epoch of Germany.* ca. 1919.

Cut with the Kitchen Knife Dada through the Last Weimar Beer Belly Cultural Epoch of Germany, she swapped out heads and bodies and fused newspaper type with newspaper images to critique the male-dominated culture of the Weimar Republic and to reflect the Dadaist disgust with German nationalism (Figure 2.29).

Höch's colleague and photomontage artist, Helmut Herzfeld (1891–1968), was equally critical of the Weimar Republic. As a protest against German militarism, he changed his name to the more English-sounding John Heartfield. He took special aim at the Nazi party—in everything from book jackets and posters to magazines and newspapers. In *Have No Fear—He's a Vegetarian,* Heartfield depicted a butcher, his head replaced by Hitler's, sharpening his knives, hungrily eyeing a rooster, the symbol of France (Figure 2.30). *Have No Fear* reflects the critical irony of Dada in a shocking and effective political statement.

Surrealism (1924–1955)

As the Dada movement was coming to a close, another twentieth century art movement came into being; **Surrealism** grounded its investigations on psychologically based images, especially ones that caused shock and surprise. The dream analysis work being done by Sigmund Freud (1856–1939) fed this movement; the exploration of the unconscious became new territory for artists. The work of American Dada artist Man Ray (1890–1976) marked a transition from Dada to Surrealism.

Emmanuel Radnitzky (1890–1976) changed his name to Man Ray because of the prevalent anti-Semitism in the United States at the time. The artist's group he cofounded was called "Others," reflecting his affinity with artists fleeing World War I in Europe. Man Ray became acquainted with Marcel Duchamp, who came to New York in 1915. He followed Duchamp back to Paris in 1921, believing his creative spirit would thrive there. It did, especially in a camera-less photographic process he called "rayographs."

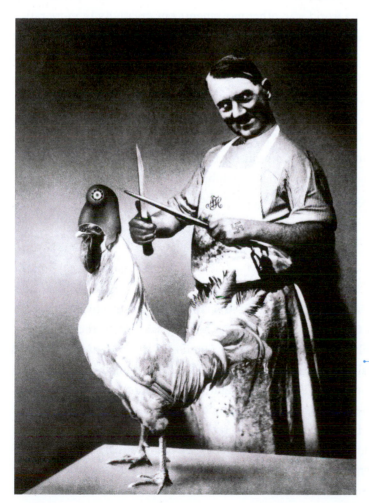

2.30 JOHN HEARTFIELD. *Have No Fear—He's a Vegetarian.* Photo-montage in *Regards* no. 121 (153) (Paris). 1936.

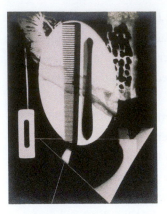

2.31 MAN RAY. *Champs délicieux.* 1922.

2.32 MAN RAY. *Keeps London Going.* 1932.

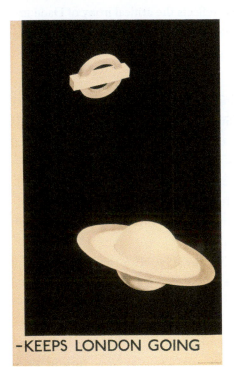

2.33 VLADIMIR TATLIN. *Project for Monument to the Third International.* 1919–1920. Destroyed.

In *Champs Délicieux*, Man Ray expanded the possibilities of photography as an expressive medium (Figure 2.31). Through pure inventiveness, he created shapes and shadows that shimmer with a three-dimensional appearance, an effect he achieved by moving beams of light across the photo paper.

Surrealism's impact on graphic design has been profound, both visually and conceptually. Man Ray's poster for the London Underground showed how the Surrealist theory could be applied to graphic design (Figure 2.32). Here, the analogy made between the logo and a planet creates an effective and humorous communication. Unfortunately, mass media has exploited Surrealism to the point that the manipulation of dreams and the use of psychology are recognized more as an advertising campaign than an art movement, but for many years, Surrealism's influence on the graphic arts was highly significant and opened designers' minds to unbridled creative possibilities.

Designing Utopia

As World War I and the Russian Revolution came to an end, artists began searching for renewed purpose in their work. A sense of starting over was in the air. Whereas Dada sought to flip art upside down in response to the absurdity of a world war, other movements saw creativity in more rationalist terms. Creative centers began to emerge, and major innovations in the arts were changing how graphic designers understood themselves and their role in the society. Some would align themselves with certain political perspectives, leading to **Constructivism** and Soviet propaganda art. Others would stand in complete opposition to those approaches, as was the case with Bauhaus principles in Germany. In all cases, there was cross-pollination as the movements influenced one another through lectures given by their proponents, exhibits, and a shared empathy between like-minded social activists. Artists began to see themselves as having a role far beyond the visual: they became spokesmen for political and social change.

Constructivism (1919–1934)

In Russia, Vladimir Tatlin (1885–1953) founded Constructivist art, which embraced Communism, rejected art for art's sake, and proclaimed that art should have a social purpose. His *Monument to the Third International* was a spiraling construction of glass and steel glorifying the technological determinism of the Bolsheviks (Figure 2.33). Meant to exist as a propaganda center, its streamlined form followed its function as an unadorned symbol of industry. If built at full scale, it would have dwarfed the Eiffel Tower. Yet merely as a model, it expressed a manifesto of sorts in support of the Constructivist aesthetic. Constructivism was concerned mostly with space, materials, and movement. Its intent was to move all the arts

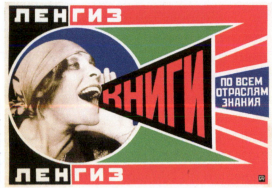

2.34 ALEXANDER RODCHENKO. *Books.* 1924.

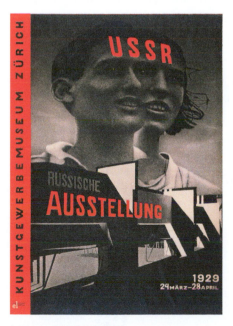

2.35 EL LISSITZKY. Title page and page 1 from *The Isms of Art* by Hans Arp and Lissitzky. 1925.

2.36 EL LISSITZKY. *Russian Exhibition.* 1929.

from expressions of personal style toward a collective style based on the machine. Writers, photographers, and designers could all follow this path.

Alexander Rodchenko (1891–1956), El Lissitzky (1890–1941), and the brothers Vladimir Stenberg (1899–1982) and Georgii Stenberg (1900–1933) helped create bold graphic designs that spoke the Constructivist language. In Rodchenko's literacy poster for a Lenningrad State Publisher a woman yells out the words "Books In All Branches of Knowledge" into a megaphone-shaped space. The socialist message and its layout are extremely utilitarian (Figure 2.34).

Lissitzky's layouts for *The Isms of Art* expressed how the functional and machined language of Constructivism could be used typographically (Figure 2.35). Because Lissitzky spoke multiple languages and collaborated with many artists and designers, he was able to spread this visual, sans serif, Constructivist language throughout Europe. Inspired by Lissitzky, designers further refined and built a complete system of typography. Lissitzky was also able to fuse his approach with the social aspects of Communism, as seen in his poster for a Zurich exhibit (Figure 2.36). In the poster, Lissitzky used a double portrait to represent the idea of equal stature of male and female youth in the Soviet Union.

For the burgeoning Soviet cinema, the artists and designers Vladimir Stenberg and Georgii Stenberg designed extraordinary work in the Constructivist mode. Working as a team, the Stenberg brothers basically invented the film poster genre, combining abstraction with visual narrative. The Stenberg brothers' poster for *Man with a Movie Camera* used typography, color, and perspective in ways that had never been seen before (Figure 2.37). The Bolsheviks saw the usefulness and value of graphic design in these commercial applications. These films, and the posters that promoted them, helped signal to the masses that a new social order was in place.

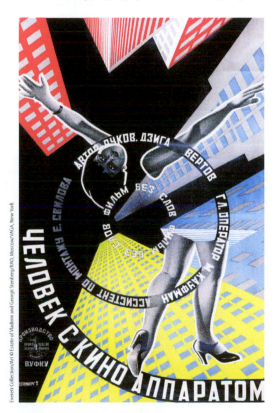

2.37 STENBERG BROTHERS. Poster for *Man with a Movie Camera.* 1929.

De Stijl (1917–1931)

A Dutch abstract-art movement called **De Stijl** ("The Style") was known for its straight lines, right angles, and primary colors. In 1920, Piet Mondrian (1872–1944) published De Stijl's manifesto titled *Neo-Plasticism*, which became another name for the movement. In his manifesto, Mondrian rejected symmetry and favored the manipulation and arrangement of geometric forms and color into what he called "dynamic equilibrium."

Gerrit Rietveld (1888–1964) brought the clean lines and dynamic asymmetry of De Stijl to architecture. His Schröder House was, in a way, the offspring of work initiated by Charles Rennie Mackintosh and Frank Lloyd Wright (Figure 2.3). Rietveld, however, made a complete and radical break from the past, establishing what would later be known as the "International Style."

Simultaneous Composition by Theo van Doesburg (1883–1931) is an example of how this spiritual and universal purity was applied to painting (Figure 2.39). The approach was also applied to graphic design, as seen in van Doesburg's many forms of promotion for De Stijl that the artist handled, including posters and booklets. A typeface van Doesburg designed in 1919 proved how far the deletion of curves and diagonals could be taken (Figure 2.40). The focal point of the movement was Van Doesburg's magazine *De Stijl*, which helped spread the movement's theories (Figure 2.41). The magazine's page layouts expressed the same dynamic conviction found in the movement's paintings and architecture. Van Doesburg's typographic arrangements were structurally poetic, like furniture on a floor plan. The typographic refinement and space created on the page matured into graphic design's typographic International Style.

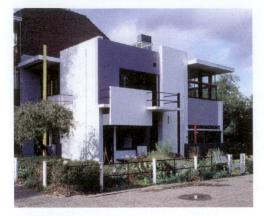

2.38 GERRIT RIETVELD. Schröder House, Utrecht, the Netherlands. 1927.

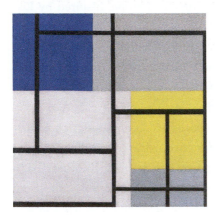

2.39 THEO VAN DOESBURG. *Simultaneous Composition.* 1929.

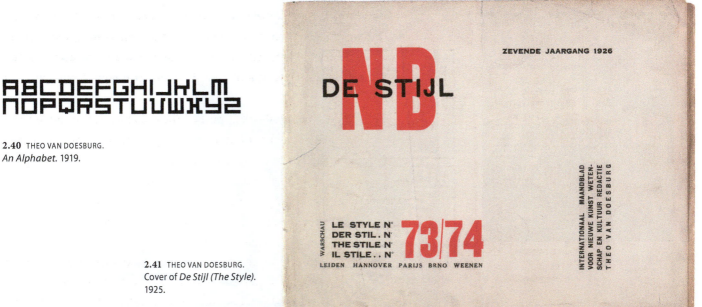

2.40 THEO VAN DOESBURG. *An Alphabet.* 1919.

2.41 THEO VAN DOESBURG. Cover of *De Stijl (The Style).* 1925.

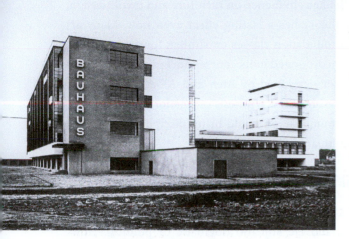

2.42 WALTER GROPIUS. Bauhaus building, Dessau, Germany. 1925–1926.

2.43 LASZLO MOHOLY-NAGY. Brochure cover for *Fourteen Bauhaus Books*. 1929.

2.44 HERBERT BAYER. Banknote for the State Bank of Thuringia, Germany. 1923.

Bauhaus (1919–1933)

No other movement influenced graphic design more directly than the **Bauhaus** (meaning "House of Construction") (Figure 2.42). The art school, founded in Weimar, Germany, in 1919 by the architect Walter Gropius, set as its goal to eliminate the distinction between the fine and applied arts. In its place would be a union of arts, crafts, and industry, working together for the greater good. Gropius and the other members of the Bauhaus formulated an approach to design that became the foundation for much of the thinking about art, architecture, and design in the twentieth century.

The Bauhaus was intensely influenced by the Expressionist theories of the artists Johannes Itten (1888–1967), Josef Albers (1888–1976), Lyonel Feininger (1871–1956), Paul Klee (1879–1940), and Wassily Kandinsky (1866–1944), who were all associated with the Bauhaus school. They established a foundation of spirituality, intuition, and universality, which focused on the physical nature of materials. From its beginnings in 1919 until 1922, Itten taught at the Bauhaus and developed the innovative preliminary course that introduced students to the basics of composition, color theory, and material characteristics.

As the Bauhaus program developed, other movements also had their influence. Theo van Doesburg promoted De Stijl's elegant geometry and economy of means on visits to the school; and El Lissitzky promoted Constructivism's socialist purpose. When Laszlo Moholy-Nagy (1895–1946) replaced Itten as the preliminary course instructor in 1923, a real shift occurred. Moholy-Nagy arrived with a vision to fully embrace the machine aesthetic as a means for connecting art and design to the masses. His design for *14 Bauhausbücher (Fourteen Bauhaus Books)* exemplifies the approach (Figure 2.43). A photo of handset metal type in its composing stick was used for the cover image of the catalog. The metal type would have been used to create the cover's title with all the proper letters in place, but instead was used to reveal the method of production. The cover also conveyed the school's emphasis on the applied arts over the fine arts.

Herbert Bayer (1900–1985) pushed the influence of the applied arts even further, designing a banknote and using multiple color overprints, instead of ornamental line engravings, to prevent counterfeiting (Figure 2.44). Bayer's solution showed how the Bauhaus agenda of applied art could advance social progress rather than merely create luxury items.

In 1925, the Bauhaus relocated from Weimar to Dessau, then moved to Berlin in 1932 when the Nazis in Dessau cut off its funding. Nazi officials wanted art and architecture that expressed their grandiose vision of Germany, not the functional, cosmopolitan International Style of the Bauhaus, and they forced the school to close completely in 1933. Its greatest legacy is its teachers and students who spread its methods and ideals

2.45 KURT SCHWITTERS. Cover of *Merz* 8/9 magazine. 1924.

2.46 JAN TSCHICHOLD. Advertisement for the Leipzig Trade Fair. 1922.

2.47 JAN TSCHICHOLD. Brochure page for *Die neue Typographie*. 1928.

throughout the world. Bauhaus influence on furniture and textile design, architecture, and color theory has a lasting effect even now. Many art schools today base their foundation classes on similar, fundamental elements that the Bauhaus incorporated in its courses, including the theories on the interaction of color developed by Itten and Albers. For graphic design, the Bauhaus proved how the synthesis of unadorned functionalism, technology, and communication could bring discipline, order, and structure to design's vocabulary.

Ideological Independents and the New Typography

Some designers found the philosophies of movements like Dada, Constructivism, and De Stijl too dogmatic or political. However, many designers were influenced by the innovations of these movements and made their own significant contributions to graphic design.

Kurt Schwitters (1887–1948) synthesized Dada, Constructivism, and Surrealism into an art movement he called *Merz*. The name *Merz* was derived from a scavenged piece of paper with the word *Commerzbank* on it that Schwitters included in one of his collages, which made a social comment about the commoditization of art. Schwitters's cover for *Merz* magazine went further, creating a self-inflicted parody of betrayal, or selling out (Figure 2.45). Its design has the typographic order and toughness of Constructivism, with the nonsensical humor of Dada. In 1937 Schwitters's work was included in the Nazi Degenerate Art exhibit, and he fled Germany for Norway and, later, rural England where he continued making creations from everyday materials.

Inspired by a Bauhaus exhibit in Weimar, Jan Tschichold (1902–1974), a recent graduate of the Leipzig Academy for Graphic Arts and Book Trades, conducted typeface experiments of his own. (See Chapter 7 for an introduction to typography.) Although the black letter, or Gothic script, was widely used in Germany, Tschichold looked at simplified typefaces to bring a modern sensibility to the country's design output, which eventually led to a practice of **New Typography**. Two examples of his work help explain how drastic his type transformation was. His centered, hand-lettered advertisement for the Leipzig Trade Fair is characteristic of the layout treatments most German designers used (Figure 2.46). Size and direction from top to bottom are the only hierarchies. In contrast, his asymmetric approach for the brochure page is architectural in its construction (Figure 2.47). He used only sans serif type and completely removed all ornament. Most important, the page elements have an integrated, functional relationship with one another, using rhythm, proportion, and tension. Tschichold's writings on the subject, especially his

2.48 PIET ZWART. Personal logo. The black square represents the designer's last name, which is Dutch for "black." 1927.

2.49 PIET ZWART. Inside page from a printing company's type catalog. 1931.

2.50 HERBERT MATTER. Magazine Cover: Typographische Monatsblatter. 1933.

1928 book, *Die neue Typographie (The new Typography),* became a handbook for modern designers and helped describe Modernist typography to the world. The rise of Fascism convinced him that Modernist design was authoritarian, and he later condemned the New Typography as too extreme. By 1947, when Tschichold became typographic designer for Penguin Books in London, he preferred classical roman typefaces and layout.

The Dutch designer Piet Zwart (1885–1977) worked a blend of Dada and De Stijl together into his projects. You can see it reflected in his personal logo where the geometry of a simple black square became a visual pun of his last name, which in Dutch means black (Figure 2.48). For a printing company's type catalog, Zwart overlaid various sizes and styles of type into a playful, Dada-like arrangement, yet they are somehow orderly and complete with the straight lines, right angles, and the primary colors of De Stijl (Figure 2.49). Zwart's Dutch contemporaries Paul Schuitema (1897–1973) and Willem Sandberg (1897–1984) also applied modern principles to page layout and commercial advertising, though they did not become members of any particular movement.

The Swiss artist Herbert Matter (1907–1984) studied with the painter Fernand Léger (1881–1955) in Paris and later assisted the graphic artist Cassandre and the architect Le Corbusier (1887–1965). By the mid-1930s, Matter developed an international reputation through his use of photography as a design tool. In his cover for a typographic journal, Matter collaged his photos with type (Figure 2.50). The elements are visually organized, yet surreal and complex: a grid of the hockey net projects onto a woman's face while the title of the magazine slides diagonally over larger type. Matter's unique visual language was a blend of playful photography with New Typography that he could also apply diversely. Matter photographed covers for Condé Nast publications, including *Vogue,* designed corporate image programs for Knoll furniture and the New Haven Railroad, and later taught photography and graphic design at Yale University.

In England, however, the British sculptor and designer Eric Gill (1882–1940) carried on the tradition of William Morris and the belief in the spiritual value of work done by hand. In his book design for *The Four Gospels,* a modern dynamic integrates all the elements, but the roman typeface and woodcuts look back to the humanist past rather than to the new, machine-oriented future (Figure 2.51). In this case, Gill was a dissenter to New Typography.

2.51 ERIC GILL. Page from *The Four Gospels.* 1931.

2.52 WILLIAM VAN ALEN. Chrysler Building, New York. 1928–1930.

Modernism in America

The Paris Exposition (1925) made Americans aware of **Art Deco** and its machine-inspired Modernism. Art Deco's sleek lines and geometry were an exciting replacement for the floral patterns of Art Nouveau. Art Deco was essentially a decorative movement, however. It lacked any specific inner philosophy and was vulnerable to superficial interpretation. It quickly became commercialized, and its architectural achievements such as the Chrysler Building became more representative of opulence and sophistication rather than a path for design and the common good (Figure 2.52).

The rise of Nazism caused many creative artists from Europe to flee to the United States. These designers and architects were invigorated by the Bauhaus and its philosophical approach; design and education communities, corporations, and publications embraced them. A pioneer in magazine design, Dr. Mehemed Fehmy Agha (1896–1978) paved the way for the functionalist approach. The son of Turkish parents, Agha was raised in the Ukraine, schooled in Paris, and worked in both Paris and Berlin. The publisher Condé Nast brought him to the United States in 1929 to be the art director of its publications, and there, Agha applied his sans serif typography and full-bleed imagery, showing how design can integrate with the editorial aspect of magazines. Agha had a unique vision for seeing layout possibilities in magazine design, but he also recognized the creative talents in people. In the midst of the Great Depression Agha hired Cipe Pineles (1908–1991) to be his full-time design assistant at Condé Nast. Pineles worked alongside Agha on the design of *Vogue* and *Vanity Fair* before becoming the first female art director of a mass-market American publication, *Glamour* magazine, in 1942 (Figure 2.53). Pineles

SPEAKOUT: Cipe Pineles by Jan Uretsky, design instructor, Pratt Institute

The designer who had the biggest impact on me was Cipe Pineles. A protégé of Mehemed Fehmy Agha, Cipe went on to art direct *Glamour, Seventeen, Charm,* and *Mademoiselle* magazines. Her designs were elegant and playfully Modernist. But it wasn't so much Cipe's exceptional work that I admired—it was that Cipe lit the way for women to enter and excel in our field. She understood the culture of her time, especially the world of fashion, and translated it to a graphic design format brilliantly.

2.53 CIPE PINELES. Cover for *Vogue* magazine. April 1939 issue.

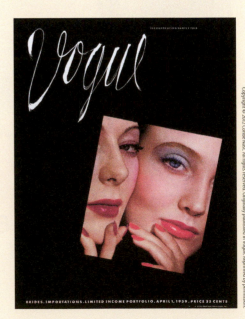

	1840	1850	1860	1870	1880	1890	1900	1910	1920	1930	1940	1950	1960	1970	1980	1990	2000	2010	2020

Victorian

Arts & Crafts

Art Nouveau

Cubism

Futurism

Suprematism

Constructivism

Dada

De Stijl

Surrealism

Bauhaus

Swiss International

New York School

Psychedelia

Digital Age

1826	First permanent photograph
1843	Rotary printing press invented
1851	John Ruskin publishes *The Stones of Venice*
1891	Toulouse Lautrec's La Goulue poster
1900	Freud publishes *The Interpretation of Dreams*
1905	Einstein creates his theory of relativity
1914	World War I
1917	Russian revolution
1929	The Great Depression
1939	World War II
1984	Macintosh computer introduced

MODERNISM **POSTMODERNISM**

2.54 HERBERT BAYER. Advertisement for the Container Corporation of America. 1943.

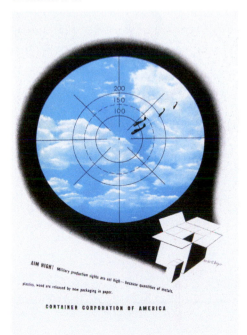

moved to *Seventeen* magazine in 1947, where she was the first to hire fine artists to create illustration work for a magazine, and then moved on to *Charm* and *Mademoiselle*. Pineles also broke ground by becoming the first female member of the Art Director's Club.

In 1937, Walter Paepcke, chairman of the Container Corporation, invited Bauhaus teacher Laszlo Moholy-Nagy to develop a similar school in Chicago. Dubbed "The New Bauhaus," it taught the same principles of functionalism and experimentation to students in America as the original Bauhaus did in Europe. Unfortunately, the school lost backing after only a single year and closed. In 1939 Laszlo Moholy-Nagy opened the School of Design, which transformed later into the Institute of Design. Moholy-Nagy's book *Vision in Motion* documented the school's curriculum, which had influenced generations of educators and design programs.

Herbert Matter and Herbert Bayer also brought their modern and functional approaches to American corporate advertising. Bayer's work for the Container Corporation clarified, through clean typography and imagery, how the company's efforts were supporting the war effort (Figure 2.54). Matter's advertising design for companies such as Knoll

furniture, which included his logo design for the company, photography, and page layout, were playful, smart, and elegant. His design advertising Eero Saarinen's Tulip chair involved two consecutive ads (Figure 2.55). In the first version, you see a wrapped chair with the request to send an illustrated brochure. In the next version, you see an unwrapped image of the chair with a young woman looking very happy to be sitting in it. The set created a mini-narrative and visual tone that the viewer couldn't help but respond to.

Ladislav Sutnar (1897–1976) was an established Czech designer when he came to work on Czechoslovakia's pavilion for the 1939 World's Fair in New York. Just as the fair opened, the Nazis invaded his country, so Sutnar stayed in New York City and established a design studio. His strong graphic vocabulary and discernible voice contributed to the evolution of information design. We see examples of this informational sensibility in the systems he created for Bell Telephone and for Sweets building product catalogs. In his book *Visual Design in Action* Sutnar explained, "The term 'information design' should be understood as the integration of meaning [content] and visualization [format] into an entity that produces a desired action" (Figure 2.56).

Agha, Moholy-Nagy, Matter, Bayer, Sutnar, and other émigrés had a great deal of influence on American graphic design, but U.S. designers were also making their mark. One early leader was Lester Beall (1903–1969). Born in Kansas City, this self-taught designer referenced the work of Dada and the Bauhaus and combined it with his own background and thinking. His output was a uniquely American style complete with woodcut types used in place of European sans serifs (Figure 2.57). In Beall's

> *Modernism released us from the constraints of everything that had gone before with a euphoric sense of freedom.*
>
> —Arthur Erickson (1924–2009)

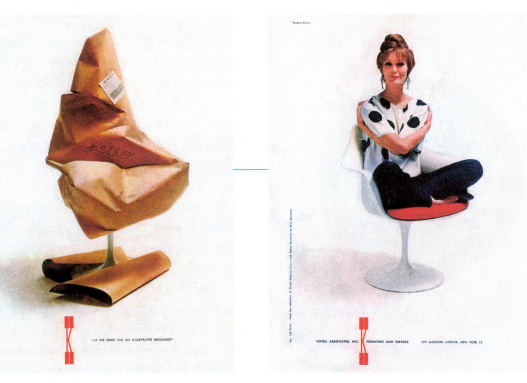

2.55 HERBERT MATTER.
A pair of advertisements
for Knoll Furniture. 1956.

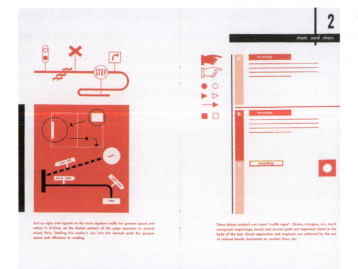

2.56 LADISLAV SUTNAR. Page spread from a paper sampler explaining controlled visual flow. 1943.

Rural Electrification poster, the metaphor of connection and support is simple and direct (Figure 2.58). Reminiscent of El Lissitzky's *Russian Exhibition* poster of two youths, Beall's photograph brings social purpose down to earth—the future of these everyday young Americans depends on the success of the program.

Probably one of the most influential American graphic designers was Paul Rand (1914–1996). His writing, teaching, and work have inspired generations of designers. Rand, who lived in Brooklyn, studied illustration at Pratt Institute in the early 1930s and later continued his design studies at Parsons School of Design and the Art Students' League. His education was built on a solid foundation in aesthetics, but his investigation of the Bauhaus and of the New Typography convinced him that illustration could be integrated within the overall design of the page. Rand switched his focus from illustration to graphic design. By age twenty three, he was art director of both *Apparel Arts* and *Esquire* magazines.

2.57 LESTER BEALL. Cover of the graphic arts journal *PM* using a Modernist-inspired composition with a nineteenth century letterform (in the lower left corner). 1937.

2.58 LESTER BEALL (DESIGNER/ PHOTOGRAPHER). Poster for the Rural Electrification Administration. A simple connection is made between the stripes of the American flag and the strips of a rural fence. 1937.

2.59 PAUL RAND. Cover for
Thoughts on Design. 1946.

2.60 PAUL RAND. Cover for
*H.L. Mencken, Prejudices:
A Selection*. 1958.

2.61 PAUL RAND.
Westinghouse trademark.
1960.

"❞ *I make solutions that nobody wants to problems*
that don't exist. —Alvin Lustig

In 1946, at age thirty three, Rand wrote his first of four books, *Thoughts on Design* (Figure 2.59). His published work helped to explain design as a process that involved reason, intuition, and intelligence—and as a service that could enrich life. Rand sought to elevate the most mundane products to a category that could be both beautiful and useful.

A book jacket for Vintage Press typifies Rand's work, the design simplified to the point of becoming iconographic (Figure 2.60). Rand used a cutout shape of the book's author, H. L. Mencken. One arm is raised upward, the gesture reflecting the author's authoritative writing. The cover was one of Rand's favorites, embodying his two greatest influences: the rough-cut edges and playful collage are directly inspired by the child-like play of Paul Klee and the Cubist collages of Picasso. In fact, Rand was considered by many to be graphic design's version of these two great artists.

You can see Paul Rand's playful and illustrative approach also in his corporate identity work. He designed trademarks for giants such as IBM, ABC, UPS, and Westinghouse (Figure 2.61). In each case, the witty, humanist voice of Rand comes through. To be able to integrate this voice into the corporate culture was a feat in itself.

Born in Colorado, Alvin Lustig (1915–1950) studied at the Art Center College of Design in California and then briefly with Frank Lloyd Wright. Later, as a teacher at both the Art Center and Yale, he shuttled between Los Angeles and New York. In addition, he operated a freelance design business that brought in a variety of projects, including advertising, furniture, fabrics, interiors, exhibits, and even the design of a small helicopter. Lustig is best known for his book jackets for the publisher New Directions. His cover for *A Season in Hell* by Arthur Rimbaud is a beautiful example of his philosophy that painting and design should inform and influence each other (Figure 2.62). Here, form and content are integrated—the contrasting colors represent heaven and hell but share an overriding biomorphic language honed directly from the Surrealist paintings.

2.62 ALVIN LUSTIG. Cover for
Rimbaud's *A Season in Hell*.
1944.

2.63 BRADBURY THOMPSON. Spread from *Westvaco Inspirations for Printers #152.* 1945.

> 66 99 *Creativity is essentially a lonely art. An even lonelier struggle. To some a blessing. To others a curse. It is in reality the ability to reach inside yourself and drag forth from your very soul an idea.*
> —Lou Dorfsman

Another American designer, Bradbury Thompson (1911–1995), from Topeka, Kansas, worked for a small print shop before moving to New York in the late 1930s. Hired by Westvaco paper company, Thompson worked on their periodical *Westvaco Inspirations for Printers* from 1938 until 1962. Westvaco appreciated Thompson's vision and simple, modernist language as he replaced the old-fashioned and decorative designs with the simple and rational Modernist aesthetic (Figure 2.63). Thompson's love of experimental typography and image manipulation made *Inspirations* one of the leading avant-garde publications in the field.

Other designers of note during this early Modernist era include William Golden (1911–1959), who created benchmark identity work at CBS; Lou Dorfsman (1918–2008), who continued the work at CBS after Golden's sudden death; Will Burtin (1909–1972) from Germany, who created groundbreaking designs and exhibits for scientific and pharmaceutical companies; and George Tscherny from Berlin via Budapest, whose sensitive and elemental solutions educated large corporate clients to the positive strategies of using graphic design for more than mere page decoration. West Coast designers include Louis Danziger (b. 1923) and Saul Bass (1920–1996). Danziger studied under Lustig and brought a sense of design history to his teaching and practice. Bass coherently unified film logos and titles with bold simplicity, thus creating a new field of work for graphic designers—motion design.

As America entered World War II, Modernism was just beginning to take hold. By the end of the war, a new vision for the American dream was in place, hand in hand with Modernism's utopian dream. Simplicity, clarity, and timelessness defined the language that corporations used to reach a global market.

American design programs began to train their students under the tenets of Modernism, and the country began to develop its own Modernist personality. The lens through which American designers saw didn't shift again until the 1970s, as Modernist ideals began to give way to a Postmodern attitude of irony and fragmentation.

The Swiss International Style

As the Modernist design sensibility became familiar in contemporary design consciousness, a philosophy of refined type and image use began to be formulated in school curriculums, especially in Switzerland. By the 1950s, outstanding design programs in Zurich and Basel developed into a clean, flush left and ragged-right typography—what became known as the

Swiss International Style. A poster by Josef Müller-Brockmann (1914–1996) is a characteristic example, the musical subject expressed through a rhythm of colored squares (Figure 2.64). Brockmann's arrangement of information achieved a visual harmony based in large part on the mathematical organization of the page.

Designer and educator Armin Hofmann (b. 1920) refined the Swiss International Style further by unifying photography and typography into striking design compositions. Hofmann's poster for a performance of *William Tell* is a perfect example (Figure 2.65). Here, a perched apple is cropped and distorted to the point of near abstraction, with sans serif typography stacked in perspective to create the perception of depth on the page—as if it is moving toward its target. Using only shades of black and

2.64 JOSEF MÜLLER-BROCKMANN.
Music Viva concert poster.
1959.

SPEAKOUT: Hans Rudolf Bosshard by Willi Kunz, author of *Typography: Macro- and Microaesthetics*, and *Typography: Formation+Transformation*

Graphic design today is pluralistic, divergent, and subjective. In this bewildering field every student needs a guiding role model that inspires not only as a designer but also through personal character and conduct.

My formative years as a designer were profoundly influenced by Hans Rudolf Bosshard, typography teacher at the Kunstgewerbeschule in Zürich, Switzerland.

Mr. Bosshard's teaching was based on the principles of twentieth century Modernism that defined Swiss typography in the 1950s and 1960s. However, aware of the limitations of the "Swiss" approach, he strongly encouraged us to explore new directions, even at the risk of failing. While he respected the commercial aspects of design he was against mimicking professional practice and following prevailing trends. For Mr. Bosshard, school was a laboratory for new ideas. This certainly is in stark contrast to design education today where teachers encourage students to use existing styles, follow trends, and imitate stars.

Mr. Bosshard's broad interest in architecture, painting, sculpture, photography, film, literature, philosophy, and music made him a fascinating teacher. He often started class by reading a few pages of avant-garde literature or Dada poetry, followed by discussing why these topics, seemingly unrelated to typographic design, were important to our education. He would bring to class original constructivist books and posters from the 1920s and 1930s for analysis and comments. The highlight of each semester was a field trip to a major museum or a modern architectural site. Each trip contributed to our education and opened our student eyes to the wider world outside the classroom.

Mr. Bosshard always reminded us to look beyond typographic design and to strive for a broad-based education in the disciplines he personally was interested in. Students today would consider this education doctrinaire; however, it was the strong guidance I needed to find my way as a typographic designer.

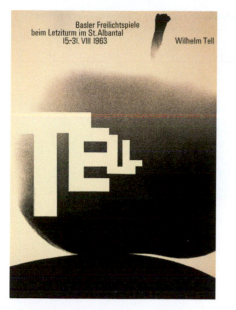

2.65 ARMIN HOFMANN. Poster for a Basel open-air performance of *William Tell*. 1963.

2.66 WOLFGANG WEINGART. Poster for an exhibition on Schreibkunst (penmanship). 1982.

white, the design seems more like an abstraction, yet we understand it in relation to the story of William Tell. The idea is conveyed with the utmost formal restraint.

Basel teacher Wolfgang Weingart (b. 1941) took a different approach to the Swiss style. A student of Emil Ruder (1914–1970) and Armin Hofmann, Weingart challenged the traditional system established by his teachers, prompted in part by the fact that typesetting was moving from lead hot type (created with molten lead), to cold type (created through photographic exposure). Weingart used this cold type process to literally sandwich type with photo-screened dot patterns. His poster for the Kunstgewerbemuseum in Zürich took advantage of the moiré patterns created by this method (Figure 2.66). The effect is controlled chaos—structured, yet rich and energized. The international students who studied under Ruder, Hofmann, and Weingart brought Swiss design and typography back to their own respective design programs throughout the world.

1960s Psychedelic Language

While Swiss typography was in full swing in America, an obscure poster language developed in San Francisco's Haight Ashbury neighborhood. The hippies who lived there embraced past styles such as Victorian and lived alternative lifestyles as an act of defiance against the clean, corporate, and modern aesthetic. The word **psychedelic** means mind-expanding, and hippies believed that the drug LSD, or acid, helped expand one's thinking and increase creativity. Hallucinogenic experiences were often accompanied by electronic music and experimental light shows, and many poster artists empathized with and shared these counterculture attitudes.

In a Fillmore Auditorium poster, Wes Wilson (b. 1937) used hand-rendered type instead of mechanical type for two reasons (Figure 2.67). First, the designer didn't have enough time or money to set mechanical type, and second, hand-drawn type could be made deliberately illegible and then become a coded message for a specific audience. This layer of counterculture rebellion clashed nicely with traditional advertising messages that focused on broad readability.

Victor Moscoso (b. 1936) was one of the few formally trained designers creating this new work. Although he arrived in San Francisco with an MFA in graphic design from Yale, Moscoso had to unlearn many of design's rules when he began making psychedelic posters. The traditional knowledge that he did use was the color theory he learned in his intensive study with Bauhaus artist Josef Albers, then chair of the Department of Design at Yale University. The psychedelic posters he made incorporated "hot" color palettes in which hues contrasted

View a Closer Look for Schreibkunst on **myartslab.com**

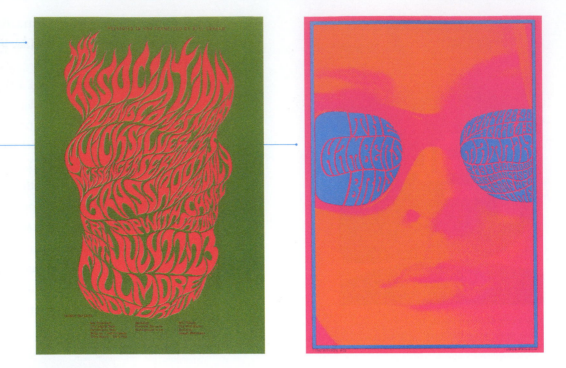

2.67 WES WILSON. Concert poster for The Association. 1966.

2.68 VICTOR MOSCOSO. Concert poster for the Chambers Brothers. 1967.

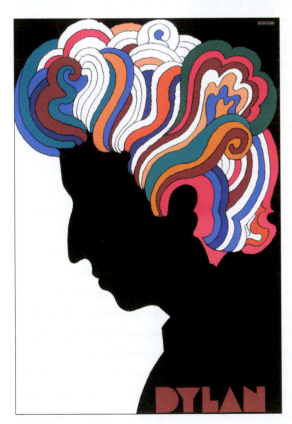

2.69 MILTON GLASER. *Dylan.* Poster advertising Bob Dylan's Greatest Hits album. 1966.

with one another so intensely that they appeared to vibrate, a phenomenon that Albers taught in his color theory class. Moscoso brought this knowledge to his poster work (Figure 2.68).

Psychedelia entered the American dialect quickly, and soon, even established graphic designers were speaking the fluid language. Milton Glaser (b. 1929) brought a conceptual approach to his illustrative work at the Push Pin Studio along with his fellow classmates, including Seymour Chwast (b. 1931) who continues to operate the studio today. Glaser's poster for Bob Dylan, which became an icon for the 1960s experience (Figure 2.69), brought psychedelic language to mainstream America.

Advertising Design and the New York School

A unique and humorous approach to advertising design developed during the 1960s around New York City's Madison Avenue, an approach in which text and image harmonized in a union not seen before. This union, known as the **New York School,** depended on a working relationship between content and form, and Paul Rand, with his playful designs for local businesses, acted as a proving ground for the approach. Rand's copywriting colleague, Bill Bernbach (1911–1982), from the Weintraub advertising agency where they had worked together, brought this word and image integration to national campaigns.

The "Think Small" campaign for Volkswagen by the advertising agency Doyle Dane Bernbach is an example of this new advertising approach (Figure 2.70). The ad, designed by art director Helmut Krone (1925–1997) has a lovable, and somewhat surreal and austere, quality. The layout and the supporting text work in union as a concept, asking the

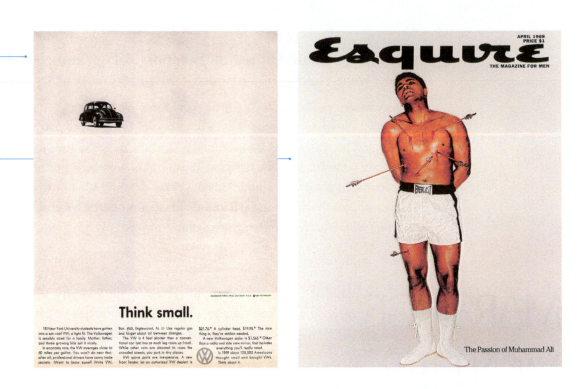

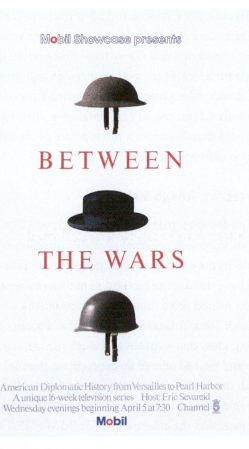

2.72 IVAN CHERMAYEFF. Poster for a television series about American diplomatic history titled *Between the Wars*. 1977.

reader to "think small." The audience was confronted with a small, economy-minded car in a country that was used to thinking big. This cool advertising, with a witty sense of humor, connected with an audience ready for change.

The art director George Lois (b. 1931) perfected this new blend of word and image with his work for *Esquire* magazine. Lois brought advertising's conceptual approach to the design of magazine covers. A 1968 cover story on Muhammad Ali posed the fighter in the stance of Saint Sebastian (condemned by the Romans for his religious beliefs) and symbolized conscientious objector Ali's refusal to be inducted into the U.S. Army (Figure 2.71). It was a provocative image with a strong social message.

Other graphic designers also incorporated this conceptual approach into their projects. Ivan Chermayeff (b. 1932) created a strong connection between word and image in a poster design for Mobil Oil Corporation's sponsored television program about events that happened between the two world wars (Figure 2.72). Chermayeff bracketed a diplomat's hat between World War I and World War II military helmets as well as the program's title *Between the Wars,* conveying meaning through the arrangement. Its centered layout forces the reader to focus on interpreting the idea. In addition, the Mobil logo itself, which was also designed by Chermayeff's design studio, is a word and image construction—the name and its circular letterforms suggesting mobility.

MARRIAGE

MOTHER
CHILD

Families
A READER'S DIGEST PUBLICATION

2.73 HERB LUBALIN. Typograms: Marriage (1965), *Mother & Child* (1965), and *Families* (1980).

2.74 HERB LUBALIN. Announcement for *Avant Garde* magazine's antiwar poster contest. 1968.

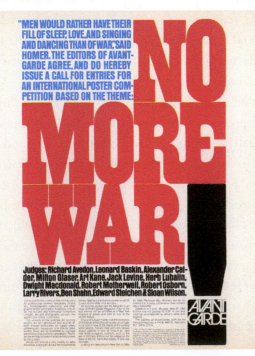

During the 1960s, as the way type was created changed from solid lead casts to a more flexible process in which letterforms were exposed onto photographic paper, designers quickly adapted. Herb Lubalin (1918–1981) showed how letterforms could be made into malleable forms to communicate ideas. His **typograms,** as he called them, had a double duty of both reading and creating pictures. These visual poems in miniature extended to page layouts, book covers, and advertisements (Figure 2.73). For example, his announcement for an antiwar poster contest, which appeared on the back cover of *Avant Garde* magazine, carried the image of type and flag and communicated the power of design and protest (Figure 2.74). Lubalin, art director for *Avant Garde* magazine from 1968 to 1971, also designed its masthead (see the ad's exclamation point). He developed the font he used for the masthead into a full typeface of the same name, a typeface that came to define the phototype period.

Conceptual Image Makers

Surrealist philosophy, part of an outgrowth of Dada, may have triggered an approach to graphic design problems that began to take hold in the early 1950s and gained more followers in the 1960s and early 1970s. The method of juxtaposed images, placed side by side, helped solve more complex problems that designers were tackling. These images spoke louder and more conceptually in conveying ideas that went beyond single-image, narrative solutions. War and protest offered an appropriate channel.

Polish designer Tadeusz Trepkowski (1914–1956) used juxtaposition in a powerful antiwar poster—an appropriate channel to voice concern in the aftermath of World War II (Figure 2.75). Rather than depict a bomb exploding or a city destroyed, Trepkowski's poster reaches further. The silhouette of a bomb reveals a glimpse of a bombarded city, the horror of war expressed simply and directly by creating a montage of the two images. A single word makes the demand quite clear—"Nie!" (No!).

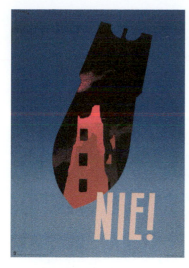

2.75 TDEUSZ TREPKOWSKI. Antiwar poster. 1953.

2.76 Jerzy Janiszewski. Solidarity logo. ca. 1980.

2.77 SHIGEO FUKUDA. Poster for *Victory*. 1975.

Twenty-eight years later, another Polish designer, Jerzy Janiszewski (b. 1953), applied conceptual thinking to another protest, one for the Independent Self-Governing Trade Union "Solidarity" (Figure 2.76). Here, a crowded street protest is conveyed through an ingenious use of letters, its characters standing together to form a unified whole, with the Polish flag streaming behind.

In Japan, designer Shigeo Fukuda (1932–2009) created a body of work using nonverbal conceptual images. Fukuda's designs are shocking yet playful communications. His *Victory* poster, a surreal depiction of the thirteenth anniversary of the end of World War II, was awarded first prize by the 1975 Warsaw Poster Contest, a competition whose proceeds went to the Peace Fund Movement (Figure 2.77). The shell heading toward the gun instead of out of the gun flips one's perception. The idea is quite complex, loaded with paradox and irony, but Fukuda's drawing is both disarming and clear.

German designer Gunter Rambow (b. 1938) also brings a Surrealist edge to photography with his work for theaters and publishers. In his poster for *Südafrikanisches Roulette* (South African Roulette), the concept of using the shape of Africa bleeding through a bandage powerfully symbolizes the play's theme of pain, suffering, and revolution in South Africa (Figure 2.78).

2.78 GUNTER RAMBOW. Theater poster for *Südafrikanisches (South African) Roulette*. 1988.

2.79 ANTHON BEEKE. *Een Meeuw (The Seagull)* poster for the play by Anton Chekhov for the Theatercompagnie, Amsterdam, The Netherlands. 2003.

> *In Modernism, reality used to validate media. In Postmodernism, the media validate reality. If you don't believe this, just think how many times you've described some real event as being "just like a movie."* —Brad Holland

Dutch designer Anthon Beeke (b. 1940) integrates performance art with photography to explain his conceptual thinking. Beeke was a member of the 1960s neo-Dada movement called *Fluxus,* and its influence on his work is especially obvious in his designs for Dutch theater companies. In *Een meeuw (The Seagull)* the image is first perceived to be a flower with a face in its center (Figure 2.79). It has a carnival-like atmosphere which, on the surface, appears simple and direct. However, when the viewer realizes that the flower was created out of feathers, and the face and feathers are splattered with blood, another layer of meaning with a much more cryptic message is revealed.

Today, Beeke's conceptual images are representative of work in this genre that relies less on stabilized ideas, ones that hit you over the head with their intent, and more on ideas that are open ended and complex in their subtlety. They do more than deliver a message; they deliver a message filled with nuance. This approach reflects graphic design's expansion into territories that were once the province of the fine arts. Juxtaposing meaning and gesture may prove to be the ultimate goal for the graphic designer as cultural image maker.

Postmodernism and the Digital Age

Fascism and Communism proved that the struggle for finding *the* perfect way, the ultimate system, could lead to frightful extremes. In response, there was a shift away from utopian ideals or movements that involved the pursuit of timelessness or perfectionism. **Postmodernism** was born after World War II and, as is clear in its name, defines itself as that which comes after Modernism. If Modernist "isms" such as Cubism, Futurism, and Surrealism shared the goal of finding an ultimate truth, then Postmodernism suggests an end to this belief in truisms and a preference for a more open-ended approach that draws from various sources, an approach with no easy answers.

French writers were the first to present an awareness of the limitations of Modernism. France's Vichy government collaborated with the Nazis, which may be the reason why French citizens had to look so carefully at the social and cultural structures that made that situation possible. By the 1960s, critical writers including Jean Baudrillard (1929–2007) and Jacques Derrida (1930–2004) proclaimed searches for anything absolute (a painting style, building form, or communication structure) as impossible paths to continue.

In architecture, Robert Venturi (b. 1925) taught a new generation of architects to appreciate the fragmented and eclectic nature of life and to work this untidy approach into a kind of counterrevolutionary architecture that could be loaded with symbols and historic references. Venturi's maxim "Less is a bore," challenged the International Style's "Less is more" functional creed that had dominated architecture since the Bauhaus. In his book *Complexity and Contradiction in Architecture,* Venturi wrote: "I

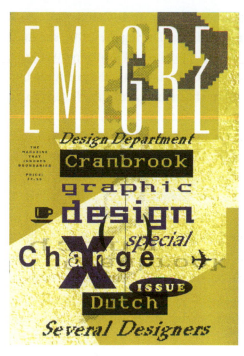

2.80 GLENN SUOKKO. Cover design for *Emigre* magazine #10. 1989.

Dead History

2.81 P. SCOTT MAKELA. *Dead History* typeface for the Emigre type foundry. 1990.

2.82 ED FELLA. Lecture announcement. 1995.

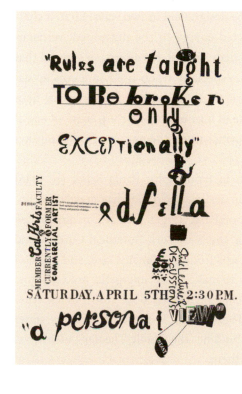

am for a richness of meaning rather than clarity of meaning…. I prefer 'both-and' to 'either-or,' black and white, and sometimes gray, to black and white." Venturi and his wife and business partner, Denise Scott Brown, together created buildings that referenced the vernacular art languages, those of untrained, local styles, culminating in their book *Learning from Las Vegas: The Forgotten Symbolism of Architectural Form.*

By the 1970s, the general public was fully experiencing Postmodernism in popular culture. Punk rock music most blatantly exemplified this new attitude and literally shocked the establishment in its reaction to conservative British politics and the processed muzak and disco of that decade. In Great Britain, most punk musicians and their fans were not interested in the skilled playing of their instruments. What mattered more was the energy and passion that Punk exuded.

Graphic design took its cues from this questioning of established structures and how designers operated within them. Layouts that had been expected to be clean to the point of antiseptic began to reveal the working process. Grid lines, tape, and pencil marks were intentionally left in the finished designs. The introduction of the Macintosh computer in 1984 didn't stop the anti-aesthetic investigation graphic designers were exploring. The raw and gritty bits of the new medium were textures to be included, not hidden.

The 1980s represented a definite rift between the residue of Modernist sensibilities and Postmodernism. And no outlet better reflected this rift than a magazine called *Emigre* (Figure 2.80). Created in 1984, its publisher, Rudy VanderLans (b. 1955) provided a forum for alternative design concepts and approaches. *Emigre* challenged established rules about legibility while embracing design's emerging **digital age.** A likeminded soul, designer Katherine McCoy (b. 1945), was found within the design department at Cranbrook Academy of Art in Michigan. Under her guidance, Cranbrook surfaced as a laboratory for graphic experimentation. Many graduates showcased their work through *Emigre* magazine. Perhaps no student epitomized the postmodern fusion of typeface design and technology better than P. Scott Makela (1960–1999). His typeface *Dead History* for the Emigre type foundry pilfered historical faces, mixed them together, and made them digitally ready for their recontextualized use (Figure 2.81).

Another Cranbrook graduate, Ed Fella (b. 1938) brought a handdrawn quality to the critical experiments happening there. Fella melded his knowledge of traditional design rules with eccentric letterforms and personal statements. For example, he created a series of hand-lettered fliers, but distributed them only after the events were over, thus causing the fliers to lose their function as announcements and change into what he calls "design/art" (Figure 2.82). This reconfiguring of design's tools, materials, and function extended graphic design's boundaries far beyond its basic service to the business community.

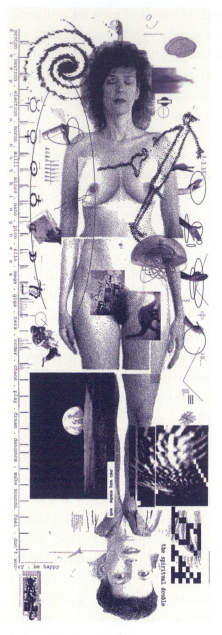

2.83 APRIL GREIMAN. Poster from *Design Quarterly*, no. 133. 1987.

2.84 TIBOR KALMAN. Print advertisement for Restaurant Florent. 1987.

A pioneer of the digital realm of design, April Greiman (b. 1948) originally trained in the Modernist tradition. During the 1970s, she studied in Basel, Switzerland, with Armin Hofmann and Wolfgang Weingart, and this experience set a solid foundation for her work that ventured into primitive, computer territory. When she returned to the United States, Greiman set up shop in Los Angeles where she began to incorporate spiritualism and Eastern philosophy into her design process. The result, stylistically labeled "California New Wave," was initially interpreted as merely a departure from the neutral, grid-oriented work in which the design community was grounded, but Greiman's work went further. It pointed to a new conceptual direction for graphic design, one driven by technology. Her magazine layout for *Design Quarterly* blended a three-by-six foot poster into the unfolding pages and layered her own revealed and digitized body into what she referred to as a "landscape of communications" (Figure 2.83). Greiman saw digital technology as its own new language "to use these tools to imitate what we already know and think is a pity."

Tibor Kalman (1949–1999), dubbed the bad boy of graphic design during the 1980s, challenged the status quo of graphic design with wit and humor. His recontextualized retro graphics looked back instead of forward with Postmodern irony. For Kalman, graphic design needed a boost because its leaning toward the corporate track was killing the creative spirit. An advertisement for a twenty-four-hour New York City diner, Restaurant Florent, exemplifies Kalman's unique perspective (Figure 2.84). Plastic letters, stuck to a letter board, were the only elements he used. Simple as they are, they succinctly communicate the everyday quality of the diner without any undue fuss. Kalman's unconventional approach broadened the design field in two ways. First, it challenged designers to see unexpected energy in the untrained, vernacular languages they normally avoided. Second, his approach showed that authenticity trumped aesthetics, especially when used in a conceptual context. Kalman changed design thinking with a Duchampian flair. His work showed a distinct sense of humor and a strong sense of social responsibility, exhibiting a wry criticism on the nature of consumption and production.

With her playful approach to typography, Paula Scher (b. 1948) has been highly influential in the design world. She has created corporate identities for Perry Ellis, Bloomberg, Target, Jazz at Lincoln Center, the Detroit Symphony Orchestra, the New York Botanical Garden, and others. Scher claims her work stems from the density, size, and noise of New York City, which pushes her to make dense, energetic, bold designs.

For The Public Theater, Scher revitalized bold wood block typefaces by angling their baselines (Figure 2.85). The result is an active series of posters whose treatment has become The Public Theater's identity as much as the logo she created for them.

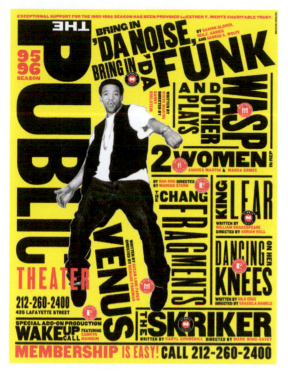

2.85 PAULA SCHER/PENTAGRAM. 1995–96 season campaign poster for The Public Theater.

David Carson's (b. 1954) association with revitalizing magazine work might best reflect the evolutionary turn toward a digitally produced, fragmented, and Postmodern design. In the same way that Punk musicians weren't interested as much in musicality as in energy, Carson's interest in magazine design isn't in its legibility or convention, but in its energy and expression. *Ray Gun* magazine (published from 1992 to 2000) was one in a series of magazines Carson art directed that was so visually engaging that it approached being a fetishized object (Figure 2.86). Most important, he was able to achieve this level of devotion on an international scale, inspiring graphic design students throughout the world.

At the opening of an exhibition at Deitch Projects, an art gallery in New York, Stefan Sagmeister (b. 1962) featured a wall of 10,000 bananas. Green bananas created a pattern against a background of yellow bananas, spelling out the sentiment: "Self-confidence produces fine results" (Figure 2.87). After a number of days, the green bananas turned yellow too and the words disappeared. When the yellow background bananas turned brown, the words (and the self-confidence) appeared again, only to go away when all bananas turned brown at the end of the four-week run.

Sagmeister relates the piece to his own process of having self-confidence—"to appear and disappear, just like my own self-confidence comes and goes." His visualization included typography as well as time and smell (as the bananas ripened). The piece was provocative not only because it reflected Sagmeister's personal idiosyncrasy but also because, despite all the technology available, Sagmeister chose a material that is more analog than digital. He also recognized that graphic art that is ephemeral and short-lived is just as valid as work that is published or reproduced. This notion is even reflected in the exhibit's announcement. Instead of distributing a postcard with an image of a banana, the gallery used a real banana—a very apt and memorable announcement for the show.

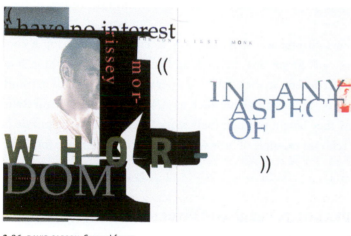

2.86 DAVID CARSON. Spread from *Ray Gun* magazine. 1994.

2.87 STEFAN SAGMEISTER. (ART DIRECTION), RICHARD THE, JOE SHOULDICE (DESIGN). Deitch Installation and invitation (banana). 2008.

In Perspective

Though its origins can be traced back to ancient cave paintings, graphic design is actually a very young profession. It has a rich history that was influenced by the major art and design movements of the twentieth century. Industrialization created a need for graphic designers, while the Arts and Crafts movement helped temper the inhumanity of the machine; Art Deco introduced Modernism as a design style, and the Bauhaus refined Modernism into a true design philosophy.

Graphic design is affected by, and simultaneously reflects, contemporary events and the world community in which it exists. For example, the Constructivist art movement of the 1920s and the Punk music genre of the 1970s both changed design in profound ways: one with the concept of abstraction, the other in its application of a stripped-down energy. The dates and audiences were different, but design's goal was the same—to communicate the aesthetics and sensibilities of an era.

This integration of graphic design and the time periods in which it is expressed emphasizes how important it is for design students to learn all they can about the history not only of their field but also of the world in which they live. An historical understanding of graphic design will help ground their ideas, and an equally important understanding of contemporary culture will bring an educated inspiration to their work. Successful designers must understand their work within the milieu of their own time.

The next chapter will focus on how to create and develop a concept. Yet we can't forget that, by looking back, we are researching how others created concepts in the context of their day. With this idea in mind, we can look to past design giants such as A.M. Cassandre or Paul Rand and see how they taught through their work. Each piece in the puzzle of design is a relevant example of how we must look back to move forward.

SPEAKOUT: Vaughan Oliver by Tamar Cohen, graphic designer, New York

Having graduated college with no formal graphic design education, I found myself working as an intern at a packaging design studio in London. I wasn't even sure that graphic design was the profession I wanted to pursue until I sat across from Vaughan Oliver. He made me laugh, had amazing taste in music (he worked for the seminal British music label 4AD), and showed me that design did not need to fit into a neat little package. He challenged convention, saw beauty in the most unexpected places and worked intuitively—more like an artist than a designer.

✓—[**Review** additional Exercises and Projects
on **myartslab.com**

Exercise 1 (Designer Profile): Write a 100-word paragraph about a graphic designer who worked solely in the twentieth century. You can reference published material, but bring your personal insight and thoughts to your writing. Pay particular attention to the designer's approach, the context in which he or she worked, and how he or she managed to connect with the audience during this time period.

Exercise 2 (Music with Design): Chose a music genre and match it with a graphic designer or a product of graphic design that has either helped influence it or has been influenced by it. Consider all kinds of music, including classical, jazz, folk, rock, punk, and so on. Document your findings.

Project 1 (Architecture and Graphic Design): Pair three different examples of architecture with graphic designs of the same time period. Organize your images, include titles, diagram dates, and teach something through the information and the design's arrangement. Full color. Size: 18" × 24."

 Things to Consider: *Think about how the form of your own layout can reflect the theoretical underpinning of the time or movement you're notating.*

Project 2 (Designer Style Poster): Create a poster on a twentieth-century graphic designer. Focus on one main point—something you discovered about that person. Consider how he or she might have used metaphor, humor, abstraction, structure, or the vernacular to connect with an audience. Teach us, but also entertain us. Full color. Size: 18" × 24."

⚡ ***Things to Consider:*** *Let this piece be a document of your research, seen through your own eyes.*

Project 2 SAMANTHA TUKEY. Visual research document/ poster on the designer, Lucian Bernhard—known for his reductionist approach to poster design.

Graphic Design Concepts

3

CHAPTER OBJECTIVES

AFTER READING THIS CHAPTER, YOU SHOULD BE ABLE TO:

- Explain the difference between an idea and a graphic design concept.

- Give an example of how graphic designers can use basic storytelling conventions in their visual communication.

- Describe the concept of visual metaphor, including three specific applications: part-to-whole representations, generalized associations, and montage.

- Interpret how analytic concepts are applied in designs such as Figures 3.26–3.32.

- Describe how meta concepts can be used in graphic design.

- Discuss how different graphic designers layer conceptual approaches to enhance communication.

Exercises and Projects

Create three different kinds of montage; make a design based on pairs of words and images; design a book cover; create a visual story sequence; assemble data to develop an information design.

For graphic designers, nearly every project begins with the same request: Create something great out of next to nothing, within a limited amount of space, and for an audience that has little time.

So how do they begin? Experienced designers know that whether creating a page layout or a motion design clip, they will first need to come up with a plan.

Design as I see it is made up of two major aspects. One is concept and the other is execution.
—George Tscherny

Watch the Video on **myartslab.com**

Opposite page: MARTIN WOODTLI. Poster (detail) for *soDA Magazine* using a clock-radio as a metaphor to describe the quirky and unexpected nature of this visual culture magazine from Zurich, Switzerland.

Essentially all the parts of a design project (the idea, words, images, sounds, formats, media, and context), need to be integrated into an effective whole—often referred to as a **"graphic design concept."**

From Ideas to Concepts

An **idea** occurs when you use things you have discovered or already know well in a new way to solve a problem. This "mash-up" process involves creative thinking. For example, if you need to cross a small, rushing river, you might try to come up with an idea to help you get across safely.

One idea might be to use a large tree branch, placed shore to shore over the river, to serve as a bridge—a new way to use a tree branch to solve the problem. The process is similar when trying to solve a design problem. In graphic design, ideas (like the tree branch in the example) become useful and relevant only when they are used to solve a communication problem.

You can push a particular idea further by making an **analogy,** comparing two things on which the project's subject is based. The analogy between a tree branch and a bridge is made because they share a certain attribute—providing a surface that allows one to cross over a space. A tree, especially when placed horizontally, can function like a bridge. In a comparable design example that you will see later in Figure 3.3, a television can function like a chair when used as a place to sit rather than as a device for watching video broadcasts. And, in a larger sense, the whole problem of getting across the river is an analogy to the problem of finding a design solution. The comparison of the bridge solution and a design solution helps to explain what an idea is more clearly.

The **form** (color, line, shape, or manner) that a design takes supports and helps to communicate an intellectual idea. For example, you may use blue in a design because the subject matter has a connection to the ocean. Form that is not connected to an idea becomes empty or meaningless to a design. When form and idea integrate seamlessly, your design will be grounded on substance.

In fact, an idea that is connected to form becomes a concept. This subtle but important distinction between ideas and concepts supports the whole process of developing more sophisticated graphic design. The ideas come first, sparked by an association, a mental connection, a burst of creative thought. You need to identify the reason for the idea, always asking yourself "why?" Why should the poster be dark and somber? Why should I use these classical letterforms? Why include this photo of a cat? When you can answer those questions, when you have sound reasons behind the

SPEAKOUT: A Unique Game by Doug Kisor, chair, Graphic Design Department, Graphic + Media Design, College for Creative Studies, Detroit, Michigan

At one level, a graphic design concept is such a curious and simple thing. It relies on an idea. But really, it's even more about how an idea becomes manifest.

There is a desire to embody essential qualities in a communication, provoking a tricky process of distillation and connotation. And yet, a concept is fully realized only when odd, and not so odd, connections are made. The negotiation gains substance as the interrelationship of elements is appraised. Through this process, meaning is synthesized into a summary vocabulary of expression. These choices are then measured against a frame of goals and specific objectives.

And still, as I think about this beginning, what is missing? Play. I love designing because it's fun. Each project is its own unique game. There are questions, patterns and connections within the interrelated elements we work with, and they occur in the most unlikely places. When you open a secret door to something unexpected (hidden in a word, an image, your head, a hairball) you can sense the connection. Listening and translating the familiar—and not so familiar—within this cyclical interplay of elements is the fun, the play, the idea.

3.1 LE CORBUSIER. Nôtre-Dame-du-Haut, Ronchamp, France. 1950–1955.

ideas you have chosen to pursue, then you begin to give them form, to make them manifest through line, shape, pattern, sound, composition, and so on. At that stage, you are beginning to develop a full design concept, making your ideas real.

There are many ways to arrive at a design concept, many approaches to take when working through a design project. You will probably need to experiment for each design problem, particularly if you don't want your work to start looking stale. Always be open to experimentation and to taking chances. Some of the best ideas might come from your risks and even from your mistakes.

The architect Le Corbusier designed the Pilgrimage Chapel Notre-Dame-du-Haut at Ronchamp, inspired by a simple animal (Figure 3.1). In The Chapel at Ronchamp, Le Corbusier wrote, "The shell of a crab picked up on Long Island in 1946 is lying on my drawing board. It will become the roof of the chapel." And so it did. The shape of the roof, which then led to the design of the rest of the building, was inspired by the structure of the crab's shell, suggesting a move beyond the Cubist or machine-like aesthetic of some of Le Corbusier's previous works. The shape of the roof also suggests praying hands or a nun's cowl, all in keeping with the notion of chapel.

This example by Le Corbusier brings up an important point in idea development—learning to see. To best prepare for a career as a designer, you have to make seeing, really looking at the world around you, an essential part of your daily activity. Carry a camera with you everywhere and always remain alert for interesting shapes, colors, textures, and juxtapositions (particular elements or things that are side by side). Take note of buildings, plants, billboards, display windows, funny hats, and interesting people. Look in unexpected places and out-of-the-way corners. Pay attention to other media—movies, TV, books, paintings, sculptures, crafts, even music. Everything around you has the potential to influence your work.

The design process doesn't just happen at your desk; being a creative artist is a lifestyle, a way of conducting your daily existence. You never know where a good idea will come from or when it will appear, but if you are always open and observant of the world around you, then you will be able to collect a storehouse of images and ideas that you can use when it comes time to start designing. Fascinating images can come from the most unexpected places.

The time to start collecting ideas is not when first confronted with a new project. You may not have enough time to gather and germinate ideas on such quick notice. But if you have a storehouse of ideas, notes jotted

3.2 JESSICA SHEERAN. Motion poster (student project). The designer's intent was to consider how context alters our perception—an example of the "odd and not so odd connection," "play," and the process of "distillation."

Don't think. Thinking is the enemy of creativity. It's self-conscious, and anything self-conscious is lousy. You can't try to do things. You simply must do things.

—Ray Bradbury (1920–2012)

down, sketchbooks full of illustrations and photos, you will be able to refer to that collection when a new project comes your way. Then the act of choosing becomes part of the creative process. Working this way means never switching off your imagination, even between jobs.

The Speakout by Doug Kisor notes the similarity between how a design concept relies on connections to communicate and how playfully finding unexpected relationships supports the creation process. The motion poster by Jessica Sheeran synthesizes this point in a design experiment created for projection on an LCD screen (Figure 3.2). This digital poster transforms as the top images combine with the left-side patterns and typography to create a synthesis. As the typography refreshes, new combinations are created.

Problem Solving

Whatever the project, the essence of graphic design is problem solving. Given a certain set of parameters, you have to come up with a solution that is creative and sends a clear message. It sounds so simple, yet it never is in practice. Sometimes, you are given the equivalent of a blank canvas, or a blank computer screen, and told to just go for it. Sometimes, you are asked to work within specific parameters. Other times, you are given an existing project that isn't working well and asked to fix it. All three approaches involve problem solving that combines imagination and practicality. One of your challenges is to learn to balance those two aspects, and you will find that challenge to be different for every new design project.

At times, rational considerations will have to take priority, perhaps when redesigning a website that has poor navigation or designing a technical magazine that has few illustrations and whose readers are looking only for facts. You may stretch your skills and your imagination to come up with a viable solution, but, in the end, it simply has to work.

Other times, you will have no limitations at all on your design and you can let your imagination run wild. You can leave your inhibitions behind and try something truly radical and confrontational. This type of effort can be the most satisfying design work, the kind of work you dream of being able to do. Believe it or not, those challenges can be more difficult than the pragmatic ones because the measure of success is not well defined.

Keeping Records

Keeping records may sound cumbersome when you are in the throes of creativity, but it can be tremendously helpful to keep a record of your thought processes throughout a design. If your design is reaching its conclusion and you realize it isn't going as well as you had hoped, you

3.3 JOHN BIELENBERG. Poster for a literacy campaign sponsored by the Colorado chapter of the AIGA, the professional association for design.

View a Closer Look for the Dare poster on **myartslab.com**

dare
dear,
read

can track back through the thought process and perhaps redirect it at a certain point, trying a new direction. When confronted with a new problem, you may want to return to a similar problem you worked through once before, and having a record of that process in front of you can prove to be quite helpful.

Most important, when presenting your project to the client, you can speak intelligently about your solution if you can review the steps of your process. Clients will come to respect your work, and colleagues can learn from your successes. That final design report becomes part of the company records and is a valuable part of its history.

Concepts Go Further

Most of us begin to understand story concepts at an early age. We listen to the fables and fairy tales that are read to us. The narratives are linear in structure (beginning, middle, and end), contain a basic plot (characters and story), and share a social knowledge in the form of an underlying moral (the best route to take or the lesson to be learned). Graphic design concepts rely on the same basic storytelling conventions. Essentially, these concepts convey things such as, "This book jacket design references and interprets the material you will read inside" or "This logo symbolizes the spirit of a company." The primary intention of a concept is to help make material more understandable.

In the *Literacy* poster by John Bielenberg, for example, the image is positioned not only to be seen but also to be read, to be interpreted like a short story (Figure 3.3). The poster is immediately readable—a young child is holding a book. The compounding factor, the point that gives the communication a twist, is that the child is using an unplugged television set as a chair. The first layer of the communication is obvious—that reading can begin at an early age. We *see* that the TV is being used as a chair, not in its intended use as a device for watching sitcoms and cartoons. In this image, the physical TV enables the process of reading.

Minimal type on the poster emphasizes a humorous irony—that the images depend on being read. The image also contains a number of symbols: the child, book, television, and plug. The result is a design concept in action.

Paula Scher's design for a literacy poster approached the topic of reading from a different angle (Figure 3.4). She simply enlarged type from the page of a book, creating four-letter anagrams (different words that each use the same letters) of *a, d, e,* and *r* rearranged into *dare, dear, and read* as an appeal for literacy. The scale challenges the viewer, as does the playful, straightforward presentation. Through its very cleverness, it shows a love of language, a love of reading.

3.4 PAULA SCHER. "Dare Dear, Read" poster as part of the AIGA Colorado chapter's literacy campaign.

Photo by Bill Kontzias

Joseph Roberts is professor of communications design and former chair of the BFA program in Graphic Design, Illustration, and Advertising at Pratt Institute in Brooklyn, New York. He was also president of Klauber/Roberts, a graphic and exhibit design corporation in New York City, and art director of the Philmont Software Mill, a computer-consulting firm in Philmont, New York.

When a designer can cause more than just a reaction, and takes us to a point where there is a returned response, then a solid communication is made.

How do you teach graphic design concept?

By sophomore year, when students begin taking design classes, they learn that they have to create work that communicates a specific message. In class critiques, the focus shifts from the pure aesthetics of foundation, where they only needed to express themselves, to an emphasis on moving messages. They discover that it's the ultimate goal of graphic design, and that all the elements they use in a design, including ideas, forms, typography, and so on, all relate to a total package embracing a concept. A famous Pratt student and graphic designer, Paul Rand, wrote that a concept is an integrated product that needs to be both beautiful and useful. Without the ability to think conceptually, it's impossible to solve most of the projects that come up in class or out in the field.

So where do students begin? What ideas stand out?

Projects that develop an understanding of contrast, both psychologically and physically, tend to produce the most outstanding pieces. One student created a welcome mat covered in barbed wire. Another used a clock with a face made of a stop sign. These raw and basic ideas carry something more with them for the viewer. The mat says, "Come in," yet warns you to go away. The clock's hands move, yet it signals to stop. The montage prods the viewer to respond in a kind of addition (1 + 1) so they can't help but add up. The surprise is that the answer is more: 1 + 1 = 3. In other words, they've forced the viewer to think.

Is there a value in forcing the viewer to think?

When a designer can cause more than just a reaction and can take us to a point where there is a response, then a solid communication is made. The opposite would be to have a picture of a rose with the word "rose" under it. Nothing happens. Now imagine putting the word "crap" underneath and think of how someone's brain would respond—the setup causes meaning to be created. Within the confines of a design problem, this is an effective way to get people engaged and get them to remember your design.

Are there other mediums besides visual ones?

We can't see, hear, touch, taste, or smell without visualizing mental imagery. I think of Robert Frost's poem "Stopping by the Woods on a Snowy Evening." That short piece of writing holds an album full of images. But I like to mix up all the senses and mediums in these early classes. As a variation to the montage assignment, I ask students to convey an idea by creating a physical montage (contrasting elements that have an associative link).

Vignette 3.1 Commemorative Coin for the Brooklyn Bridge sound and light spectacle.

Vignette 3.2 The associative link is sincerity.

They have to cover their project until it is revealed to the rest of the class, but by watching each face respond, you can actually see an idea hit their brain. Visual aesthetics matter very little in relation to the idea conveyed in the mind. But, of course, the final presentation of the concept must be well crafted to speed the communication.

How do you bring this approach to real design projects?

Well, we don't think of designers creating concepts for radio ads, but that doesn't mean they can't. I assign a 30-second spot for New York's Water Taxi, and, as research, I actually require the students to take the taxi. The setup for a contrasting montage to take place is the same, except that students work with sounds. What says "water" and what says "taxi"?

The solution begins there—the only visuals are the ones created in the audience's mind. It's good training for the real world, especially when they find they have to communicate a message for a company or service that doesn't have any product that can be visualized (an insurance company, for example). Designers will understand how to develop ideas into concepts that speak. And part of that speaking will come from the viewer.

Vignette 3.3 The associative links are shape and motion.

Finding ideas through research and sketching are the beginning of the conceptual process. See Steps in the Design Process (page 83) to understand how ideas for a poster for William Shakespeare's play *Macbeth* might develop.

A very unassuming concept forms the basis for the design of an annual report created by Pentagram for the National Audubon Society. The title "Birds, Wildlife, and Habitat" suggests that there might be something more to the report than simply budgets and numbers (Figures 3.5 and 3.6). Not that a review of the year's financials isn't the main point of this piece, but the report is also a beautiful guidebook. Teeming with color illustrations, photographs, and other information, the piece immediately grabs the reader's interest. The design makes a connection between birds and their environment as well as between nature and the purpose of the organization. Creatures sit on, crawl around, and otherwise interact with the type. The interplay between text and image guides the structure of the design. The content of the annual report is presented in a way that is playful and informative at the same time. The designer makes great use of animal imagery and the text of the report to create an imaginative, intelligent publication.

Metaphoric Concepts

The Greek philosopher Aristotle (384–322 BCE) wrote, "The greatest thing by far is to be a master of metaphor." A **metaphor** is used to explain one thing in terms of another seemingly unrelated thing or idea, creating a special type of analogy. A typical analogy will suggest that two things are similar (a book is like a doorway to another world); a metaphor actually uses one thing to substitute for another very different thing (a book becomes the doorway itself). The use of metaphor helps to explain the meaning of the original thing or idea. It encourages you to look at something in a way you have never considered before. Think of the famous line from the poem "The Highwayman," by Alfred Noyes (1880–1958): "The moon was a ghostly galleon tossed upon cloudy seas."

3.5 WOODY PIRTLE/PENTAGRAM. Annual report cover design for the National Audubon Society.

3.6 WOODY PIRTLE/PENTAGRAM. Annual report interior layout/ spread for the National Audubon Society.

3.7 WORKSIGHT. Poster for Shakespeare's play *Macbeth.*

Design Process for a *Macbeth* Poster

1 In Shakespeare's play *Macbeth,* the classic theme (the contest between good and evil) has been given a twist in which evil is depicted as good, while good is rendered as evil. A starting point for developing a design such as the poster shown in Figure 3.7 is to find keywords and paraphrases that boil it down but also help visualize the subject. The concept of "duality" is one such keyword.

2 Duality can be visualized through contrasting elements such as *black and white, positive and negative, top and bottom,* and a *split image.* Here, verbal thinking becomes woven with visual imagery.

3 Literal images help, too. An angel and a devil are sketched out, suggesting the duality of good and evil. Yet, full images seem too literal. An angel's wing and devil's tail have more graphic power; they can be read as meaningful signs rather than as illustrated scenes. The idea of using the devil's tail hanging above an angel's wing coordinates nicely with Shakespeare's concept, and the imagery reads as heaven and hell are being flipped.

4 Another factor in the design of the poster is that the director set the play's performance for October 25th—the same date as Russia's October Revolution (according to the old-style Julian calendar). A heavy use of the color red along with minimalist graphics will connect it to this point in time.

5 The choice of a soft and rounded typeface is made to create visual unity between letterforms and images. Its playful exploration within the composition reveals another idea: the flip of the title *Macbeth* reinforces the connection to duality and to Russian letterforms that also flip.

6 The final design is tested out on a small cross section of the poster's audience to determine whether the concept (its meaning and form) is being adequately conveyed. Feedback will help further refinements.

CHRONICLE BOOKS

3.8 DANA SHIELDS. Logotype for *Chronicle Books.* A pair of glasses coupled with supportive type form a metaphoric concept for this publisher.

Just as poets use verbal metaphors, graphic designers use visual metaphors, substituting one thing for another based on a resemblance of form, function, or meaning. For example, in the Speakout on Polish poster design, Jacek Mrowczyk shows how a tiny worm is used as a metaphor for consumption (Figure 3.10).

When one image is used in place of another, the new context of that image creates a different interpretation of its meaning. The publisher Chronicle Books uses a pair of eyeglasses to identify itself (Figure 3.8). The eyeglasses become a metaphor for reading-related adjectives such as *clarity* and *vision.*

Using visual metaphors can add an element of surprise or shock as the viewer grasps the connection and the unexpected image sparks interest in the message. Metaphorical messages are relayed in a way that can be more nuanced and complex than messages that are straightforward and

Poland is very much known for its posters, and among the most influential poster designers was Henryk Tomaszewski (1914–2005). A poster created for Henry Moore's exhibition in 1959 is especially reflective of his approach (Figure 3.9). Tomaszewski's design was simple in form and he expressed himself in an unassuming way. Using only cut paper and one solid color, Tomaszewski was able to reflect the natural spirit of Moore's sculptures. Tomaszewski's many pupils, young designers from all parts of the world, studied under his supervision at Warsaw's Academy of Fine Arts. He became known as the father of the Polish poster school.

Today, Polish posters are no longer the independent medium they once were and have become part of larger identity projects. A young generation of designers is finding its way within this scene. Kuba Sowiński (born in 1973) has incorporated an approach of combining an intellectual understanding of the subject with contemporary typography and form. His poster "Dealing with Consumption" is an excellent example, created for an exhibition of work by fellow industrial designers (Figure 3.10). The poster was designed to coordinate with other formats and media (catalogue, invitation, advertising, website, etc.), using a worm-like larva as motif to be used in all formats.

The larva is being used primarily as a metaphor for consumption, yet can be perceived as having the ability to transform into a butterfly. The interplay between the two meanings suggests futile consumption but also the hope for a better way for industrial designers to apply their talent. The typeface Dead History, designed by Scott Makela, compounds the effect of either having an end or a beginning.

Masters such as Tomaszewski upheld the conceptual approach to design. Sowiński and many other young Polish designers continue the tradition of including conceptual metaphor and formal richness in their work.

3.9 HENRYK TOMASZEWSKI. Poster for an exhibit of Henry Moore sculptures.

3.10 KUBA SOWIŃSKI. Poster for an exhibition *Dealing with Consumption*.

direct. Poets have long understood the power of metaphor in language, and graphic designers use that same power with both words and images.

The cover for the latest edition of *The History of Western Philosophy* by Bertrand Russell (first published in 1945), was revitalized through the use of a metaphor (Figure 3.11). The subject matter is quite dense, and designing a new cover made for a difficult project. Paul Sahre could have opted for a safe cover, using the reproduction of a Renaissance oil painting that spoke of history, academics, and Western civilization. Instead, he took a somewhat more daring approach, depicting Western philosophy as a lonely road, with a rich yet simple result.

See the Speakout by Martin Woodtli, where another simple image, a juicer, is used as a metaphor for the complex economical, political, and social systems of the world (Figure 3.12).

3.11 PAUL SAHRE. Cover design for *The History of Western Philosophy* using neutral type reversed to white on an equally neutral photograph by Jason Fulford.

⊗ **SPEAKOUT: Logicaland** by Martin Woodtli, designer, Zurich, Switzerland (Figure 3.12)

The invitation for Logicaland (Figure 3.12) announced a collaborative project—an online study for visualizing our world's complex economical, political, and social systems. Logicaland tries to engage people in strategies of raising human sensibility and responsibility within the global networked society. I looked for an image that wasn't a typical symbol for resources and social problems (like north and south or rich and poor). The juicer was a good metaphor for resource division and exploitation—the diodes represent game participants. I knew the symbolism wasn't so easily understandable, but on the other hand, the card was for a specialized audience so I took it as an opportunity to do something unusual and specific.

3.12 MARTIN WOODTLI. Card invitation for *Logicaland*. The juicer is a good metaphor to explain the world's resource division. The image is potent because it is so unexpected.

PEACE 平和

3.13 TOM GEISMAR. *My Daughter's Hand* poster as part of a joint exhibition of American and Japanese peace posters.

Special Applications of Metaphor in Design Communication

One way designers can express metaphor is by using one specific part of something to represent the whole (part-as-whole metaphor). For example, a human hand can be used to signify the entire body. The value for designers is that a part may simply have more graphic holding power for the viewer than a whole thing.

Another way designers can express metaphor is by substituting one thing for another based on some generally understood association or concept (general association metaphor). An example of this metaphor by general association is Wall Street, a street in lower Manhattan that is also used to refer to the entire American financial industry. Wall Street is not actually the entire industry, but it has come to be strongly associated with it. It is important to know your audience when using general association metaphors because not all associations will be understood in all cultures.

Tom Geismar uses a bit of both part-as-whole and general association metaphors in the peace poster shown in Figure 3.13. The photograph of a young person's hand, palm facing forward and nearly filling the space, offers friendship and peace. In this case, the hand represents all of humanity (part-as-whole), but the poster quickly shifts to a personal level, associating caring about the future (peace) with the hand-scrawled type at the bottom (not quite visible in Figure 3.13) that reads "My Daughter's Hand" (general association). The use of this simple image as a metaphor made the poster stand out from other posters presented at the same event, which were predominantly images of death and destruction—ironic for posters about peace.

▶ *In Practice: The life line of the palm is very evident in this photograph (Figure 3.14), which adds another layer of meaning to its interpretation. Can you identify the kind of metaphor it is expressing?*

3.14 JOHN ARMSTRONG. The montage of a jawbone with a jellybean set in place of a tooth suggests a story of tooth decay.

3.15 MAX PITEGOFF. Shelf brackets with a drape of fabric instead of a shelf is aesthetically interesting, but useless.

3.16 TAMAR MEIR. Cinderblock with plastic handles suggests futility.

The Montage Process

A **metaphoric concept,** or a complex expression of a metaphor, can be created by piecing together disparate elements into a single image called a **montage.** Artists first created the word in the 1920s to better describe the seamless techniques that film and photography offered. Proponents included the artists Man Ray and John Heartfield (see Chapter 2), who used jarring juxtapositions to present surreal views of the world.

A montage may look simple, but its meaning can be loaded with a surprising amount of intellectual depth. Designers search for images that don't seem to belong together, but that have a meaningful link. This link provides the glue that will generate an unexpected composite with unique meaning.

In a set of montage experiments, created as part of a class exercise, students attempted to elicit a psychological response from the viewer (Figures 3.14, 3.15, and 3.16). We are confronted with a jellybean set in place of a tooth, bookshelf brackets holding draped fabric, and weak plastic handles attached to a concrete block. Students used these creative juxtapositions in very compelling ways through which to tell stories.

Take a moment to consider the montage process in reverse. In fact, the viewer must look at montage in this way to decipher the meaning. Figure 3.17 combines two separate images that fit together so seamlessly, you almost believe they go together. The meaning is unstable until a specific problem is identified. If the image is for a television show (clapboard, which identifies scenes in filming) about fixing up old houses (plaster knife), then the meaning becomes stabilized, but the audience must be able to make the connection themselves.

You can use montage to create memorable logos. Woody Pirtle's design for the film studio Fine Line Features (now defunct) combined the image of a filmmaker's clapboard with the initial letterform of the company into a single composition (Figure 3.18). The clapboard calls to mind the craft of directing; the extra bold *F* feels solid, strong. Fusing the two elements resulted in a successful visual identity for the company.

3.17 Clapboard mashes up with a plaster knife. Its meaning becomes clear when the design problem—a television show about fixing up old houses—is identified.

3.18 WOODY PIRTLE/PENTAGRAM. Logo design for Fine Line Features, a film production company that was based in New York.

▶ *In Practice: A montage generally involves no more than two images—using more than two images tends to confuse the overall idea in a visual communication.*

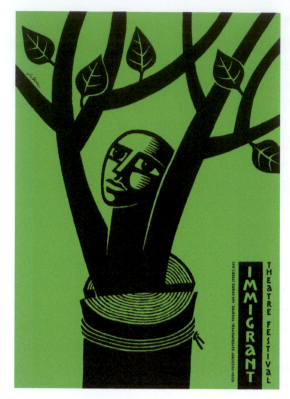

3.19 LUBA LUKOVA. Poster for the *Immigrant Theater Festival* in which an immigrant is symbolically grafted onto a new culture.

The design concept for the Immigrant Theater Festival poster montages two related metaphors into an effective whole (Figure 3.19). Luba Lukova used a tree to represent the idea of culture and a tree limb, in the shape of a person, grafted onto the tree trunk to represent an immigrant. Together with the simple green coloring, they send a message that an immigrant can grow in a new country and shouldn't be regarded as alien and separate from that culture. The simplicity of the poster image and its hand-drawn typeface add to the concept by bringing a human touch.

Two images are also combined in the cover of a brochure for Mohawk Fine Papers, Inc. (Figure 3.20). The title, *Speaking Volumes: The World of the Book,* uses an intriguing montage of books and a globe stand, making a compact combination that is itself a unique symbol. Montages have the capacity to be very simple, yet extremely rich in meaning.

Successful montages are difficult to create. The designer will need to experiment with many combinations until the fusion of images sends a greater message than the parts would individually. Two separate designs by Adam Palmer for *The New York Times* use the montage technique to supplement editorials (Figures 3.21 and 3.22). One suggests globalization and interconnectivity, and the other, puzzling U.S. foreign policies. The combinations in each montage work well because they capture an intellectual idea and trick the eye into thinking they belong together.

The Speakout by Xu Guiying describes how design elements themselves—rhythmic flow and implied meaning—can be montaged to create

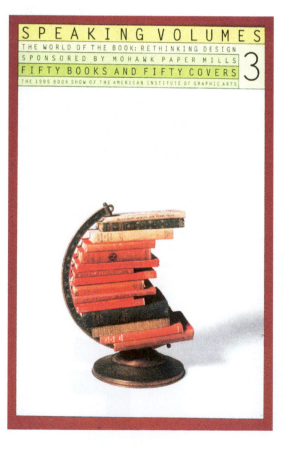

3.20 MICHAEL BIERUT / PENTAGRAM. *Speaking Volumes,* the third issue in Mohawk Fine Papers promotional brochure series "Rethinking Design."

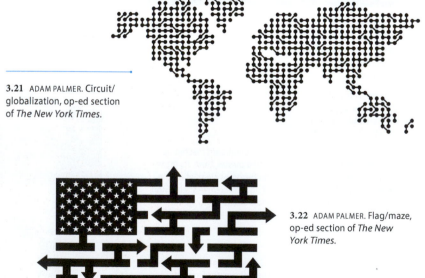

3.21 ADAM PALMER. Circuit/ globalization, op-ed section of *The New York Times.*

3.22 ADAM PALMER. Flag/maze, op-ed section of *The New York Times.*

harmonious solutions. In the two examples he provides, the designs are meant to include the audience in the creative process, allowing them to complete the picture and connect the dots of the idea. For a chordophone concert (harps, lyres, and zithers), the color and bleeding form seem to have the same soft and high-pitched reverberation as the instruments themselves (Figure 3.23). And for an advertisement advocating a shouldering of environmental concerns with economic development, the phrase *Live Harmoniously* is expressed in the biomorphic drawing of a person's face (Figure 3.24).

SPEAKOUT: Cadence and Subaudition by Xu Guiying, instructor of graphic design, Dahongying Vocational Technical College, Zhejiang, China (Figures 3.23 and 3.24)

When I teach, I often ask my students, "Why does a design look ugly, or chaotic, or vulgar?" I will then explain that the most important reason involves cadence—a balanced and rhythmic flow. Graphic design is a kind of art, and just like all good artworks there is a common characteristic—all have a beautiful cadence. I encourage students to look, and to listen, to other fields within the arts when they are searching for ideas; they should consider how a work moves from fast to slow, from close to sparse, from big to small, from noisy to quiet. It is a way to both see and feel design.

Chinese designers and artists alike also use another angle to solve problems. This involves what's called subaudition. With subaudition, an understanding is supplied, but not necessarily expressed. It is a *reading between the lines,* and you find it especially in traditional Chinese painting. In graphic design, a solution might not be so clear or concrete, but when subaudition is included as an aspect of the work, one is almost forced to think. To me, cadence and subaudition are a perfect complement to each other and a beautiful way to work as a graphic designer.

3.23 LIU JUNLIANG. Poster for a chordophone concert in which a blurred image of the musicians reverberates.

3.24 LIU JUNLIANG. *Live Harmoniously.* Advertisement advocating a shouldering of environmental concerns with economic development.

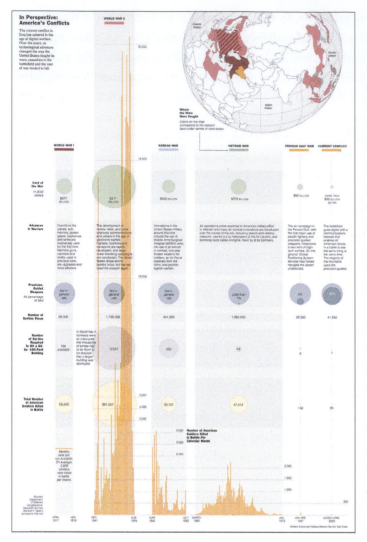

Analytic Concepts

Just as metaphoric concepts rely on an audience recognizing analogies that add meaning in a design, **analytic concepts** rely on the audience recognizing how treatments and relationships affect meaning. The simple act of juxtaposing one thing with another (to point out similarities, dissimilarities, and relationships) is an analytic process that builds meaning. When a designer decides to develop a concept through an analytic approach, he or she places a priority on the act of "referring to" something instead of on the creation of new meaning through analogy, as image-based metaphors do. Analytic concepts tend to convey information in a way that is more easily digested by an audience. They are less open-ended and more direct than metaphoric concepts.

Form, line, color, and texture play a considerable role in the development of analytic concepts as do abstract properties such as structure and alignment, pacing and flow. They all become a part of an analytic language that an audience is able to perceive and interpret.

Perhaps the most direct application of an analytic concept is in information design. The creation of charts, graphs, and maps requires the analysis and structural organization of data. The newspaper chart titled *In Perspective: America's Conflicts* represents a system of interrelationships between technology, cost, and casualties of war (Figure 3.25). The visualization makes it easy to see that as technology advances, casualties and cost fall. The overlay of distinctive dots, lines, bars, typography, and color-coding has a very rational structure and makes this analytic concept especially effective. The information and precise visual language work hand in hand.

Analytic concepts can take many forms. As we showed with Le Corbusier (Figure 3.1), a shape derived from nature can be used as inspiration to create a new design; an existing construction can be reused for a new and different context; a series of alignments can bring consistency and rationality to a subject. In the project titled *Per Diem,* by Wes Kull,

3.25 MATTHEW ERICSON, FARHANA HOSSAIN. Chart design for *The New York Times.*

3.26 WES KULL. *Per Diem* (student project) pairing the collected data of personal living expenses from the summer and from the fall semester.

3.27 WILLI KUNZ. Poster for a two-city program of Columbia University's Graduate School of Architecture Planning and Preservation.

3.28 WORKSIGHT. Visual identity for the New York City Alliance Against Sexual Assault.

the main image, a paper receipt, is used as a structural element to hold data (Figure 3.26). The term *per diem* usually refers to a daily allowance for living expenses while traveling. The student juxtaposed his summer receipts for travel, food, movie tickets, and so on with the same expenses for a semester at college. The shape morphs and bends while it compares and contrasts information.

For a Columbia School of Architecture poster, Willi Kunz used an analytic concept to convey informational relationships in a promotional way (Figure 3.27). The poster announces a program on architecture, urban planning, and preservation that takes place in two cities, New York and Paris. The program itself is about comparing the two cities, so the poster's comparison of two street grids is an effective and meaningful visual. Juxtaposing grid-like New York City streets with organically winding Parisian streets is something the students would actually study. The circular arrows, city names, and oceanlike shape amplify the concept. The typeface and alignments speak an architectural language that coordinates with the subject and focus.

Analytic concepts rely on individual parts all working together toward the success of the whole piece. In fact, the parts are subordinate to the whole (see the section on gestalt in Chapter 9). Metaphoric concepts have these same requirements, and in those treatments, the parts are subordinate to the basic idea being translated. As discussed, the cover of a brochure for Mohawk Fine Papers (Figure 3.21) uses the books inside a globe stand to express the dominant idea in the design that books are global.

The logo for The New York City Alliance Against Sexual Assault, created by Worksight, uses a series of lines to analytically represent this nonprofit group (Figure 3.28). The reach of the alliance—to hospitals, clinics, and help centers—is translated as a solid circle with radiating lines that are focused and interconnected, just as the organization is. The goal, preventing sexual violence and limiting its destabilizing effects, is further visualized through collateral material like the brochure shown. The spirit of the alliance's identity is reinforced by the weaving of symbol, photo, line, and text together into a unified composition.

❝❞ *The idea becomes a machine that makes the art.*
—Sol LeWitt, from "Paragraphs on Conceptual Art,"
Artforum (June 1967)

3.29 NASA. Website for the National Aeronautics and Space Administration (NASA) that uses an analytic approach in its design.

3.30 & 3.31 JOHN MAEDA. Pages from a paper promotion for Gilbert Paper showing how the boundaries of printing can be pushed when using their uncoated paper stock.

Websites are inclined to rely on analytic approaches because their nature is more navigational than interpretative. We browse through sections by clicking on links, and this action becomes a driving force. For NASA.gov, an analytic concept is very appropriate (Figure 3.29). The design's treatment reflects the subject matter of the site: technology, observations, and verifiable facts. Metaphoric interpretations would have no place in this design. The photographs and illustrations are examples of the wonder of space exploration, but they are deliberately positioned within an orderly structure. This approach reflects the site's personality—organized and controlled—without being dull.

The analytic approach is also exhibited in the work of multispecialists like John Maeda. A page from a promotional brochure montages computer programming with his artistic vision to create a fresh message suggesting that as design evolves, its partners will include programmers, poets, and fine artists (Figures 3.30 and 3.31).

Meta Concepts

When a design concept refers to itself or to an audience that works within the genre, we can call it a **meta concept.** These concepts have a kind of double coding to them. They are created to satisfy a design problem, but they have an additional layer, which has an appeal to fellow designers—or,

View a Closer Look for the SVA poster on **myartslab.com**

at the very least, to specific audiences. In other words, a meta concept offers a visual conversation about the communication itself.

A meta concept is the driving force behind the design of a poster promoting the School of Visual Arts (SVA) by James Victore (Figure 3.32). The posters are intended to be pasted onto subway walls, but arrive "pre-graffitied," celebrating the public, and sometimes illegal, act of self-expression. Graffiti tagging is particularly popular in big cities, and its use in the poster targets a young audience, an audience of prospective SVA students.

On another level, the poster diffuses the advertising aspect of promotions like these by making fun of itself. It encourages participants to add their own graffiti. The more handwritten quotes and drawings added to it, the better—a wiki-poster, in effect. Any additional marks made on it make the case that the school encourages self-expression.

John Bielenberg, using the pseudonym Virtual Telemetrix, Inc. (VT), used meta concept in a project created as a series called *Stuff* (Figures 3.33 and 3.34). Here, both the practice of graphic design and corporate America are directly satirized. *Stuff* pokes fun at annual reports and other communication vehicles and, in so doing, questions the role of the designer. The meta aspect of the piece is the acknowledgment that graphic designers produce a lot of stuff, most probably unnecessary stuff.

3.32 JAMES VICTORE (DESIGNER); SILAS RHODES (CREATIVE DIRECTOR). Poster, complete with its own graffiti, for the School of Visual Arts.

3.33 JOHN BIELENBERG. The packaging for Virtual Telemetrix's Stuff.

3.34 JOHN BIELENBERG. Typographic effect when one of the fanned booklets in the Stuff series is spread open (reads "Think Design").

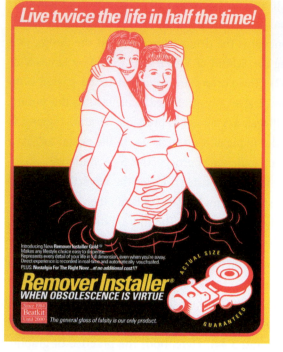

3.35 SHAWN WOLFE, BEATKIT. Advertisement parody for a purposeless product called the Remover Installer.

Shawn Wolfe's *Beatkit* advertises a nonsense product that has no function and doesn't even really exist (Figure 3.35). His Remover Installer does, however, do its job of slowing down the viewers long enough to understand that they've become part of the anti-branding shenanigan within a culture gone mad with consumerism. According to Shawn Wolfe, the campaign was meant "to harvest eyeballs long enough to force the otherwise complacent viewer to look closely and ask themselves…Is there anything there?"

Just as with VT, *Beatkit* is a meta concept directed at the perceived ills of advertising and design. Both projects require the designer to hover above in observation mode. The goal is not to trick or berate, but to sharpen the senses of both the designer and general public. In the words of Shawn Wolfe, "a contemplative pause seems sorely lacking with many advertising messages. We allow them to just wash over us."

For the cover of a catalog for Williams College Museum of Art, Barbara Glauber used a meta concept to present an exhibition titled *Beautiful Suffering* (Figure 3.36). In fact, this work is a portrayal of extremely troubling images of pain, torture, and death. But the repeated presentation of such images in the media begins to transform them into acceptance and reduces their impact. The catalog's cover pictures a newspaper article with one of these disturbing images being held by someone (we see the viewer's thumb). What brings this cover into meta territory is that the thumb on the frame's edge is in the exact position that the viewer's thumb would be in while holding the catalog. The viewer is forced to observe his or her own participation in this disturbing situation.

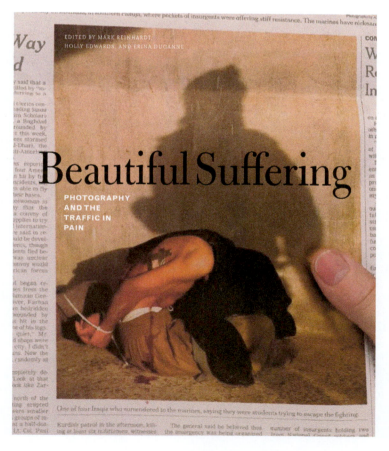

3.36 BARBARA GLAUBER. Catalog cover for the exhibit *Beautiful Suffering,* adding a meta layer of self-awareness to the design by including a viewer's thumb.

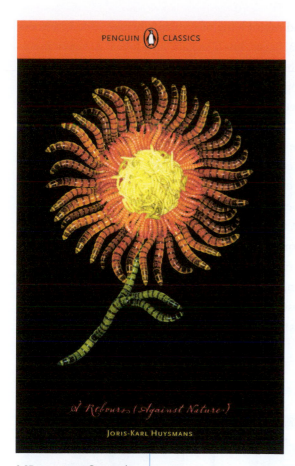

Applying Conceptual Approaches

For effective verbal communication, we use language, including metaphors and other figures of speech, but we also use hand and facial gestures and a varying tone of voice. Similarly, a design might use a layering of conceptual approaches to accomplish effective communication, especially when design problems require complex solutions.

Many of the design examples shown in this chapter have a multi-layered conceptual approach. The cover design for *The History of Western Philosophy* is, on the surface, a metaphorically based concept in the way it is presented. Its disjointed combination of Western philosophy with the image of a winding road sets up a metaphor that begs for interpretation (Figure 3.11). The cover's austere treatment—its empty road, neutral type, and basic color—conveys an analytic approach. Without the metaphoric interpretation, the cover reads simply in a no-nonsense way. Both approaches operate at the same time. But what makes this layering so accomplished is that the two concepts support each other in a kind of endless, pure, but lonely way.

A cover design for Joris-Karl Huysmans's book *Against Nature* orders the layering another way (Figure 3.37). In this case, student designer Nick Wilton used an analytic approach, focusing on the book's time period (it was published in 1884). He centered the elements and made the axis symmetrical. The hand-script font is also consistent with the concept of looking to the past (looks as if made with a quill pen). From a branding point of view, the orange petals reflect the orange band for which Penguin's soft-cover book series is so well known. The only reference to a metaphor seems to be in the fact that the flower represents a general association with nature itself.

But on closer examination, the full metaphoric concept becomes apparent. The flower transforms into something surreal; the ordinary becomes strange. The flower is created entirely out of maggots, a metaphor of decay. This metaphor perfectly characterizes the principal figure in the book, des Esseintes, an eccentric and depraved lover of beauty who is bored with the excesses of his Parisian lifestyle and obsessed with exotic flowers and perfumes.

3.37 NICK WILTON. Proposed book cover (student project), illustrated with a flower made entirely out of maggots.

▶ *In Practice: Using imagery too literally limits a design. Designers can communicate more powerfully through symbols and metaphors.*

Designers who design like machines will be replaced by machines. It is not the digital but the intuitive, not the measurable but the poetic, not the mechanical but the sensual, which humanize design.

—Katherine McCoy

The overlaying and multiplying of concepts brings added richness and depth to posters, packages, book jackets, and logos. A heavy metaphoric approach might be best suited for a project that encourages interpretation. An analytic approach—architectural in its construction—might be better suited for something that is focused on relaying data and factual information. And a meta concept might predominate when the designer feels the audience is able to hover above a solution and make meaningful observations. The three conceptual approaches are even more discernible when presented next to one another (Figure 3.38).

Concepts also depend on the person doing the designing. The richness of personal insight and experience adds to the creative process. In the Speakout by Professor Saki Mafundikwa, he explains how the students of his school are encouraged to find inspiration by first looking inward rather than by mimicking international examples. We see an example of this approach in the poster for a Zimbabwe film festival, where cultural elements (hair and dress) are integral to the solution (Figure 3.39).

3.38 A comparison of three conceptual directions that designs might take.

Metaphoric Concept

Analytic Concept

Meta Concept

Metaphoric concepts rely on the reader understanding the significance of images, especially when one image is used to represent another, in this case, a television set for a chair.

Analytic concepts rely on the reader recognizing treatments and relationships. The use of form, line, color, and texture have a considerable role in how the information is translated.

Meta concepts rely on the reader understanding the self-mocking aspect of the design, as in this poster's double coding, which solves the problem, but also points to itself and says "Look at me, I come pre-graffitied."

⬤ **SPEAKOUT: Cast Down Your Buckets Where You Are** by Saki Mafundikwa, founder/director, Zimbabwe Institute of Vigital Arts (ZIVA), Harare, Zimbabwe (Figure 3.39)

Graphic design is problem solving; therefore, defining any graphic design concept is finding the perfect solution to the problem presented. Getting this through to my students is no easy task—I encourage much research and sketching—they prefer jumping on the computer and "playing around until something comes up." Graphic design is a very new area of study in my country and most designers are more used to aping concepts from the West than coming up with solutions that are fresh and their own. As a result, one of the main requirements for most projects I give is that it be African in general and Zimbabwean in particular. "Cast your buckets where you are," I admonish them, citing Booker T. Washington's famous International Exposition speech in Atlanta of 1895.

This is no easy task since there are no precedents—as is the case in the West where one can claim inspiration by masters like Paul Rand and Armin Hofmann or David Carson and Neville Brody. Instead, I encourage them to look at nature since we are so blessed with fantastic flora, fauna, and a breathtaking landscape, making Zimbabwe one of the most beautiful countries on the continent.

It's a double-edged sword since most parents would rather their kids become "good" designers (meaning their work should look as Western as possible) so that they can find work more easily, rather than have a portfolio full of experimental stuff. Our task is to strike a balance, thereby fostering a thirst for experimentation in our students. We are further handicapped by the fact that ours is only a two-year program, which doesn't give the students the time needed to implement the theory learned into practice, but we do the best we can.

3.39 TATENDA GOMO (2ND AND FINAL YEAR, ZIMBABWE INSTITUTE OF VIGITAL ARTS, HARARE, ZIMBABWE, AFRIKA) CLASS: GRAPHIC DESIGN 2. Film festival poster designed at the request of the annual *International Images Film Festival for Women,* a local initiative by Zimbabwean women film makers.

SPEAKOUT: Translating Concepts into Forms by Inyoung Choi, Ph.D., Department of Graphic and Package Design, Hanyang University, South Korea (Figures 3.40 and 3.41)

During my teaching experience in the United States and Korea, I have found that the greatest challenge for me as an instructor is to teach design students not only how to get ideas and develop concepts, but also how to translate them into forms. I believe this is a common challenge for students and instructors from all over the world.

A unique concept, based on an everyday pool of ideas, can be the most effective action to work from. My teaching method is very simple. First, understand the client, their target audience, the society and culture they are part of, and their ethics. Second, develop an analytical strategy based on extensive research and approach it with a quantitative methodology. Third, translate the information into visual form with the understanding that design styles of the past might affect how the content is perceived.

In a way, everyone is a designer because we all have been taught to understand visual communications. But trained graphic designers can help people to understand even better, and this is what makes our field so important.

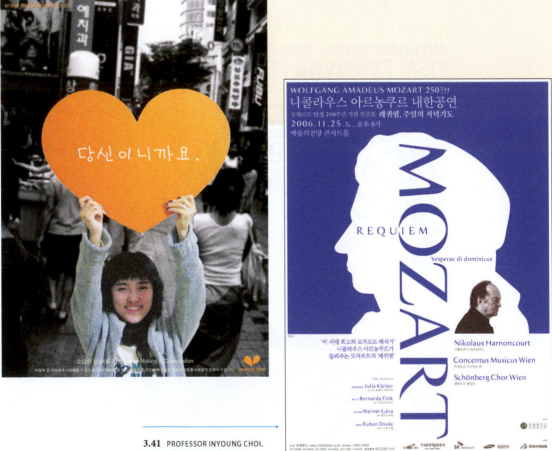

3.40 SANGHOON PARK, YOUNG SUP SHIN, HYUNG JIN KIM. **Senior** branding project for Orange-Love, a fictitious company that helps shy, young adults find romantic relationships.

3.41 PROFESSOR INYOUNG CHOI. Poster for the 250th Anniversary Mozart Concert in Seoul, Korea. The paired profiles of Mozart and conductor Nikolaus Harnoncourt reflect a similar pairing of Western and Korean typefaces.

Creativity—like human life itself—begins in darkness.

—Julia Cameron

In the same spirit, the Speakout by Professor Inyoung Choi explains how important it is for design students to understand their own society and culture when developing ideas. Two examples are noted: Figure 3.41 reflects societal constraints associated with finding romantic relationships. The design portrays a person fearlessly holding up a sign in public, announcing her own search. In Figure 3.42, Choi pairs the profile of Mozart with that of a conductor, while also pairing Western and Korean typefaces.

In Perspective

Imagine a contemporary poster design appearing in 1890. How would the concept be perceived? Expecting a distant audience to connect the *conceptual dots* would be as hopeless as asking a fifteenth-century painter to create an abstract painting. Concepts are created and understood through the context of time and cultural exposure. They fold into our language and psyche just as everyday words do. The words "daybreak" and "rainbow" are two such metaphors: a day "breaks" over the horizon and rain "bows" into a colorful shape. These mental constructions form the basis for graphic designers' concepts.

Designers also build on one another's work. The new metaphors and structures that unify into concepts are created by teachers, students, and professionals alike. Paul Sahre's road metaphor (Figure 3.11), Luba Lukova's immigrant montage (Figure 3.19), Willi Kunz's grid analogy (Figure 3.27), and James Victore's pre-graffitied meta concept (Figure 3.32) are all examples of how designers have found a way to speak elegantly and emphatically.

It is no small thing for a designer to keep up with all the necessary computer and technical skills, especially in the rapidly changing fields of Web design and video. However, a designer who has those skills, but who can also think and create, is valuable beyond measure.

The next chapter explains how to research a project. Research defines your audience and, as a result, answers the question of whether to use a metaphoric, analytic, or meta concept. The design process is made easier when you know who to talk to, what to say, and where to go with your work.

EXERCISES AND PROJECTS

Review additional Exercises and Projects on **myartslab.com**

Exercise 1 (The Montage Process): Make two lists of random objects. Think first with images in mind and then with a kind of free association that ranges from residential to industrial, local to global. When you have reached twenty items for each list, begin pairing one image from each list together in Surrealistic fashion. Choose five of the most interesting montages and present them to the class.

Color: black and white. Size: centered on an 8.5" × 11" page.

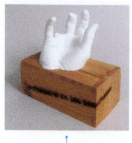

Exercise 2 (Editorial Montaging): Create an image-based montage on one of the following editorial subjects: The Other Black Gold (making synthetic fuels from American coal); Mission Creep (using soldiers to perform traditional Peace Corp functions); Doctors as Guinea Pigs (self-experimentation with new drugs by doctors); Swimming without a Suit; Speed Shrinking (psychologists who offer three-minute sessions); Dial-a-Driver (service that delivers inebriated people and their cars home). Visualize the issue, but also allow the irony and/or humor to come through. If assigned to work during class time, break into groups of three.
Color: black and white. Size: centered on an 8.5" × 11" page.

Project 1 (TOP) CARLO FERNANDINI. Montage sculpture that protests Peru's Shining Path terrorist group by raising awareness of the 30,000 civilians killed during the 1990s.

(BOTTOM) KAREN SAWICKI. Montage project through which the artist makes a montage statement about caffeine.

Project 1 (Three-Dimensional Montage): Physically assemble two three-dimensional objects into one montaged creation. The objects should share an associative link, yet contrast with each other in a kind of conflict. Create something that evokes a response from the viewer. Find combinations and blends that initiate a psychological response rather than a perceptual one. Color, shape, or any other aesthetic characteristic should factor into the solution only if they help elicit a conceptual response.
No restriction on size. Time frame: one week. Finish neatly presented (on a base if necessary).

⚡ Things to Consider: *A good way to approach this problem is to consider a social cause. Your two objects can be shocking and surreal, but they must also connect in the viewer's mind and add up to some kind of solution.*

Project 2 (Word and Image): Find five words that have multiple definitions. For example, the word *match* can mean a sporting contest, the uniting of a couple, or a stick of sulfur (researching these words in the library or on the Internet will help). Choose one word from your list and find ten to fifteen visuals that exemplify or support the various definitions. Now combine and pair images into eight sets. The objective is to form new associations that comment on or alter the most common meaning of the word. This formula works best when imagery is allowed to dominate over type, so make sure the typography is fairly neutral.

PHASE 1: Full-scale ideas in black and white (no pencil sketches). All imagery and type must be represented as close to final art as possible. Please bring your original word list, your ten to fifteen research examples, and your eight sets to class.

PHASE 2: Three final examples (8" × 10"), full color, mounted on board, flush on all edges (no border).
—*Provided by Anita Merk, professor, Pratt Institute*

⚡ Things to Consider: *Finding a juicy word with many interpretations will help immeasurably. Be sure your final montaged visualizations are beautiful. They can be thought of as mini signs, yet have the ability to suggest complex narratives.*

research has a significant impact on all phases of the design process, from creating confident sketches to developing a full concept to making sophisticated revisions to presenting final designs.

Gathering Information

You have just been handed a design assignment, and you know very little about its subject. Going online or peeking into a dictionary may jumpstart your research process. However, as you find ways to push your research further, you begin to realize that the more you know, the more prepared you are to create sketches and solve the design problem. This learning curve for each new project makes graphic design an interesting field and makes you a more knowledgeable person.

The Client, Subject, and Audience

Becoming familiar with a client, the project's subject, and the target audience should be considered the front-end work of a design project. This background information also includes the company's marketing strategy and overall mission, the product or service they want to promote, and the competition they have (competing products, services, and strategies). Much like an actor studies a character's behaviors and experiences, a designer needs to investigate the client, subject, and audience. In effect, designers portray their clients. Their work is seen by the audience as something the client created. Convincing the audience that the message comes directly from the client is part of the designer's job.

This responsibility leaves you with a challenge of speaking in the voice of each client. Therefore, you need to understand your client as well as possible, and researching the client's history is a good place to start. You will want to ask questions that unearth your client's intrinsic qualities, for example, "What are your most important goals?" and "How do you want to be perceived by your target audience?" It's possible that the principals of the company have never seriously considered these questions, but getting the answers is an essential part of the designer's job. Think of yourself as a detective, figuring out just what questions to ask to find the answer to the mystery. Working closely with the client to uncover the answers will tell you as much about the client as the answers do. And it will help the client to guide the direction of the project, to rethink what is really needed from your design. If this first step is done well, it greatly improves the success of the relationship and the final product.

Conducting this research with a new client is particularly important. Offered a project to design a poster for a Jewish Film Festival, Lucille Tenazas had to begin by doing significant research because she was unfamiliar with both her client, the Smith Rafael Film Center, and the subject matter, Jewish film. Through attending meetings, trolling bookstores and the library, asking friends for articles about Jewish culture, and find-

> *Research is to see what everybody else has seen, and to think what nobody else has thought.*
>
> —Albert Szent-Györgyi

4.1 Fuller Brush Man envelope opener leave-behind—another way the Fuller Brush salesmen left an impression.

EXCERPT: From *Contempt of Consumer: It's a Real Crime* by Seth Godin

The Fuller Brush Man knew what he was doing. In the old days, Fuller's door-to-door salesmen learned a basic rule: After you ring the bell, take a step or two backward. That way, the woman of the house won't feel intimidated opening the door for a stranger.

It wasn't just a tactic, though. It was a strategy—one designed to help the company grow by treating people with respect, in contrast to rival salesmen who were taught to jam a foot in the door. (Figure 4.1 shows another strategy the company used.)

4

Researching a Graphic Design Project

→ **CHAPTER OBJECTIVES**

AFTER READING THIS CHAPTER, YOU SHOULD BE ABLE TO:

- Describe how a graphic designer gathers the necessary information about a project and what information might appear in a client's design brief.

- Differentiate between types of virtual and actual research that contribute to a successful design project.

- Discuss the strategies graphic designers use to define the problem to be solved in a project.

- Give an example of each of the techniques used to record research in visual formats.

- Outline the steps of the research process that lead to creating a graphic design.

Exercises and Projects

Gather information about a client and put it in a presentation format; research the Swiss International Style and select a company it could be used with; map a day in your life; chart information based on a survey.

Research is a crucial and potentially engaging step in the design process. Inexperienced designers envision themselves sitting among piles of reference books, frantically flipping pages in a painful waste of time when all they really want to do is to start designing.

The irony is that we *are* designing when we research. The wheels in our brain start turning the minute we begin questioning and collecting.

The idea of language, and story-telling, and the expression of culture was something that always fascinated me. —Somi Kim

👁—[**Watch** the Video on **myartslab.com**

Opposite page: SEAN DANA. Page spread (detail) from *Lost Berlin* (full image, see Figure 4.7).

As you ask just the right questions or explore the right avenues, you reach a point where your creativity and experience can shine. As you gain more experience, your research skills will develop in the same way as your technical and creative skills do.

Imagine designing without any research at all. You have just been assigned a project, and the design is, of course, due *yesterday*. The only information you have right now is the name of the client, the kind of material the client wishes to produce, and whatever you already know about the subject (perhaps close to nothing). Chances are good you are totally lost, missing vital information while trying to assemble a design that you soon realize has no sense of direction and looks bland and cliché.

If you have developed your research skills, you will be more prepared to handle such last-minute projects. You won't find yourself designing "blind" with no resources and background information. As you develop your design skills, you will quickly come to realize that strong

Project 3 (Sequencing a Story): Within a series of eight frames, tell a story that has meaning for you. Include at least two scenes, and by the last frame, give your story an ending or resolve it in some way. Consider time and sequence in building the story.

Full color. Size: make your presentation large enough to be readable (4" × 6" horizontal snapshots).

PHASE 1: Rough sketches

PHASE 2: Finished presentation

 Things to Consider: *Researching silent films will help you to understand the techniques they used to counter the absence of sound.*

Project 5 ALICE LEE. Poster detailing recipe for dreaming good dreams. Reading from bottom to top, the piece mimics how brain activity transitions from a conscious to an unconscious state.

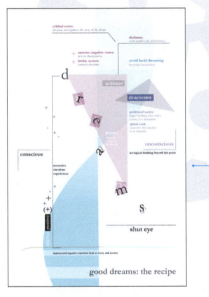

Project 4 (Book Cover Design): Choose a book you have read whose cover does not represent it very well. What did you love or find interesting about the book? Redesign the cover using the most significant metaphor that represents the content. Consider the metaphor in conjunction with the title, subtitle (if any), and author's (or authors') name(s). Do not include miscellaneous information you may find on the cover, for example, review quotes or marketing information.

Full color. Size: same as preexisting jacket

Things to Consider: *A book cover is a mini poster. It needs to make a strong visual statement. Consider how an image will create dominance within the composition, especially on a shelf next to other books.*

Project 5 (Information Design): Assemble and present data on one of your activities. You can choose from among significant activities or from those that are more routine. Cross-reference the information using location, frequency, and so on. Color, symbols, and type should be the only elements in this information-oriented piece: no photographs unless used as a graphic background. Keep in mind that the way you organize your data should add to the information being conveyed in some insightful way. Full color. Size: designer's choice.

Things to Consider: *Consider how even the most ordinary information can be presented in exciting and inventive ways that help draw viewers in and keep them there.*

Project 4 CRAIG TITUS. Sketches and final design for this self-initiated student project to create a cover design for the book *1984*.

4.2 (above) and 4.3 (below)
LUCILLE TENAZAS. San Francisco Jewish Film Festival posters for the California Film Institute's Smith Rafael Film Center.

ing visual references on the subject, she developed a basic knowledge of Jewish culture and the way it has been portrayed through film historically.

This project required a new design in honor of the film center's twenty-fifth anniversary. As Tenazas explained, "The client pulled previous posters from their archive, mostly clichéd images of film reels and the like—not very unique to the center. The archive was a valuable resource, but only because we could agree that the previous posters didn't do a very good job in advertising ground-breaking films. Many used generic metaphors that didn't match the sophistication of the films they were advertising." Tenazas decided to use black and white film stills suggesting the historical nature of the event, unconventional typography to give new energy, and a distinctive color to capture the spirit of the event (Figure 4.2). When the series continued the following year, the client repositioned the poster's direction to appeal to a younger audience. The integration of youthful images, color, and a more playful layout became the focus of the design (Figure 4.3). Each successive poster was equally powerful, with the intention, knowledge, and creativity behind them and with the blessings of the client.

Reviewing the previous design work of a new client will clarify where they've been and where they might go in the next stage of their communications. This type of research is equally valuable when done also on the client's competition. Questions might include "What advantages do you have over your competition? What designs have your competitors used that you like? What are the biggest challenges presented by your competition and how do you hope to confront those challenges?" Such questions help target goals, identify untapped directions, and help you to understand your client better. You need to know their business nearly as well as they do.

Asking the Right Questions

There are times when you will need to gather basic information yourself, for example, when a client has no prewritten brief to submit to you. Especially at these times, asking the right questions becomes an essential part of the design process. The classic "five w" questions (who, what, when, where, and why) help start the process:

- Who is the company you're creating the design for?

- What does your client do better than anyone else?

- When is the project due?

- Where is the design appearing (newspaper, website, billboard)?

- Why is the message being conveyed to an audience?

Keeping a journal is a great method to record the answers to these questions and to note other useful information (see the Speakout by Michele Washington on page 107). You can add thumbnail sketches

4.4 ALEXANDER GELMAN AND DAVID HEARTY. Logo identity for Hell's Kitchen restaurant (HK), applied to the business's outdoor awning.

4.5 ALEXANDER GELMAN AND DAVID HEARTY. The HK logo in animated form.

alongside your notes, which help to jumpstart the form your ideas will eventually take. You can easily add notes and ideas to your journal as they occur to you. A journal also becomes a very good record of your thought process, which you can use as reference for later projects.

In the research for the Hell's Kitchen restaurant logo, designers Alexander Gelman and David Hearty spent time in the local library hunting for historical material on this Manhattan neighborhood and found information that proved vital to their project. They decided to embrace the restaurant's location in a neighborhood with a troubled history and significant criminal element. The only problem, however, was that the words "Hell's Kitchen" seemed a bit too off-putting, especially for a restaurant so close to the theater and tourist districts.

Gelman and Hearty found an idea in the image of tally marks—the kind that referenced the marks that incarcerated people often make to track their time served. Within that context, they constructed the letters "HK" (Figures 4.4 and 4.5). The design resolved the naming issue, "HK" sounding more palatable than "Hell's Kitchen," and it also created a memorable and creative mark, something that would lend itself well to the restaurant's menus and even the interior furnishings.

Preparing the Design Brief

For larger projects, the client usually supplies a design brief, detailing the project's most important data. The brief helps to establish trust between the client and designer by confirming the project and enumerating all the relevant details. A design brief includes the following information:

- Company Profile—A synopsis of the company's history, including what the organization does, for how long, with how many employees, and the specific segment of a market they dominate.

- Design Objectives—Details about the design's objectives such as to generate sales, increase subscribers, gain visibility, or encourage participation. Clear and simple written objectives help the designer achieve the desired results.

- Target Audience—A list of first-, second-, and third-level audiences that also indicates whether the company wants to shore up their existing customer base or appeal to a new base. Demographics such as figures on age, sex, income, occupation, and location can help.

- Main Competitors—A description comparing the strengths and weaknesses of the product or service with any relevant competition the client identifies.

- Product or Service Details—A list detailing the competitive advantages of the product or service. For example, for an event, the list might include the easy access or the minimal ticket cost; for packaging, it might mention how easy the item is to open.

When I teach, I ask students to consider a process that I go through when working on a design—to notate their thoughts in a journal. These words, doodles, drawings, and swipes get the juices flowing. In addition, I require them to write formal design briefs and statements about their projects. It's challenging for some, but notating and writing are crucial when formulating ideas, especially when students want to communicate not just ideas, but a voice within their work.

"These words, doodles, drawings, and swipes get the juices flowing."

- Market or Legal Requirements—Details about size or proportion, printing processes, packaging specifications, or website formats. For example, food packaging might be required to display information on quantity, weight, calorie calculations, and nutritional benefits.

- Media—An explanation of considerations related to media. For example, a design's proportions and content hierarchy may be affected by media considerations, and knowing whether a package will be showcased on television, in an advertisement, or used in a special display will affect how legible the main logo must be. For a poster, the issues might be how the piece will be distributed—folded or mailed in a tube. Standard paper sizes might be an important consideration.

- Scope of Work—A description of the extent of the work and how it will be organized. Typically, a project is broken into phases. For example, Phase 1 might include research and analysis, followed by concept development of the design problem; Phase 2 might involve cover review and refinements; and Phase 3 might be implementation of the design. For an advertisement, Phase 3 could involve preparing the file for a magazine; for a signage project, it may entail installation of the signage; for a website, it might include the final programming and uploading.

- Budget and Timetable—A description of the costs and schedule. Cost might include the pay rate and the amount of time the designer can spend on the project as well as how large a staff is needed. The timetable would also determine deadlines. For example, two weeks may be allotted for idea development, two weeks for refinements, and one week for final comprehensives.

- Design Examples—Samples of historic and recent designs, which can help a designer visualize what is expected. These samples function like clues, offering a starting point, but not limiting creativity or driving a design in any particular direction. The designer can begin to understand the client and the project's direction through seeing the personality and attitude found in previous writing, photography, and elements of form such as color, texture, and font.

Somi Kim is global creative director of Johnson & Johnson Family of Consumer Companies. She has had a distinguished career as a creative thinker, driving design and brand strategy initiatives for such clients as MTV, IBM, and Motorola. Through global consumer discovery projects she unearthed insights that were developed into campaigns by Sony Electronics and Hewlett-Packard. • Somi graduated from Harvard University and the California Institute of the Arts and is a visiting lecturer at numerous educational institutions. Before joining Johnson & Johnson, she ran Ogilvy's Brand Integration Group in Los Angeles and was a founding principal of ReVerb, a multifaceted and highly influential Los Angeles design firm that won the Chrysler Design Award in 1995.

▶ **The term *research,* like design itself, has many different meanings and applications. What's your approach to it?**

To some it might connote book learning, quantifiable data, or consumer focus groups, but for me there's much more. Here's how I break down research in my own creative process, though not necessarily in this order:

1 Understand the client. This includes key objectives, the nature of their business, vision, or mission, decision-making criteria, and budgetary limitations for project production.

2 Understand the audience/end user. This includes cultural context.

3 Understand the marketplace, including the client's competitors.

4 Understand the content of the communication and the delivery mechanism (whether online, printed, environmental, etc.).

5 Draw upon my own experiences and observations, both primary (direct) and secondary (other sources).

6 Identify new ways of telling the story—through nonverbal means such as icons, color palettes, composition, and photographic style.

You mentioned the value of understanding cultural context. How does that factor into research?

Communication is at the heart of humanness but clients often discuss their products and services using "insider" language that the public doesn't relate to. On the other hand, graphic designers have an affinity for cultural understanding. We're readers of culture and cultural artifacts. Therefore we are able to translate content and organize information in tangible and compelling ways, incorporating aspects of popular culture, corporate culture, ethnic or political perspectives, and global or local trends.

Understanding an audience outside of one's own culture is very challenging. If you're working on an international design project or even something geared to a particular subculture—such as librarians or skateboarders or diabetic teens—then knowing a few key aspects of that culture will increase the effectiveness of your communication. An example would be the simple act of reading. Starting from the upper left across to the right and then down to the second line is a Western construction that other cultures may not subscribe to. Also, color, photographic content, and copy have the potential to translate into cultural faux pas. If some consideration is given, the chance that the design will succeed, and even be appreciated, is greatly enhanced.

How we shop and where we do it continue to evolve. Yet online auction sites such as eBay still retain certain communal aspects of older marketplaces, bazaars or auction houses. Whether it's a yard sale or an international trade show, there are social aspects to shopping that are common to venues or transaction zones that seem at first glance to be very different. Successful retailers such as Whole Foods remade their categories by learning from older, more intimate ways of shopping. This chart ["What Is Retail?"; Vignettes 4.1–4.3] brings attention to the links between the many different places where retail happens. Unexpected connections highlight human aspects of the retail experience as a thought-starter for the client's retail ventures. —Somi Kim

Vignette 4.1 Cover for the report "What Is Retail?" a trend report written, compiled, designed and produced by BIG LA for Motorola to inform their retail strategy.

What additional research can complement the objective research that a marketing team might conduct?

I strongly believe in the value of a designer's point-of-view in processing and filtering data, and arriving at insights. When designers connect dots from whatever material they've found or that's been supplied to them, they always enrich the deliverable, dialogue, or solution.

All in all, does research stifle your creative work or empower it?

Research is not just a stack of paper full of statistics or definitions. I feel energized and inspired by the entry points or unexpectedly powerful juxtapositions that are identified through the hunting and gathering that I call research. Too often these days people think that research means using an online search engine. While the Internet is a valuable tool, I prefer a combination of research methods, especially firsthand experiences and conversations with end users and experts in other fields.

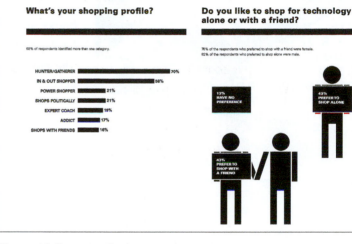

Vignette 4.2 Consumer poll results from "What Is Retail?"

Vignette 4.3 Retail landscape chart for "What Is Retail?"

4.6 SEAN DANA. Cover from the self-initiated book design project titled *Lost Berlin*.

4.7 and 4.8 Page spreads from *Lost Berlin*.

"I got lost for the sake of being somewhere else and finding my way back." —Sean Dana

Conducting Virtual World and Actual World Research

Online computer stations at a library next to shelves of actual books create one effective research combination. Browse the Internet, but also browse the aisles of a library; click through a site, but also thumb through pages of a book; allow yourself to embrace both worlds.

There are some differences between the virtual and the actual that can't be ignored. For example, the classic book *A Dictionary of Symbols* by J. E. Cirlot can certainly be viewed online, but having the physical book in your hand can more profoundly influence your understanding of the cultural definitions of objects, shapes, and colors. Also, though there are a vast number of photos now available online, you will probably find that taking your own photograph whenever possible works better for capturing your own ideas.

Thoroughness is the ultimate goal, whether you use physical books or online sources, your own interviews or published ones, hard copies of images (your own and those of others) or downloads. The point to remember is that convenience should never replace value when doing serious research. You wouldn't ever say to your client, "Oh, I didn't have time to look that up."

In a self-initiated book design project about the city of Berlin, the designer Sean Dana compiled research beforehand on the geography, hot spots such as clubs and cafés, exhibitions, and the language (Figures 4.6–4.8). But, as the designer expressed it, "When I landed in Berlin I switched to relying solely on my instincts, gathering everything I could—from pamphlets to tickets and maps—in order to see the city from an alternate angle. I got lost for the sake of being somewhere else and finding my way back." The book's design goes off the beaten path, too. Its spontaneous approach becomes a strategy that incorporates the idea of just getting lost in its pages.

For a poster on the work of graphic designer Stefan Bucher, Echo Keaney did her homework by learning everything she could from books, magazine articles, and websites (Figure 4.9). Her base of knowledge helped formulate the next stage in her research—a series of questions to ask the designer himself. "The interview helped visualize the final poster," she said. In fact, the questions and answers are included in the design, as are graphic interpretations of key points. For example, the image of a chicken and egg raises the question of what comes first for the designer—the idea or the form the idea takes.

The result was a document of research that reflected Stefan Bucher's unique way of working. Although the poster could have easily looked as if Stefan had designed it himself, the piece was, instead, a visualization of his design approach as seen through the eyes and mind of another graphic designer. Thorough research brought insight and interpretation rather than mimicry.

4.9 ECHO KEANEY. Design history research project on graphic designer, Stefan Bucher.

4.10 and 4.11 WINTERHOUSE (WILLIAM DRENTTEL AND JESSICA HELFAND). Cover and inside pages from *Below the Fold:*, a Winterhouse Institute publication.

▶ *In Practice: Sending an e-mail message to a client might save time, but meeting in person can be a much more productive experience for both the client and the designer.*

Using Design's Rear-View Mirror

Looking back to something done in the past—reflecting on design history—can lead to a forward-thinking idea. What you're after is an understanding of how an experienced graphic designer handled a design problem. If you can see through the designer's eyes, even for a moment, you will find that your own knowledge has grown.

Numerous publications cover graphic design history. For example, an issue of the journal *Below the Fold:* by the Winterhouse Institute (Figures 4.10 and 4.11) documents the extraordinary achievements of Imre Reiner (1900–1987) as a graphic designer, writer, calligrapher, and typographer. The issue is a visual narrative and academic thesis. Its simple design, proportioned as a broadsheet, offers readers a comfortable viewing format and is something that they might want to keep to look at again and again.

View a Closer Look for *Below the Fold:* on **myartslab.com**

Going to art galleries and museums, conducting online research, reading books and magazines, collecting graphic design examples, and gathering information from interviews or your own observations will help you generate your own design ideas. This information can be forgotten or hard to locate later, so keep it in a way that allows you to refer to it in the future. In particular, hang on to well-designed brochures and keep track of creative websites because they can be great inspiration for future works. These "keepers" help us know where we are coming from and where we might go.

▶ *In Practice: Keep a bookmarked list of websites that archive the inspiring work of historic and current graphic designers. Here are a few:*

aisleone.net	internationalposter.com
alvinlustig.com	grainedit.com
designersandbooks.com	paul-rand.com
designarchives.aiga.org	posterpage.ch
designmuseum.org/design	sutnar.cz
designobserver.com	typographica.org

Doing Individual Research

We tend to turn first to roommates, friends, teachers, and fellow classmates when communicating ideas. They become our audience to whom we first present our sketches and mock-ups. We test out our designs to find out whether they make sense to someone other than ourselves. If they do, then we feel a bit more confident that the ideas and visualizations might make sense to the audience for whom we're creating the work. This strategy is a good place to start, but audience research must go much further and be done more systematically.

Researching a specific audience involves looking for clues that help you to communicate better. Race, ethnicity, religion, age, gender, and income can all become important here—not in terms of stereotyping or typecasting, but in terms of understanding those people in the actual audience who will be seeing your work. This information will help determine how someone might think and feel about a topic, what background or experience they might bring to your work, and ultimately, how they will construct meaning from your design. The excerpt from Gary Larson's *The Far Side* is a humorous example of not speaking the right language.

Here's a test case: Imagine designing an announcement for a classical music performance. You come to the project without any prior knowledge of the audience who usually attends these performances, which makes your design job much more challenging. The client hasn't given you any budget or time for interviews or in-depth research, but luckily the client does, in fact, know its audience quite well. And all you need to do is ask a few questions:

- What is the age range—people in their mid-thirties or mid-sixties?

EXCERPT: From *The Far Side* by Gary Larson

What We Say to Dogs: "Okay, Ginger! I've had it! You stay out of the garbage! Understand, Ginger? Stay out of the garbage, or else!"

What They Hear: "blah blah GINGER blah blah blah blah blah blah blah blah GINGER blah blah blah blah blah…."

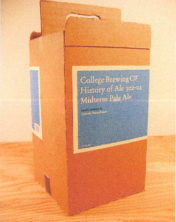

- Does the audience have a background in music or are they novices who simply enjoy listening to it?

- What media will we use? Are the announcements going to be mailed out directly or distributed in the neighborhood?

- What designs were used in the past? What have attendees responded to before? Were the designs edgy or traditional?

As you learn the basic profile of the audience, you will be able to engage in a more focused design exploration going forward.

Design student Robert Bolesta shows how his own college experience and a background in beer and the brewing process might speak to, and connect with, the product's audience (Figure 4.12). In the designer's own words: "My dad brews beer as a hobby. He's a perfectionist in the extreme and his beer is very good. We talked about what it might be like if microbreweries were inspired by academia, even naming varieties after different stages in a college career (midterms, finals, senior, alumni, etc.). The discussion led me to design along the lines of term-papers, textbooks, course numbers, and all the stuff that I'd been exposed to in school. The raw cardboard carrier pack with a rectangular sticker on the side seemed to symbolize college to me—living out of boxes and moving from one apartment to another."

In a repackaging project for a soymilk beverage, a problem with the existing label design immediately became obvious: the label information's hierarchy was wrong and downplayed the actual product (Figure 4.13). An update was overdue. The designer solved the problem by first asking basic, pertinent packaging questions (see Jeff Zack's Worklist on Package Design Research, page 114). The result is dramatic. The brand was completely rejuvenated into a refreshed identity (Figure 4.14).

4.12 ROBERT BOLESTA. Student project for a supposed College Brewing Co.

4.13 Original identity for Westsoy beverages.

4.14 JEFF ZACK. ZACK GROUP LLC. Westsoy Plus label redesign that reorganizes the information and enhances the product shot.

Package Design Research by Jeff Zack, zackgroup.com

- Does the package design stand out among competitive products on the store shelf? (shelf impact)

- Is the brand name prominent enough to hold presence?

- Does the package clearly communicate the identity and the function of the product? (functional attributes)

- Does the brand image and design style target the right age group and create the right personality? (emotive attribute)

- Has the hierarchy of communications been addressed for easy shopping? (brand, product visual, descriptor)

- If there are many similar products, is it easy to differentiate among them?

- Does the structure of package work well to contain, display, or protect the product?

- Is the brand name or logo usable in places other than on the package, such as online, print advertisement, or signage?

> Avant-garde music is sort of research music. You're glad someone's done it but you don't necessarily want to listen to it. —Brian Eno (British musician, record producer, and visual artist)

When a product, brochure, or website has to connect to an audience in stylish ways, a contemporary look would be important. However, such a look won't work with every audience and in every situation. You have to know the culture for which you are designing, as you will see in the Speakout by Katherine McCoy. A style that was considered to be a clear means of communication at the time failed because the target audience could not understand it.

Observational Research and Focus Groups

When budgets allow for a marketing research firm or department to become involved in a design project, the results and direction can become very specific. Market researchers have made a science of determining what consumers will like and dislike and their discoveries can prove very beneficial to a designer. Two of their most important methods of data collection are observational research and focus groups. **Observational research** is conducted in actual environments. Researchers observe the choices people make at stores or events in real time and in natural settings. In the Speakout on Design Intervention, Tina Park describes observational research targeted at baby boomers, the generation born between 1946 and 1964.

SPEAKOUT: The Chrysler Corporation Cleaning Manual by Katherine McCoy

In 1969 I really tried very hard to make the Chrysler Corporation Cleaning Manual a good application of information design and functionalist Swiss (Figures 4.15 and 4.16). I think I succeeded in a formal sense. The content described detailed procedures and sequences for cleaning that involved numerous dangerous chemicals, so the text is very organized and the hierarchy is well structured. My Chrysler client was pleased with the design, and the manual was printed and distributed. But about three months later, I was told that no one was reading the manual. The staff was still making many mistakes, which endangered themselves and damaged the facilities.

Some possibilities for what went wrong: My criteria for legibility, and hence comprehensibility, were Modernist. I assumed that all audiences received and decoded information in the same way, and that a "universal" design language would work equally well for everyone everywhere. The type was 9/10 point Univers Condensed—small, dense, and very "textbook" and "scientific" in appearance. This media type—an instructional manual—was probably unfamiliar and unpleasant for this specific audience. The manual's design looked like the textbooks that this interpretive community, or audience subculture, had probably found intimidating and dull during the short time that they were able attend school. I failed to ask what media this audience was comfortable with and what their literacy levels might be. Looking back, I realize that many of the Chrysler Corporation office maintenance staff (unskilled inner city hourly workers) were probably uncomfortable reading even a daily newspaper; it was likely that a percentage were unable to read at all. Furthermore, the manual's abstracted diagrams of proper office cleaning patterns were probably difficult for this audience to comprehend. Had I conducted any research into this audience's visual and verbal literacy and preferred media types, the design solution would have taken a much different form.

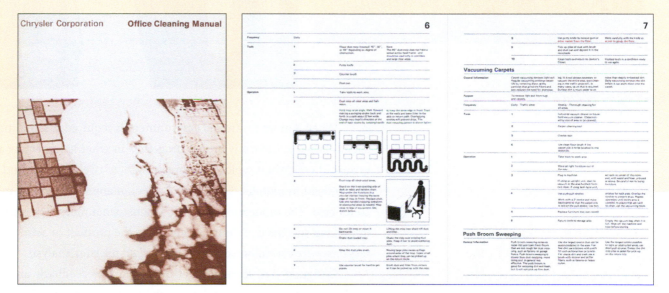

4.15 KATHERINE MCCOY.
Cover of a Chrysler Corporation
office cleaning manual. 1969.

4.16 KATHERINE MCCOY.
Interior spread of a Chrysler
Corporation office cleaning
manual using typography and
graphic illustrations inspired
by Swiss functionalist
design. 1969.

SPEAKOUT: **Design Intervention** by Tina Park

Designers often confuse research with school papers, bibliographies, and footnotes. And when studying design, our research shifts to a visual process, searching through design catalogs for inspiration or a solution we can mimic. But design research can be much more, and even quite exciting and fulfilling. For example, I worked on a design intervention that looked to engage the baby-boomer generation and to create an open forum that could be visualized and exhibited in various venues. We began conducting interviews with the goal of understanding the social concerns baby-boomers had and several personas were created to represent their voice (Figures 4.17 and 4.18). Issues ranged from the environment to the future of social security to the current state of education. Through our qualitative research we began to empathize with our audience—creating an unexpected and integral emotional connection. We could see the world through their eyes, which informed the final outcome of the design.

4.17 and 4.18 TINA PARK. Exhibit and interviews as part of a student research project involving the social concerns of the baby-boomer generation.

When a more controlled environment is required, a sampling of the client's target audience is brought together in what is known as a **focus group.** These groups typically comprise eight to twelve people and are led by a trained moderator. For a large project, many focus groups might be conducted. The moderator's job is to discuss what motivates each person in making specific decisions pertaining to the product or service. All the responses are carefully recorded and tracked for later analysis.

Designers can learn a great deal from the feedback and reports generated from observational research and focus groups. They must be cautious not to edit or make preconceived decisions about the results to support a predetermined direction or design. Also, designers must understand that both types of research use a limited number of subjects, so designers must not assume that the research proves universal truths. These studies are only guidelines and should be considered as such.

4.19 Original Domestic Workers United website.

Defining the Problem

Once designers have finished gathering research material, they need to identify the problem more clearly. If the problem has not been well identified originally, then asking the most obvious questions is a start. Questions such as "What is the real problem?" or "What is the project really about?" can potentially help to uncover the essence of the design problem. The answers those questions reveal will help to clarify the possible directions a solution can take (see the Speakout by Anna Gerber on page 118). The focus of the research may shift at this point toward asking more imaginative questions pertaining to the basic problem. The effort you make to research affects very strongly how productive you can be in creating your actual designs.

The Domestic Workers United (DWU) had outgrown their one-page website (Figure 4.19). DWU is an organization in New York of typically Caribbean, Latina, and African nannies, housekeepers, and caregivers to the elderly, asking for fair labor standards. Their site was a simple downloadable PDF with basic information about the organization. They knew it no longer served their needs. The design studio partners met with DWU and asked basic questions to identify the problems with the site.

When asked "What is it that you want to communicate?" DWU explained that they needed to be taken more seriously as an organization, particularly since they had such strong female leaders behind it. A proposal for a new site design demonstrated both their serious goals and the professionalism of the group (Figure 4.20). Active images, searchable text, clear navigation, and a proposed logotype to bring a visual identity to the site, helped make the DWU organization more vital and "real" to the general public. As the organization grows and its needs change, the designers can explore further possibilities for the site, but for the moment, it serves the needs of its members and those of the general public who might come to the site for information.

4.20 CHAKARAS JOHNSON (1973–2010). Updated Domestic Workers United website (mock-up).

In order for graphic design to continue to progress, evolve, become richer and deeper as a practice, it is important for us to think more about what goes into or what drives any given graphic design project. We need to turn our gaze away from the "pretty pictures," or put another way, to remove ourselves from the outcome or the result. Instead, we need to embrace the research, the stories, the process of getting there rather than just being there.

When we focus on the idea of being there, we lose sight of all that came before and we end up downplaying the long, involved thinking and research process that lies at the root of graphic design. When we talk about research, we can think of a considered, meticulous research, the kind of research we expect to carry out in a dark, stuffy library with rows of leather chairs and green lamps. But we can also think of the research process as being something completely unpredictable, where the unexpected or the unknown brings us to an altogether new place.

We research all the time, drawing from politics, literature, cooking, travel, construction, history, or even walking down the street. Whether the research process is planned or entirely unexpected, it continues to be a vital part of our working and thinking practice. And it is this process that we need to be thinking about, looking at, and reveling in. Graphic design is so much more than just pretty pictures.

Research is formalized curiosity. It is poking and prying with a purpose.

—Zora Neale Hurston (American folklorist and writer, 1903–1960)

Using Deconstruction to Define a Problem

In his writings from the 1960s, the French philosopher Jacques Derrida coined the term *deconstruction,* describing it as a strategic device in our way of thinking—a way to critically consider what literature, power structures, and cultural values are telling us. **Deconstruction** involves pulling something apart to understand it better. The process can be a complex one, yet extremely useful for designers to adopt when researching a design project.

Take, for example, the promotion of a public service such as a city offering free flu shots. Part of the designer's research would be to consider how to present, or to **frame,** the very idea of getting a flu shot within a specific context. In other words, how could it be promoted in a way that acknowledges that there might be some fear attached to being immunized or even to being stuck with a needle? Would high-income neighborhoods have the same concerns as low-income neighborhoods? And how would neighborhoods with a high proportion of immigrants respond to the idea? Thinking in this deconstructionist mode offers the chance to approach the problem from a social, cultural, and even political point of view.

Deconstruction has become a factor in designing packaging. Consider how products were presented up until the late 1970s. Brands were generally differentiated by their **unique selling proposition.** If you looked on any grocery store shelf, for example, one laundry detergent was presented as being good at eliminating tough stains, another as making

clothes smell nice. In this way, a brand could claim a particular characteristic as giving it a competitive advantage over another brand.

But by the end of the 1970s, research proved that a brand needed to connect more to social, psychological, and aesthetic concerns of the consumer. A unique selling proposition wasn't enough; deconstruction was required. For example, consider Starbucks coffee shops, whose main product is roasted coffee. Forty years ago, the brand's unique selling proposition might have claimed that their coffee had a superior aroma. But today, Starbucks's main brand identity describes less about the coffee and more about the consistently safe and pleasant environment they create for people in cities around the world.

In the Worklist by Kareem Collie, a set of analytic questions pushes designers to deconstruct their particular approach to a project, and in doing so, learn a great deal. Researching a project is likened to finding a story to tell, but in Collie's questions we see that research can also help decide *what kind* of story to tell.

WORKLIST

Researching a Project by Kareem Collie, dimitrious.info

Determining the Story

- What is the story that I want to tell? *What research have I done?*
- What is the purpose of the story to be told? Is it a poster design, logo, website, employment application, product label?
- Is the story complex or is it direct? Direct does not mean without dimension or depth.

Determining the Audience

- Who is my audience? Do I know my audience—have I researched them?
- What is the mood that I want to capture? What emotion do I want the audience to feel or understand?
- What questions would I like to ask the audience? Do I want to ask questions?
- What questions would I like the audience to ask? Are we asking them to participate and, if so, how much detail do I give them?

Determining the Elements

- What are the symbols or characters that best describe the story I am telling?

- What typeface am I using and what does this typeface choice communicate to the audience? Will it be perceived as funny, smart, strong, fierce, dramatic, elegant, and so on?
- What are my image choices? Do they compare, contrast, or harmonize with other page elements?
- What does my color choice convey aesthetically and emotionally?
- What is the medium that I will be communicating in?
- What are the tools I'll need?

Determining the Parameters

- What are some constraints or potential constraints of the design process? Is money an issue? Is time an issue? What are other constraints?
- What are the deadlines and will I be able to meet them?
- Have I met all of the criteria for the project?

4.21 CHARLES EAMES. An accompanying diagram of the design process drawn by Charles Eames, in a statement sent to Madame L'Amic—for the catalog of the exhibition *What Is Design?*

4.22 LUCILLE TENAZAS. Lecture series poster *Sublime Subversives* for the American Institute of Graphic Arts/ SFMoMA.

Considering the Overlapping Interests of Design

In the sketch shown in Figure 4.21, architect and designer Charles Eames (1907–1978) illustrated the overlapping interests and concerns of the designer, client, and society as a whole. Eames wrote, "As client and designer get to know each other, they influence each other. As society's needs become more apparent, both client and designer expand their own personal concerns to meet these needs." Eames defined the big picture for design, where the designer can work with conviction and enthusiasm.

Lucille Tenazas, who designed the poster for *Sublime Subversives*, had a vested interest with her client, a museum that was hosting a series of design lectures (Figure 4.22). Tenazas knew the audience quite well—fellow designers in her own community. For this reason, she took liberties with the design, flipping images and breaking words apart into a codelike typography. While she winks at how existing design rules can be so wonderfully overthrown, the viewer is drawn in by the perception of space. The tone coordinated perfectly with what the design community wanted to see and what the museum wanted to express.

Techniques for Visualizing Research

Graphic designers are visual people. We like making forms and putting them up on the wall for review. Research that is converted into visual form helps us make sense of what we're doing. We need the raw material of words, colors, and images to begin to manifest our ideas. We need to be able to experience them and challenge them. As the cartoon from *Scientific American* illustrates, what we make may be misinterpreted, but we might not know in advance exactly how (Figure 4.23). Research increases our chances of getting it right.

4.23 Originally from *Scientific American*, reprinted in *The New Yorker*, 1961.

4.24 Mood boards create a visual outline for a design to work from.

4.25 Positioning charts quickly determine the paths a design exploration can take.

Mood Boards

Designers use a collection of visual material, or **mood boards,** to help explain references, provide inspiration, and build consensus (Figure 4.24). Although these boards may remind you of collages done in grade school, don't let that association undermine what this technique can help you achieve. Mood boards are made by physically cutting and gluing images and typefaces from magazines and other printed sources, and the result helps you better harmonize your ideas. Forget the computer at this stage; working with physical materials is much more effective. You can create the mood board yourself or invite a team of designers, and even the client, to participate. The collaboration will help to build consensus on which path your design should take.

Positioning Charts

A quick way to visualize the strategic position of a company is to create an x- and y-axis chart, or a **positioning chart.** The x- and y-coordinates describe the design's personality in terms of adjectives. In this technique, words work better than images to help you explore your creativity.

The redesign of an ice cream package might be diagramed as shown in Figure 4.25. Let's consider its current package. It has brand equity in that consumers recognize it on the shelf. It is familiar, but the design is stale, especially for a more youthful audience. Two opposite points are set on the chart to reflect this issue—the first is the word "staid," and the other, the word "innovative."

The logo on the current package is set in capital letters, which gives it an authoritative feel. This fact generates a second set of adjectives in which the word "authoritative" sits opposite the word "amiable." Once the chart is set, each mark's position notates a potential design direction. The chart can help the designer cover all the bases in a design exploration: Number 1 is where the package is now (staid and authoritative); Number 2 keeps its authoritative feel, but is more innovative in appearance; Number 3 is conservative in its design, but friendly; and Number 4 is the diametrical opposite of Number 1, with a design that is both amiable and innovative. The sketch phase of the project can now begin with focused and deliberate paths to take.

A positioning chart can be used for any kind of design project, from logos and book covers to websites and motion designs. It's never too late to create one, even in the midst of a design exploration where your goal is to consider many design strategies.

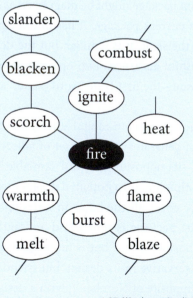

computer

hardware software

input devices applications

mouse word processing

keyboard databases

output devices spreadsheets

printer page layout

monitor network

... internet

...

4.26 Wordmapping that begins to organize information.

4.27 Wordmapping links can help you flesh out ideas that are embodied in words.

Word Techniques

Mapping of words into a diagram-based sketch is another research technique. By linking ideas, **word mapping** organizes information and activates your creative process (Figures 4.26 and 4.27). A thesaurus will help you find related words and construct an extensive word map. You can create the map on a simple sheet of paper or you can work with a group of colleagues and map out your words on a larger surface that everyone can see and comment on. In either case, what's important is to jot down words quickly, making spontaneous associations. Any idea that comes into your head, no matter how ridiculous it may seem, should be included. Later on, as you start to evaluate the exercise, you will see the potential in some of the words and associations, and you can then choose those to develop further. This technique is a valuable one to use in exploring possibilities that are not obvious and those that are perhaps even more daring.

▶ *In Practice: See visualthesaurus.com, which literally branches word connections off each other.*

Another word technique involves the montage process. For example, within a word map for packaging material (net, cardboard, twisted, bottle, window, and door), a number of pairings will immediately move your thoughts in new directions. The word *net*, combined with the word *cardboard*, might lead to research in paper packaging that can both reveal and contain the contents. With a montage of words such as *twisted* and *bottle*, you might propose using plastic technology in ways that challenge traditional container shapes. Each montage has potential as a springboard for multiple directions. Try combinations that seem unlikely; they might spur your imagination most.

As part of a research project for Hewlett-Packard, the design studio ReVerb collected, assembled, and compared cultural profiles of two nationalities—the Japanese and the Finnish (Figure 4.28). This visual and verbal map was part of a printed report and summed up insights and opportunities based on mobile technology adoption in Tokyo and Helsinki. The map provoked thinking, questions, and debate about a number of critical issues concerning wireless technology. Statistics about the two populations were woven with psychological and sociological aspects of the two cultures to describe the qualities that they shared.

The heart of design research is to provoke the thought process in relation to an actual project. The same curious spirit can be applied toward the generation of personal, experimental work. In the Speakout "Daily Research, " Kjell Reigstad explains how he pushed his own boundaries through this approach.

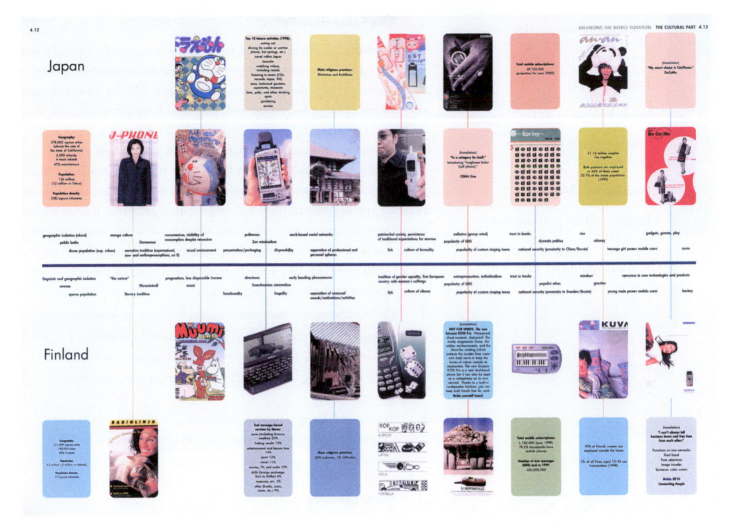

4.28 Cultural comparison chart comparing Japan and Finland, from "Roaming," an international research report produced for Hewlett-Packard.

🌏 **SPEAKOUT: Daily Research** by Kjell Reigstad

I often over-think projects and sometimes feel that my work suffers from a lack of spontaneity. In order to counter this, I decided to do a poster every day, each inspired by, and containing text from, something I'd overheard during that day (Figure 4.29). To keep these as a cohesive group, each poster would contain one design element from the previous day's poster. The elements could be as simple as a single black rectangle, a type treatment, or a photograph. I think the series is a portfolio example of how I'm able to listen, observe, and come up with designs quickly and creatively.

4.29 KJELL REIGSTAD. A student-initiated project based on the daily visualization of an overheard comment.

► *In Practice: Many libraries have files of picture collections. The images usually include photographs, illustrations, and engravings that can be checked out just as books are checked out.*

The Saturation Point

Every project's deadline, coupled with its budget (usually limited), will inevitably dictate an end point in your research. In the next phase of design, you will get involved in the experimental editing, arranging, and rearranging of the information and ideas you have compiled. This next stage of the design process is an opportunity to investigate any possibilities that you may have considered but have not yet pursued.

While researching some projects, you may also reach a saturation point, which signals the need for you to put some mental distance between you and the all information you have gathered. If time allows, give yourself a chance to let the ideas simmer while you work on something else for a while, but always keep that sketchbook handy in case you are hit with a brilliant idea while in the midst of another project.

Here's how the process might work:

1 Collect and absorb information until reaching an end point.

2 Categorize, edit, and process the accumulated material.

3 If possible, allow some time to pass, working on other projects, while continuing to absorb the accumulated knowledge from your research.

4 Review and analyze the information you collected to generate insights and imaginative concepts that will help you to create the design.

In Perspective

Research is essential for a successful design. The more effort put in to research, the more your design will communicate effectively. For most design problems, identifying the "five w's"—who, what, when, where, and why—is a way to approach design research. These questions generate important information about the client, subject, time frame, media type, and audience. The research process can also involve rewarding and engaging techniques that energize your work and activate your imagination.

The client usually supplies a design brief for large design projects, but for smaller ones, the designer must be resourceful in finding ways to probe and explore the problem. The Internet, libraries, friends, experts, and the material on the shelf next to you—the books that you know so well—all become ways to build knowledge about a new project. There are many tools to use, including mood boards, positioning charts, and word maps. With experience, you will figure out which of these tools works best for you. Each has different advantages. At the end of your research, you will be ready to embrace the creative process, which is described in the next chapter on proactive thought starters. Remember that the more research you do, the more skilled you will become at doing it. Research will no longer feel like a chore, but will become an integral part of your role as professional designer.

View a Closer Look for Make My Day on **myartslab.com**

EXERCISES AND PROJECTS

Review additional Exercises and Projects on **myartslab.com**

Exercise 1 (Company Research): Break up into teams of two or three and select a potential client to research. Gather information by phoning the actual business, searching the Internet, and using a business library.

Learn the history, mission statement, and advertising strategy, noting the following information: the product or service they provide, who their competition is, who their audience is, and the directions they might take to communicate more effectively. Compile and edit your evaluation into a format for presentation.

Exercise 2 (Design History Research): Research one significant designer connected with the Swiss International Style movement and his or her particular interpretation of that style. Now make a case for using that designer's style with a particular company of your choice. Support your case using quotes and a design example from the designer as well as a concise description of the company you choose with clear reasons why the style is appropriate.
Black and white. Size: 18" × 18"

Project 1 (Charting Information): Ask twenty people this question: What is one thing you did today that you wish you could do over? Record the results and produce a chart that notates at least three other components, for example, gender, location, time of day the question was asked, and so on.
Full color. Size: 11" × 17" horizontal.

Things to Consider: *The success of this project relies on an inventive use of icons and typography. Experiment with visual vocabularies that will help make sense of your collected material for the viewer.*

Project 2 (Mapping Data): Map one day in your life. Notate the experiences—no matter how mundane—of things you heard and saw. Decide on one incident or occurrence that stands out for you, and use words and images to document it. Full color. Size: Designer's choice.

Things to Consider: *Include photography and found objects to help transform a simple subject into something intriguing and revealing about who you are.*

Project 2 KATIE CHOW. A series of infographics visually documenting the processes involved in the making of one day and how the needs of the individual affect the macro chain of larger industries.

"I SAID, 'GRAB MY FEET.' AND SHE GRABBED MY FEET. SHE SAID, 'I CAN'T HOLD ON, HARDY,' SO I SAID, 'WAIT, DON'T GIVE UP!' SO I GAVE HER MY HAND. I SAID, 'HOLD ON, TONI.' I SAID, 'YOU CAN DO IT, DON'T LEAVE ME, PLEASE DON'T LEAVE ME.' I TRIED MY BEST TO PULL HER UP, BUT I WAS SO WEAK I COULDN'T DO IT. I TRIED. SHE LOOKED RIGHT INTO MY EYES AND SAID, 'HARDY, LET GO. TAKE CARE OF THE KIDS AND THE GRANDKIDS.' I SCREAMED, I HOLLERED. IF I COULD HAVE DONE ANYTHING, ANYTHING IN MY HEART OR MY POWER TO SAVE HER, I WOULD HAVE. THAT'S MY BEST FRIEND. I HELD HER HAND AS TIGHT AS I COULD, BUT SHE TOLD ME, 'YOU CAN'T HOLD ME.' ...I'M LOST...THAT'S ALL I HAD...THAT'S ALL I HAD." HARDY JACKSON, HURRICANE SURVIVOR

THE HURRICANE POSTER PROJECT _LAURIE DEMARTINO DESIGN 2005 _HAND SILKSCREENED BY STANDARD DELUXE _PRINTED ON FRENCH PAPER

Generating Ideas

5

⊙ **CHAPTER OBJECTIVES**

AFTER READING THIS CHAPTER, YOU SHOULD BE ABLE TO:

- Explain the importance of making your own work environment.

- Put into practice specific techniques for actively generating ideas, giving primary consideration to the message you want to emphasize.

- Demonstrate how the technique of montage can quickly embody a complex thought.

- Explain how playful accidents can aid in generating ideas.

- Discuss why taking a break can improve your ideas, and list five strategies for temporarily detaching from your work.

- **Exercises and Projects**

Perform warm-up sketching exercises; practice the random word technique; create word lists and montage them into thumbnail sketches; engage in the high-speed 100 Arrows exercise; montage images of tools; create a logo.

Waiting patiently for an idea to simply arrive in your head is generally quite futile, especially in a high-pressure deadline situation. And in graphic design, deadlines are always looming, which can be both a curse and a blessing. Although deadlines can add inhibiting pressure and stress, they can also start an adrenaline rush that prompts ideas. Adrenaline, however, is not the preferred tool for generating ideas.

I think you come up with ideas when you deeply care about what you do. —Luba Lukova

⊙—▯Watch the Video on **myartslab.com**

Opposite page: LAURIE DEMARTINO. Poster (detail) for *The Hurricane Poster Project* (full image, see Figure 5.15).

As you will see in this chapter, there are many other ways to spark that creative energy. As you begin to use them, the number and quality of your ideas may improve.

Despite their best intentions (and even after years of practice), many designers harbor an underlying fear of beginning a project. As you learned in Chapter 4, well-done research can create fertile ground for ideas to germinate. In addition, engaging in techniques that activate your creativity will broaden design thinking and reduce the fear. Clear strategies for finding ideas and unleashing creativity—**thought starters**—allow us to take an active role in our own creative process. As inhibitions to creativity crumble, solving design problems becomes a positive and exciting experience. Anticipation for the challenge of the new project begins to crowd out any lingering anxiety about what to do. After all, feeling the excitement of creativity is why we choose to become designers in the first place, isn't it?

5.1 TOP (L+R): WORKSIGHT; BOTTOM (L–R): JAN URETSKY AND NICKI WRAGG. Atmosphere and meaningful images spur thoughts that can add to a design project.

5.2 Mixtures of books on the subject of design, reference material relating to design, and books outside the realm of design are important to have on the shelf.

> ❝❞ *I've never thought of myself as getting an idea. I always discover it.*
> —George Lois

Making a Creative Work Environment

Look around your workspace. There's a good chance that you have surrounded yourself with meaningful images and objects. These things aren't simply decorative. They are photos and mementos of the people in your life, the trips you've taken, and the life experiences you've had, all there to remind you of the fullness of your life. The setting in which you work also helps set a creative tone. There's no doubt that an environment that is physically and psychologically comfortable will foster your creativity. You might work best in a space that is obsessively clean, or you might feel more comfortable in a space that is cluttered and messy. There's no correct way to create a space. What is important is to figure out what works best for you and then shape your space in ways that inspire you. Figure 5.1 shows various designers' workspaces, each creating a different mood and displaying meaningful objects, from framed designs to pop culture statues.

A bookshelf can have a similar stimulating effect (Figure 5.2). The lineup of books creates a mix of subjects that live together. In the midst of a design exploration, you can examine the titles and perhaps trigger a memory that adds some unexpectedness to your thought process. You may find inspiration just from scanning the spines and being reminded of your favorite books, and you will certainly want to pull them off the shelves and refer to them often when contemplating a new project. Sometimes just grabbing a book randomly and skimming the pages can evoke all sorts of ideas. These chance encounters help germinate ideas; designers don't operate in a vacuum.

Actively Generating Ideas

Part of being human is our unique ability to think creatively. We exercise our creative mental skills to navigate around a traffic jam or make an appetizing sandwich from leftovers. But when it comes to a design problem, many of us have a tendency to wait for that magical burst of ideas. In fact, problem solving, whether for simple everyday situations or for graphic design, shares the same techniques and skill set. Artists, scientists, engineers, and just about everyone else you can think of all engage in similar processes that trigger, evaluate, and connect creative sparks for the purpose of generating ideas and solving problems.

The main consideration when developing ideas is to decide what message to emphasize. Research will point you in certain directions, but in the end, you will have to make decisions on what avenue to follow. Asking questions that help you evaluate can be useful. For example, if you're creating publicity materials for an event, you might want to ask yourself "Will this idea help fill the auditorium?"

5.3 Multiple ideas increase the likelihood that one will hit its mark (or be perfect for your design project).

Make it happen and let it happen.

—George Tscherny

Don't be satisfied with your first idea; instead, keep pushing yourself to search further. Designers too often want go with their first viable solution and move quickly to the production phase of the project—to actually start making the website, poster, or logo. But the time spent thinking through ideas, moving past the first idea to explore others, will lead to a much richer result. You may end up deciding that your first idea was best, but you won't know that unless you go through the process of coming up with other options. Exploring multiple ideas is similar to making throws at the dart board (Figure 5.3). With each throw, you increase your chance of hitting the bull's-eye, just as you increase your chance of finding the most creative solution when exploring many ideas. As you become skilled at generating ideas, you will be able to aim your "throws" with more confidence.

Brainstorming

Brainstorming is an activity best done in groups. It is a technique for solving problems that involves spontaneous contributions and rapid responses from all the participants. Brainstorming is a great way to work through many ideas very quickly, allowing one to flow into and build on the next, without concern for viability or practical issues. It works best when done with unrestrained, free associations. Brainstorming is a process that creates chaos and then allows you to make order from that chaos. One person in the group should volunteer to take notes, so ideas don't get lost in the session. At the end, the group can go over the notes, identify ideas that seem to have merit, and pursue them to see whether they might lead to a sound solution to the design problem at hand.

If you don't have a group to work with, you can also brainstorm with just one other person, or even by yourself. With practice, you can develop individual brainstorming techniques that work well for you and that will get you through many a tough spot in your creative work.

You can use this technique at any point in the design process. At the beginning of a project, it can help you generate many possible directions to take. But it can also be a great tool to use as the project proceeds; anytime you feel stuck or when it seems that all the elements are not coming together as they should, you can take a break and brainstorm to come up with possible solutions. Setting a time limit on the session before it starts will prevent it from disintegrating into meaningless banter.

Thinking beyond the Obvious

It is difficult to adjust our mindset to explore in completely new ways. We tend to use techniques that we already know, approaching the problem-solving process the same way every time, with a preconceived notion of possible solutions. Our tried-and-true approaches help dissipate some of the fear of starting something new because we're familiar with our estab-

5.4 A puzzle in which you must connect all nine dots with four straight lines (without lifting your pencil).

5.5 The standard way of thinking might result in this failed attempt.

5.6 Going past the limits of the box allows for a full connection.

5.7 In 1974, the idea for a multiprocessor with access to the same memory sped up processing time.

lished processes, but sticking to only what we know also puts severe limits on our creativity and usually results in rather mundane, obvious designs.

The way to open a new territory of possible solutions depends on *thinking beyond the conventional or obvious.* Your objective should be to explore new associations—to see how they work within familiar parameters. Figure 5.4 illustrates this idea. The purpose of the puzzle is to connect all nine dots with four straight lines without lifting your pencil off the page. This task seems to be impossible only if we limit our usual way of thinking—of connecting the dots as if they were in a box (Figure 5.5). The solution is to connect the dots by drawing lines that reach outside of the box (Figure 5.6).

The design of the multiprocessor inside the computer you work on is another example of thinking outside the box (Figure 5.7). A computer's processing time was cut in half when engineers used two processors instead of one. The idea of multiples might have come from observing the holes in a colander or the pistons in a car engine.

WORKLIST

Helpful Questions to Expand Design Thinking

Ask the following questions when beginning a project.

- *Wouldn't it be funny if…?* This question sets up the potential for a humorous solution by getting the reader to laugh along with you.

- *Isn't it odd that on the one hand it's…and on the other it's…?* By asking this question, you are on the path to finding a double meaning or an ironic twist in your subject that you can share.

- *Can I use this image as a sign (to represent an idea) rather than as an illustration (to represent a particular place, thing, or action)?* Signs can communicate ideas more powerfully than scenes.

- *Will this design attract attention?* More specifically, will my poster reach out from the wall with appeal? Will my book cover speak intelligently about the contents inside?

- *How can I bring a unique quality to the project?* How can I make something ordinary become extraordinary?

 The greatest freedom comes from the greatest strictness.

—Paul Valéry

5.8 WORKSIGHT. Thumbnail sketches, photos, and word lists mapping phase of a project to design a brochure promoting a paper mill (below).

5.9 WORKSIGHT. *Honest Beauty Gilbert Paper.* Promotional brochure showcasing Gilbert Paper's mill and the process of making paper.

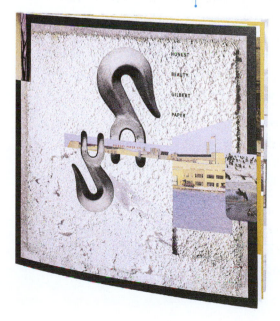

Creating Thumbnail Sketches

Thumbnail sketches might just be your handiest tool; they will never become technologically outdated and they don't need an electrical charge to function. You can use a roughly drawn rectangle to read as the outer shape of a page. Smaller boxes inside are placeholders for photos, their inner shapes suggesting actual content. Squiggly, repeating, horizontal lines indicate the density and position of lines of type. The heavier the weight of the line, the bolder the typeface it represents. But beyond these basic notations, you can use thumbnails to indicate conceptual directions for your design. They can lean toward the analytic, where the emphasis is on structure, typography, and alignment. Or they can lean toward the metaphoric, where images create meaning through their combination and juxtaposition.

Thumbnails should be small—about the size of a business card or an index card. This small size works well because you can generate them quickly and easily fill a page with them, learning something about your thinking process as they progress from one to the next. Keep them simple, using gestural lines for people, solid forms for basic geometric shapes, and horizontal lines to represent type. The idea is not to create perfect little drawings; what is important is the thinking process and rapid recording of ideas.

Using the proverbial cocktail napkin or the back of an envelope can prevent you from forgetting ideas, especially when they come to you while you're away from your studio, but carrying a small sketchbook is a better solution. Sketchbooks are a more permanent and portable place to record thoughts in chronological order as the project develops. You can also paste photos, color swatches, and bits of text into a sketchbook. Furthermore, you can save them for future reference when working on similar projects later.

If pencil and paper seem too out of date to you, try using the same approach with your desktop computer or handheld electronic device. The point is to flesh out ideas as quickly as they come so you will have them handy when you're ready to start your actual design. You can focus solely on the ideas rather the execution of those ideas by deliberately keeping thumbnails rough and sketchy. Don't worry about the form these ideas might take until later. Include even ideas that seem far-fetched or silly, and try to avoid making judgments at this stage. Just draw.

A brochure design that Worksight created for a 100-year-old paper mill began with the simplest of sketches (Figure 5.8). These sketches developed an idea around an object found on the floor of the mill—a heavy, metal hook. The hook inspired words and drawings that focused on its authentic quality (it was used to transport paper rolls) and its simple functional beauty (industrial, yet elegant). The mill itself had a similar sense of function and utilitarian beauty. The connection triggered an idea

View a Closer Look for the Ed Fella flier on **myartslab.com**

KEEP THE
IRREGULARITIES INCONSISTENT.
VARIOUSLY DIFFERENTIATED,
AND ★OTHERWISE UNMATCHED
IN ALL MANNER OF WAYS
AND VARIETY OF SORTS.

'DEED I DO

SO, SO.

5.10 ED FELLA. Design for the front and back of an announcement for a lecture by the designer. Sketches during the exploration served as art for the back side of the flier. (Detail below)

▶ *In Practice: A way to engage design thinking immediately is to begin sketches during project meetings.*

to present the mill in a way that didn't hide its tough and gritty textures but, instead, celebrated them as a real working factory.

Trial sketches of the hook on the cover of the brochure clearly suggested that this object would be the perfect graphic "hook" to bring the viewer into the piece. In these sketches, the hook also began to resemble the silhouette of a duck, which led to another unexpected connection to the famous Hans Christian Anderson story: was the mill an ugly duckling or a beautiful swan? A real duck pond in front of the mill's main office might have triggered that connection and did seem to pull all the parts together. On the final cover solution, made using paper produced at the mill, is the image of paper pulp stuck to the lid of a grinding machine, a photo of the duck pond, and the hook shown both in its functional position and flipped upside down as a beautiful ducklike object (Figure 5.9).

Thumbnail sketches can literally become the design, as they did in a flier announcing designer Ed Fella's own lecture (Figure 5.10). The "shiny boot" image on the back cover is self-referential, representing the highly crafted and professionally slick work of Fella's early career. The flier design is an example of a meta concept (see Chapter 3), with sketches supporting the idea of keeping one's self a little off-center during the design process. Fella, well known for his move toward hand-drawn designs, exemplified this concept of keeping off center by actually doing it, using sketches as the final artwork. In keeping the design crowded and busy, he avoided choosing which images to delete and which to save; consequently, his design becomes a statement about making choices—often one of the greatest difficulties in moving forward (see the excerpt *A Psychological Tip*).

EXCERPT: A Psychological Tip by Piet Hein (1905–1996): Danish mathematician, inventor, author, and poet.

Whenever you're called on to make up your mind,
and you're hampered by not having any,
the best way to solve the dilemma you'll find,
is simply by spinning a penny.

No—not so that chance shall decide the affair
while you're passively standing there moping,
but the moment the penny is up in the air,
you suddenly know what you're hoping.

5.11 WILLI KUNZ. Thumbnail pencil sketches for the poster *Cyberspace* (below).

5.12 WILLI KUNZ. *Cyberspace.* Poster announcing a symposium about the transformation of traditional public space into cyberspace and its deterioration into hyper-ghettos.

The thumbnails for a Columbia University architecture poster by Willi Kunz show how his final design uses structure to create meaning (Figure 5.11). The poster's subject, a symposium on the transformation of traditional public space into cyberspace (and its deterioration into hyper-ghettos, where hood culture is celebrated) is quite abstract, and the poster's graphic elements are equally abstract, in keeping with the subject matter. Yet they do express a hyperactive, multi-layered quality that relates to the urban environment, as will be discussed by the diverse set of panelists at the event the poster is promoting. The roughing in of type, lines, and shapes are just quick sketches, but they convey the visual depth the designer intended. Through a series of refinements, he transformed the simple thumbnails into a spirited poster that portrays both the content and spirit of the conference (Figure 5.12).

Some designers use thumbnails as inspiration for projects that require a more deliberate interpretation through metaphoric concepts. They sketch a mix of readable images that work together to create meaningful communication. In the thumbnails Luba Lukova drew for a poster that was part of a series on social justice, her thought process is clear. Each sketch is a step in her investigation to interpret the impact of a large income gap in society (Figure 5.13). In this case, the fork and slice of cake or pie are used as symbols to make a metaphoric connection to the subject—a smaller proportion of the population gets a much larger proportion of its bounty. After completing a number of thumbnail sketches, Lukova tries to determine which one works best to not only convey her message but also to grab her viewers' attention.

Luba Lukova is a renowned artist and designer working in New York City. Her distinctive work uses metaphors, juxtaposition of symbols, and economy of line and text to succinctly capture humanity's elemental themes. She has held solo exhibitions at UNESCO in Paris, DDD Gallery in Osaka, La MaMa in New York, and the Art Institute of Boston. Her many awards include the Grand Prix Savignac at the International Poster Salon in Paris, the Gold Pencil from The One Club in New York, and Honor Laureate at the International Poster Exhibition in Fort Collins, Colorado. Her work is represented in the collections of the Museum of Modern Art in New York, the Library of Congress, and Bibliotheque Nationale de France. Lukova is the creator of the critically acclaimed Social Justice 2008 poster portfolio containing visual reactions to many of the pressing issues of our time. The portfolio has been exhibited around the world, including the prestigious exhibit at the inauguration of President Barack Obama. The Social Justice 2008 poster portfolio was recently added to the permanent art collection of the World Bank.

► How do your ideas take form?

I have to be really moved and interested in the project to put my brain to work. Everything begins with shapeless, almost chaotic, pictures that come to my mind. Then I learn as much as I can about the subject matter by reading and researching. And then I try to forget about all those facts I have absorbed and let my intuition lead me. I usually start making very loose drawings until a line or a shape suggests a more defined idea (Vignette 5.1). I guess the process is similar to a sniffing dog following his nose. I think with experience we need less time to do preliminary drawings. Sometimes the idea just comes right from the very first time I sketch it.

Where did you get the idea for the Sudan poster?

The idea came after watching a television documentary about that impoverished country. At the end of the film there was a commercial promoting low-calorie food. The contrast was so striking that while watching the ad I had the idea for the image in my head. In one hour I completed it without actually having been given an assignment for it (Vignette 5.2).

Where was it published?

I contacted *The New York Times* op-ed page art director who had encouraged me to propose images for the publication. Unfortunately, at that time the editor thought that "Sudan was not in the news" so the collaged drawing was not published in the paper. Another year passed before I received a phone call from a young graduate at Columbia Law School. She and a couple of her colleagues had started an organization called Anti-Poverty Law Center and needed a visual identity. While working with them, I showed my rejected Sudan image and we decided to use it as a poster for the organization. Sudan has won numerous design awards including ICOGRADA Excellence Award and gold medal at the International Poster Biennial in Mexico.

When a client comes to you with something specific, where do you start?

I start by immersing myself in the client's project. After I accept the job it becomes my own project. I begin to care about the problems that the client wants to address, as if they were my own problems. Only then am I able to put myself in that state where I feel inspired to work and I am able to come up with ideas. I think this is what people need from us: to feel sympathy for their issues and use our skills to resolve them. I usually present several ideas to my clients. But there are exceptions where I feel so strongly about a concept that I don't want to show anything else but this piece. This works well with people who trust me and know that I put a lot of effort into seemingly simple solutions (Vignettes 5.3 and 5.4).

View a Closer Look for the Sudan poster on **myartslab.com**

Vignette 5.2 Sudan. Poster for the International Anti-Poverty Law Center.

Vignette 5.1 Cover sketch for War Resisters League 2010 Peace Calendar.

Vignette 5.3 *Say It Loud!* Poster/logo for Say It Loud!, an Orlando, Florida advertising agency.

Vignette 5.4 *Water.* Poster for the Union Theological Seminary.

DESIGNER VIGNETTE: LUBA LUKOVA

5.13 LUBA LUKOVA. Thumbnail sketches for the Social Justice poster campaign: *Income Gap* (below).

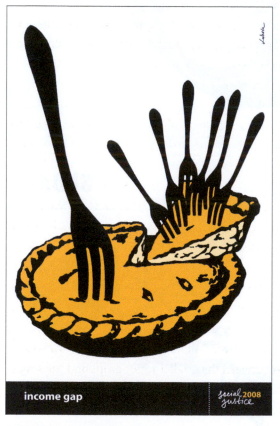

income gap

social 2008
justice

5.14 LUBA LUKOVA. Final poster for the Social Justice poster campaign: *Income Gap.*

In the final poster, the image of the pie speaks with an immediacy much more powerful than words (Figure 5.14). Her distinctive style, simple forms, and sensitive use of color work together to distill the issue into a powerful image. The large fork dominates the image, while the smaller forks compete over a much smaller piece of the pie. It's a simple yet dramatic image that carries the message of economic inequality quite poetically and emphatically.

> *"i tao pi pu tao:"*
>
> *If the idea is there, the brush can spare itself the work.*
> —Ancient rule of Chinese painting

Associating Words with Ideas

An effective (and fun) way to generate new ideas is to apply the **random word technique** to your design process. First, simply choose a word and find its definition (or definitions) in the dictionary. Then distill one of those definitions to some keywords or ideas, and apply those keywords or ideas to the subject of your project (see Steps in the Design Process: The Random Word Technique). Bringing an idea down to a **keyword** helps you to get to an essential part of that idea. Think of the process as a kind of structured stream of consciousness in which you associate key ideas from a random word with the design topic at hand.

Let's imagine you are working on a website design for a hardware store. You randomly choose a word such as *telephone.* A telephone has nothing to do with a hardware store, but that doesn't matter for this technique. What does matter is that you consider its meaning. In this case, the two roots of the word—*tele,* which refers to transmitting over a distance, and *phone,* which refers to sound and language—clarify the meaning *telephone,* which is a device to transmit a human voice over a distance.

Thinking about this definition leads us to the following chain of key ideas: transmitted voice > distance > making connections. That chain begins to evoke ideas for the hardware store's website: if we bring the idea of making connections to hardware, then we can imagine objects being paired, for example, a hammer to a nail, paint to a brush. You can worry later about how you might make this concept visually concrete (perhaps in a language diagram or a montage). But for now, just concern yourself with making the associations. Try choosing another random word and see where its meaning and key ideas lead you in terms of that website for the hardware store. You might discover something completely unexpected and stimulating.

Using random words forces you to explore new ideas. The entire world is fair game for random words and associations. The words *shoe,*

The Random Word Technique

1 Randomly choose a word (noun, verb, adjective) from a novel, newspaper, or magazine, or instead, simply point to an object or an activity.

2 Look up the word's definition in a dictionary to determine its basic meaning (or meanings). Paying attention to the root, or origin, of the word is especially useful.

3 Summarize into as few words as possible the principle meaning (or a particular meaning) of the word.

4 Use your summary words from Step 3 to prompt associations and connections with elements of your project. (See the example in the text under "Associating Key Words with Ideas.")

5.15 LAURIE DEMARTINO. *The Hurricane Poster Project*—a design community initiative responding to flooded New Orleans.

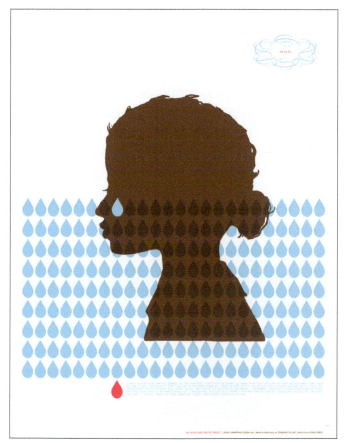

soda, or *magazine* all have the potential to evoke ideas. Even verbs such as *dance* and adjectives such as *beautiful* can produce surprising results. Be creative and open to embracing true randomness.

The words people use to tell stories, express their feelings and experiences, or make an appeal can also lead to associations that produce meaningful ideas. The poster by designer Laura DeMartino was inspired by a Hurricane Katrina survivor, Hardy Jackson, who recalled his last moments with his wife as she was swept away by the floodwaters. "I tried to pull her up, but was too weak. She looked into my eyes and said, 'Hardy, let go. Take care of the kids.' If I could have done anything in my heart or my power to save her, I would have. I'm lost, that's all I had" (Figure 5.15). Hardy's words triggered ideas for DeMartino that led her to create a poster with a single human portrait. In this work, one person's silhouette represents many people, just as one tear becomes a symbol to represent the many tears triggered by this tragedy. She created a visual analogy between tears and flood waters that resonates because of the irony of New Orleans being known as a port city. The emphasis created by the solid silhouette makes the poster's composition work quite well. The viewer is drawn in by the contrast between the smaller water drops and the single tear, causing an emotional response. The hurricane survivor's words triggered ideas that DeMartino translated into visual form. The Worklist on Poster Design identifies some of these points, and In the Speakout "On Visualizing Ideas," Charles Goslin suggests some strategies that help in this process.

▶ *In Practice: Note how a repeating pattern of drops has been used here to create meanings. Laura DeMartino used drops to represent many tears shed, whereas Charles Goslin used repeating drops to represent many people giving at a blood drive. Both are symbols, though of a very different sort. Symbols can be very powerful in a design, so use them wisely.*

5.16 ELI KINCE. Dining hall poster making a request (left), and a second poster (right) that was posted (as a replacement) one week later.

A poster design is especially dependent on a solid concept to reach out and grab the viewer's attention with (see the Worklist on creating a poster design). For a dining hall where students needed to be reminded not to remove food, Eli Kince went a bit further to explore how the same words could be transformed to function in different ways over time. In the first poster, all of the letters "o" were replaced with images of food, a simple change that might make one notice and smile. In a second poster, hung a week later, the food images were missing, as well as the letters, and the poster suddenly became quite funny with its big blank spaces that implied missing food (Figure 5.16). The designer used humor to deliver the message quite effectively. He knew his audience would respond better if they could laugh along with the poster. He gained their attention with the first poster and gained their empathy with the second.

Poster Design

Before you begin to come up with ideas for a poster, become aware of important considerations that apply to almost all posters. The purpose is not to allow these parameters to inhibit your ideas but, instead, to allow these parameters to work unconsciously in the background while you explore ideas.

- Have you identified the target audience?

- Is a clear message being conveyed through a solid and memorable concept?

- Is the poster visible from a distance?

- Does the poster's design stand out both on its own and adjacent to other posters?

- Is there a dominant image that creates a visual entry point for the viewer?

- What is the second element you want the viewer to see?

- Are there any visuals codes connecting the poster to the specific subject, product, or service? For example, is the subject serious, humorous, academic, architectural, organized, or fluid?

- Have you conveyed any emotional cues?

- What makes the poster memorable: its form, its meaning, or both?

- Should the installation or handling and shipping of the poster factor into its design?

SPEAKOUT: On Visualizing Ideas

by Charles Goslin (1932–2007)

Charles Goslin used to tell his students that an idea was the hat rack to hang everything on. In other words, an idea is the necessary element to support all the other details. The sketches and final symbol exemplify this search for ideas in his poster for a blood drive (Figures 5.17 and 5.18). His design used many small drops of blood and one large drop as a metaphor to symbolize the group effort required for a blood drive. The following tips explain how one might expedite the idea-generating process.

Goslin: Visualizing ideas is the most important thing we do as graphic designers. Without an idea, you've said nothing. But it's not only expressing an idea, it's also about making it a graceful and beautiful idea. Here are a few suggestions I make to students when working on a design problem:

5.17 CHARLES GOSLIN. Thumbnail sketch exploration (partial) toward developing a symbol for Merck & Co. blood drive.

1 Apply the seat of your pants to a chair in a very quiet room.

2 Focus with undivided attention. There shouldn't be any distractions, especially no music blasting through earphones.

3 Conceptualize, conceptualize, conceptualize. Students often say they made a design because they felt like it. They too rarely say they did it because they thought it through and wanted to use THIS concept.

4 Sketch out thumbnails with a thick black marker—a pencil or pen will make your drawings too fussy. Fussy is good when refining an idea, but you can't refine "nothing."

5 Ask yourself questions to help define the problem—you are your own best resource.

6 Push yourself to explore something new. There are wonderful things inside you, and if you don't try things you've never done before, you will never find them. Keeping yourself off balance will help.

7 Enlarge some of your thumbnail sketches. There are times when a wonderful little fragment of a drawing is there, but you don't know it or see it when it's too small. Do it mechanically—on a copier or scanner. The tools are there, so use them.

8 Don't be afraid to put stupid things down as ideas. The point is to keep moving forward—you can weed out bad ideas later.

9 Use symbols. Don't make pictures of whatever happened—there is rarely an idea in that approach. BUT, don't take the search for a symbol too literally by making a trademark.

10 Be your most severe critic. The only person you ought to be competing with is yourself. Push yourself in your sketch phase. Think of it as climbing a hill with a rock on your back—it seems like you are never going to get anywhere, but what you're actually doing is investing—in the project and in yourself.

5.18 CHARLES GOSLIN. The final symbol after a series of submissions and refinements.

5.19 "The danger in Disguise." World War II Soviet propaganda poster using the "Sheep's Clothing" fable to allude to Nazi Germany's treachery in their invasion of the Soviet Union. The poster captions say: "The enemy is insidious, so be alert!"

禾 (grain, hé)

+ 火 (fire, huò)

秋 (autumn, qiū)

5.20 Chinese characters montage into a compound idea.

5.21 ALEXANDER GELMAN. Graphic image to accompany an article of a terrorist attack in a Russian theater. The montage is revealed in a step-by-step process.

Generating Montaged Ideas

Montage is a workhorse technique in graphic design. Designers use this valuable tool to encapsulate a thought quickly, making it especially useful when creating thumbnail sketches. Montage is often confused with collage because both involve pasting things together onto a single surface. But whereas collage is an additive process, montage is reductive. With montage, you choose images to express the essence of an idea. The technique generally works best when you combine only two images at a time. Combining more than two images can make deciphering the meaning more difficult.

The concept of pairing objects and ideas is quite old, possibly first tried by the ancient Greeks. The Greek word *synectikos* means to bring diverse elements together into a unified connection. Aesop (620–560 BCE), a Greek slave and storyteller, brought this idea to children's fables. In his popular fables, including *The Tortoise and the Hare,* animals personified both problems and their solutions to teach morals and life lessons.

One of Aesop's fables was used as the design idea for a Soviet propaganda poster during World War II. In *The Danger in Disguise,* a wolf, identified clearly with a swastika, is revealed under sheep's clothing (Figure 5.19). This same montaging technique can be used to solve complex design problems. You can use it to promote or explain any event, service, or product by using odd combinations and conveying ideas in surprising ways.

Chinese characters also involve a simple montage technique that creates complex meaning. Writers take single words, made of signs and shapes, and combine them to create a word that holds yet another meaning. For example, in Figure 5.20, characters for grain and fire combine to create the word for autumn.

Another good example of montage is seen in the final design by Alexander Gelman (Figure 5.21) to accompany an op-ed, a commentary printed on the page opposite the editorial page in a newspaper. The subject involved a Russian hostage crisis in 2002 in which Moscow authorities pumped a gas typically used for anesthesia into the theater to neutralize Chechen militants, but in doing so killed 129 hostages, many of whom were children. The design uses two forms that symbolize the theater (happy = comedy and sad = drama), but the addition of a third mask, a gas mask drawn in the same style as the other two, redirects the meaning toward something completely different.

We can see here how a thumbnail sketch might have translated directly from sketchpad to final design. When we create thumbnail sketches, we are searching to visualize the same reductive, yet meaningful thinking. Thumbnail ideas stand out as tiny triggers that make connections to the subject. Using a similar style and scale, the designer made a close connection among the three masks, creating a kind of horrible

5.22 CHANG-SOO CHOI. Thumbnail sketch toward a proposed book cover for *M Butterfly*. The mash-up of images lead to a more complex thought about the play and its characters.

5.23 CHANG-SOO CHOI. Finalized design for the cover of *M Butterfly*.

▶ *In Practice: Graphic designers are experts at communicating through signs and symbols. Signs and symbols "read," and they do so with the kind of graphic power necessary to hold attention.*

irony—a sequence of events from theater to death. The design spoke as clearly as the published article.

When creating thumbnail sketches, the designer has to determine whether the image will "read" (convey a special meaning) in the culture in which it will be seen. The happy and sad mask images are a standard symbol for *theater,* but if only those two images were used, they would have not expressed the full depth of the idea behind the op-ed piece. In this instance, their use helps a large segment of the audience begin to understand the subject, but the addition of the gas mask, drawn in the same icon-like style, brings new meaning. However, in a culture that doesn't recognize the original masks as symbols of the theater, the entire message would have been lost. The designer must know the cultural background of the intended audience when using such symbols.

The thumbnail for a book cover for *M Butterfly* by Chang-Soo Choi uses montage as a technique, where pins that usually hold butterflies now hold the letterforms in place (Figure 5.22). This simple switch underlies the storyline of distorted relations between a French diplomat (Bernard Boursicot) who falls in love with a male Peking opera singer (Shi Pei Pu) and the disastrous outcome of their affair. When brought to a final, refined design, the addition of a hand, transparent veil, type position, and an overall dark atmosphere, help portray this dark fantasy (Figure 5.23).

 EXCERPT: Lewis Carroll, **Through the Looking-Glass,** Chapter 5

…Alice laughed. "There's no use trying," she said: "one can't believe impossible things."
"I daresay you haven't had much practice," said the Queen. "When I was your age, I always did it for half an hour a day. Why sometimes I've believed as many as six impossible things before breakfast."

A graphic illustration by Adva Meirovitch for an op-ed article describes the search for a super gasoline that offers improved mileage, yet doesn't pollute (Figure 5.24). In the montage, she has combined a classic gasoline pump with a photograph of Superman. The images are reduced to black and white (**posterized**), so they function more as signs that are to be read, rather than as photographs that offer particular details and include shades of gray or shades of the color spectrum. The montage supports the article, but also adds to it by questioning whether this search for a miracle product is similar to waiting for Superman to come and save us. (See Steps in the Design Process: Creating a Graphic Montage. It explains the steps the designer took to solve the editorial project using sets of keywords, a process that can be useful for any designer who needs to interpret information to relay a message.)

Benefitting from Playful Accidents

When developing design ideas, it is always useful to keep an eye out for the playful accidents in your sketches. Instead of being undesirable or unfortunate, these accidents can reveal ideas that might have been otherwise discarded or overlooked. It may seem strange that an error might possibly lead to a great design direction, but famous inventions are studded with examples. Charles Goodyear (1800–1860) spent years of research trying

▶ **In Practice:** *Posterizing the gasoline pump and Superman images—and thus eliminating the photographic (grayscale) quality—allow the graphics to integrate more easily with each other.*

5.24 ADVA MEIROVITCH. Student op-ed project on the subject of the world needing a kind of "Supergas."

Creating a Graphic Montage

1 Research the subject: Find material that will build knowledge for a full exploration, and summarize the content into keywords. What is the subject *really* about? Flesh out the main points. In the case of the article referred to here, the premise is that America needs a super gasoline for both economic and environmental reasons.

2 Decide on at least three sets of keywords that embody the basic aspects of your content. For the article, one keyword set might be "America" and "gasoline," another could be "America" and "pollution;" and a third word set is "super" and "gasoline." Think of each set as a conceptual path. For example, the conceptual path of the keywords "America" + "gasoline" leans toward patriotic; "America"+"pollution" is environmentally minded; "super"+"gasoline" is perhaps the most direct but might leave out some important messages. Comparing multiple concepts offers the chance to challenge one against the other.

3 Choose one set to begin. List as many images as you can for each keyword (Figure 5.25). The words should be image-based nouns, not adjectives or complex ideas. For example, don't use the word *angry* because it can't be portrayed as a single image. Instead, use a word like "frown," which can be visualized.

4 Cross-reference list A with list B, thumbnailing images of each possible pair as montages, for example, "muscle" with "engine," then "burst" with "engine," and so on. Each pair holds the possibility of an idea. Continue down the list, remembering that with thumbnails, it doesn't matter how well the images are drawn. Their purpose is only to record ideas.

5 After making many thumbnails, review them all to see which ideas stand out from the rest. Choose two or three to **mock-up**, bringing each idea to a more resolved form. Get feedback from fellow students or coworkers to determine the best solution.

A) Super	B) Gasoline
muscles	engine
burst	gas cap
cape	car
superman	gas can
(super) glue	gas pump
(super) bowl	flame
(super) sized	nozzle
Nintendo	oil
…	…

5.25 Keyword list that breaks down main points of the article to make a distilled summary.

5.26 GIORGIO BARAVALLE, DE.MO.
Cover and book design for
Forgotten War.

to find ways of giving rubber strength and elasticity, but only when he accidently spilled sulfur into rubber that was heating on his stove did he discover a viable solution—vulcanization.

Inventor Arthur Fry (b. 1931) found that a glue deemed "not sticky enough" by his company, 3M, worked well as a coating on a hymnal bookmark. After being inundated with requests from coworkers for more of "that sticky notepaper," Fry turned a mistake into a significant office supply, Post-it® notes, now as common as the paper clip.

You can generate a playful accident by embracing the creative process—a process that can be messy and chaotic or clean and organized. The various techniques described in this chapter will help the process along, as will looking outside the window, daydreaming, or throwing an image or bit of type into a composition, among a host of other approaches. The associations you make will open new conceptual territories, and maintaining an open mind toward whatever happens will allow you to recognize the playful accidents that will inevitably occur.

For example, imagine using the same set of familiar hues for everything you design. By mistake, you drop a new color into the mix. What's normally blue and beige now has bright green next to it. Your first response might be one of dismay, but on second look you might say, "I never would have chosen that color, but I like how it works there."

Playful accidents are, by nature, imperfect, which creates a nice contrast to the technically flawless designs one can create with a computer. We see digital "grit" being deliberately added as texture to help loosen up the page and increase the emotional response in a communication. We see designers using computer techniques to make images look hand drawn or worn. Weathered rawness, glitches, and mistakes add a human element to what might be an otherwise impersonal communication.

The design by Giorgio Baravalle for the book *Forgotten War* has many raw elements (Figure 5.26). Its front and back covers are made of rough corrugated cardboard, and its spine is made of a thick rubber band, holding all the pages together. The idea is meant to set a tone for the book's subject—a photographic journal documenting the work of the organization Doctors Without Borders. In keeping with the organization's own finances, the book was produced with limited means. Even the cover graphic, a continuous torn texture, silkscreened in white ink, coordinates with the raw and immediate story of emergency aid. A high-gloss, fussy jacket wouldn't have conveyed the story or the organization as sensitively or expressively.

The value of imperfection isn't a new concept. According to type designer Oswald Cooper (1879–1940), "sleek perfection palls on the imperfect persons who buy and use type." His typographic design from 1916

Harrison 7771

Bertsch & Cooper have a new telephone number. Or you can call Harrison 7772—for they now have two (2) lines (Mercy!) and a switchboard (Imagine!)—a regular "private exchange, all departments." (Well, forevermore!)

15th Year
at 59 E. Van Buren St.
(How time flies!)

5.27 OSWALD COOPER. This typographic flier from 1916 announced a new telephone number with imperfect type quality and deprecating humor (Mercy!, Imagine! Well, forevermore!, and How time flies!).

5.28 DYNAMIC DISPLAYS: LISA STRAUSFELD/PENTAGRAM; ENVIRONMENTAL GRAPHICS: PAULA SCHER/PENTAGRAM. Environmental graphics and dynamic media displays for Bloomberg L.P. corporate headquarters, New York.

made the statement tangible (Figure 5.27). There is an imperfect quality in the typeface he designed and used here, but in addition, the sentences themselves are playful and imperfect. Words such as *"Mercy!,"* *"Imagine!,"* and *"Well, forevermore!"* imply that Cooper was simply thinking out loud—the humorous design resonates with us even now.

In a much more contemporary environmental signage design, we see similar ideas that incorporate imperfect, playful accidents (Figure 5.28). The horizontal bars of the Bloomberg LP sign shift left and right, with parts of numbers missing, and yet this uneven presentation is exactly what makes the sign so noticeable. Its fragmentation creates an energy that fits perfectly in the environment for which it was made, an office building for a major news and media corporation.

Positive things can happen if you build a design process where accidents are welcome (see the Speakout by Stephen Banham). Bring your own visual language to the process as a start. Always asking the question "What if…?" allows you to see an alternate view in solving a design problem. Ask what other angle there is, make an unusual comparison, reverse the order of something, bring asymmetry to something normally symmetrical, use type to solve something you would normally solve with an image. Be aware of your reactions during this process, and capture some of the inventive directions in your sketches.

Refreshing Your Vision

The previous chapter recommended temporarily separating yourself from the research you gather, which allows you to absorb the material. The same is true for your own thumbnail sketches. Returning to your work after a break allows you to see it with fresh eyes, with a new perspective, and designers need as many perspectives as possible to fully explore the possibilities of a design. Your refreshed vision sharpens and broadens your insight.

SPEAKOUT: The Character of Accidents by Stephen Banham, Letterbox, Australia

During the printing of a popular Melbourne, Australia, street map, a solitary ant wandered unnoticed onto the black printing plate of a first-page detail of the central city. Literally embedded into the plate, its image was printed on 20,000 copies of the first edition, creating a surreal image of a giant mutant insect menacing what is now Southern Cross Railway Station (Figure 5.29). What is so appealing about this story is how the ant brings a welcome organic element to an otherwise abstracted depiction of geography.

Everyone knew of the "special edition" that year and the ant gained an almost folkloric status. This offered a way for the public to find an immediate and accessible entry point to a broader design discussion—one that celebrates the role of the accident. In effect, no matter how we may deceive ourselves in trying to attain technical perfection, we must always acknowledge the existence of the chaotically playful world that we operate within.

5.29 Detail of printed ant on a popular Melbourne, Australia, street map.

Imagination is more important than knowledge. —Albert Einstein

> *Do something, do something to that, and then do something to that.*
>
> —Jasper Johns

When vacationing from your design process (by simply doing something else for a short time), carry a notebook wherever you go so you can record every idea, however insignificant, that comes to you. Remember that you are sidetracking, not derailing; synthesizing rather than coasting. Creative distractions might include a visit to a museum, seeing a film, browsing through a library, reading a design article, taking a walk around the neighborhood, going to an actual bookstore, looking for odd gadgets at a hardware store, drawing or doodling, attending a concert or performance, sitting in the middle of a mall for an hour to just watch and listen, or observing kids in a playground. Learn to notice everything around you, and note how it sparks your imagination and brings a new level of sophistication to your work. The value of this exercise is based on the will to continue throwing dart ideas at the targeted design problem to increase the likelihood that you will score a bull's-eye. Your process will continue as you begin to evaluate your ideas, but you need to do all the prerequisite imaginative work first.

In Perspective

Creativity is a complicated and mysterious process. There are times when ideas simply pop into your head and other times when coming up with ideas becomes a grueling process requiring an extraordinary amount of work. As this chapter makes clear, you can be proactive in developing powerful ideas or you can settle for less-than-inspiring solutions. Which kind of designer do you want to be?

Establishing a comfortable work environment allows you to focus on creating and not on settings that distract or inhibit. The objects you choose to surround yourself with symbolize experiences and hold memories that have an influence on the designs you make. Brainstorming can help you generate a wide variety of ideas, and becoming competent at thumbnailing allows you to generate equally wide varieties of visual ideas. Other techniques that can get your thoughts churning include making random word connections, creating visual montages, and even embracing accidents, all of which broaden the possibility of unexpected solutions. The goal is to get to the point where you have enough ideas to begin the process of identifying, weighing, and categorizing which of those ideas are worthy of more refined form.

 EXERCISES AND PROJECTS

✓—▢**Review** additional Exercises and Projects on **myartslab.com**

Exercise 1 (Sketching Warm-Up Exercises):

Primary shapes: Begin drawing primary shapes—circle, square, and equilateral triangle. Transform these shapes through distortion into ellipses, rectangles, and other triangles. Extend or rotate combinations of these primary shapes to generate volumes—spheres, cylinders, cubes, cones, and pyramids.

Gesture drawing: Using a wide-tip marker, create quick sketches of objects—a crumpled piece of paper, a pencil, your watch, cell phone, shoe, or anything near you that sparks your interest.

Tonal drawing: Choose an object and draw it using only tonal values; imagine that there are no lines around this object. Use only the side of your lead pencil, not the tip.

Negative-space drawing: Instead of drawing the positive space occupied by an object, draw the negative space that exists around it. Consider how the space creates an abstraction, one step removed from the reality of your object's context.

Composition thumbnails: Using simple thumbnail sketches, produce a compositional layout idea that redesigns the opening spread of a magazine article.

Image thumbnails: Sketch ideas for the phrase "time flies." Consider keywords for each word of the phrase and then create metaphoric montages in thumbnail form.

Exercise 2 (Random Word Technique): Look up the principal meaning for each of the following words: *telephone, rope, apple, quotation,* and *zipper.* Use the results to create sketches for a logo design for an architectural firm called *Formation.*

Exercise 3 (Word List): Create three keyword sets for the design of a newsletter masthead titled *The Art of Cooking.* List images under each keyword of the set, and then montage them into thumbnail ideas.

Exercise 4 (100 Arrows): The client will be here in 10 minutes to review your design of "100 different arrow shapes." Start now.
—*Provided by Geoffry Fried, chair, Design Department, The Art Institute of Boston at Lesley University*

Project 1 (Montaging): Montage images of two tools together to invent a single, but nonfunctional, fantasy tool. Optional thought-starter combinations to consider: cell phone, coffee cup, computer mouse, dice, eyeglasses, frame, megaphone, pencil, plug, wheel, or wrench. Present your final design with an explanation as to why it might be useful.

Full color. Size: centered on 11" × 17" vertical or horizontal.

Things to Consider: *Combine two objects in an unexpected way, in a way not normally thought of as going together.*

Project 2 (Logo Design): Develop a visual identity for the *Used Book Café*. Use the random word technique and montages from word lists to develop a logo that resonates with the viewer. Think beyond your normal parameters and pull new associations into what this visual identity could be. The final design must include the name, if only in a supportive role, to the mark. Use no more than two colors. Present your final logo centered on 11"× 17" vertical in two sizes (large version above approximately 6" diameter, and small 1.5" below).

 Things to Consider: *Think about how the name integrates with your mark—adjacent to it or as an integral part of the symbol itself.*

Project 3 (Project Design): Clotheslines are being banned in communities around the country. This trend has inspired a local exhibition in which artists from all media have been asked to create a piece reflecting on the subject. Your job is to design an 18"× 24" vertical poster announcing the exhibition titled FREE TO DRY. Research the subject (see laundrylist. org) and generate at least ten thumbnail ideas. From those thumbnails, develop three distinct poster comps. Include the title, but all other information is up to you, including the date of its run, the place (a local gallery of your choice), and any additional information that you feel is necessary. Note that while advocates for drying laundry outdoors feel that it is the right of the homeowner, others argue that it brings down the aesthetic appeal of a community. Bring your own bias to this subject (pro or con).

Present each comp at half size of the final size, and center it with a thin border on an 11"× 17" page. Include copies of your ten thumbnails and an explanation for why you chose the three ideas for your comps.

 Things to Consider: *Find ideas that visualize this controversial subject in inventive ways. Also note that if the gallery likes your idea, they will want to extend the design to an invitation, website, and catalog.*

Project 2 MARY DEAN (TOP) AND SHIRLEY FRIEDLANDER (BOTTOM). Two visual identity designs created by students for the Used Book Café.

The Elements and Principles of Form

→ **CHAPTER OBJECTIVES**

AFTER READING THIS CHAPTER, YOU SHOULD BE ABLE TO:

- Discuss how form and function work together to convey meaning in a graphic design.

- List the six compositional elements of design and give examples of ways they can be used to convey meaning.

- Explain how artists use the seven compositional principles of design to organize compositional elements and communicate meaning.

Exercises and Projects

Find existing designs that exemplify each of the principles of composition; change the meaning behind a photograph by cropping; create a design from a piece of litter; create an abstraction from a photograph; describe a specific location with one adjective and a color palette; design four compositions based on themes.

6

W hen we speak, we use tone, emphasis, facial gestures, and body language to add meaning to our words. Usually these are subconscious additions, but they do have an impact: they clarify our words and thoughts, adding subtleties of meaning. Nuances of facial expression and gesture are components of the whole package of verbal communication, as much a part of a specific culture as its language or regional accent.

I don't think you grow up dreaming to be a graphic designer. I think you find it at some point, and things click, and you start doing something that you love.
—Paul Sahre

⊙—Watch the Video on **myartslab.com**

Opposite page: WAX, CALGARY AB, CANADA. Poster (detail) for the Victoria Symphony (full image, see Figure 6.8).

In graphic design, visual gestures work in much the same way. To convey a feeling of awkwardness, an artist could use an image of a crooked smile or could intensify that awkwardness by adding an unnatural color (such as green lips). A word (such as *pause*) can separate the dialog of two paragraphs, or a thin line can serve the same function. A tough, no-nonsense personality could be conveyed through a caption that says "Don't mess with me," which could be made stronger with a bold, sans-serif typeface. Color, line, and shape can also be used to capture such expressions. This chapter will explain some of the principles that guide the use of these elements for making clear and expressive communication.

Physical form can engage the reader's eyes, but, as this chapter explains, form can also engage the mind, pulling it into a particular communication to decode the meaning. An intelligent idea, coupled with skillfully used form, makes the language of graphic design not only speak but also sing. In other words, form, when well crafted, enriches meaning.

Form and Function

Just as with architecture, form has an important function in the field of communications. Something colorful, expressive, or perfectly ordered is probably going to grab the viewer's attention. However, overindulgent form can get in the way of content, especially when there is no clear connection between the form and the subject. In other words, if something looks pretty, or tough, or expressive for its own sake, there is most likely going to be a disconnect from the content. The principle for architecture also holds true for graphic design—the form must follow the function.

The form a design takes will convey meaning whether the designer intends it or not. Even an attempt to escape direct meaning communicates something substantial. Whatever vehicle for a design is used, an idea is going to be conveyed. The designer's job is to control that idea. The interpretation of that meaning will be influenced by the viewer's own experience, knowledge, and culture, and designers must take that influence into account while maintaining as much control as possible.

To achieve the most effective communication, you need to find the best point of intersection between what you are able to convey through form and content and what the viewer will perceive. All the elements of your design should be deliberate and carefully chosen. Step back from your first drafts and ask yourself why the design looks the way it does. Can you find a reason for every aspect of the design? Did you make the best choices? Questioning is a good strategy to get to the core of the junction of form and content. (See a further discussion of this critical-thinking process in Chapter 10, Visual Coding: Loading Form with Meaning.)

For a poster announcing a lecture by the Dutch designer Gert Dunbar, viewers might initially be attracted by the bright color and gesture marks (Figure 6.1). It's true, the design is filled with energy, but not in the superficial way we might think. The poster's primary function is as an announcement, and graphic designer Wes Kull provided all the pertinent information about the event, but there's more to what you see here.

The premise begins with the notion that Dutch design is sometimes perceived as pure eye candy. On closer inspection, the dense black mass in the center changes from an abstract blob to something literal and meaningful. It is, in fact, candy. This salty black licorice, called salmiakdrop, is found throughout the

▶ *In Practice: Visual depth is a dominant element in this poster's composition. The stepladder is layered behind the black licorice shape. It is also further "echoed" in incomplete copied images that create a sense of further depth. In addition, the diagonal lines, especially reaching to the 4, add to the dimension of the piece.*

6.1 WES KULL. Proposed poster for a lecture by Dutch designer Gert Dumbar.

> *It is the pervading law of all things organic and inorganic, ... That form ever follows function. This is the law.*
>
> —Louis Henry Sullivan (1856–1924)

> *Form follows function—that has been misunderstood. Form and function should be one, joined in a spiritual union.*
>
> —Frank Lloyd Wright (1867–1959)

6.2 LOWELL SANTORO. Line as a sketchy, hand-made doodle.

6.3 Line as a hard-edged graphic.

6.4 THE BRAND UNION, WALLY KRANTZ AND SAM BECKER. Time Warner Cable logo (based on an original mark by Steff Geissbuhler).

Netherlands. Kull uses it here as a visual substitute for Gert Dunbar, himself an icon of Dutch design.

If you read the poster more closely, you will find that the image and content meet and that other supportive elements enter the picture. The playful yet ordered typography directly suggests Dunbar's work, and the layered imagery (such as the stepladder in the background) suggests a sense of reaching further, beyond the easily accessible, as Dunbar is known to do.

Compositional Elements

Compositional elements are the building blocks of principles. For example, the principle of contrast becomes tangible only when elements such as color or texture create the contrast. The principle of direction is made real by bringing the elements of line or depth to the page. A graphic design project might focus on a principle to solve an intellectual idea, but the elements themselves make it concrete. Line, shape, pattern, texture, space, depth, and color are the most important elements to consider.

Line

Line is one dimensional, having length, but no height or depth. It is the basic element used to describe a shape and can be actual or implied, vertical or horizontal, diagonal, or contoured. Line has the power to activate its surrounding area. A thick, bold line conveys a feeling of strength. A diagonal line that changes from thick to thin creates the illusion of spatial perspective. Line can define form, divide space, create the illusion of depth, suggest movement or energy, or anything else the artist needs for it to do. Figure 6.2 shows line as a quickly sketched doodle, and Figure 6.3 shows it as a hard-edged graphic. Its capacity is endless.

Designers can also use line to convey meaning or ideas. Lines used in this way are often a learned response based on cultural norms, and their use in a design becomes an important element not only in a composition but also in terms of meaning. For example, a group of thin lines that encounter a bold vertical one can suggest the idea of struggle. A jagged line might indicate stress or energy. A curved line can convey playfulness because it seems to have a free-flowing life of its own. This free-flowing quality is evident in signatures, where the expressive force of a personal characteristic is effortlessly created. That same quality is used more intentionally when designers use hand-drawn lines in their work. The use of expressive line is quite evident in the familiar Time Warner Cable logo (Figure 6.4). The original mark by Steff Geisbuhler uses curvilinear lines formed into the shape of an eye and an ear, implying the act of both hearing and seeing, which presumably occurs while watching your Time Warner-supported cable TV service. The mark's line and color were later revised to integrate with the company's name.

6.5 CAROLINE WOOLARD. Proposed logo for Bugoff Exterminators.

6.6 MAX FRANOSCH. CD cover design for *Meditations on Coltrane*.

Designer Caroline Woolard used line quite inventively in her bird's head logo for an exterminator (Figure 6.5). In the design, Woolard used a different strategy, making the bird's head a continuation of the line that inscribed the company name. But instead of sending a message to chemically exterminate bugs, Woolard has changed the logo to one for environmental policy. Her bird is eating a bug, suggesting a more natural approach to pest control.

For a CD cover, Max Franosch made a quick scribble into the artwork for a modern jazz album, *Meditations on Coltrane* (Figure 6.6). A quick stroke of chalk on a sidewalk would have had a much different look and meaning, as would a broad brushstroke. But the designer found that the rhythmic strokes of ink on paper, reversed and colorized, then held together with a floating, torn strip, connected the two subjects—meditation and jazz—in a way that is both gestural and controlled, just as the music of jazz is both gestural and controlled.

Wilson Bonilla used a very expressive line to create the impression of kinetic motion for a poster profiling the graphic designer Paul Rand (Figure 6.7). The line creates a visual sort of "sound" that is amplified by its contrast to the clean and cool image of Paul Rand. The lines and shapes tease, poke, pounce, push, and pull, with what Rand himself referred to as the "play instinct." The vigor of form enhances the message, the expression of energetic ideas emanating from Rand's mind.

Shape

Shape is a two-dimensional space, created by joining the two ends of a line. Shape can be a predominant element in a design, from a random ink blob to a geometric circle, triangle, or square. But shape can also be created from other elements such as color and texture.

The poster series by Wax, and illustrated by Heads of State, uses color and texture to create gritty, tactile shapes that have a dominant presence (Figure 6.8). We can't help but try to interpret their subtle ideas. The montage of a tree with a violin, a skyline with piano keys, and a butterfly with a clarinet speak to the organic nature of live music. The result is a communication that resonates with its audience.

6.7 Wilson Bonilla. Poster profiling the graphic designer, Paul Rand.

❝❞ *Most people make the mistake of thinking design is what it looks like. People think it's this veneer—that the designers are handed this box and told, "Make it look good!" That's not what we think design is. It's not just what it looks like and feels like. Design is how it works.* —Steve Jobs (1955–2011)

6.8 WAX , CALGARY AB, CANADA. Illustration by Heads of State. Each poster (as part of a series for the Victoria Symphony) uses montage along with color and texture to create shapes that resonate with meaning.

6.9 CHRISTINE MAU, KIMBERLY-CLARK WORLDWIDE. Tissue packaging titled *Slice of Summer*.

6.10 TERRENCE MCCARTHY. Proposed visual identity for Used Book Café—with and without a textured effect.

Shape can also be brought to three-dimensional package designs. Christine Mau converted a conventional box for facial tissues into a pyramid shape and added photorealistic illustrations to make the boxes look like pieces of fruit (Figure 6.9). The assignment was to create a product that screams summer, and the result is a set of colorful boxes that are functional, clever, and most definitely evocative of summertime.

> **❝❞** *The first question I ask myself when something doesn't seem to be beautiful is why do I think it's not beautiful. And very shortly you discover that there is no reason.*
> —John Cage (1912–1992)

Pattern and Texture

Visual **pattern** is repeat of an element whose total effect is more than the individual parts. The repetition of lines or shapes of a pattern can bring visual energy and motion to a composition. Pattern can be used to create **texture,** a two- or three-dimensional tactile quality, either real or perceived, that causes an emotion or sensation in the viewer. Designers are always hoping for such a response to their work.

In a proposed logo for the Used Book Café, Terrence McCarthy used a slice of pie (with filling made of book pages), enhanced by the addition of texture (Figure 6.10). The rough, worn finish of a used book on top of a cherry-red color is the final touch. The gritty feel adds another dimension of emotional information to the logo image.

The texture created by the materials and processes used to produce a design can also be part of meaningful form. In the design of a cover for *Geek Love,* Richard Yoo used a woodcut illustration with an antique, handbill quality, in keeping with something the story's cult-like family

April Greiman studied graphic design at Kansas City Art Institute and later at the Allgemeine Kuntsgewerbeschule in Basel, Switzerland. She moved to Los Angeles in 1976 where she established a design practice [design using multiple platforms and formats]. She is recognized as being one of the first graphic designers to embrace computer technology as a design tool. From 1984 on she pioneered digital design, becoming renowned for her unique experiments with the Apple Macintosh. She is a recipient of the AIGA Medal and the Chrysler Award and is a member of the Alliance Graphique Internationale. Her ideas and work have appeared in broadcasts such as the PBS TV series Smithsonian World: From Information to Wisdom *as well as in articles, interviews, and reviews in* Time Magazine, The New York Times, USA Today, *and on CNN. Her books include* Something from Nothing; April Greiman: Floating Ideas into Time and Space, It'snotwhatAprilyouthinkitGreimanis; Hybrid Imagery: The Fusion of Technology and Graphic Design; *and* Seven Graphic Designers. *April has honorary doctorates from the Kansas City Art Institute (2001), Boston College of Art, Lesley University (2002), and the Academy of Art University in San Francisco (2003). Her work has been exhibited internationally.*

▶ What is your approach to form in relation to content?

There is no separation between form and content. Form is content. Typography, illustration, images, axonometric drawings, a swash of color—they all are separate objects that I orchestrate in space. I try to define, articulate, and create a visual hierarchy with these objects. The goal is to be more the tour guide who can take a viewer on a visual/spatial journey, with each object playing a part in an overall communication and field of the space.

People might access a plethora of objects upon first glance, but I also want them to go beyond the initial reading and understand some of the ideas I've built in, some that are deeper and perhaps more subtle, even if the understanding occurs later. I want to allow access to complex readings and yet try to achieve that without making it complicated. There's a huge difference to me between the complex and the complicated. HUGE.

You use color fearlessly. Do you have a philosophy about its use?

Color is space; space is color. Color evokes an emotional response. The more vibrant the color, the quicker someone might get drawn in. For example, a tiny object that sits on the page might project forward and have dominance because of its color. Conversely, a neutral or muted color, regardless of size, can also play dramatically in the environment that contains it. A white space can contain other objects and provide a scaffolding for text, images, and so forth, big or small. It can provide so much contrast that the size of the object is irrelevant or super-prioritized. In some cases, I might rely on a specific reading of a color I'm using, but in others I might treat color as a purely optical component. Color should have an equal exchange and importance with other objects in space, but be free from the hold of them. It's a way to get color to dance, play, and hold its own.

Why does the desert have such a presence in your work?

The desert is design in real time. It offers peace of mind for me, through vastness of space.

The desert is its own educational vehicle. While many natural processes occur at an invisible or microscopic level, the desert reveals its evolution in its very existence. You see layers of minerals on mountain walls, an enormous stretch of dry land that was once a lake bed, and the budding, blooming, dormant, or dying plants in their natural cycles—all revealed as information to observe in real time.

Vignette 6.1 19th Amendment commemorative stamp design for the U.S. Postal Service.

Vignette 6.2 Visual identity and letterhead design for RoTo Architects.

Vignette 6.3 Commemorative poster for an exhibition celebrating the works of Frida Kahlo and Diego Rivera.

Vignette 6.5 Mixed use project with the MTA of a hand holding a bowl of rice/video image wall mural in downtown Los Angeles at Wilshire/Vermont.

From the very first visit, my eyes were opened wide to growth, evolution, and change. I aspire to extend that clarity into what I make and do as a visual communicator—that same spatial, time-based, and spiritual quality is reflected and translated.

Vignette 6.4 Poster for the Selby Gallery, *Objects in Space* exhibit.

6.11 RICHARD YOO. Proposed cover design for the book *Geek Love.*

of circus performers might have used to promote their act (Figure 6.11). Even the irregular frame image has texture. The illusion of the yellow and dented surface becomes an active, textured space, hinting at the bizarre environment in which the story takes place. This design is a good example of how layers of thinking can be built into a design concept. See the Worklist on Compositional Exploration for some suggestions that may help you push your designs further.

Space

The area between elements on the page is called either **white space** (although it is not necessarily white in color) or **negative space.** It is formed by the space between and around shapes and in the background of the page. White space activates a composition by creating contrast and tension. It can also improve a design's legibility, giving the eyes resting points that allow the mind to comprehend the ideas being presented. It gives a design a chance to breathe.

Negative space exists inside letterforms, too. The capital G shows us a counter shape, the space held within the letterform (Figure 6.12). The form of the counter shape isn't noticed as much as its positive letterform, but it exists and affects our perception of the character of a letter, for example, making it bold, graceful, or authoritative. Looking at a full page of type, you can see that white space also exists between each letter, between each word, and between each typeset line of text, known as the leading (see a more detailed discussion about leading in Chapter 7). White space in typesetting affects the visual

Compositional Exploration

- Change the scale, direction, or movement of a main element in your design (see Chapter 6).

- Create a grid that will guide the structure of your information (see Chapter 9).

- Consider using only typography and no images to solve your design problem (see Chapter 7).

- Use the negative space in your design as actively as the positive space (see Chapter 6).

- Allow past experiments to influence your current design project (see Chapter 2).

- Associate a feeling with the product or service associated with your design, based on the specific audience you are addressing (see Chapter 4).

- Bring texture, pattern, or a color you wouldn't normally use into your design (see Chapter 6).

- Reference designs from earlier decades to see how they can be rejuvenated (see Chapter 2).

- Make a comparison of two unrelated things (see Chapter 5).

- Control the visual code of your design by considering adjectives, for example: academic, scientific, tough, or cute (see Chapter 10).

6.12 Positive shapes and negative counter shapes are inherent in letterforms.

6.13 WORKSIGHT. Design for a photographer's website. Space left empty (white space) helps bring attention to images on the page.

weight of a paragraph on the page and of the body of text in contrast to the margins. All in all, white space is a significant compositional element in any design that uses text on a page.

White space should also be a consideration in the design of websites. The balance created between navigational elements, the information presented, and the images allows the viewer to discern how to navigate the page, what to read, and where to go next. For a website designed for photographer Andrew McCaul, the type and images rely on the empty areas of the page to create contrast, tension, and flow (Figure 6.13). Sites that are too busy, that don't have enough negative space, give the viewer's eye no place to rest. White space is necessary for both print and exhibit design work. Motion design, on the web or in video, also uses white space by providing a pause or a bit of quiet in the midst of information being delivered. Viewers need a chance to absorb what they've seen or learned.

You can see white space used to varying degrees in many kinds of graphics. In a 1950s brochure about flight transportation, graphic designer Ladislav Sutnar used aerial perspective to create the effect of floating above an airport (Figure 6.14). White space is incorporated with many other compositional principles and elements to bring organization and drama to the design. The result is a design that translates information in a cohesive way that keeps the viewer interested.

6.14 LADISLAV SUTNAR. Page layout as part of a promotional brochure for the Canterbury Printing company. The piece titled *Transport—Next Half Century* is as graphic and dramatic as the subject it explains. 1950.

line: The stroke thickness allows for overprinting as well as knocking out to white.

color: A neutral blue complements the dominance and immediacy of red and black.

contrast/emphasis: A dominant image grabs the viewer's attention through contrast of scale and color next to other page items.

repetition: Dynamic angles animate an otherwise static image.

positive/negative: The areas in between the lines energize the overall shape.

shape: A unique form that has visual holding power.

white space: Left deliberately empty, this area gives the viewer a chance to visually breathe.

direction: Vertical red type guides the eye. It establishes a **hierarchy** for the text and activates the space.

rhythm: Linear consistency of type lines helps organize the textual information.

spatial depth: A change in scale between aircraft gives the viewer the perception of depth on the page. The effect is enhanced by the shape appearing to sit under the type.

6.15 Two lines seem to reach toward one vanishing point (one-point perspective).

6.16 The sides of the cube converge toward two outer vanishing points (two-point perspective).

6.17 PHILIPPE APELOIG. Cannes Festival poster. Projected type creates the illusion of depth and an appealing dramatic effect.

6.18 LORENZO ROMERO. Rome & Gold Creative. Logo for Shepherd's School.

6.19 HENRY BRIMMER. Exhibit graphics for an alumni exhibition titled *Design Experiences.*

Depth

Visual perspective is an effective way of creating the illusion of **depth**—giving the viewer the perception of physical space. Developed during the time of the Renaissance, the theory of vanishing points changed the way we perceive three-dimensional space on a two-dimensional plane. Figure 6.15 demonstrates **one-point perspective** using two lines (on two axes) that reach toward one vanishing point. **Two-point perspective** is a little more complex visually. It uses two vanishing points instead of one, creating an image that is a little closer to the way we actually perceive distance on the curved earth (Figure 6.16).

The Cannes Festival poster by Philippe Apeloig is a good example of how type itself can be used with one-point perspective (Figure 6.17). The line tracks reach into the far distance, with the words getting smaller as they move into space. The design serves as an announcement for the festival, inviting viewers to experience the projected light in a film theater setting. In this image, content and form meet beautifully in an almost poetic way, with all the components working together harmoniously.

The iconic representation of books, created by Lorenzo Romero, serves as a compelling logo for Shepherd's School (Figure 6.18). Romero used two stacked books to create a three-dimensional effect of spatial depth. Two-point perspective gives the covers an added sense of dimension—the layering and perspective angles trick the eye into believing it is seeing physical depth. But what makes this image especially clever is the resulting letter S (for "Shepherd"). Of course, objects can be stacked front to back, as well as top to bottom, to create an illusion of space.

Even when three-dimensional space is a part of a design problem, depth and perspective can be manipulated to make that space more active, as you can see in the exhibit graphics for *Designing Experiences* created by Henry Brimmer (Figure 6.19). Here Brimmer played with the junction of two walls to humorously engage the audience. The experience of interacting with the lettering as it bends around the corner further illustrates the

6.20 MARK ROTHKO. *No. 14 (Brown over Dark)*. 1963.

experiential point of the show. It is an ironic twist and an inventive use of typography in the third dimension.

In addition, **scale** (the relative size, extent, or degree of elements within a design composition) can also generate a sense of depth. The airplanes presented in varying scales in Figure 6.14 give viewers an idea of spatial depth. The Speakout "About Rudolf Arnheim" by Gusty Lange offers further understanding on the visual perception of depth.

Color

The artist Mark Rothko (1903–1970) said that the colors he used in his paintings were performers. In the work *No. 14 (Brown over Dark)* you can begin to see what he meant (Figure 6.20). Using color as the primary element of his work, Rothko allows color to define the painting, creating a sense of space, mood, dimension, form, and content. Rothko's portals, as he called them, are formal and aesthetic problems solved beautifully through paint and color.

 Colours are the deeds of light, its deeds and sufferings.

—Johann Wolfgang von Goethe, Theory of Colour (1810)

SPEAKOUT: About Rudolf Arnheim by Gusty Lange, professor, Graduate Communications Design, Pratt Institute

In 1954 Rudolf Arnheim published the groundbreaking book *Art and Visual Perception*. Today, it is the basis for visual thinkers to understand how form and space work together. All fields of visual expression have benefitted because Arnheim gave us tools for critically understanding visual thinking, making our work certainly more valid to our audience.

Form is the result of visual expression. Rudolf Arnheim succinctly addresses this idea using a simple but profound quote by the painter, Ben Shahn: "Form is the visible shape of content." This set the stage for Arnheim's theory that the essence of form is found in the unseen, and more in how we perceive it to be. For example, the illusion of depth on a two-dimensional surface is made by using the tools of overlapping, foreshortening, perspective, and more. Arnheim goes even further, suggesting that three-dimensional illusion is interpreted by the perceiver through past experiences, cultural roots, inner emotions, and the senses. So we can say that visual perception involves the essence of the whole (the gestalt).

Form is what takes shape when we design. But when we understand form beyond what literally meets the eye, we can move past the boundaries of physical shape and toward the symbolic and metaphorical edges of the unconscious. Only then does form become a powerful tool in defining our work as visual communicators.

6.21 ANITA MERK, FLYLEAF CREATIVE.
Art & Ideas banner design.

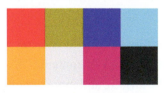

6.22 The palette of colors shown here were used in Figure 6.21. Similar color values (brightness) coordinate as a system to help bring unity to the design.



6.23 OFFICE, JASON SCHULTE DESIGN. Views of the fund-raising kit for the National Institute for Play.

In the design by Anita Merk for the poster of the International Festival of Arts & Ideas (Figure 6.21), the elements include words, images, and shapes, all within a specific color palette (Figure 6.22). Their elegant fusion tells a story and creates a formal unity, allowing the information to peek through, hinting and teasing the viewer about the event's performances and panel discussions.

In a fund-raising kit for the National Institute for Play, Jason Schulte used colorful objects to capture the attention of potential donors (Figure 6.23). The design piques interest through its use of bright colors, sleek transparent boxes, and fun items that show how life can be made more energized and pleasurable through the benefit of play.

Color is a most active visual component in design. Yellow expands outward and forward toward us, while blue recedes, drawing us in. Artist Wassily Kandinsky (1866–1944) described it well when he wrote "Keen lemon-yellow hurts the eye in time as a prolonged and shrill trumpet-note in the ear, and the gazer turns away to seek relief in blue or green." Color, alone or in combination with other colors or other principles and elements, can bring contrast and unity. Colors can vibrate and move, create unity and discord. Artists can manipulate color with the rationality of a scientist or with irrationality based on emotion. Arbitrary use of color can destroy an otherwise fine design, while truly brilliant use of color can make a design soar.

6.24 ANDY MATHURIN. Design titled *Everything Ties* explaining how a past experience (working at a flea market) affects how he sells himself as a graphic designer today.

6.25 TATIANNA HOLIDAY-NOWDEN. Proposed advertising campaign for an arts organization devoted to raising America's social consciousness.

Nobody cares what your favorite color is. Color isn't about preference; strategic use of color is part instinct, part skill, and a great deal of science. Take, for example, a design by Andy Mathurin, Everything Ties (Figure 6.24). The piece describes how the artist's past experience (of working at a flea market) affects how he sells himself as a graphic designer today. There is a limited amount of color, which he used with clear intent: the shoe he used is old and worn, but bright enough to set itself off from the solid black background; white hand-drawn type reverses out, not only to give the design a personal feel but also to create the shape of a white tie; and the blue stenciled type (the first three letters of the designer's last name) integrates with the shoe by having the same level of brightness.

Color should be part of the original design concept, not something added at the end of the process. A good example of this approach is seen in a proposed advertising campaign by Tatianna Holiday-Nowden for an arts organization devoted to raising America's social consciousness (Figure 6.25). A set of colored triangles create the Art + Consciousness (AC) monogram. The triangles then take on a life of their own as they form into shapes and wrap around iconic photographs of media, money, and authority. Each triangle of color interacts with adjacent colors to form a unique spectrum.

▶ *In Practice: When making your choices, remember that color doesn't exist as an absolute; it always interacts with the adjacent colors.*

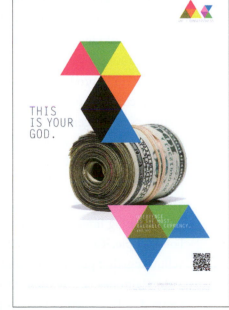

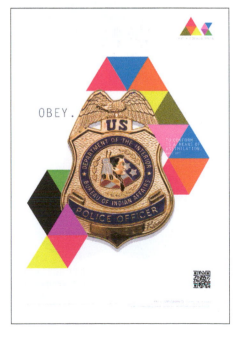

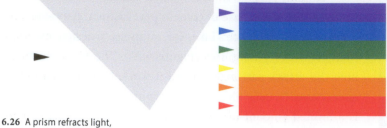

6.26 A prism refracts light, which appears to be white, into a spectrum of colors based on long and short wavelengths.

6.27 A value chart from white to black. A 50 percent strip appears to change from darker to lighter depending on which gray value it is next to.

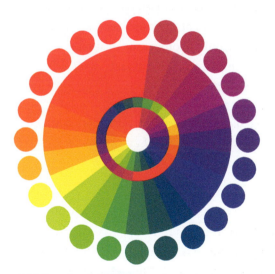

6.28 The color wheel bends the spectrum into a circular relationship of opposite, or complementary colors.

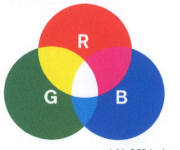

6.29 RGB (red, green, blue) is an additive process of color where an electronic source adds each to an otherwise black screen.

Color Systems

An explanation of color systems begins with the prism—a triangular piece of glass. White light enters the prism and produces a spectrum of colors based on long and short wavelengths (Figure 6.26). Red has the longest wavelength, violet the shortest. The colors blend into each other, with red, orange, yellow, green, blue, and violet as the most distinguishable bands. **Color** is defined in terms of three attributes: **hue** (for example, red, orange, yellow, green, blue, or purple), **value** (light versus dark, or white versus black; see the value scale, Figure 6.27), and **saturation** (intense versus dull).

The color wheel bends the color spectrum into a circle, placing the colors in a specific, standard arrangement or relationship (Figure 6.28). Colors that sit adjacent to one another on the color wheel are called **analogous colors,** and colors that sit opposite on the wheel are called **complementary colors.** When placed next to one another, complementary colors of the same value will appear either to vibrate or to blend. In theory, equal parts of complementary colors mixed together will produce gray. A good designer can use all these properties to great advantage.

There are big differences in the way color functions as pigment (such as paint), as light (such as on a monitor), and as ink (such as in printing). **Primary colors** (red, blue, and yellow) are identified as such because they cannot be obtained by mixing any other colors when using pigments such as paint. When two primary colors of pigment are mixed, they produce **secondary colors** (purple, orange, and green).

The color we see on computer monitors and television screens, however, functions differently from pigments because those screens are backlit with light. In contrast to pigments, red, green, and blue are the three main hues that produce all the other colors on the screen (Figure 6.29). Combinations of these colors produce resulting hues that are different from those of pigments. For example, when green is added to red using light, it produces yellow. All electronic devices use the **RGB** (red, green, blue) system to produce color images.

In contrast, printed color, or process color, usually uses four main colors: cyan, magenta, yellow, and black, referred to as **CMYK** (Figure 6.30). Because there is no backlighting on a piece of paper, the inks must be transparent, allowing their hues to show through layers and blend. Using this method, colors are created by overlapping screened dots, known as **halftones,** in what is referred to as **four-color process.** Effects of combining hues can produce results similar to those using pigments. For example, if a cyan dot overlaps yellow, it produces green; magenta and yellow together produce red, and so on (Figure 6.31).

Halftones are predominately printed using the **offset printing** method, a lithographic process in which an inked image is transferred

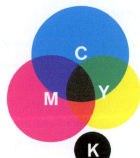

6.30 CMYK (cyan, magenta, yellow, black) is a subtractive process of color where each printed ink reduces the light that would be reflected from white paper. The overlay of CMY makes black, but the addition of K (black) is needed to bring density to the printed page. Black is considered the **k**ey plate.

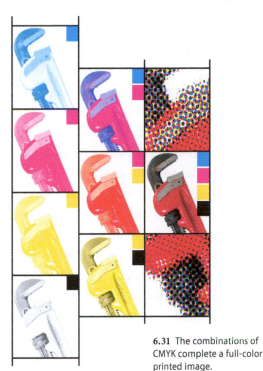

6.31 The combinations of CMYK complete a full-color printed image.

6.32 Pantone® Color Selector guide indicating solid match colors printed on coated papers.

6.33 An example of a warm and a cool gray.

from a metal or silicon plate to a rubber blanket and then to the printing surface, usually paper. This method creates specific colors perceptually. The size of each dot, and each dot's relationship to another dot, increases the possibilities for color variation; the combinations of CMYK complete the full-color printed image. You can see the dots clearly if you enlarge the printed image.

An alternate method to achieve a spectrum of printed colors is to individually premix and print specific hues, called spot colors. Pantone, Inc., has developed a scientific matching system of these colors for professional printing. Their guidebooks are used to specify exact colors, and printers work from recipes for precise color reproduction (Figure 6.32). No designer's toolbox is complete without a Pantone Formula Guide.

In addition to the attribute of hue, color can also be considered in terms of saturation, or intensity. Pure primary colors are the most saturated. Add a bit of another color and they become less saturated, less intense. Colors that are more intense tend to move forward on the picture plane and those that are less intense tend to recede. This characteristic can be quite useful when creating the illusion of space on a two-dimensional plane or when trying to give emphasis to specific parts of your design. Through color, you can create the illusion of depth and space, which allows you to mold objects into three dimensions and establish foreground and background.

▶ *In Practice: Both process color systems—as cyan, magenta, yellow, and black (CMYK)—and spot color systems are used as specifications for offset printing. But generally only spot colors are specified for silkscreen, engraving, and stamping.*

Color Temperature

Color can also be categorized in terms of warm and cool temperatures. Color temperature is actually the visible light in a spectrum that is measured in Kelvin (K) units. Temperatures measured above 5,000 K have a cool bluish-white tone; temperatures between 2,700 and 3,000 K have a warmer yellowish-red tone. But translating temperature to actual, printed color can be difficult to specify.

The two gray squares shown in Figure 6.33 are of equal value (brightness) but have different temperatures. The square on the left has more red in it; the one on the right has more blue. When placed next to each other, the warm and cool differences are most apparent. Becoming sensitive to these subtleties can enhance your power as a designer. For example, the scene outside becomes more vibrant and multifaceted when warm and cool shades are used. Imagine a tree with warm, green leaves, hovering above a cold, blue street, with the bright, warm yellow yield sign. Warm colors tend to move forward on a picture plane, while cool colors recede. When mixing warm and cool colors, you can learn to control those relationships very precisely.

▶ **In Practice:** *So-called "white" paper actually contains subtle color, giving it either a warm or cool tone. Your choice of white paper can have an impact on the formal qualities of the design as well as on the message it relays.*

Orange is the happiest color.
—Frank Sinatra (1915–1998)

When I paint green, it doesn't mean grass; when I paint blue, it doesn't mean sky.
—Henri Matisse (1869–1954)

Any colour—so long as it's black.
—Henry Ford (1863–1947)

Some people give a lot of weight to the psychological effects and associations of color, while others prefer to use color based solely on the visual impact. The psychological implications of color can be very complex and subtle. They also vary from culture to culture, so you should try to learn something about your audience when making color choices. However, there are some basic associations with colors to take into account when designing. You can manipulate these associations by slightly altering hue, saturation, and value.

The warm colors—red, orange, and yellow—have associations ranging from anger, agitation, and excitement to warmth, security, and new growth. Red is often associated with passion and with aggression. Yellow has strong associations with sunlight, warmth, and growth and, at the same time, can be considered cowardly or sickly. The cool colors of blue, green, and purple are generally thought to be calming and peaceful and are associated with stability, but they can also evoke sadness and despair. Blue often connotes authority and stability, but can serve equally well to invoke the sky and dreamlike, soothing states. Green has taken on a whole new range of associations with the interest in environmental issues. Black connotes stability, power, authority, and death and is often considered sinister or evil. White is usually associated with purity and light. However, many of these associations are different in other cultures. For instance, in some cultures purple, rather than black, is used in mourning. In India, white has negative associations and well as positive; in Japan, white is connected with death. In all cases, you need to consider your audience and do some research before making assumptions about color associations.

You will want to be particularly aware of certain color combinations commonly used in our society and make conscious decisions about how to use them. For example, green and red will always mean Christmas in the United States (and in many countries). Orange and turquoise remind especially older Americans of Howard Johnsons restaurants. Orange and black are used for Halloween. These associations don't necessarily restrict you from using those color combinations; just be aware of the potential underlying messages. Use of colors also changes just like fashion. Pay attention to the "fashionable" colors of the season, not with pressure to use them, but to be aware of what they are when making choices. For example, if you're designing a building's signage system, then you might not want to use a color that will be trendy.

Also keep in mind that approximately 8 percent of men and .5 percent of women are colorblind. If your message is dependent entirely on the use of color, you may be losing part of your audience. Try to make sure that, even if color is a major design component, it is still possible for a viewer to understand the information if they see only shades of gray.

6.34 Balance and contrast are created by differences in scale in relationship to each other and to the proportion of the page.

Compositional Principles

Compositional principles are broad aesthetic strokes that organize elements into pleasing visuals. Studying each principle starts by examining how it is formed in a particular situation. For example, if you place a large single word on a page, then there are three compositional principles at work, some standing out more than others. The first is the principle of direction, created by the word reading from left to right; the second is the principle of dominance, created by the word's ability to attract attention, either through its meaning or its visual qualities; and the third is the principle of proportion, created by the word's size in relation to the page itself. In most cases, these principles are embodied by elements such as color, texture, size, scale, and shape. All the elements must work together in the complex process of making compelling graphic design. Among the many principles that underlie good design, seven stand out: balance, contrast, direction, dominance, proportion, rhythm, and unity.

Balance

Balance is the distribution of items in a composition to achieve equality either symmetrically or asymmetrically. For example, both of the circle compositions shown in Figure 6.34 achieve a sense of balance. On the left, the two equally sized circles are centered; on the right, a large circle is positioned on one side of the page, which is countered by a much smaller circle. The space is balanced by their relationship. One of the advancements explored in twentieth-century design is the premise that a design could be freed by moving type and imagery away from a centered axis to one that is not centered. It may seem so obvious to us now, but it was considered quite daring at one time.

The identity design for Chaqwa (a brand of coffees, teas, and cocoas) uses symmetry together with just a hint of asymmetry to create a harmonious relationship (Figure 6.35). The mark, a series of patterned circles, is centered above a cup of coffee. The symmetry suggests a pleasant environment for the café—balanced and uncomplicated. It also suggests the pleasant warmth and aroma of the steam coming from the coffee. The only hint of asymmetry is the logotype, Chaqwa, which hangs off the center line, but even that is balanced by the line of steam from the cup that expands into the large, circular logo.

6.35 OFFICE, JASON SCHULTE DESIGN. Visual identity for a brand of premium brewed coffees, teas, and cocoas.

All the compositional principles are at work, but the principle of balance sets the main tone of the design. The white circles hold a dominant position against the black background. There is contrast in the size of the logotype relative to the circles as one mark and in the slightly off-centered position of both in relation to the cup. Rhythm is set by the pattern of circles themselves, with their movement and direction drawing the eye toward the center of the circle pattern. The proportion of the graphics to the size and shape of the page helps the image to stand out visually. All the elements work together as a whole, creating a unity of composition and message.

Balance can surprise you, however. Something that appears to break all the rules might actually achieve a delicate balance both visually and through content. Take a look at the page spread by Alvin Eisenman for a book on Eero Saarinen (Figure 6.36). At first glance, all the weight of the image is on the left, throwing the balance off completely. But the text, daringly crossing the boundary of the spine break, is so carefully placed and so integral to the overall design that it restores the balance. When thinking about balance, consider additional principles such as contrast, rhythm, direction, and the compositional elements that help create those principles such as color and texture. All should work in harmony with the actual content to create an impact.

> "Art is an idea that has found its perfect form. —Paul Rand

6.36 ALVIN EISENMAN. Book design for *Eero Saarinen on His Work.*

6.37 Complex compositions need elements that work off one another in order to create pleasing visual contrasts.

6.38 PAUL SAHRE. Book cover design for *Adultery*. Beacon Press.

Contrast

Contrast occurs when juxtaposed forms, treatments, and ideas create visual or intellectual tension. The result is an enhanced perception of differences between paired or grouped elements. This dual function makes it a most useful and challenging design tool.

Tension, visual strain based on imbalanced relationship of contrasting elements, creates energy which, in turn, can create power and impact on the page as well as in the mind. The elements we use to create contrast and tension are quite simple—shape (straight and curved), size (big and small), and value (black and white). Figure 6.36 demonstrates the potential of this energy using geometric shapes.

Designers use contrast and unexpected juxtaposition to amplify the message they are conveying. For example, by juxtaposing a fork and a chain (two objects that normally don't go together), the resulting image will stand out because of the oddness of the pairing. In bringing these two objects together, the image sends an idea that is much more complex than the two objects alone might convey—the challenge of eating with restraint. The message can be enhanced by heightening the visual contrast. For example, by using an ornately decorative fork against the blunt weight of a heavy construction chain, you can create a higher contrast and thus relay a stronger message. As a designer, you have to decide whether boldness or subtlety makes your message more compelling.

In the examples shown in Figure 6.37, the circles, lines, and shapes work against one other, and yet seem to belong together; they are all in the same family of black and white geometric forms. In contrast, the book cover for *Adultery*, designed by Paul Sahre, is an example of how principles and elements can work together to create contrast and meaning that is specific to the subject (Figure 6.38). The premise of the book involves a coming-to-terms with marriage and fantasies about adultery. The image of crumpled notepaper is indicative of the frustration. The scribbled word "Adultery" is repeated down the page, contrasting the loose arrangement against the orderly horizontal blue lines of the notepaper. The author's nervous ruminations and uncertainty are portrayed by her repetition of the word, her inability to stick to the lines of the paper, and by her erasures and cross-outs. Is she trying to come to an understanding of the term, her feelings, or her actions?

The crumpled sheet of paper itself uses a contrast of imagery. It is clearly a standard note paper, but the crumpled texture also suggests wrinkled bed sheets. The printed blue lines of the paper are straight, contrasting with the fabric-like curves of the wrinkles. The effect adds tension and angst to the book cover in both an aesthetic and intellectually meaningful way.

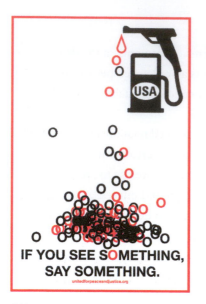

6.39 CAROLINE WOOLARD. First effort of a flier as social comment for the MTA campaign *If You See Something, Say Something.*

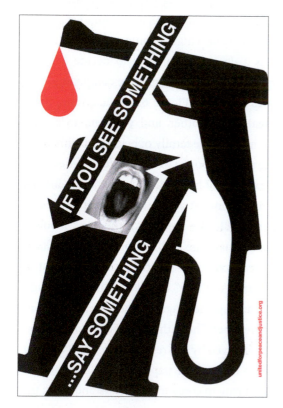

6.40 CAROLINE WOOLARD. Revised version of *If You See Something, Say Something.*

In a two-color flier, student Caroline Woolard makes a social comment in response to a campaign by the Metropolitan Transportation Authority (MTA) of New York City (Figure 6.39). The tagline of the MTA campaign "If You See Something, Say Something" reminds bus and subway riders of the need to stay aware and to report any suspicious activity. The designer's idea was to flip the intended message by using the montage of a pistol and gas station pump. By changing the visuals, the artist changed the meaning completely, telling viewers instead that Americans might help the energy crisis by voicing their concern over wasteful energy consumption.

In the first design, the centered layout lacks the energy needed to convey such an urgent call to action. In the revised design, however, the audience is confronted much more forcefully (Figure 6.40). The image now fills the page. The increased **scale** of the graphics creates a more powerful contrast of shape. Even the negative spaces, the white areas between the black shapes, activate the composition. A restrained use of color adds to the tension. The words are no longer resting in a passive horizontal position but have been upended at a dynamic angle. And even a subtle grammatical change adds a longer pause to the sentence and thus adds meaning—the comma has been replaced with an ellipsis. What was once fuel dripping from the nozzle is now colored red, suggesting blood.

The revised design creates a stronger relationship between the message and its form. But how did the designer get there? First, she thought that the design needed more impact. The original may have felt weak or flat to her. By further considering the message and exploring the composition by pushing all the elements of its form, she ultimately devised a solid refinement of the poster. In the Speakout "Make without Knowing," Matthias Brendler contends that the mere act of assembling can kick the creative wheels into gear.

Direction

When we refer to the compositional principle of **direction,** we're really describing the orientation of elements within a design. When we consider direction, we're thinking about how to give a design vigor and life. A composition's elements seem to move because the eye moves to follow them (Figure 6.41). Without direction, a design can seem static or dull.

In Figure 6.42 the text from the back of a Brillo® soap pad package has been arranged according to hierarchy of information. The name is at the top-left side of the image, with the remaining information reading left to right and top to bottom—a very logical arrangement. But in a second piece within the experiment, gestural marks made with an actual steel wool pad replaced the printed type to reveal the dense areas of words as well as the flow and direction of the text (Figure 6.43). **Flow** creates a stream of connections which, in turn, helps direct the eye to specific

SPEAKOUT: Make without Knowing by Matthias Brendler

Sometimes the harder we look for a solution, the less we are able to see one. "Make without knowing" is the way I describe an essential phase in my design process and a tool I use to help students with this conundrum. It is an informed act of improvisation, wherein making is the process of discovery. By creating without an intended outcome, anything is possible—the very act of making can reveal what we hadn't even known to look for.

Think of it as hands-on dreaming—freely putting together visual assemblages for later assessment. Since opportunity favors the prepared mind, it all begins with preloading your brain with relevant project information, parameters, and content. This is your raw material for discovery. Now erase it from view, let your rational, analytical, left brain take a nap, and start making "things." Anything will do, and the faster you work and the more you make, the higher your imagination will fly. It's like jazz. So with your design tools as the instrument, start to jam and the music will simply flow. As Miles Davis said, "I'll play it first and tell you what it is later."

6.41 (top left) The most basic shape can lead the eye through a composition.

6.42 (bottom left) Text from the back of a package reorganized within the grid structure.

6.43 (bottom right) Notation created with a steel wool pad of the directional flow of text.

focal points. This type of exercise is a good one to do on top of any body of text because it enables you to see a layout in a whole new way. After doing this simple exercise, you might want to move the text around, create new areas of blank space, or change font size.

Direction has a diagrammatic aspect to it because something is placed in conjunction with something else. In a public signage project by Altyn Chiang, arrows and dotted lines change size, shape, and color as they direct us through a mini-narrative notating the process of finding love (Figure 6.44). The first sign in the figure intermingles verbal jargon. That sign is paired with another that intermingles graphic icons. The diagrammatic expression causes occasional bursts of visual energy. The clusters and breathing points create unexpected surprises—valuable when the need is to hold someone's interest.

6.44 MS. ALTYN CHIANG. Paired public signs using the principle of direction to help notate the process of love.

EXPLODE TO BE
INTO SCATTERED
A MILLION AND IN
PIECES LOVE
WALKING ON
CLOUD NINE

6.45 JANET LEE. Proposed advertising design for the nonprofit organization Outreach Center.

6.46 The dominant element draws the viewer into the composition.

The principle of direction is used nicely in an advertisement for a nonprofit organization (Figure 6.45). In the ad, a red sign (at top left) and the words "Donate Your Car" begin the flow, moving the eye from top left, across, and down. The images used along this route sit in the background, giving the piece the perception of physical space or visual depth—in other words, the direction can also move front to back or vice versa. The images simultaneously translate the organization's objective—to encourage people to donate used cars as funding for educational outreach centers. The page is visually activated and simultaneously loaded with information.

Dominance

Unlike a painter or sculptor showing work in a gallery, a graphic designer rarely has the luxury of an attentive audience. Usually a design needs to stand out, arouse interest, reach from the page or the wall, and pull the viewer into the scene. So think of **dominance** as the hierarchy of a composition in terms of what is emphasized first—the core activity of design. Our page, space, screen, or package needs to grab the viewer's eye. If it doesn't, it fails.

Notice in the diagram (Figure 6.46) how a single dominant element grabs the eye's attention. Once you've gotten your viewer's attention, you can lead his or her eyes to other details within the composition. In this example, the dominance of the large shape usurps the traditional hierarchy of top to bottom and left to right.

Dominance may help explain the reductivist, or minimalist, nature of many design solutions. One main point has to get across to the viewer, but just as with a short story or short film, there is a limited space or time for an idea to be conveyed. In the same way that a book cover must reveal the gist of the entire book and a film title must embody the spirit of a complete movie, a design must reduce the elements to their essentials. A concrete and succinct word, image, or shape will be more powerful and effective than one that is vague or too general. It is a mechanism that the public understands.

For a student project to design a poster on a famous graphic designer, Thomas Gnahm, a student from East Germany, used a banana as a metaphor for graphic designer Milton Glaser (Figure 6.47). His reasoning for this somewhat odd choice was actually political. Gnahm saw the banana as an unofficial symbol of German unity and liberty because West Germany had bananas while East Germany did not. Gnahm

View a Closer Look for the banana poster on **myartslab.com**

6.47 THOMAS GNAHM. Student project to design a poster about a famous graphic designer.

6.48 JOHN LUI. Proposed book cover for *The Birds*.

compared this situation to the creative sense of humor and freedom he saw in Glaser's work. The banana is presented large; it visually dominates the page, causing the eye to be pulled in before it swoops to various points within the composition. But all the text must be read for the message to be deciphered. Typography leads viewers to the wording. Type layers over the dominant image to create visual depth on the page, and changes in type size and hierarchy give the reader digestible bits of information.

In another example, a solid black silhouette creates the dominant image for a proposed cover design by John Lui for *The Birds* (Figure 6.48). Lui has montaged the image of a bird with a crown in this silhouette. He carefully refined the contours and position of the bird's beak and chest so it became symbolic of royalty. The image hints at the political satire and comedy that is present throughout the play by Aristophanes. Smaller birds, also silhouetted in black on the points of the crown create a sharp contrast of size, compounded against a rich blue sky. The placement of one lone white silhouette of a bird flying just above the only empty point on the crown draws the eye up to the title and author of the play. Lui managed to create a rich visual impact through strong form but with a minimum of color.

For a logotype, John Lui again used a dominant image to create impact (Figure 6.49). Using another montage process, he combined an ant with a bomb to create a bizarre contrast. The images both relate to the exterminating business, but the humor defuses the deadly aspect.

In replacing the letter "O," the bomb creates a second layer of contrast. Together, the principles and elements make for a logo that is visually intriguing and resonates with meaning.

▶ *In Practice: When you use only two colors for a book cover, you can keep printing costs to a minimum. To give the cover a customized appearance and save even more money, you can choose a specific spot color, for example, a color specified using the Pantone Formula Guide. Spot colors are inks in the actual color and do not have to be created through the CMYK process. They can include varnishes as well as metallic and fluorescent colors.*

6.49 JOHN LUI. Proposed logo for Bug Off exterminators.

6.50 One photo, cropped three different ways, can change how the image is *read* in terms of content and emotion.

6.51 The elements (dots) are in proportion to one another and to the page.

6.52 JOHANNA TYSK. Student project: transportation options between two American cities.

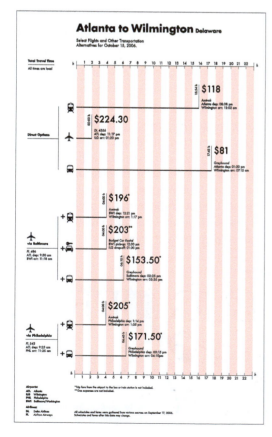

Lui also used a process known as **cropping,** or reframing, to refine the dominant graphics in his book cover and logo. Pushing and pulling an image—left and right or in and out—changes the area of focus. The designer can zoom in on the desired image, framing it in relationship to the other elements. In Figure 6.50, the image has been cropped three different ways to show some options. In the first photo, the boy and the fallen tricycle have equal dominance. In the second, the image is cropped to allow the boy to dominate the frame. In the third, the background has been almost completely eliminated, and the boy's expression now dominates the photo.

Each version tells a slightly different story. Cropping also affected other principles and elements such as balance, tension, and direction. But besides affecting the formal elements, it is important to see that by altering the parts, the designer has changed the entire meaning of the photo. It went from being a whole story about a young boy who has fallen from his overturned tricycle to a sensitive portrait of a distraught and pensive child. This gestalt aspect will be further explained in Chapter 10 Visual Coding.

Proportion

Proportion is defined by relationships of size and number to the whole, and just about every design project begins with this principle in mind. Whether a page, a computer screen, a package, or an environment, design involves a relationship of elements. The diagram in Figure 6.51 demonstrates this dynamic: the circles sit in relationship to one another, to each group, and to the page, centered left and right.

To see a more complex use of proportion, take a look at Johanna Tysk's chart analyzing transportation alternatives between Atlanta and Wilmington (Figure 6.52). The design is positioned on the vertical page and uses that same verticality, emphasized by the lavender stripes, to present hours, transportation modes, and so on. You can see how she created movement in this simple chart through the vertical proportion from which it stems. Its color, typeface, and clean treatment all contribute to the ease of communicating the information.

In Wes Kull's book cover design for *Chronicle of a Death Foretold,* horizontal and vertical divisions signify meaning (Figure 6.53). In this classic book, twin brothers use pig-slaughtering knives to kill and gut the main character. The design offers an interpretation of this horror, splitting the image of the pig into two parts, positioning it as if it wraps around the lower proportion of the book. The vertical proportion also adds to the design's meaning by splitting the cover into thirds. The emptiness of the top space and the cold gray metal wall reflect the eerie context the main character finds himself in, running through a town that feels empty, where no one is willing to help him.

6.53 WES KULL. Proposed book cover for *Chronicle of a Death Foretold.*

6.54 The rhythm of three dots repeats left and right within the composition.

6.55 OFFICE, JASON SCHULTE DESIGN. Visual identity for a brand of premium brewed coffees, teas, and cocoas.

I shall define beauty to be a harmony of all the parts, in whatever subject it appears, fitted together with such proportion and connection, that nothing could be added, diminished, or altered, but for the worse. —Leone Battista Alberti (1404–1472), *Ten Books on Architecture* (1452)

Rhythm

In graphic design, **rhythm** is basically a pattern that relies on **repetition**—the recurrence of a shape, word, or thing—to create unity and energy in a visual design. In the diagram in Figure 6.54, repeating black dots move rhythmically across the composition as the pattern appears to vibrate. In Chapter 2, the words Moulin Rouge repeat rhythmically in Toulouse-Lautrec's poster (Figure 2.16).

Rhythm is at work in the identity for Chaqwa coffee that was discussed earlier, tying the design together through the circular motif used throughout the interior set (Figure 6.55). The simplicity of the multitude of circles carries a vibration that extends into many related components, including the company's advertising, furniture, and interior design. The Chaqwa design transcends the actual text and maintains its strong identity no matter what the language (Figure 6.56).

The general public approaches a design with the expectation of harmony, of principles and elements working together, in whatever form it takes. The audience can appreciate this harmony when they see how a unified design is crafted, even if done in unconventional ways. Just as with other team efforts, the emphasis is on the success of the whole. However, sometimes that sense of unity isn't so clear cut. You might have to work a bit to discern the unifying features and spend some time looking at a particular design before the full impact takes effect. Just because its message

6.56 The logo maintains its strong visual identity regardless of the language that appears under its main graphic.

6.57 KATHERINE MCCOY. Words integrate with a photographic collage of student work to help diagram McCoy's communications theory of seeing/reading.

6.58 The consistent size, shape, and color of the circles as well as the underlying grid that the circles are spaced within unify the design.

isn't immediate doesn't mean the design is lacking, however. Complexity has its place in the world and can be quite effective for a message that has depth of meaning. Consider, for example, a poster by Katherine McCoy for the graduate design program at Cranbrook Academy of Art (Figure 6.57).

There's a lot going on here. It takes a while even to figure out just what the poster is about. The words and images blend into one, in keeping with McCoy's communications theory that words are both read and seen, and images are both seen and read. In this sense, McCoy is teaching through the piece. The poster has rhythm and unity; it is complicated and multifaceted; and just as with the graduate program being promoted, the eye and brain are required to work together simultaneously.

Unity

Any given graphic design project might include words, images, colors, and shapes to tell a complete story. The **unity** of the whole—the ability to work as one thing or idea—offers a greater impact than the individual parts. The diagram in Figure 6.58 is an abstract example. The single circle contrasts with the group of circles, yet their consistent size, shape, and color as well as the underlying grid that the circles are spaced within unify the composition. Unity is generally important for a website, where each navigable section needs to operate as if it is part of one system, and for a book design, where each chapter becomes part of a larger whole, using a consistent typeface and page format.

Color is a dominant element in creating unity for the series of ice tea bottles shown in Figure 6.59, created by the design studio The Gooder. The simple bottle shape, the unified font on the label, and the distinct logo also help create a sense of unity and a strong message. In a display setting, an individual vertical bottle stands within the layered horizontal bands, making the entire group appear interconnected, not just repeated.

Stationary systems (business cards, letterhead, envelopes, mailing labels, etc.) need to relay a similar sense of unity. The design elements, including the logo and address position, typeface, hierarchy of information, and color palette, should be consistent across all the components

6.59 GOODER COMPANIES. Teas' Tea package design system.

continued on next page

6.60 WILSON BONILLA.
Proposed visual identity and application for Carpet World.

because they serve as immediate identifiers for the individual or company. Since most companies have significantly reduced their use of paper and postage, they now apply these same design elements to websites and e-mail messages.

In a logo design for Carpet World, Wilson Bonilla created a very simple spiral shape to signify several ideas at once. The logo is a rolled carpet, a global circumference, and a suggestion of the letter C for "carpet" (Figure 6.60). The simple shape unifies the entire system, from business cards to the sides of a delivery truck.

In Perspective

This chapter's focus can be boiled down to one main point: aesthetic presentation can cause an idea to resonate with its audience. Knowing the principles and elements of form shouldn't interfere with the pure joy of visual expression. Your desire to simply make something, to design something, has value. The crayoned pictures we all made as children are testament to the aesthetic freedom of which we are capable. The fear of making something "the right way" shouldn't ever get in the way of a designer's creativity.

Keep in mind that what has been discussed here are elements and principles, not rules. They are guidelines to help you in your work. Read them carefully, learn them well, and use them assiduously. And when you are comfortable enough with all their parameters, begin to defy them and break the rules. At that point, your years of experience will prove most valuable, and your designs will begin to break new ground. You will have developed your craft into a real art and can start to take risks. That is the point when your designs will soar.

Expressing intellectual ideas through supportive form defines graphic design. In the next chapter, you will see how you can use type in conjunction with the principles and elements discussed in this chapter to push your designs even further.

 A designer is a planner with an aesthetic sense.

—Bruno Munari (1907–1998)

EXERCISES AND PROJECTS

✔ **Review** additional Exercises and Projects on **myartslab.com**

Exercise 1 (Principles and Elements): Find one existing design example in which each of the following principles is the defining element in its composition: balance, contrast, direction, dominance, proportion, rhythm, and unity. Consider how the principles are accomplished through elements such as color, line, and texture.

Exercise 2 (Photo Cropping): Choose a photograph and scan it digitally. Then crop the image three different ways, using one rectangular proportion. The goal is to shift the image's meaning in each version. Present your set as a horizontal arrangement on a tabloid sheet of paper (11" × 17").

Exercise 3 (Abstract Composition): Pick up a piece of paper litter from the outdoors. It can be a ticket stub, a candy wrapper, a flier on a telephone pole, a note someone wrote and drew on—something that has both text and image. Bring it back to class and use whatever is on it as the raw material to create a 17" × 17" abstraction. Experiment with it freely, taking into consideration all the compositional elements including scale, contrast, unity, positive and negative shapes, depth, and repetition. For inspiration, look to Russian Constructivism and Bauhaus compositions (see Chapter 2).

Exercise 4 (Point/Line/Plane): The purpose of this exercise is to create abstractions of the elements of point, line, and plane from something visually familiar such as a photograph. You will isolate these elements through simplification and use of organic and geometric forms. To begin, choose a magazine photo of a landscape, cityscape, building, or interior (avoid portraits for this exercise). Look for an interesting composition; you will be abstracting elements from the photo, retaining its relative size and position. Converting the photo to a black and white may help you see the elements better. Study several photos for contrast of shape, size, texture, position, direction, and negative/positive space before making your final selection. Translate only the most important elements of the photo and crop it into a square format (4" × 4" or 6" × 6") to make a strong composition. Mount your photo on an 8" × 8" illustration board.

Using tracing paper overlays and a fine-line black marker, interpret the photo as follows: (1) Contour drawing (show major shapes and objects); (2) Isolated points; (3) Isolated lines; (4) Isolated planes; (5) Geometric interpretation of points; (6) Geometric interpretation of lines; (7) Geometric interpretation of planes; (8) Planes interpreted as texture; and (9) Positive and negative of Number 4 reversed. Note: Tissue exercises 1–9 should show three–four drawing variations. When complete, then overlap tracings and start finding new combinations, including point and line, line and plane, point and plane, and finally point, line, and plane.

Experiment with combining organic and geometric elements, omitting unimportant areas and varying the weight and size of points and lines. You don't need to follow your tracings exactly, but make them neat, using templates and a straight edge where necessary. Choose the best composition from your sketches and do a finished composition, using marker on tracing paper and refining where necessary. Use this comp as a tissue overlay, affixed to your mounted photograph. Flap and trim three sides. Using a grid for enlargement, increase your final solution to an 8" × 8" square. Render this final solution on hot press illustration board cut to 12" × 13", leaving a 2" margin on the top and sides and a 3" margin on the bottom. Outline your shapes with a ruling pen; then fill in with black ink or gouache. Use templates and other technical tools for professional results.

Materials: Photograph, tracing paper, fine-line marker, broad-nib marker, illustration board, ink or gouache, brushes and tray, rubber cement, X-Acto knife, ruler, t-square, triangle, and templates. —*Provided by Paul Sahre, professor, School of Visual Arts*

Project 1 SCOTT W. SANTORO. Shuttered, one adjective and color palette describing a photographed scene.

Project 1 (Color Palettes): Visit a specific location and describe it with one adjective: for example, a cemetery as serene, a dump as gritty, a parking lot as bright, a gym as tough, an alleyway as mysterious, and so on. Photograph the site and create a palette of colors that describe the site. Choose nine colors that harmonize based on a consistency of value (brightness) and temperature (warm or cool). Find each color's closest match using the Pantone color system, and present the group adjacent to your photograph: photo on the left, color grid on the right, as 2" × 2" squares with ⅛" between, stacked three across and three down. Present the adjective you chose above the color palette.

 Things to Consider: *Pay attention to the emotional effect of the colors and how they relate to the adjective you choose.*

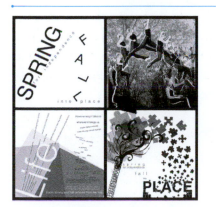

Project 2 MAY PARSEY. Four-part theme composition.

Project 2 (Four-Part Theme Composition): Choose one set of the following themes: good/evil, black/white, spring/fall, or right/wrong. Then design four separate compositions based on the theme you choose. Each of your compositions should show dominance in one of the following categories: (a) image, (b) cropping, (c) typography, and (d) open (your choice). Do not repeat categories. All images and text should relate directly to your chosen theme. Your solution should have four unique and compelling compositions that work individually as well as in combination as one larger composition. Single compositions: 10" × 10", flush-mounted onto foam core board. Final size of the four together: 20" × 20". Color: Black and white. —*Provided by Paul Sahre, professor, School of Visual Arts*

 Things to Consider: *The most valuable part of this project is in finding a shared theme in the relationships—an approach, motif, or compositional principle—to link all four parts together.*

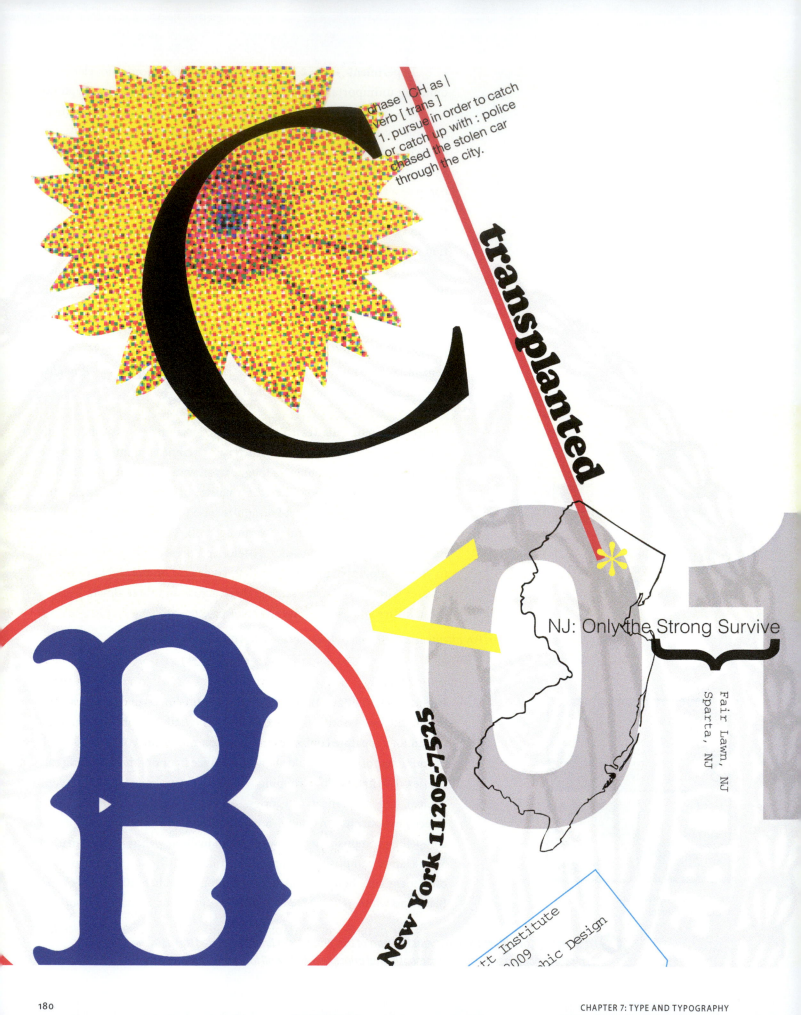

chase | CH as |
verb [trans]
1. pursue in order to catch
or catch up with : police
chased the stolen car
through the city.

transplanted

New York 11205-7525

NJ: Only the Strong Survive

Fair Lawn, NJ
Sparta, NJ

...tt Institute
...2009
...hic Design

Type and Typography

7

Graphic designers communicate using many tools, for example, elements such as line, shape, and texture. Computers and software applications have liberated the process of visual creation, and "mindware tools" such as visual metaphors and montage can amplify meaning. But perhaps the most powerful tool is type—typefaces and their typographic arrangement. Type not only can complete a message but also can function as the image.

If you work on a nice scratchy paper you can get an antique look. The sound made is a clue to how you're actually making things so you should listen to it.
—Paul Shaw

👁—⎡Watch the Video on **myartslab.com**

Opposite page: CHASE HILL. Typographic promotion (detail) documenting the designer's transplantation from his home to his school (full image, see Figure 7.24).

Designers use type in almost all of their work. They might use large amounts of type, flowing it across multiple pages, as in a book, newsletter, or website; they might use small amounts of type in harmonious integration with imagery, for example, as part of a brochure cover or logotype. The designer's job in using type effectively is to make the most of its dual purposes—to read as legible text and to convey meaning.

Speaking with Type

If you say the word *rose* very softly, it implies something delicate. Shouting the same word gives it a whole different meaning, adding an unexpected harshness and thorniness. Designers can convey similar nuances of meaning through type, using elements of type to express mood and suggest tones of voice.

Any **typeface**—a single design of type comprising the full alphabet and all corresponding **fonts** (variations such as regular, italic, bold,

Rose
Rose
ROSE
Rose

R o s e

7.1 A particular typeface can extend the perception of a word and its meaning.

7.2 Typography involves use of compositional principles in the arrangement of letters.

and bold italic)—suggests these nuanced meanings. A light **serif** typeface (its main strokes finished off with shorter perpendicular ones) has a classical connotation, and a bold **sans serif** typeface (without any finishing strokes) conveys a more industrial feeling. Each adds meaning to the word it creates, just as adjectives add meaning to nouns. In the example shown in Figure 7.1, the serif typeface Garamond helps express the idea of a *delicate* rose; the sans serif Trade Gothic, a *machined* rose; the serif Minion in all caps, an *authoritative* rose; and the sans serif extremely bold Champion, a *tough* rose. The arrangement of letterforms, the **typography,** adds a compositional aspect to letters and words. Principles such as contrast, unity, and rhythm should all be considered when designing with type (Figure 7.2).

The history of a typeface, why and by whom it was drawn as well as how it has been used by other graphic designers, is valuable information that can strengthen how you make decisions in choosing typefaces. This knowledge helps you make thoughtful choices, not random selections based only on what you think looks nice. Although aesthetics are important, type and typography involve much, much more.

For a design to consider the question of whether the established visual language of graphic design quashes the chance for other visual languages to exist, Designer Yannique Hall chose the typeface Helvetica (considered by many to be *the* most widespread and neutral of typefaces) (Figure 7.3). "GRAPHIC DESIGN IS … IS GRAPHIC DESIGN" becomes part of the placard covering the portion of a T-shirt often used for political statements or expressions. The typeface and its typographic play, or wordplay, make a statement that "graphic design is" but also imply a question—"is graphic design."

The animal shelter logo by Yevgeniya Falkova uses type in another way, its letters blending into an illustration of creatures, creating a friendly feel for the organization (Figure 7.4). Whereas the "GRAPHIC DESIGN IS" placard appeals in a conceptual way, the animal shelter logo appeals to our emotions. The animal faces stare out at us, and chances are, we smile back with empathy.

7.3 YANNIQUE HALL. Design solution in response to a project that asked students to define graphic design as if it were a slogan on a T-shirt.

7.4 YEVGENIYA FALKOVA. Proposed logo for a local animal shelter.

❝❞ *Typographical design should perform optically what the speaker creates through voice and gesture of his thoughts.* —El Lissitzky

7.5 Page from Gutenberg's Bible. 1454.

7.6 Typesetter at his composing stand of upper and lower case cast-metal letters.

7.7 Composing stick and metal letters in a type case. Small sections of text were set by placing individual letters in the stick and then transferring them to larger sections of type to create a page.

Photo courtesy Otis Lab Press

Historical Type

Since Johannes Gutenberg (c.1398–1468) first set type for a Bible in 1454, standards concerning type legibility have remained fairly consistent (Figure 7.5). The proper spacing of letters or the handling of column widths and paragraph breaks all continue, learned by each new generation. What has changed most is the technology of type.

Hot lead casts of individually carved letters (**hot type**) and later type produced by photocomposition devices of the 1950s (**cold type**) were made by mechanical means. It wasn't until the early 1980s that digital bits replaced the type previously made with wood and metal or with camera lenses and exposed film. Digital technology has put type much more directly into the hands of graphic designers, who can now manipulate type with a freedom and accessibility never before available.

The professional typesetter's stand and a hand-assembled set of letters are now historic icons (Figures 7.6 and 7.7). To us today, the mechanical processes seem as though they would have been too bulky to have produced sensitive letterforms and compositions, and yet the typefaces and arrangements by many early designers, including Americans such as Frederic Goudy (1865–1947) and Bruce Rogers (1870–1957), were amazingly graceful and functional. The type specimen book designed by Rogers for Goudy's typeface Italian Old Style is a beautiful example (Figure 7.8). Although nearly 100 years old, the piece still looks fresh and inventive. The appeal of the design endures to this day, just as many typefaces themselves have endured. See the Worklist "Typefaces from the Eighteenth, Nineteenth, and Early Twentieth Centuries"—all of which are still in use today because each of the letters possesses careful, intelligent, and lasting form. Type has this potential for enduring quality and appeal.

7.8 BRUCE ROGERS. Type specimen book designed for Frederic Goudy's typeface Italian Old Style. 1924.

Typefaces from the Eighteenth, Nineteenth, and Early Twentieth Centuries

Caslon | William Caslon (1724)

Baskerville | John Baskerville (1757)

Didot | Francois Ambroise Didot (1784)

Bodoni | Giambattista Bodoni (1791)

FAT FACE | Robert Thorne (1803)

Egyptian | Robert Thorne (1821)

Clarendon | William Thorowgood (1845)

Century | Morris Fuller Benton (1894)

Cheltenham | Bertram Goodhue (1896)

Akzidenz Grotesk | Hermann Berthold (1898)

COPPERPLATE | Frederic Goudy (1901)

Korinna | Hermann Berthold (1904)

Franklin Gothic | Morris Fuller Benton (1905)

Kennerly | Frederic Goudy (1911)

Souvenir | Morris Fuller Benton (1914)

Cooper Black | Oswald Cooper (1920)

Perpetua | Stanley Morison (1925)

Futura | Paul Renner (1927)

7.9 Versions of the capital letter T is sans serif (left) and serif (right).

Type Classifications

In the early nineteenth century, typeface was classified in an attempt to simplify it. The three main movements—Old Style, Transitional, and Modern—are effective groupings because they correlate so well with printing techniques of their time.

The first classification is for type of the fifteenth and sixteenth centuries. Referred to as **Old Style typefaces,** these early printing types had yet to be inspired by mechanical printing. Instead, they mimicked pen-based letterforms, using strokes with a right-leaning inclination.

By the mid-eighteenth century, typefaces were moving away from their calligraphic past and toward designs that embraced printing technology. These typefaces, called **Transitional typefaces,** were less concerned with mimicking the pen stroke. Instead, Transitional typefaces were drawn with structured and consistent strokes in mind. They bridged the gap between the past and the next generation of more refined, stylized, and modern letterforms.

The **Modern typefaces** of the late eighteenth century aren't the same as what we think of as twentieth-century modern. These typefaces made a complete break from the calligraphic past. Their classification is such because of the high contrast between strokes, a uniform and mechanically balanced shape, and horizontal serifs. Modern typefaces opened the door for the relatively abstract "slab" and "grotesque" typefaces that were to come a few decades later.

The first letterforms created by the early Greeks are described today as sans serif (the French word sans meaning "without" and serif from the Dutch schreef meaning "line"). Letterforms were refined by the Romans who found that their chiseled application onto stone monuments was made easier by finishing the coarse ends of each stroke with a smaller, perpendicular stroke. Serifs gave letters visual feet to stand on. They also provided a horizontal alignment of those feet—or **baseline**—for words to run along (Figure 7.9).

Sans serif typefaces were reintroduced by the British as a letterform style in 1816, but were considered grotesque (Italian for "from the cave") because they lacked the refined serifs. It wasn't until Bauhaus embraced sans serifs for their boldness and simplicity of design that they gained their popularity.

Slab serifs (often called **Egyptian serifs**) are typefaces that have thick rectangular finishes to their vertical strokes. They were created in the mid-1840s when the industrial revolution was in full swing, especially in Great Britain. Mass production increased the need for more advertising, which in turn created the need for bold headline displays using slab serifs that stood out on the page (see Chapter 2).

There has been a strong revival of slab-serif typefaces in the past half century. Slab-serif typefaces generally have thick, block-like serifs that are

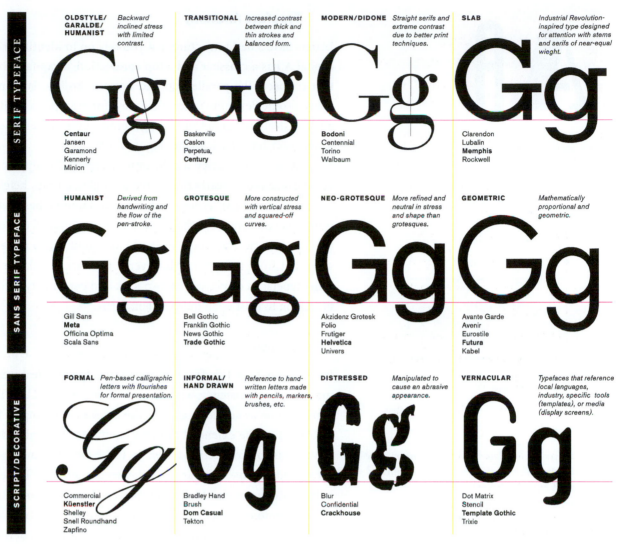

SERIF TYPEFACE

OLDSTYLE/GARALDE/HUMANIST *Backward inclined stress with limited contrast.*

Gg

Centaur
Jansen
Garamond
Kennerly
Minion

TRANSITIONAL *Increased contrast between thick and thin strokes and balanced form.*

Gg

Baskerville
Caslon
Perpetua,
Century

MODERN/DIDONE *Straight serifs and extreme contrast due to better print techniques.*

Gg

Bodoni
Centennial
Torino
Walbaum

SLAB *Industrial Revolution-inspired type designed for attention with stems and serifs of near-equal wieght.*

Gg

Clarendon
Lubalin
Memphis
Rockwell

SANS SERIF TYPEFACE

HUMANIST *Derived from handwriting and the flow of the pen-stroke.*

Gg

Gill Sans
Meta
Officina Optima
Scala Sans

GROTESQUE *More constructed with vertical stress and squared-off curves.*

Gg

Bell Gothic
Franklin Gothic
News Gothic
Trade Gothic

NEO-GROTESQUE *More refined and neutral in stress and shape than grotesques.*

Gg

Akzidenz Grotesk
Folio
Frutiger
Helvetica
Univers

GEOMETRIC *Mathematically proportional and geometric.*

Gg

Avante Garde
Avenir
Eurostile
Futura
Kabel

SCRIPT/DECORATIVE

FORMAL *Pen-based calligraphic letters with flourishes for formal presentation.*

Gg

Commercial
Küenstler
Shelley
Snell Roundhand
Zapfino

INFORMAL/HAND DRAWN *Reference to hand-written letters made with pencils, markers, brushes, etc.*

Gg

Bradley Hand
Brush
Dom Casual
Tekton

DISTRESSED *Manipulated to cause an abrasive appearance.*

Gg

Blur
Confidential
Crackhouse

VERNACULAR *Typefaces that reference local languages, industry, specific tools (templates), or media (display screens).*

Gg

Dot Matrix
Stencil
Template Gothic
Trixie

7.10 A summary of typeface classifications.

▶ *In Practice: Old Style and Transitional typefaces tend to work well set as body text because they were designed for legibility and flow. Modern typefaces tend to be used for display purposes, their serifs being too thin for small text sizes.*

7.11 Examples of slab serif typefaces: Clarendon Bold, by Freeman Craw for American type foundry; Serifa Black, by Adrian Frutiger; Lubalin Graph Demi, by Herb Lubalin for ITC; and American Typewriter, by Joel Kaden and Tony Stan for ITC.

either blunted or angular. They work well for display type, but tend to look awkward as body text. Figure 7.10 summarizes and describes the various typeface categories and provides examples of typefaces that fit into them.

In the 1950s, especially with the reworking of Clarendon Bold by type designer Freeman Craw for the American type foundry, slab serifs were used extensively on Blue Note Records album covers. In the 1960s, Adrian Frutiger's Serifa was extremely popular for its challenge to the predominance of sans serifs. Designs made for the International Typeface Corporation (ITC) in the 1970s included two important typefaces that are still popular today. Lubalin Graph, designed by Herb Lubalin, has a clean geometric form that redefined slab serifs. American Typewriter, designed by Joel Kaden and Tony Stan, parodies the letterforms and the mechanical process of the typical typewriter (Figure 7.11).

Attempts to classify typefaces and trends that favor some groups over others have continued through the decades. Technology has an impact, but so does pop culture—think psychedelic- or grunge-inspired designs. Typefaces reflect our own faces.

7.12 The capital letter A in Adobe typefaces Stencil and Industria.

7.13 An example of the geometry system that might be used to create a letterform.

▶ *In Practice: Mid-to-late nineteenth century typefaces had spurs finishing the strokes that mimicked the Victorian era's accentuated styling, for example, in the curl at the end of men's mustaches and the puffy bustles in women's fashion. When designing a typeface, it's a good idea to consider contemporary styles and how your typeface will reflect them.*

Typeface Anatomy

Letters have a basic structure that you rely on to identify or read them. A capital A has a crossbar and a top connection; a capital Z has a diagonal that connects the parallel top and bottom strokes. Within these structures is some flexibility for creative play; for example, a capital A can have a squared-off or curved top. But generally, every letter, both upper- and lowercased, has a basic shape (Figure 7.12).

When you overlay a grid onto a capital (or uppercase) letter A, you can see more clearly the degree of angles, curves, height, and stroke weight (Figure 7.13). Typefaces develop and mimic these details. The goal is to achieve a consistent shape and feel throughout all the letters of a particular typeface. The typeface should look unified, so none of the letters stand out from the others. However, a typeface should be distinct from other typefaces, displaying its own look and personality. Otherwise, it has no reason to exist as an independent form.

Components

In addition to a typeface's proportions, specific features help letters maintain a consistency with one another (Figure 7.14). These components can be as subtle as a spur (the stroke extending as it finishes) or as blatant as the extended tail of a capital Q. They also designate negative areas, or counters, as seen in the bowl of a lowercase d, or in a growth-like shape, or "ear," in a lowercase letter g. These components help create the overall look of a typeface. A counter or spur might carry through onto other letters, numbers, and even punctuation. For example, the counter in an n will be similar to the counters of the h, m, and u. Particular components are emphasized throughout the typeface, giving it personality and consistency.

Stress

Letters drawn with a brush or quill exhibit stress angles. As the brush stroke changes direction, the thickness of the stroke changes. The resulting tension between thick and thin is called stress. A calligraphic pen nib exaggerates the effect even further (Figure 7.15). A straight pull downward creates a thick stroke because it uses the square end of the pen or the broadest part of the brush. On the curve, a thinner stroke results because the angle of the nib or brush changes. Part of the fine art of calligraphy is in the control and rhythm of these strokes.

Digitally created typefaces are far removed from the pen nib, but the idea of building in stress remains an important design consideration. Stress helps a typeface achieve personality by making a direct reference to the past, as in a revival typeface. It can also create a vertical, horizontal, or oblique balance as in a condensed, expanded, or italic font (Figure 7.16).

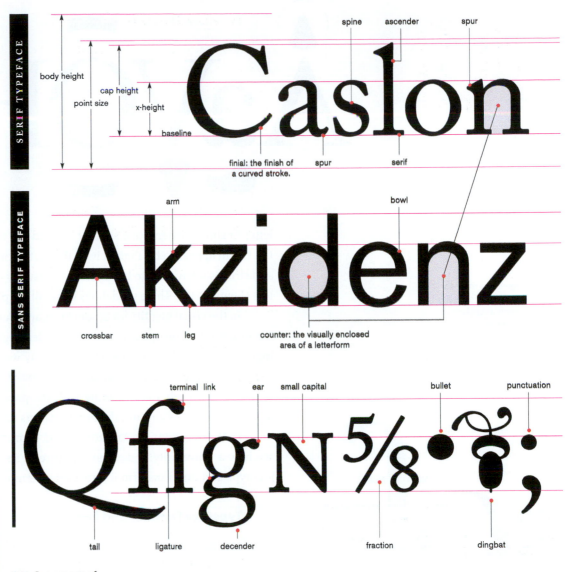

spine ascender spur

body height
cap height
point size
x-height
baseline

finial: the finish of a curved stroke. spur serif

Caslon

arm bowl

crossbar stem leg

counter: the visually enclosed area of a letterform

Akzidenz

terminal link ear small capital bullet punctuation

tail ligature decender fraction dingbat

Qfig N ⅝ • 🐝 ;

7.14 Components of letterforms that influence a typeface design.

7.15 The pen creates thick and thin strokes depending on the tip's direction.

7.16 Stress angles created by the thick and thin segments of the strokes.

Optical Considerations

At first look, a line of letters seems to be generated mechanically, with letters running along their established baseline. But on closer examination, you can see subtle fixes, which adjust things that might otherwise look awkward. For example, the crossbar in the capital letter H should be positioned slightly above center to look balanced. Similarly, the topmost tip of the capital A should sit slightly above the upper line of letters, as is true for the letters with curves. For example, the top and bottom curves of the

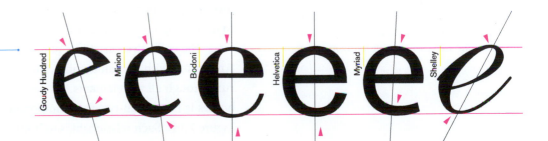

Goudy Hundred Minion Bodoni Helvetica Myriad Shelley

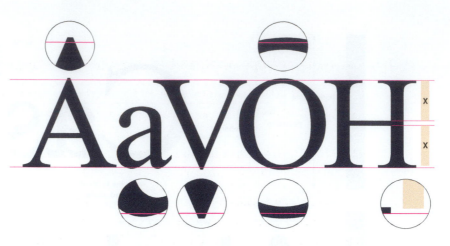

7.17 Enlargements show some of the adjustments needed to visually correct a typeface's curves and strokes.

STUDENT
ORGANIC
FARM

7.18 KEVIN JAMES MEDLYN. Logotype conveying the idea of growth.

▶ *In Practice: Whenever using text in your work, keep in mind how very easy it is to make spelling errors or typos that will ruin your project. Double-check all names and dates, and always ask someone else to proofread your work just to ensure that your text is correct. Almost every designer has horror stories of getting something back from the printer and discovering an error in the text. A simple extra proofreading step can prevent many mistakes.*

letter O should extend just slightly beyond the upper and lower lines so the O will appear to be aligned with the rest of the letters. Curves, points, and strokes often need to be adjusted to visually match the rest of the letters (Figure 7.17). These guidelines generally apply to all fonts.

In the visual identity for Student Organic Farm, Kevin James Medlyn has exaggerated the optics to convey the idea of growth (Figure 7.18). The **logotype**, an identity created predominantly with type, appears to sit on a single baseline—cut at the bottom as if growing out of the ground. The letters progressively rise, finishing with the green color that suggests the idea of farming. As a result, the organization's name is more memorable.

In the Speakout on Amazon Brand Identity (Figure 7.19), you can see how a universally understood gesture (a smile) can be brought to a logotype and can transform it into a very memorable logo.

Typeface Families and Fonts

Typefaces have qualities that can be understood in terms of human personality. For example, the sure footing and historic legibility of the serif typeface Caslon expresses sturdy practicality in a body of text, whereas the high contrast between the thick and thin strokes of Bodoni suggest a delicate and stylized attitude wherever it is used. In the case of sans serif typefaces, Akzidenz Grotesk has a consistent stroke weight and a spartan aesthetic that reads as bold and efficient, whereas Futura, with its geometry of perfect circles and squares, suggests forwardness and simplicity. These differentiations (both of form and history) are the distinctions designers have to consider when choosing a typeface.

A typeface will not only reflect its time period but also the history that came before it. As you buy, use, and even design a typeface of your own, you will become more and more familiar with these differentiations that make up the amazing and multifaceted world of type.

The collective variations of a typeface make up a **typeface family**. And just as with human families, there are distinctive characteristics that run through all the elements. It's possible that the connection to human bodies is the reason typeface components are called "legs" or "ears" (see Figure 7.14). Such relationships to bodies make typefaces memorable.

A logotype is, as the name describes, an identity made of type, and the amazon.com logo is a great example. Designed by Turner Duckworth, it is a widely recognized visual identity. Two considerations were involved in its redesign. The first was for the redesign not to stray too far from the original so as not to alarm Wall Street or confuse customers. This was solved by simply flipping the underscoring arc into a smile-like arc (Figure 7.19).

The second consideration was to convey the idea that the site had everything anyone would want to buy. Here's where the alphabet came into play. The smile emphasized an idea inherent in the name—the letters *a* and *z*, as in "a–z," signifying a full array of items. The arc actually points from "a" to "z" and the "z" has an added curve on its baseline to give it a bit of zip (Figure 7.20). The typographic elements all add up to a smart and successful branding concept, from the Amazon.com website to the boxes the items ship in (Figure 7.21). Jeff Bezos, CEO of Amazon.com, is quoted as saying, "Anyone who doesn't like this logo doesn't like puppies."

7.20 An arrow points from a to z, representing the range of items for sale on the website.

7.19 TURNER DUCKWORTH, LONDON + SAN FRANCISCO. The Amazon.com logo before its redesign (top) and after (bottom).

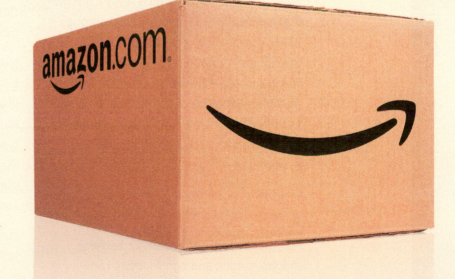

7.21 TURNER DUCKWORTH, LONDON + SAN FRANCISCO. Logo application to a shipping box. The smile shape is used as a graphic element to extend the identity.

Photo by Catherine Rebois

Philippe Apeloig studied at École Supérieure des Arts Appliqués and the École Nationale Supérieure des Arts Décoratifs in Paris from 1982 to 1985. Apeloig worked as a designer at the Musée d'Orsay in Paris from 1985 to 1987 and as design consultant and art director at the Louvre since 2007. In 1989, Apeloig established his own design studio in Paris. His projects include posters, logos, typefaces, and communication materials for cultural events, publishers, and institutions. Apeloig has produced award-winning poster designs for museums and for cultural events, such as Chicago for the first exhibition at the Musée d'Orsay (1987), Bateaux sur l'eau, an exhibition of ancient models of boats and barges in Rouen (2003), and the recent exhibition Bewegte Schrift at the Museum für Gestaltung in Zurich. He has designed experimental typefaces and has also designed logos for the Museum of Jewish Art and History in Paris (1998), the IUAV (Instituto Universitario di Architectura di Venezia) (2002), the "musées de France" (2005), and "Châtelet," the musical theater of the city of Paris (2006). Apeloig taught typography and graphic design at the École Nationale Supérieure des Arts Décoratifs in Paris from 1992 to 1999 and at the Cooper Union School of Art in New York City from 1999 to 2002. He is a member of the Alliance Graphique Internationale, and his work is in the collections of the Bibliothèque nationale de France in Paris and the Museum of Modern Art in New York.

▶ What kind of training in typography did you have?

I learned calligraphy before I touched upon typography. My teacher in Paris at the École Supérieure des Arts Appliqués introduced us step by step to designing letters by hand. With each shape, we observed their counter-shape—the white spaces inside and between the letters. These silent, negative spaces opened a whole new world of typography for me.

My school's curriculum brought me from the basics to more complex ideas. Now, when I design with or manipulate letters, I consider the type's technical, historical, stylistic, and semantic dimensions. My exploration is really a discovery that has developed in many ways—through travel and meeting other designers, and through the computer. The extraordinary digital speed and versatility has made everything possible and has brought a sense of freshness and freedom. But even with the computer, the most important aspect of typographic design is simplicity.

Why is typography such a profound component of your work?

Typography is a perfect balance between shapes, images, and significations. I am fascinated by the way in which letters can work in unlimited combinations to create form and meaning. The playfulness and power of designing with letters, to give the reader an unexpected and conceptual approach to what he or she reads, is very important to me.

There is a bridge between typography and fine art because of the complex subtleties they share. I still remember the very first time I saw the *Black Square* (1915) by Kazimir Malevich of the Suprematist Movement and Piet Mondrian's paintings from the De Stijl period. They were great moments of enlightenment for me—I was touched by the materiality of the paintings. The simple shapes organized with a mastery of light and geometric dynamism was something that I had never felt before. Typography shares this straightforward, conceptual, and appealing quality in its strict, geometric vocabulary.

Modern typography opened up a whole world full of aesthetic and intellectual meanings. The idea, the method, and the honesty of expression must be central to any designer who works with type. By following these principles and realizing the goal of communication, typographic design can go beyond pure function and become something fresh and liberating.

How does typography specifically influence your poster designs?

Usually posters are first seen from afar—the experience being more communal rather than

Vignette 7.1 Logo for Contemporary Africa.

personal (the way books are). They speak and interact with their audience to both attract and communicate. Therefore, a poster's typography is central to its design. It must be lively, readable, expressive, visually arresting, bold, and striking—never neutral or merely decorative.

Vignette 7.2 Poster; *Wim Crouwel—A graphic odyssey.*

Vignette 7.3 Poster; *October Makes the Season Dance.*

Vignette 7.4 Poster; *Boats On the Water, Rivers and Canals,* exhibition.

Vignette 7.5 Poster; Type Directors Club (TDC). *Typography 54* call for entries.

Myriad Pro Regular
Myriad Pro Italic
Myriad Pro Semibold
Myriad Pro Semibold Italic
Myriad Pro Bold
Myriad Pro Bold Italic
Myriad Pro SemiCondensed
Myriad Pro SemiCondensed Italic
Myriad Pro Condensed
Myriad Pro Bold Condensed

7.22 A partial list of the fonts within the typeface Myriad Pro, designed by Robert Slimbach and Carol Twombly for Adobe Systems.

Caslon in 7 point type

Caslon in 10 point type

Caslon in 12 point type

Caslon in 18 point type

in 24 point type

in 36 p

The typesize (36 pt.) is determined by a letter's full body height plus a smidgen.

in 42 point

7.23 Point size is based on the overall height of a letter's body plus a slight amount of clearance above and below.

Typeface Fonts

Certain sets of variations within a typeface family are referred to as fonts. Specific font names such as Helvetica Bold Condensed describe the type, the weight, and the stress, in this case bold and vertically oriented, with the letters taller than they are wide. There are similar descriptors for regular, light, italic, bold, black, and expanded. All these variations give the designer more options when using type to express an idea. Within most projects, you probably won't need to use multiple type families, for example, Helvetica with Akzidenz Grotesk and Caslon. The benefit of working within one typeface family is the consistent look it brings (Figure 7.22). Keep in mind that although some typeface families have many variations, others are more limited. You will need to see what options exist when making your choice of typeface.

Type Size

A typeface's size is based on a measurement system of **points** and **picas** (Figure 7.23). There are 12 points in a pica and approximately 6 picas in an inch, or 25 mm. Small point sizes, between 6- and 8-point type, are appropriate for captions and footnotes. For reading text, a size between 9 and 14 points is the standard. For subheads it's 14 to 24 points, and for display headlines, 24 points or greater is practical.

Type size can become the tool for directing the eye around the page, as we see in the playful student piece by Chase Hill (Figure 7.24). In addition to size, the angle, geometry, color and variation in typeface design create a liveliness that energizes the composition. The few images help in decorating an otherwise typographic design. The piece documents the student's design training in a way that a simple typed résumé of information could never match.

7.24 CHASE HILL. Typographic promotion documenting the designer's transplantation from his home in New Jersey to his school's campus in Brooklyn.

7.25 AMBICA PRAKASH. Typographic exploration that synthesizes Hindi with English; Indic scripts with Western letterforms.

7.26 LOUIS LIM. Literacy poster that makes an analogy between a coded word (literacy) and the 30,000,000 Americans who can't read it.

Analytic Typography

Alphabets are some of the world's greatest inventions. The most complex thoughts can be conveyed by an alphabet's individual letters, combined into words and sentences. Typography can be used to augment this system. Its vibrant form creates additional meaning. But what sort of meaning?

You learned about two kinds of meaning—analytic and metaphoric—in Chapter 3, Graphic Design Concepts. Typographic solutions can be thought of in the same way. There are analytic and metaphoric uses of type, and these type-based approaches also overlap each other.

Analytic typography involves arranging text methodically, without the use of direct metaphors. Formal issues such as shape, density, order, and spacing weigh heavily in solving the problem. If there is an interpretation of the subject, it will lean toward the abstraction of the type as a visual image. For example, one can convey an idea through distressed or particularly curvilinear letterforms. This analytic treatment of type should meet standard expectations for readability and legibility—just as metaphoric treatments should, especially in terms of the images they bring to mind.

In her typographic exploration, Ambica Prakash fuses roman-style letters with the Devanagari script of the Hindi language, creating a synthesis of the Hindi and English—what the designer refers to as Hinglish (Figure 7.25). Although the idea of overlap and convergence could be explained by composing a lengthy text description, the all-type composition conveys a deeper visual meaning that is understood in a more holistic way using only type to symbolize and inform. This piece is a clear example of analytic type; it uses position, structure, depth, and color without the use of metaphoric interpretation. See the Speakout on Typographic Narrative as an example of how the treatment of type can be handled in a way to mimic sounds, shapes, and processes.

In another example, a poster by Louis Lim uses the idea of comparison to visualize the issue of literacy in America (Figure 7.26). On the left side sits the word literacy, presented as a coded message. The letters are hidden, canceled, and denied. On the right side is the number 30,000,000—the statistic cited by the National Assessment of Adult Literacy in 2003 for the number of Americans who performed below the basic literacy level for such things as signing a form or adding the numbers on a bank deposit slip. In between is the statement (at a very small font size): "Literacy is the ability to use printed and written information to function in society...." The analytic concept here surmises that literacy has more to do with penetrating a communication system than with simply reading. The single-color, sans serif type, and dashed line all help convey the division between those who can and those who can't.

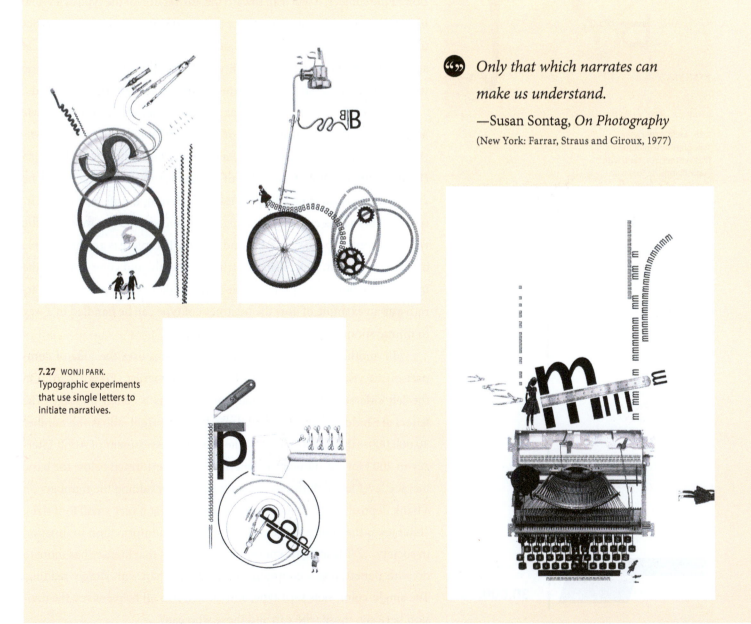

SPEAKOUT: **Typographic Narrative** by Joshua Ray Stephens

Many ancients were intuitively skeptical of written language. Perceived as something potentially dangerous for individuals to possess, writing was initially confined to the realm of mercantilism, for keeping records such as stored and traded foods. But its implicit potential to enable handing down ideas and stories from generation to generation was just too powerful to resist.

I suppose I have a bit of the ancients in me. I feel a deep responsibility, as a designer and artist, to treat the written language with piety, but also as a wondrous gift. So when words come alive at the hands of a gifted design student, it truly electrifies my soul.

Typography is an alchemical paradox that can breathe life into a single letter, effectively turning thought into gold. Wonji Park's student work is an example of this alchemical power (Figure 7.27). Her playful creations use letters, images, and shapes to transform abstract glyphs into concrete expressions of fearless spirit.

Only that which narrates can make us understand.
—Susan Sontag, *On Photography*
(New York: Farrar, Straus and Giroux, 1977)

7.27 WONJI PARK. Typographic experiments that use single letters to initiate narratives.

Readable Texture

Notice the block of text you are reading right now. Just look at its form instead of reading it. Is there a tactile quality on the page? The gray value of the block of text against the white background should suddenly become more noticeable. Look at it in relation to the other elements on the page—the figures, the page numbers, the footer, the margins, and so forth. Do all the parts work together harmoniously to deliver a clear message?

Drawing the reader in with aesthetics is integral to readability. Every individual letter, the space between letters—microcosms within the larger formation of type—combine in ways that give a visual weight to areas of text. The typeface Garamond is different from Times, which is different from Futura, which is different from Helvetica. Each will create a different sense of weight and texture that will emphasize its particular typeface "personality." Letter spacing, leading, and alignment are specific elements of readable texture that influence how any particular typeface will read.

Letter Spacing

Adjusting the space between letters and words is done through a process called **kerning.** The more space there is between the elements, the lighter the feel; the less space, the heavier the feel. A typeface designer predetermines this space, but a graphic designer can make further adjustments to the individual pairs of letters, fine tuning the spacing between them to work perfectly within the set space of the page. A process called **tracking** is used to create consistent spacing within a group of letters. Generally, kerning and tracking adjustments are made to display-sized headline settings, especially in the case of capital letters, where inconsistencies are more apparent. In Figure 7.28, the kerning issues between the letters t and y are quite clear. Inconsistent kerning and tracking can make a design look amateur or clumsy.

In addition, type uses two units of measure within its point system called **em** spacing and **en** spacing. Em spacing is proportioned to the width of a capital M and en spacing (generally proportioned to the width of an N) equals one-half of an em space. The em is further divided into units used to calculate precise adjustments. Kerning and tracking changes are measured in thousandths of an em space. The em and en spacing is also used to create two kinds of dashes that are commonly used in text (Figure 7.29).

Letter spacing also applies to hand-drawn letters. In the Speakout on Casual or Spontaneous Writing, Paul Shaw explains how letters created by hand can be refined by letter spacing.

▶ **In Practice:** *Be careful to use regular apostrophes (') and quotation marks (" ") where appropriate. Often, software will transpose these marks in to vertical marks that are really symbols to show measurements for inches (") and feet (').*

7.28 Creating an even and consistent visual rhythm within a word is based on the counters between letters.

7.29 There is a distinction made between hyphens and dashes based on how they are used.

- Hyphen: joins words and separates syllables in a word
- En dash: the width of a font's capital N (represents the concept of "to," as in 19–20)
- Em dash: the width of a font's capital M (used to separate thoughts within a sentence—you see what I mean?)

7.30 PAUL SHAW. Calligraphic examples created on the same paper—Arches MBM. The ink used was Higgins Eternal. Individual letters were cut out and reassembled to produce a rendition that is rhythmic and lively.

EYE DROPPER 1

EYE DROPPER 2

COLA PEN 1

COLA PEN 2

OLD TOOTHBRUSH

NEW TOOTHBRUSH

DOT MARKER

Q-TIP

7.31 PAUL SHAW/LETTER DESIGN. Ten renditions of the word *design* created with ten different tools.

GRAPHITE STICK

FELT PEN

Casual or spontaneous writing at its best is often neither casual nor spontaneous but laborious and carefully contrived. It is an illusion. It can be accomplished with mechanical tools (3M Magic tape, whiteout, razor blades, and felt-tip markers) or digital ones (scanners and illustration programs) or both. But it must start with the basics: writing tools, liquids, and papers. The first step is to write out the text over and over again. But do not expect to achieve a single perfect rendition. Instead, work on the overall rhythm and focus on difficult letter combinations. Then mark the portions of each version of the text that are the best. Next, cut out each one and reassemble the text, all the while maintaining a pleasing rhythm (Figure 7.30). Horizontal rhythm is the result of balancing the space inside the letters and between the letters. Do not expect a consistency of type. Sometimes the rhythm needs to be livelier than a two-step or a waltz; a Lindy Hop, Charleston, or something exotic such as a tango is more in order. Vertical rhythm is also important. It is achieved by adjusting the baseline as well as monitoring the length of ascenders and descenders. Do not leave letters as they emerge from your writing instrument. Be willing to lightly retouch them to delete an errant stroke, smooth out a curve, or balance negative space. The only thing that matters is that the final result looks spontaneous.

The writing tools available today include dip pens (with both broad and pointed nibs), brushes (pointed, flat, stencil), ballpoint pens, felt-tip pens, gel pens, China markers, oil crayons, pastels, charcoal, colored pencils, spray paints, and so on (Figure 7.31). There are also other tools and ordinary objects that can be used for writing: ruling pens, tongue depressors, Q-tips, eye droppers, toothbrushes, lipstick, fingers, and more—even credit cards!

Writing requires not only tools but also liquids and surfaces. A variety of inks and paints can be used with dip pens, brushes, and ruling pens. Each has different properties of flow, absorbency, and opacity. For all tools the writing surface is crucial. Papers can be smooth (even slick), rough, corrugated, or absorbent. Non-paper surfaces such as Styrofoam, cloth, plastic, and even glass can be used to write on. The different surfaces affect gestural movement and speed which in turn influences the rhythm of writing.

In the end, successful casual writing is the result of experience combined with a willingness to experiment.

Casual or spontaneous writing at its best is often neither casual nor spontaneous but laborious and carefully contrived.

Papers can be smooth (even slick), rough, corrugated, or absorbent. Non-paper surfaces such as Styrofoam, cloth, plastic, and even glass can be used to write on.

Leading

The third variable of readability is distance from one baseline of text to the next. This spacing is called **leading** because, during the age of hot type, a strip of metal was actually inserted between lines of lead type to increase vertical spacing. Most computer layout applications automatically add a space between the lines, but designers can make their own decisions about the size of that space and can adjust it manually.

The same sizing system of points is used for leading. A few points of leading are added between the lines of body text. For example, 9 point or 10 point Myriad Pro type, with the addition of 2 points of leading—expressed as 9pt/11pt or 10pt/12pt—makes for a comfortable read. Adding more leading lightens the text block visually. Tracking will also lighten a text block, but when either leading or tracking are pushed too far, they begin to diffuse the type, causing legibility problems (Figure 7.32).

▶ *In Practice: Running body text is usually set without adding extra tracking. A typeface already has kerning built into each pair of letters, but a graphic designer can make minor adjustments to spacing. An example is a word set in capital letters where a consistent rhythm is desired beyond the default of the typeface; for example, in the word SPACING, the +80 word tracking evens out the letter spaces.*

Paragraph Spacing

There are many different ways to separate blocks of text into paragraphs. Traditional ways to break two paragraphs apart are to insert a full line break (a space equal to the height of a line of text); to insert a half line break, in which the space after a paragraph is half the leading (for 9/12, the half line break space would be 6 pt.); or to indent the first line of each paragraph (Figure 7.33). More unconventional ways include separation with rules, small graphics, or color. Each option has an impact on the overall look of the page and the sense of balance between the blocks of text.

In an example of cookie packaging, Chiu Li Design used type, leading, and paragraph spacing to bring hierarchy and order to the printed information in a way that is quite Baroque (Figure 7.34). The design choices also add to the overall message of the product—traditional, tasty baked goods. On the front of the package, what is normally an informational description of the contents shifts toward the promotional using a scripted logo, centered text, and colorful graphics. The same is true for the back, with heavily leaded text and cookie images inserted for paragraph breaks.

9/11 Myriad Pro Regular

At arcimpe lignis re, tem verchicia volupta tatur? Rate ilitaquat. Libeaquis debisquia plaut illibusdam, ut resersped et eat et quia dolum, cullabo rectempor sed et magnimil ilit volum solorep taectus moluptaquam est, si nobis quibea debis.

10/12 Myriad Pro Regular

At arcimpe lignis re, tem verchicia volupta tatur? Rate ilitaquat. Libeaquis debisquia plaut illibusdam, ut resersped et eat et quia dolum, cullabo rectempor sed et magnimil ilit volum solorep taectus moluptaquam est, si nobis quibea debis.

10/14 Myriad Pro Regular, tracking +50

At arcimpe lignis re, tem verchicia volupta tatur? Rate ilitaquat. Libeaquis debisquia plaut illibusdam, ut resersped et eat et quia dolum, cullabo rectempor sed et magnimil ilit volum solorep taectus moluptaquam est, si nobis quibea debis.

7.32 The setting of text blocks is optimized when the designer balances legibility with aesthetics. The words and leading in the 10/14 Myriad Pro Regular with +50 tracking is too loose a setting for reading comfort here.

At arcimpe lignis re, tem verchicia volupta tatur? Rate ilitaquat. Libeaquis debisquia plaut illibus dam, ut resersped et eat et quia.

Da porrorum quibus alit pero blam, accuptatum aut is enienmagnate mporpos qui con et rendantur si con ne volorep ernat.

Bus alibusd aeptatur, sae volorum rae praturepro ilibusci sint derrore pelenda enisi odipiet quis delecer chiligenda cus excestis aut quia.

Invereped est molore occum il ipid milibusam ea verorio est, volupta quibus simendandis voloreptatem quidel et duciliq.

Bereperunt. Rum volores eost, consequ odignimporae velluptia im eiumqui deniend ellest.

7.33 Paragraph spacing separating text blocks in three conventional ways: full line space (24 pt), half line space (18 pt), and indent space (18 pt).

7.34 CHIU LI DESIGN. Package design in which the text about the product and product itself (cookies) intermingle.

9/11 Myriad Pro Regular, Justified Column

Itatis nullor alibusc iusapicae venes pratin con pa sum as eos int verum eostionsed qui atiat eaquid molores elisqui sant este porepra quam hari aturent as dolorum alitia ipsapienis autem ratem qui doluptibus, que vit alique voluptae volupit aquodis minti consed excesciet eicimet vellibeat qui vel ipsam quae con et, cum, unt et ut ipsum et

9/11 Myriad Pro Regular, Flush Left, Rag Right Column

Itatis nullor alibusc iusapicae venes pratin con pa sum as eos int verum eostionsed qui atiat eaquid molores elisqui sant este porepra quam hari aturent as dolorum alitia ipsapienis autem ratem qui doluptibus, que vit alique voluptae volupit aquodis minti consed excesciet eicimet vellibeat qui vel ipsam quae con et, cum, unt

9/11 Myriad Pro Regular, Flush Right, Rag Left Column

Itatis nullor alibusc iusapicae venes pratin con pa sum as eos int verum eostionsed qui atiat eaquid molores elisqui sant este porepra quam hari aturent as dolorum alitia ipsapienis autem ratem qui doluptibus, que vit alique voluptae volupit aquodis minti consed excesciet eicimet vellibeat qui vel ipsam quae con et, cum, unt

9/11 Myriad Pro Regular, Centered Column

Itatis nullor alibusc iusapicae venes pratin con pa sum as eos int verum eostionsed qui atiat eaquid molores elisqui sant este porepra quam hari aturent as dolorum alitia ipsapienis autem ratem qui doluptibus, que vit alique voluptae volupit aquodis minti consed excesciet eicimet vellibeat qui vel ipsam

7.35 Legibility is balanced with aesthetics when typesetting. Alignment possibilities (above) use 9/11 Myriad Pro Regular.

Text Alignment

Most readers don't realize the effect that text column alignments can have and may even assume they don't matter. Yet when alignment is combined appropriately with typeface choice, leading, and paragraph spacing, the result is text that is readable and has personality. Two basic aligning concepts apply: **flush** (aligned evenly with the margin) and **rag** (unaligned so words can flow more naturally).

The four examples in Figure 7.35 show how legibility can be balanced with aesthetics to create a tone. In the top example, the column is **justified** (flush with left and right margins). The feeling is clean and precise. The second example is a flush left, rag right text column. The rag on the right feels a bit freer and brings some airy white space to the page. It also has a built-in contrast—aligned versus unaligned.

The rag can also be switched to rag left, flush right, as in the third example, although a rag left alignment decreases legibility, making it difficult to find one's place when reading line to line. Yet being set rag left can work quite successfully if its usefulness in a layout supersedes legibility. It suggests a sense of rebellion against convention.

A similar legibility issue can be true for a centered column (fourth example). Ease of finding the next line in a sentence is somewhat compromised, but symmetry can add a poetic feeling, especially in short amounts of text such as a poem or announcement. In the left side of the fourth example, justified centered columns also present issues with the spacing between letters, especially if your text includes long words. Your computer will use programmed algorithms to determine spacing that keep the lines

7.36 ARMANDO DIAZ.
Proposed book cover design
for *The Da Vinci Code.*

justified on both sides, but those algorithms might leave uneven gaps in your text, as the red arrows in the figure indicate. You have to go back through the text and adjust spacing and line breaks to even out the white space. Centered columns, flush left, rag right (bottom right example) tend to produce more readable text with fewer spacing issues.

Every individual letter, every word, and every block of text has all the elements discussed in Chapter 6—line, shape, negative space, balance, rhythm, and direction. Designers must train their eyes to look at text not just as word information but also in terms of design elements.

▶ *In Practice: Typically at least seven words per line are required for a justified column to avoid word spacing problems, or for a rag left or rag right column not to have too many hyphenations.*

The proposed book cover design by Armando Diaz uses alignment as part of a typographic idea to communicate the book's premise (Figure 7.36). The reader must decode the words that are formed from high-lighted text to understand the title and the idea simultaneously. The left and right alignments are the edges of the book, so the type **bleeds** (runs off the page), further engaging readers by forcing them to interact with it. Typography alone becomes the cover design, independent of images. Image-only designs are usually less successful because images usually need type to help convey the message.

For the book *The Art of Light and Space,* the subject of artists using light and space as media became the inspiration for the cover and the layout (Figure 7.37). The designers at Worksight used a single justified text column wrapped around photos and sidebars—the seeming random-ness of the layout was a reflection of methods that the artists themselves used to create their art.

7.37 WORKSIGHT. Cover and
book interior design for *The
Art of Light and Space.*

7.38 JOHN LEPAK. Proposed logo for Botanica florist shop.

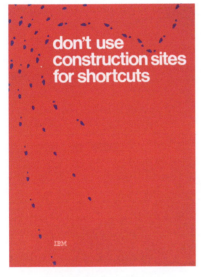

7.39 ELI KINCE. Poster that instructs the public not to use hazardous shortcuts.

For a florist shop called Botanica, John Lepak used a single letter b to identify the business (Figure 7.38). The monogram reverses to white from an overlay of abstract flower-like petals. The connection to a real flower is just enough to make it identifiable. The biomorphic shape is contemporary in its approach; it distances itself from traditional plant and flower shops that typically use script typefaces. In addition, it doesn't use the clichéd image of flower bouquets. The designer found a way to give a special identity to this particular shop, so customers perceive it as being a bit more contemporary in its aesthetics, with a bias toward science rather than romance.

Humor can also become a part of analytic concepts that include both text alignment and directional flow to convey an idea. Eli Kince's poster instructing pedestrians not to use construction sites as shortcuts runs a set of messy footprints around flush-left text to illustrate the problem (Figure 7.39). The poster is authoritative and succinct, but also funny.

▶ *In Practice: Humor is a way to both engage the viewer and soften the imperative command.*

Metaphoric Typography

Metaphor and typography can combine into a singular force that speaks. The literacy poster by Mariana Silva is an example (Figure 7.40). A person's hands have been bound together, and above them the word READ is shown with scissors that replace the letter A. Together they suggest the means of escape from bondage. We immediately understand that reading can free one to do more, but the designer has added some depth to the piece by making it apparent that it would take quite a bit of work with the scissors to cut the cord, suggesting that reading takes effort. The poster is loaded with elements used as meaningful symbols, begging for action.

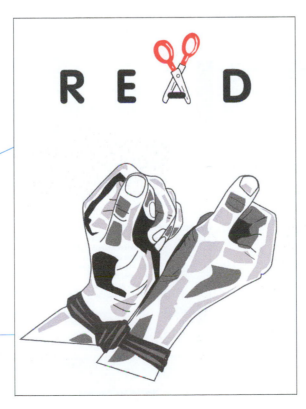

7.40 MARIANA SILVA. Poster promoting literacy as a kind of personal freedom. The word READ is typographically montaged with a pair of scissors to solidify the idea.

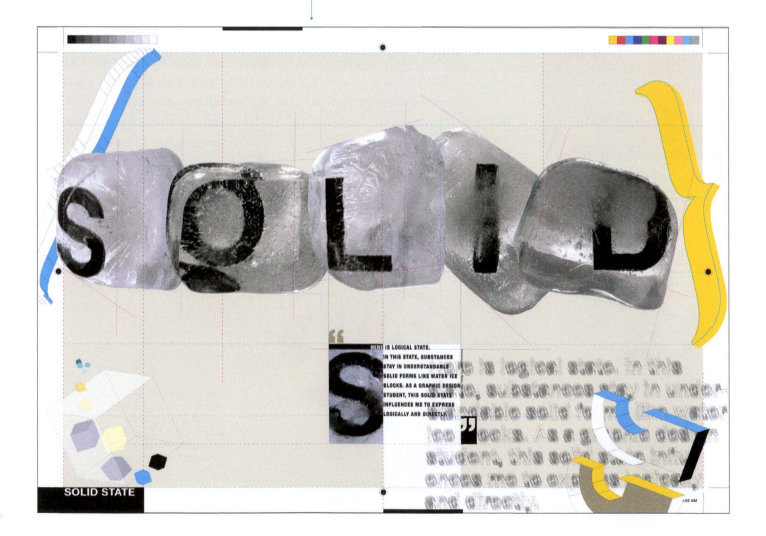

7.41 JASON LEE. Proposed logotype for Dave the Handyman.

The double-duty of reading and meaning becomes especially apparent with metaphoric typography. In the proposed logotype for a handyman, created by Jason Lee, the type morphs into a symbolic tool—a hammer as metaphor for the handyman business (Figure 7.41). Analytic hierarchy is created through position and color, the name Dave having first priority as a red hammer head, The Handyman having second priority as handle in sturdy black. Overall, the letters have the distressed look of a well-worn tool.

In another use of metaphoric typography, this time to interpret an abstract idea, design student Changsoo Choi conveys his approach to design. The construction of frozen letters symbolizes the goal of stabilizing the meaning in a communication (Figure 7.42). The design uses brackets, color bars, and register marks to emphasize the thought. Choi has taken liberties with a text column positioned below—the flush-left line sits tight against its edge, further suggesting his role as an experimenter.

7.42 CHANGSOO CHOI. Visual statement exploring the student's design process.

Vernacular Inspiration

> *Often typography is the main or only graphic element in a design. This is a common solution when the subject matter is too broad or complex.... Letterforms are inherently more abstract than pictures, consequently more useful for this kind of problem.*
> —Milton Glaser

Imagine exploring your downtown neighborhood in a search for hand-drawn typography. What would you find? Most likely, you would see inventive uses of the available tools and materials—chalk, tape, plastic letters, spray paint. And the signs and banners would also reveal something else—the particular cultures of the people who made them. This unorthodox, local language is what designers refer to as the "**vernacular.**" They are seen as experiments that don't fit the rules because, in fact, the people who make this vernacular typography haven't been taught the rules (and probably don't care about them either).

Yet the pieces are quite experimental and creative in their own way—for example, letters and numbers spray-painted, cut out of wood, or reconstituted from preexisting signs. The designs are based on the purely practical, the need to communicate some necessary information, and at the same time, they are filled with character. In the example in Figure 7.43, black tape was used to create a numbered street address. The solution is simple, the numbers are spontaneously constructed, and yet, this "tape type" maintains a consistency similar to that of a carefully designed typeface! The same is true for the template used to create the number 13 on the wall of the parking garage (Figure 7.44). Was it the result of a lack of white paint or mere indifference to the number covered over? In either case, the resulting typography varies substantially from what we might normally expect to see.

7.43 Black tape is used to create door numbers. This tape type, when seen as an experiment, triggers ideas for designers that break self-imposed constraints of proper typography.

7.44 One number is canceled out by another painted over it. The cancellation is humorous because we see how the need for white paint was avoided.

 View a Closer Look for Template Gothic on **myartslab.com**

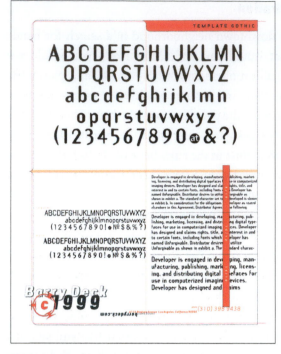

7.45 BARRY DECK. A type sample sheet for the designer's typeface Template Gothic.

The vernacular is, in fact, an abundant well of experimentation seen in every city, neighborhood, and street, offering something unfamiliar or, perhaps, even peculiar. The typeface Template Gothic, designed by Barry Deck in 1990 after graduating from CalArts, was inspired by a stenciled Chinese Laundromat sign (Figure 7.45). Encouraged by his teacher, the well-known designer Ed Fella, Barry created an entirely new typeface by filling in the stencil spaces. In Barry's words, the typeface "reflects more truly the imperfect language of an imperfect world, inhabited by imperfect beings." In use, we see how Template Gothic, and other typefaces in this genre, offered designers like Rudy VanderLans an edgy alternative to conventional typefaces (Figure 7.46).

But the vernacular can also inspire processes not normally associated with design and letter making. The typeface Tailor, designed by Terrence McCarthy while a student at Pratt Institute, derived its form from sewing machine stitches (Figure 7.47). Interconnected and consistent, it's hard to believe that the letters weren't actually made with a sewing machine. But it was, in fact, the designer who found the way to make each form consistent and to make it all work cohesively as an evocative new typeface.

View a Closer Look for Tailor on **myartslab.com**

7.46 RUDY VANDERLANS. Emigre Recording Artists promotional poster for the band Every Good Boy, using Template Gothic typeface

7.47 TERRENCE MCCARTHY. The typeface Tailor that mimics a sewing machine's stitches.

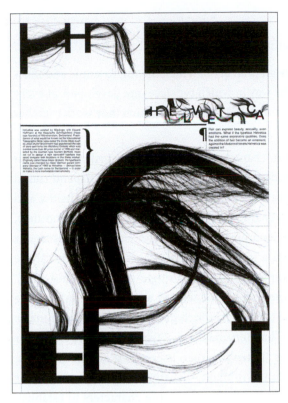

7.48 CHANGSOO CHOI. Helvetica poster pairing hair with Helvetica to explore how a neutral typeface can be used expressively.

Recontextualizing Type

Recontextualization is an inherent process in graphic design through which elements, signs, and meaning are introduced into a new context. For example, a 300-year-old typeface originally created for use in books might now find itself as part of an advertisement or cell phone screen—a context never dreamt of by its original designer. Unexpected pairings work well in design solutions. The montage technique discussed in Chapter 3 (for example, the jellybean montaged with a jawbone) is just as useful in merging typefaces (for example, a serif with san serif). In two separate projects, type is montaged with an image into a somewhat surreal context. Both designs share the idea that the typeface Helvetica can be recontextualized from its neutral state into a more dreamlike one. The first experiment by Changsoo Choi pairs Helvetica with a strange bedfellow, human hair (Figure 7.48), drawing the viewer in through its intriguing contrast of straight-edge letters and curvilinear hair.

The same contrast occurs in the hand-drawn blend of biomorphic growth with Helvetica (Figure 7.49). Inva Cota created a dynamic fusion of plant and letter forms. Like a sturdy gate covered with ivy, this usually structural typeface has become more inviting and personal in a way we might not have imagined it could.

In the Speakout "Designing a Typeface," Jonathan Hoefler explains type design as having its own montage in which the microscopic and macroscopic converge, the result of which is a distinctive but unified set of letters.

7.49 INVA COTA. Biomorphic growth covers Helvetica's letterforms in this typographic exploration.

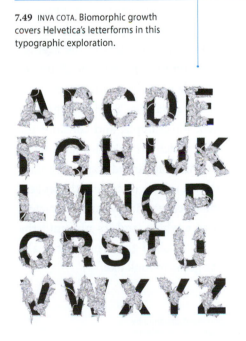

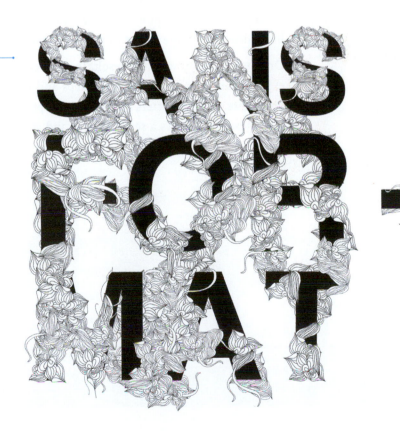

Robert Bringhurst famously observed that type design is an art in which the microscopic and macroscopic constantly converge. That's very true for the way in which typefaces are developed: at every stage, it's not merely letterforms that are being examined, but the ways in which they work together (Figures 7.50, 7.51, and 7.52).

We usually start a typeface by drawing a handful of characters that suggest the general direction that the design will follow. A capital H and O embody the basic distinction between flat and round letters, and the lowercase letters nopha will describe the overall dimensions of a font—its flat and round shapes, its width (and the degree to which its character widths will differ from one another), the height of its lowercase letters, and the lengths of its projecting strokes (for example, a descender in the p, and an ascender in the h). The lowercase a is often a telltale character since it can be constructed in any number of ways; most fundamentally, it can be a single-story "ball-and-stick" design or the more traditional two-story shape. The size of its enclosed aperture will inform the proportions of other characters such as e and g, and the way in which its topmost stroke terminates will become a theme for other related characters: a "ball terminal" [see Figure 7.14] here will recur in the letters fgry, and perhaps later in the numbers. Taken together, its topmost and bottommost strokes will suggest the kinds of gestures that the font will make—whether they're introverted or extroverted and how fussy their details will be. It often takes several more characters to establish concretely that the design is following the right path: some designs start out with a beautiful a, but can't seem to accommodate a sympathetic g.

Once these characters are drawn, they're proofed on paper at a range of sizes and in every possible context. At this point we're trying to establish some generalities about the design, both visual and emotional: as important as its color and fit, we're curious about the sorts of feelings the font conveys. Also at this point, we'll be looking at every possible combination of characters, to spot inconsistencies in the design or problems that should be addressed at a more fundamental level.

Once we're happy with the result, the rest of the project is essentially a matter of continuing to expand the character set in small steps and repeating the process of reviewing the results to see how these new characters change the big picture. There are about 600 characters in the average font these days, so it's a series of slow and steady steps. It's not uncommon for a single character to bring the whole underlying structure crashing down—think about the "8"-shaped grid on a digital watch, for example, and consider the difficulties with which it could display a letter M. Even in its most advanced stages, typeface design is always a matter of constantly brokering agreements between individual characters and the font as a whole, and it's not until the entire design is finished that you ever really know what it's going to look like.

7.50 Gotham Condensed designed by H&FJ; Typeface ©2000, artwork ©2002 Hoefler & Frere-Jones, Inc.

7.51 Archer Typeface designed by H&FJ; Typeface ©2001, artwork ©2008 Hoefler & Frere-Jones, Inc.

7.52 Whitney typeface designed by H&FJ; typeface © 1999, artwork © 2004 Hoefler & Frere-Jones, Inc.

Even in its most advanced stages, typeface design is always a matter of constantly brokering agreements between individual characters and the font as a whole….

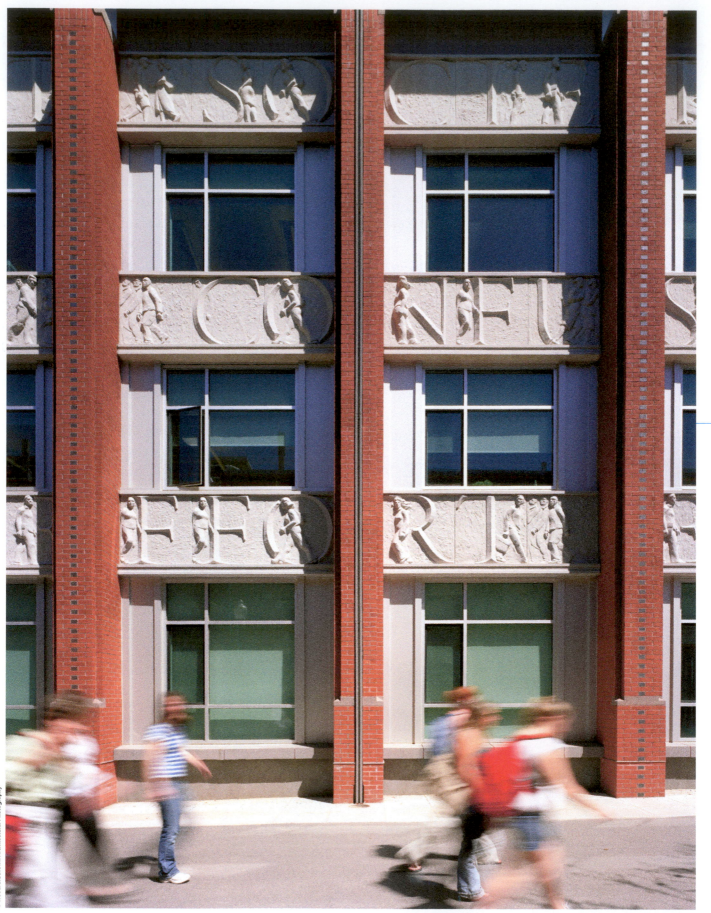

7.53 RANDALL HOYT AND MARK ZUROLO (ASSOCIATE PROFESSORS OF COMMUNICATION DESIGN, UNIVERSITY OF CONNECTICUT). School insignia shown complete and with twelve common letters called out.

© Woodruff/Brown Architectural Photography

7.54 Facade typography/relief sculpture for the Neag School of Education.

Type in the Third Dimension

We tend to think of type as being flat—as vinyl letters stuck onto a pane of glass or as a thin layer of ink offset-printed onto the surface of a sheet—glyphs without dimension. Yet this form isn't always the case. Even ancient letters had a sculptural aspect, chiseled into Roman columns and buildings.

Today, type can be cut, spliced, splattered, and animated easily with the help of computer software. Bringing a third dimension to the equation seems a bit more difficult to do, and yet, when we do it, type feels fresh, tangible, and new.

The design of a relief sculpture for the University of Connecticut by Randall Hoyt and Mark Zurolo looks back to these early forms of public typography. The result is something refreshingly surprising. The idea stems from the twelve common letters in the school's name "U-V-R-S-Y-O-F-C-N-E-I-T," depicted in the UCONN insignia they designed (Figure 7.53). The twelve letterforms are then composed in three dimensions with human figures, which symbolize the intellectual journey students take (Figure 7.54). The design idea then extends to the inside of the building where the twelve letters are recombined into positive words such as curiosity, future, and strive.

The third dimension can also include shredded typography. In the student newspaper design by Inva Cota and Monica Nelson, the broadsheet format unfolds to force an interaction with its student audience (Figure 7.55). As Nelson explained, "We wanted the initial issue to both make a statement and have an extended life as a poster. The idea was that students would hang it in their studios or dorm rooms."

The poster side is one giant statement reading "The Prattler Loves You." Although printed in two dimensions, its form appears to be three dimensional. Shredded letters create an emotional effect; they seem to ask for reaction and discourse from the students. Type has an uncanny ability to offer unusual solutions such as designs that read *and* mean—that go beyond the ordinary. For this reason, it is important to devote serious effort to developing a working knowledge of not only how to use type legibly but also how to take it to new heights.

7.55 INVA COTA AND MONICA NELSON. Two sides of a student newspaper as broadsheet.

7.56 JESSICA RIVERA. Proposed logo for the Drama Book Shop.

7.57 ANDREW DEROSA. Typographic experiment on the perception of letters as flat forms that quickly change when seen from a three-quarter view.

7.58 GEOFF KAPLAN/GENERAL WORKING GROUP. The side and front views of the letters A and Y from the typeface Transgression.

Jessica Rivera used scans of printed letters and book pages to create a design for the Drama Book Shop (Figure 7.56). She began the project with the idea of using pages as leaves on the stem of a rose (the rose suggesting both passion and drama). She could have gone in a number of different directions with the montage idea, but Rivera chose a three-dimensional approach that added a kinetic effect of movement to her solution.

Andrew DeRosa created words as sculpture, offering an unexpected dynamic with his letters (Figure 7.57). Viewed head on, the words line up evenly to create the proper letter forms, but as soon as the viewer moves to either side, thus viewing the letters at an angle, the dynamic letter forms are revealed, forms stretching into abstract and visually playful three-dimensional shapes.

Manipulating type can be a very hands-on, mechanical process, but in an experiment created by designer Geoff Kaplan, the virtual world can also be brought into typographic play (Figure 7.58). Driven by the computer's mathematical calculations, both the uppercase and lowercase of individual letters, as well as their supposed internal and external perspectives, are created according to the logic of perspective drawing. The logic of two-dimensional type is shredded as the uppercase and lowercase of each letter are blended. So are the relationships of internal shape. As the designer puts it, "The result is a new form—an object as much as a letter. It can exist on the screen with the perception of infinite perspective, or a flat and sobering form printed on the page—letters that are two-and-a-half dimensional."

In Perspective

Page layout software makes it easy to set type. The kerning, tracking, and leading of a block of type have automatic settings assigned. Don't use them. The manual adjustments you make to the typeface, the size, and even the way a sentence breaks to the next line will all help create something more readable and engaging. The text will certainly flow better visually if you make the effort to adjust the type. Your eye and good judgment will render much more beautiful results than the software's mathematically generated algorithms can. Everything in this chapter stresses the need for designers to develop a sense for type and typography, which you can do only by grappling with it. Push it around and make mistakes with it until, like osmosis, it sinks in and starts to become natural to you.

You will know you are developing a feel for type when the excessive kerning in a sign (such as "ass ociates") seems funny to you or when a movie scene using a 1950s typeface for a turn-of-the-century period scene is annoying. Just noticing these problems means that you're learning. We are all perpetual students of type and its use. As you will see in the next chapter, grids and alignments can further organize and enhance type and typography. Because of its technical nature, type can be quite challenging, but also the most rewarding. When it works well, when the typeface, the layout, and the imagery all function together in perfect harmony, you know you've created a successful design.

EXERCISES AND PROJECTS

✓—Review additional Exercises and Projects on **myartslab.com**

Exercise 1 (Type Styles): Typeset your first and last name fifteen times, each in a different typeface, using roman fonts only (upright, not italic). Variations should include at least one serif, sans serif, Old Style, Transitional, and Modern. Notice the personality that each typeface carries. Be prepared to discuss your choices and why they do or don't make sense.

Exercise 2 (Typeface Research): Research an Old Style serif typeface and write 100 words about it. Include the designer, historical facts about its use, and any revivals of the typeface that have occurred. Next, find a sans serif typeface and do the same. For each typeface, print out the capital H and O, as well as the lowercase g and t at 72 pt. On a sketch pad, recreate the letterforms at 400% of the 72 pt size by first pencil-ruling parallel lines for baseline, cap height, and x-heights for each typeface (see Figure 7.14).

Project 1 (Typesetting) PART 1: Select a block of text containing at least 750 words and paste it into a page layout application (not a drawing or image manipulation program). Use the following specifications: page size: 8.5" × 11" with margins set at 4 picas top, 5 picas bottom, 6 picas left, 4 picas plus 2 pts right. Within the margins, set two text columns, each 20

picas wide, with 1 pica of gutter space between (the space between columns or the blocks of type). Type color should be black, and size with leading should be 10 pt / 13 pt, flush left, rag right, with a half line space between paragraphs (6.5 pts). Choose a typeface and experiment with font variations, including roman (regular), italic, bold, condensed, all caps, caps with small caps. Reconsider bad rags (line breaks that split a word awkwardly. Adjust the height of your text columns from the bottom, and avoid orphans (the first line of a paragraph on the last line of a column) and widows (the last line of a paragraph on the first line of column).

PART 2: Using the same text, write and add at least eight subheads, and explore ways you might include them. Consider weight or case, font, color, tracking, indent or flush, spacing (before and after each paragraph), rules, graphics, and reversals (white type) to bring personality to the design.

Things to Consider: *Be obsessive in following the instructions to get the typesetting exact.*

Project 2 (Mechanical and Hand-Drawn Expression): Visually illustrate a quotation using both a typeface (your choice) and your own hand-drawn forms. Both must be included. Make your point as expressive and clear as possible. Full color. Size: 10" × 10".

 Things to Consider: *Consider traditional mediums such as ink and brush, pencil, or charcoal as well as nontraditional ones, including crayons, sandpaper, steel wool, ketchup, and so on.*

Project 3 (Visual Narration): Visually narrate the first few pages from a published children's book using only type. Retain the existing page proportions, but bring typography, color, and energized composition to create a fun and graphically dramatic design. Full color.

 Things to Consider: *When designing the typography of these pages, take into consideration the flow of the type. It will help create a stream of connections, which, in turn, will help the eye move from one focal point to the next.*

Project 2 ANDY MATHURIN. A phrase turned into a logo for a pest control company. Logo design (above) drove the creation of the advertisement (below).

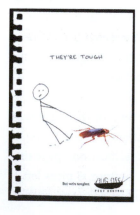

Project 4 (Type Treatment): Create ten visually compelling compositions, each of which uses only one different letterform from the Univers typeface family. For each, use a different mix of one design principle and one contrast set from the lists below. Strip away the literal meaning of each letter and focus on the form and structure. Avoid patterns, and work toward the goal of creating something dynamic. Your final set should be ten completely different compositions. Black and white only. Format: 7"× 7" on an 8.5"× 11") vertical page. Design principles: balance, contrast, direction, dominance, proportion, rhythm, unity. Contrast sets

Project 4 RACHEL CAIRES. Two treatments using letterforms from the Univers family.

are as follows: figure/ground, large/small, texture/mass, stable/unstable, bold/light, thick/thin, static/moving, rectilinear/curvilinear, hard/soft.

—*Provided by Paul Sahre, professor, School of Visual Arts*

 Things to Consider: *Use design elements (texture, scale, repetition, etc.) as treatments to achieve your design principles (see Chapter 6). Be playful and experimental—take chances.*

Project 5 (Type and Packaging): Typeset all the words from a food package and reapply them using more extreme typography that pushes the boundaries, yet still explains the product and its benefit. Bring something inspirational into the project: consider art movements (Futurism, Dada, Surrealism, Abstract Expressionism) or music categories (rock, punk, grunge). Full color.

Things to Consider: *Consider how the design will help the package stand out from other products on the shelf (contrast, dominance, rhythm).*

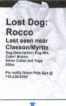

Project 6 MAY PARSEY. A flier announcing a lost pet (top) and Parsey's redesign of the flier (bottom).

Project 6 (Typographic Flier): Find a flier (on the street or online) for a lost pet and redesign it. You can include an image of the missing pet, but place emphasis on the typography so the flier provides a colorful description and relays the information. Black and white only. Present the redesigned and original versions. Size: 8.5" × 11" vertical.

Things to Consider: *It might be fun to include some of the vernacular elements of the existing flier in your design, but don't "stray" too far from a reductivist-oriented typographic language.*

Project 7 (Book Typography): Redesign a chapter opener for a coffee-table style book of your choosing. Your design should include a full-bleed image on the left (verso) side of the introductory spread. On the right (recto) side, create your typographic redesign. Include the chapter title and chapter number, page number (folio), and three short paragraphs of text. Treat each element graphically to create compositional poetry and personality on the page. Follow up with an additional set of spreads (four pages) showing how other pages in the book fill out in terms of images and a full body of text. Full color and at least 9" in width and height.

Things to Consider: *Consider the subject, the chapter's title, the image that sits opposite, how to begin the text, and the system you are inventing that will apply to the other chapters in the book.*

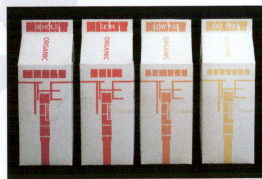

 Project 5 HYOCHIN KIM. Typographic design for a milk carton using the De Stijl art movement founded in the Netherlands as an inspirational aesthetic.

01 All lectures take place
Auditorium, Architecture Building,
ted.

itecture, Paris;
ew York University
a with the exhibition
65"

y, Columbia University

Department of Architecture and Urban Design, UCLA

Le Cor
Jean

19th-Cen
Jonatha

Plastic
Sylvia

8

Proportion Systems: Grids and Alignments

→ CHAPTER OBJECTIVES

AFTER READING THIS CHAPTER, YOU SHOULD BE ABLE TO:

- Identify grids in existing designs.
- Develop a modular grid, determining its structure and elements.
- Illustrate how modular patterns can be used to convey ideas.
- Demonstrate the basics of using typographic grids for organizing type on a page or website.
- Explain how use of freestyle alignments differs from use of grids.
- Describe examples of ways that designers have exploited the grid structure to push information unconventionally.
- Define the golden ratio and summarize how it is used to achieve visual harmony.
- Identify standard paper sizes and formats in the United States and Europe.
- Describe basic paper folds and their uses.
- Define the rule of thirds and explain its application in design.

When a composition works—when your intuition tells you there's something right about it—chances are good there's a structural harmony behind it. Music works this way. It's generally easy to hear whether harmonies are in tune or whether the rhythms are synchronized. With graphic design, the arrangement of visual elements needs to work in coordination, just as musical elements need to work in harmony.

Exercises and Projects

Find examples of and manipulate existing grids; construct five compositions using type in grid structures; redesign a published article using a five-column grid.

There's a conceptual strategy I have that works in tandem with the grid and the type choices I make. —Barbara Glauber

◉ Watch the Video on **myartslab.com**

Opposite page: ALLEN HORI. Lecture series poster (detail) for the Princeton University School of Architecture (full image, see Figure 8.28).

Books, business cards, posters, website pages, packages, and video screens are all predominantly rectangular. The elements that flow within those rectangles naturally find vertical and horizontal alignments. For this reason, grids are effective to use for alignments. As you read through this chapter, you will come to understand how the basic structure of grids and alignments help to create a rationality and sense of proportion in a design. These tools will enable you not only to be more proficient in organizing information but also to create visual poetry on the page. Using a grid as a basic structure may seem restrictive at first, but it actually provides the framework within which to be inventive and experimental. Ironically, the underlying structure of the grid can help you unleash your imagination.

8.1 A grid is always present in the facade of high rise buildings.

8.2 When we look for them, grids begin to surface in every-day objects.

Velestrud ming ero cor sum inisl er
aliquam num et nullam:

Et, sum velestrud ming ero cor sum
inisl er aliquam num et nullam, vulla consequi estin
henim iure vel dit vel doloreetuer alisi. Unt auguer siscip
eu faciliq uisit, consectetue erostrud et am ipit nulput alis
exeriur eriusti onsent nulla facidunt ullummodio dolor
sismod endrem augiatin estin ea autat wisisi euiscipisl
dolutat loreet lut dunt wisis nulput veraesed eriusto esto
consed dolutatue molortin vel ip eraesse quisse tat.
Modolorero od dolore del er am, sis do dolore feugiat,
quatem zzrit iriliquat. Ullummodio dolor sismod endrem
augiatin veniamet do ea aute dolesequisim non vel esto
odolore feuis alissi tionulput lumsandignit lut eugait adit,
quiscilla am venis nos do odolortie velenimDeliquatum
nim il inis do odit dolorer ostrud tie dolumsa ndreetu
mmolorp ercipismod et wis nullametummy num diam
vendre vent loborper ilit iriuscincip exercinit exer
suscipisi tatuer ilit luptatum eu faccum dolorpe rilismo
diamcon sequat, quametummy nostrud minit adiam
dolore tio dolobor periust ionsequat ulput nullaor
perostio. Vel ip eraesse quisse tat. Modo lorero od dolore
del er am, sis do dolore feugiat, quatem zzrit iriliquat,
veniamet do ea aute.

1

8.3 A simple block of text placed within an established proportion. The red lines notate the grid system.

Defining a Grid

A **grid** is a framework of horizontal and vertical lines that cross each other at regular intervals. When you look for them, they start to become apparent everywhere. Consider, for example, the facade of a building (Figure 8.1). Its system of windows and columns translate easily as horizontal and vertical lines. The abstraction of underlying horizontal and perpendicular coordinates, or a **grid system,** can be used to inspire other kinds of projects. For example, the system might inspire an interior designer's floor plan, or a graphic designer might use it as inspiration for the layout of a page. Many constructed objects have this structure; an old window grate or a gate sitting in front of a wall both have lines that layer from top to bottom, left to right, and back to front (Figure 8.2). The lines create a visual pattern and a structural integrity.

This same grid structure applies to a page of text. Simply placing a block of text on a rectangular page begins the process of establishing the grid and its proportions. The text block's position, its size, and the margins around it, are all ingredients of a proportional formula (Figure 8.3). The column width and the size of type in Figure 8.3 seem familiar and comfortable on the page for a number of reasons. Five equal **modules,** or repeating shapes, determine the beginning and end of the text's width, thereby determining a system for the page. The same measurement is used for its height. Slight adjustments have been made so the distance from the top of the page to the top of the first capital letter in the paragraph is one module. Modules for elements such as a headline, page number, and image all correspond and guide their placement. Your eye notices a rhythm that has been determined mathematically.

The use of proportions, modules, grids, and alignments is even more essential for projects that involve multiple pages or similar sections, for example, books, magazines, websites, or wall panels in an exhibition. The uniform underlying skeletal structure unifies all the pages or other sections of the design. And, as you will see in this chapter, breaking the grid and creating playful variations gives the design its vitality and expression.

8.4 Position and direction are the only variables.

8.5 Word spacing and scale are introduced for impact.

8.6 Shapes, values, reversals, and additional typefaces are introduced to the composition.

Developing Modular Grids

The empty space of a page can be as small as a business card or as large as a billboard. As a designer, your goal is to create a striking design in a controlled space. One way to achieve that goal is to use a **modular grid,** a system or plan with a structural pattern of repeating shapes or lines that helps you guide the organization of typography or images.

Designing a page is not much different from placing furniture in a room. Your eye enters the page much as you might physically enter a room. In both cases, you interact with the individual elements. In a room, the doorways are the points of entry; you walk in and encounter the furniture and personal objects, all working together to create an inviting, functional living environment. On the page, your eyes tend to look to the top left first because we read top to bottom, left to right, and then your eye will take in the general layout of the page with all its images and visual elements. (Of course, the point of entry will be different for people whose languages run right to left.)

You can determine what elements will dominate the page, just as a big, red couch might dominate the room. Other text and visual elements create contrast and give a sense energy in their relationship to the dominate elements, much like a coffee table and lamp might relate to a couch. The placement and relationship of all these parts is determined by the overriding grid structure.

Take a look at Figures 8.4–8.6 to see how a modular plan is used in the layout of a few words. A square has been repeated to create a modular structural system. A module can be any shape, of course, but the simple symmetry of a square module gives it a flexible and neutral quality. It allows you to change the text direction from horizontal to vertical without altering the grid.

The first example shows some possibilities for presenting a very small amount of information (Figure 8.4). The title sits on the top left, and all visual effects are restrained. The space is handled very simply, with the position and direction of the text as the only variables.

In the second example, the designer has added word spacing and dramatic scale changes (Figure 8.5). Contrast and scale create a strong visual impact on the page. The negative spaces between the text elements serve to intensify the user's perception and experience. Again, it reminds you of a room, with large and small furniture carefully placed within the confines of the space.

For the third example, the designer has added some new elements, including shapes, tints, letter reversal (white against black), typeface additions (the script letterform inside the circle), and font changes (light, regular, and bold). All of these elements activate the composition, making it more lively and inviting (Figure 8.6), and suggest something about what the course might have to offer.

> *I still reserve the right, at any time, to doubt the solutions furnished by the Modular, keeping intact my freedom, which must depend on my feelings rather than my reason.*
>
> —Josef Müller-Brockmann

A modular approach underlies a three-ring binder cover design for a textile company (Figure 8.7). In this case, the project called for a predominance of colorful imagery rather than type and typography because the cover needed to illustrate the range of fabrics the company sold. Various photographs and colors were loaded into the underlying modular grid, but some modules were left empty to allow room to play. Here, type and logo integrate into the space. The lines of type are heavily leaded to fill the space within a module, and the logo hangs off of a horizontal grid line, but breaks the vertical grid, centered between two coordinates. This small move brings an active spirit to the design. It respects the grid, but plays within the rules.

In Figure 8.8, you can see the possibilities in multiple arrangements. These variations could be used as options in your presentation, used for other covers within the collection, or used for interior binder pages. The gray boxes in the design shift like sliding tile puzzles, allowing for many variations.

▶ **In Practice:** *Modular grid systems don't need to be squares. Any repeating shape or proportion (horizontal or vertical) within the format will work. The main goal is to use the composition to convey information logically.*

8.7 WORKSIGHT. A modular grid system was used to design a textile manufacturer's three-ring binder cover.

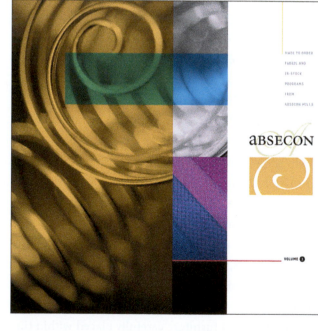

8.8 Possible arrangements using a modular system. The far left grid was used for Figure 8.7.

8.9 Both natural and man-made patterns can inspire a grid system.

Developing Modular Patterns

You can find modular patterns in nature, in constructed objects, and in environments. Any repeating shape can be used to create a system to organize information. The art is to recognize a beautiful repetitive pattern and abstract it into something you can use for your project. For example, you can translate the stem of a leaf or a honeycomb into pure line and form and use it as an underlying structure in your design (Figure 8.9). The more you look for modular patterns, the more you will find intriguing patterns that you can alter and use for organizing the elements of your design—and the more your creativity and imagination can really come into play.

The poster by Willi Kunz shows how to use a modular pattern to convey an idea—in this case, how to explain the integration of architecture and urban design (Figure 8.10). Kunz literally layers one pattern over another to suggest the duality, with lines and edges perfectly coordinating with one another. Together, the modular patterns order the hierarchy of information, but also create the perception of depth, all of which are in keeping with the complexity of the program that the poster is advertising. Figure 8.11 shows the freedom a modular pattern can provide and still maintain its structure.

▶ *In Practice: Posters need to grab the viewer's attention because most people won't stand in front of one for very long. One way to attract your viewer and hold them for more than a moment is through the illusion of depth perception.*

8.10 WILLI KUNZ. Poster announcing a graduate program at Columbia University in architecture and urban design.

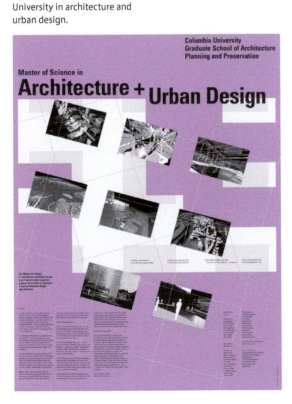

8.11 Modular arrangements as thought starters for organizing a poster's information.

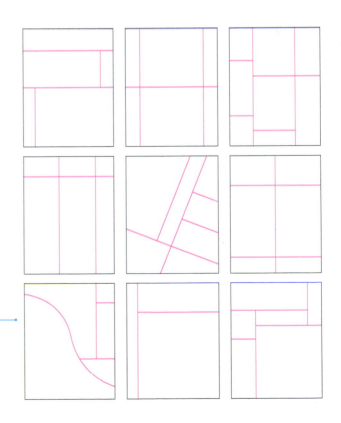

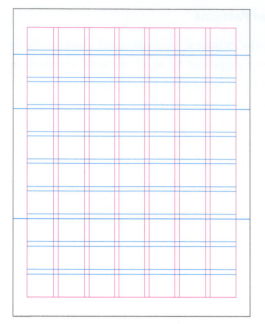

8.12 A seven-column typographic grid system.

8.13 The components of a typographic grid.

Typographic Grids

The layout of a 320-page book would not be particularly feasible if a designer had to make decisions anew for each page, which is why designing an efficient grid system is especially important with multiple pages. In effect, you are devising a formula that will help guide the arrangement of text-based information. Creating a template based on a grid eliminates the need to repeatedly decide where to place headlines, page numbers, captions, headers, and footers for each page. The result is a weave of alignments that unify the design. **Cascading Style Sheets** (CSS) serve a similar function for designing on the web, establishing templates to be used across the site. The biggest advantage of CSS is that you can make a change on the primary style sheet and the change cascades across all the secondary pages.

A **typographic grid** is based on a column rather than on a module. These columns have a predominantly vertical flow since type lines read top to bottom (Figure 8.12). A small distance between each column called a **gutter width** is built into a typographic grid. It controls each text column space so the type will not run into or touch the type in the column next to it. As a page fills out with elements, the grid remains a mechanism for organizing the composition and always bringing the text back into proper alignment after the interruption of a figure or other element (Figure 8.13).

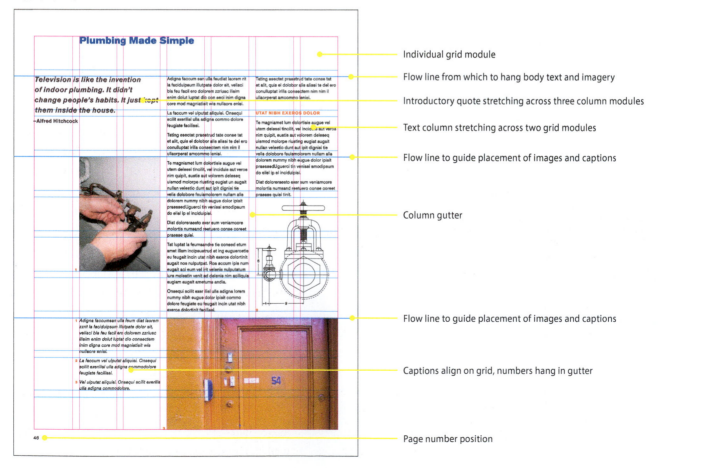

Individual grid module

Flow line from which to hang body text and imagery

Introductory quote stretching across three column modules

Text column stretching across two grid modules

Flow line to guide placement of images and captions

Column gutter

Flow line to guide placement of images and captions

Captions align on grid, numbers hang in gutter

Page number position

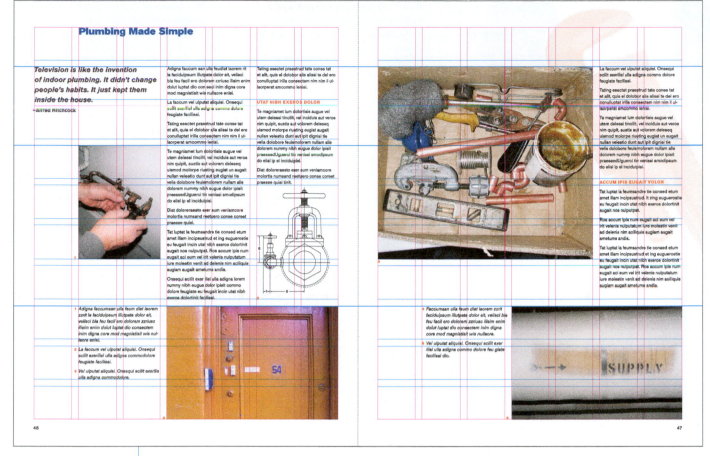

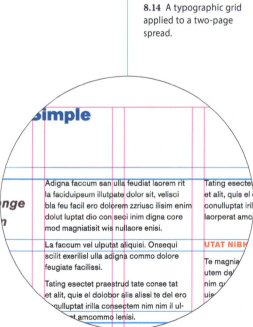

8.14 A typographic grid applied to a two-page spread.

▶ *In Practice: Constructing a set of grid lines as its own layer in a page layout application will allow you to turn it on and off as needed throughout the process.*

For a two-page spread, the grid system continues, taking into consideration how the reader will view left and right pages (Figure 8.14). A grid's horizontal guides, called **flow lines,** create continuity between pages. Top and bottom text columns, captions, and image placement all correspond, no matter how far apart they are—page to next page. The designer brings variety by creatively shifting and adjusting elements within the grid, making decisions about altering column length and photo size.

The layout of this textbook is designed to create clarity not only for the reading of the text but also for the images to which the text refers. The wide single text column accommodates images that might intrude into it, or sit under or above it, which creates a playful dynamic, while the heavy leading of the typeface reduces the chance of one line visually bleeding into the next. A second narrower column holds the bulk of the images and captions. This simple grid sets a compositional tone for each two-page spread in which text blocks, artwork, page numbers, rules, and graphic shapes are treated as equal elements in creating contrast, direction, and unity. Some elements overlay one another or ghost back to create visual depth, while other elements are scaled up to create dominance. The goal is for each page spread to have an aesthetic that works cohesively in conveying the information as well as visual intrigue and balance.

Willi Kunz was born and educated in Switzerland. He apprenticed as a typographer and earned his postgraduate degree in typographic design from Kunstgewerbeschule Zürich. In 1970, he moved to the United States. • Currently, he is the principal of Willi Kunz Studio, New York, a design firm specializing in print communications, visual identity, and architectural graphics. He has taught typographic design at the Ohio State University and the School of Design, Basel, Switzerland. • He has authored Typography: Macro- and Microaesthetics *(Niggli, 1998), plus a revised and expanded edition, 2000 and a third edition, 2002, with editions also in German, Chinese, and Spanish. • In addition, he has authored* Typography: Formation and Transformation *(Niggli, 2003). • Willi Kunz has won numerous national and international awards; his work is exhibited and published widely in the United States, Europe, and Japan. • His works are included in the collections of the Museum of Modern Art, New York; the Cooper-Hewitt National Design Museum, New York; the Cooper Union Lubalin Center for Typography, New York; the RIT Graphic Design Archive, Rochester; the Getty Museum, Los Angeles; the San Francisco Museum of Modern Art; the Denver Art Museum; Museum für Gestaltung, Zürich, Switzerland; Kunstsammlungen Cottbus, Germany; Bibliothèque Nationale de France, Paris, and important private collections worldwide. • Willi Kunz is a member of Alliance Graphique Internationale (AGI).*

► Why should a designer understand how to use grids and alignments?

By using a grid, the designer starts working with a basic structure as opposed to facing a blank page without any visual cues. Working with grids and alignments leads to well-organized information that looks more inviting and is easier to read than a casual, haphazard visual arrangement. As an organizational device, the grid helps establish a visual hierarchy and creates unity between text, pictures, and other graphic elements.

In creating a large publication, adhering to a grid provides continuity from page to page and helps coordinate the creative efforts of members of the design team.

Does it matter if the reader notices?

A grid is primarily developed and applied as a guide for structuring typographic information. It is not important for the reader to notice the grid. In fact, an elegant design solution does not easily reveal the grid; the grid structure remains hidden behind the information. Readers, however, will always—consciously or subconsciously—recognize the organizational rigor and design integrity a grid provides and will appreciate the designer's care in making the information readable. Lack of structure and visual hierarchy makes information daunting and irritating.

Can structural proportions express emotions and convey ideas?

All graphic or typographic information has a certain fundamental structure that can be increased or manipulated to express emotions and convey conceptual ideas. The designer, however, must carefully decide when to use structure to convey an idea. On an architectural poster, for instance, the strong structure of a grid may express the content of the events it announces and attract the intended audience; on a concert poster, an overly structured approach may be inappropriate or misleading and may require an improvised visual structure where graphic elements are arranged optically.

Vignette 8.1 Merit gasoline stations, symbol.

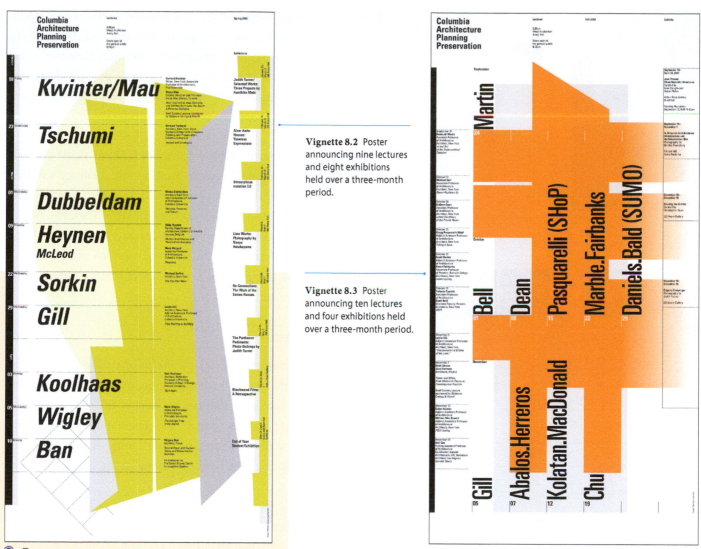

View a Closer Look for the Columbia poster on **myartslab.com**

Vignette 8.2 Poster announcing nine lectures and eight exhibitions held over a three-month period.

Vignette 8.3 Poster announcing ten lectures and four exhibitions held over a three-month period.

Vignette 8.4 Willi Kunz Studio logotype.

Vignette 8.5 *Typografische Monatsblätter* magazine cover.

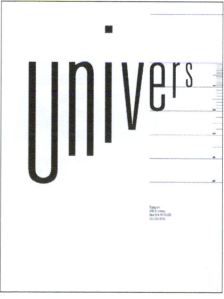

Vignette 8.6 Univers type specimen book, back cover.

In the page spreads for a real estate company by the design studio Object, a two-column grid is the principle component that drives a very centered and symmetrical layout (Figure 8.15). But note how tiny shifts of additional elements such as numbers and captions give the design an asymmetric edge. The result is a design that is in keeping with a contemporary building constructed within a nineteenth-century traditional setting.

In the chapter opener by Object for a book about skateboarders, a number of contrasting elements create exciting visual energy within a two-column grid (Figure 8.16). First you see bold, sans serif headlines set against serif body text, creating a high contrast in style. Then you notice the extreme change in scale of the type. The designer broke the grid by shifting baselines of sub-headlines and running captions in and around the main body text. The energized page reflects the frenetic energy of its skateboarding subject matter.

Grid System Research

Understanding how someone will access the information presented in your design is perhaps the most valuable component in researching grids. As the previous examples show, simply considering the subject and the audience is a good start (Figures 8.15 and 8.16). These reflections will help you determine whether a design should be entertaining or serious, restful or energized; whether it might be read in a living room, on a train, or in an office; and so on.

If the subject is entertaining, then playful graphics and typography working within a flexible grid might be a good approach. If serious, for example, a legal document, then an efficient and consistent design would

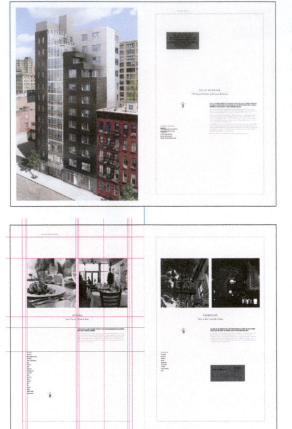

8.15 WESTON BINGHAM, WARREN CORBITT, OBJECT. Real estate brochure describing a specific property.

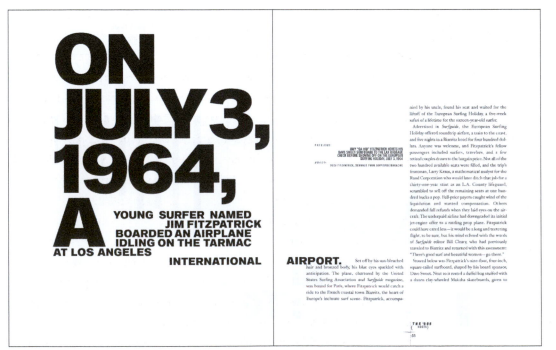

8.16 WARREN CORBITT. Chapter opener for the book *Scarred for Life.*

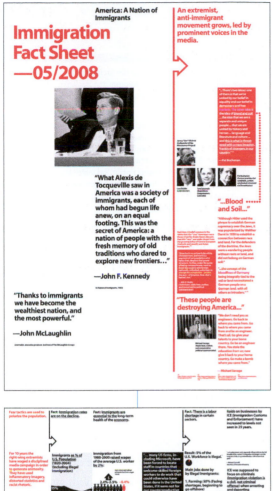

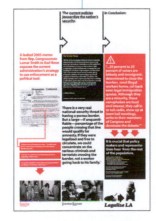

8.17 BENNO RUSSELL.
Legalize LA Immigration
Fact Sheet for American
Apparel.

be more appropriate. These considerations translate into the visual codes that carry your message. Such subtle codes are built into the grid so they convey meaning, just as the text and images do. (You can read much more about visual codes in Chapter 10.)

Take, for example, the Legalize LA's Immigration Fact Sheet designed by Benno Russell (Figure 8.17). Here, the grid works quite well in displaying a large amount of information in a way that is both clear and visually active. Available at the entrances of retail stores and coffee shops, the fact sheet is targeted at readers who are socially minded but have only a limited amount of time. The fact sheet encourages them to learn more about this important subject. The large headlines, short clips of paragraphs, quotes, charts, and images are all essential in conveying meaning. The design creates a visual language that attracts attention but is also clear, succinct, and urgent in its message. If the same subject were presented as an oversized coffee-table book, it would have a completely different look and grid structure. It might have wider columns and longer lengths of text for a more leisurely read. It would probably include more photographs—and more negative space to allow for ease of absorbing information. But most printed brochures don't have the luxury of space that a coffee-table book offers.

Pages and Spreads

In a book, various pages and page spreads have repeating visual and text elements. The research you do before determining the grid structure is essential and includes getting a count of the total words, chapters, photographs, illustrations, caption lengths, and pages. These totals will affect your choices of font size, font weight, margins, column widths, and image sizes. All this information is equally important when working on any project with multiples—books, magazines, websites, and catalogs. The intended audience and the tone of the content will also affect your choices.

As an example, consider a soft-cover book. For starters, its interior page proportion might be 6" × 9", perfect bound (pages held together with an adhesive binding), 144 pages, 12,000 words, with 30 small photographs. A grid that adapts to a functional type size, perhaps 10 pt, and a medium column width becomes important for a publication with far more words than images. If the book comprised more images than text, then designing the grid to adapt to the size and proportion of the images would take priority. A young audience might benefit from slightly larger type. The tone of the content may also affect the grid structure.

Your next step in designing this book would be to determine the size and weight of chapter titles, headlines, subheads, and captions. Review all the material to get a rough count of these elements in each chapter. The length of headlines, number of subheads, and caption lengths are key issues to consider in terms of the grid's design; in particular, column

8.18 Three type arrangements using a consistent 10 pt gutter width inside a seven-column grid system.

> ❝❞ *The composition is the structured whole of the internal functions or expressions of each part of the picture.* —Wassily Kandinsky

widths should accommodate these elements. As you make design decisions, keep in mind that the text itself has meaning. The editors might have something to say about words that can't be hyphenated or elements that should be emphasized over others. Be sure to consult with the publication's editorial staff before making final decisions on the design.

As you develop a familiarity with the material, you will get a better feel for how all the parts work together. You will develop a sense of legibility and flow as you see how pages, and the underlying grid, serve as a device to support the content. Elements such as margins, page numbers, **headers** and **footers** (which state the title, chapter name, and page number on each page at the top or the bottom) as well as supplementary elements such as rule bars and symbols will need special consideration because they occur throughout. Finally, don't forget to think about the negative space on the page. It takes up real estate within the grid, but often serves an important function in giving the eye a place to rest. Every change in one of these elements impacts all the others. Making subtle (or not so subtle) changes becomes a careful balancing act. Try looking at your design up close and from a distance to grasp the overall effect, and don't be satisfied until all of the elements work together harmoniously.

Text Columns

Columns are designed to control text placement, determining the length of words per line and the alignment of graphics and images. The seven-column layout shown in Figure 8.18 includes a large numeral positioned in the first column. The next column comfortably holds caption material, and the third and fourth align an image (shown as a gray tinted box).

In this grid, the single column is too narrow to hold body text, which is sized larger than caption text. A wider column is necessary because fewer than seven words in a line of text will result in excessive hyphenation. In the example shown, a combined span of two or more columns allows the text to span a width that is more readable.

If a column block is too wide, however, readers will lose their place when moving from line to line, especially if the leading between each line is tight. Nevertheless, drawing readers into a piece is as much an issue of aesthetics as legibility. Aesthetics do have a purpose in design. If, for whatever reason, a wide column makes sense, then you need to strike a balance between legibility and aesthetics. For example, you might be able to improve readability over a wide column by adjusting leading or paragraph indentation. The goal is balance and harmony.

For an architecture book, the design studio Worksight used a wide text column to solve a unique problem (Figures 8.19 and 8.20). The editor's introduction and the start of the chapter text begin on the same page. It could have been confusing, but a single, shifting text column solved the problem. A gray tinted area set behind the introduction distinguishes it from the main body of the text. Both use a wide column, and any possible loss in legibility is more than made up for in the unifying simplicity of each page.

8.19 WORKSIGHT. Two-page spread (layout for *Modern Architecture and Other Essays.*

8.20 WORKSIGHT. Two-page spread from printed book *Modern Architecture and Other Essays.*

8.21 JANET ODGIS AND BANU BERKER. ODGIS + COMPANY. Grid structure and layouts for the magazine *View*.

Smart use of a grid can help create beautiful compositions, especially those that are complex. For the magazine *View*, Janet Odgis and Banu Berker created a simple three-column grid, coupled with horizontal flow lines (Figure 8.21). It sets up a system that works quite well in handling the most complex information. There can be up to three text columns across each page. But in addition, a center grid line splits the middle column, actually making six modules. This extra module is useful when the article includes charts and lists that might occupy space outside of standard text and images.

An even closer inspection reveals how the article openers bleed to the outermost edge of the grid, with the remainder of pages within the story aligning to the inner grid margin. These subtleties cue the reader to priorities in the text by adding a hierarchy to the information (only the

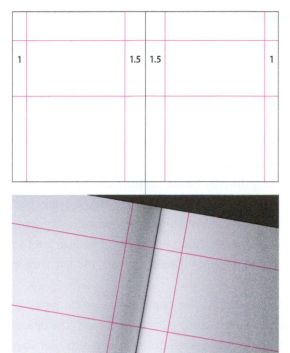

| 1 | | 1.5 | 1.5 | | 1 |

8.22 The inside gutter of a multi-page printed document is designed to be wide enough to compensate for the curl that occurs in between spreads.

8.23 RANDALL HOYT AND MARK ZUROLO. Website design for *Yale Alumni Magazine.*

start of an article bleeds to the outer coordinate) and by accentuating a layout whose sophistication makes the information itself more convincing.

The physical binding of the pages can also affect a grid's design and viewable area of a page. For example, a stitched (stapled) binding opens flatter than one that is perfect bound (with a flat, glued edge) or bound with side grommets. Similarly, a sewn binding (used for some books) lays flatter than a glued binding, which tends to close. The grid can compensate by giving extra space as necessary to the inside gutter (Figure 8.22).

Website Column Grids

Legibility of type on a screen is an important issue with websites. If type is too small, **anti-aliasing** processes (which minimize jagged distortion in curved and diagonal lines) can make type appear to blend together. If type is too large, it uses up valuable screen space. Also, not all fonts created for print will translate into digital fonts. In such cases, the software will substitute a different font, and your layout may not look at all like what you had intended. So for online text, be sure either to choose a digital font or to save your text as a PDF and embed it on the web page.

Designing a column grid to compensate for minimum and maximum type sizes is essential because there are only so many words you can fit across the web page. Height issues on the web page are less of a problem than on a physical piece of paper. A page or column can scroll down as long as necessary. Most publications, however, set a limit on the length of a scroll, and when that limit is reached, they create a new page to continue the content (as the *New York Times* does).

The grid for the navigation menu of a site is somewhat different. The navigational tools are an essential part of the grid structure. Menus generally need to include keywords such as Home, About, and Contact, but most websites need a more complex navigation bar. The site designer must accommodate this need, making the navigation bar fixed on the page, but modifiable in its content. However, anchoring the navigation bar at the top or either side of the page will have a significant impact on the rest of the site design. Another challenge is to create a design that will function well across all monitors because, depending on monitor size, embedded images and other elements may not sit exactly where you placed them. Similarly, some browsers may distort your designs more than others. It is always wise to check your designs inside every web browser option and every screen size before you consider them finished.

The website for the *Yale Alumni Magazine* by Randall Hoyt is an example of a tight structural grid that offers complete flexibility (Figure 8.23). Its front-page grid is designed to offer immediate accessibility to navigation and content throughout the site. It is readable and contains the most important features at the top of the scroll, viewable on an average-sized monitor.

Freestyle Alignments

Modules and grids rely on alignments, but the use of alignments alone also can lead to the creation of organized and expressive designs. Designers can take advantage of a more freestyle approach by using alignments without the formal structure of a grid or predetermined modules. For example, information in the business card and website for a real estate developer, Orange Management, is not held to any overriding grid system (Figure 8.24). Instead, the business card's alignments are primarily based on how the logotype positions itself. The distance to the left of the logo is segmented by a notch, creating an alignment for the person's name and e-mail address. The remaining information is flush left to a second notch, comfortably distanced from the left trim of the card.

In similar fashion, the company's website bases its coordinates on a clearly distinguished logotype. The images that sit to the right of the text scroll left, as if a drawer were pulled open, literally covering over the text information to display the images of the property the company manages.

For a proposed brochure design documenting the New York Public Library's picture collection, Max Pitegoff began with a simple idea: explain the library's picture service by using historic imagery of the library itself (Figure 8.25). The freestyle layout runs single words along horizontal rules that simulate file cabinet pockets, suggesting the same file cabinets the library uses to classify and contain images within the collection. The information is treated precisely in describing the subject. In this sense, the text's fragmentation becomes as much a part of the content of the piece as the text itself.

8.24 WESTON BINGHAM, WARREN CORBITT, ALLEN HORI, OBJECT. Business card and website design where the freestyle alignment of information becomes part of the visual identity of the company.

CHAPTER 8: PROPORTION SYSTEMS: GRIDS AND ALIGNMENTS

8.25 MAX PITEGOFF. A self-initiated project researching and documenting the NYC Public Library's picture collection service.

8.26 STEPHEN CASSIDY. Proposed wall design for an exhibit titled *Free to Dry.*

Freestyle alignments and typography are used figuratively as a wall-sized graphic by Stephen Cassidy to introduce an art exhibit. Titled *Free to Dry,* the theme challenges the issue of clotheslines being increasingly prohibited in residential communities (Figure 8.26). The perspective is that of looking up at multiple clotheslines, with typography that seems to hang. Text clusters and flaps as if blowing in the wind, and fonts, leading, tint, and alignments shift and break through one another's territory. All provide meaning ingeniously and without actual images of clothespins or fabric.

🌐 **SPEAKOUT: On Constraints** by Khoi Vinh, subtraction.com

The central challenge of any design problem is defining the constraints—the rules, frameworks, limitations, and so on that are so often the spark that ignites an ingenious solution. A grid system is more than just a set of rules to follow, but also a set of rules to play off of, and even to break. Given the right grid—the right system of constraints—very good designers can create something that is both orderly and unexpected. When this happens, a grid is more than just a style tool, but also a tool for advanced creativity.

8.27 WESTON BINGHAM. Three spreads from issue 6 of the SCI-Arc publication *Offramp*, a student journal of architecture.

8.28 ALLEN HORI. Poster for the Princeton University School of Architecture.

View a Closer Look for the Princeton poster on **myartslab.com**

Exploiting the Grid

Designers can challenge the conventions of the grid in two ways: analytically, where mechanically ordered information is pushed to its visual limit, and metaphorically, where an emotional connection is made with the viewer. Both approaches can exploit what we normally think of as a grid construction.

In the page spreads for the essay *Out of Order*, Weston Bingham created a grid and series of alignments that are loosely organized to present and express the subject (Figure 8.27). The essay, which is about interlocking plots of land within the grid of Los Angeles, is illustrated with pictures of a church located in a grocery store parking lot. Text boundaries morph into shapes, and columns intrude on territories, so the orderly flow of information is interrupted. The unusual shapes of the text body keep the reader engaged and intrigued as the images, text, colors, and structure together tell the story.

The idea for a poster announcing the spring lecture series for Princeton's architecture department begins with the metaphor of a flower (Figure 8.28). Allen Hori used a tulip's natural shape and bright color to contrast with the warm grey type that lists the events in a stair-step logical sequence. Still, the system is exploited by the infusion of an additional element—colorful purple shapes that seem to embed themselves into the type, raining down on it like a springtime thunderstorm. In fact, the angles, at 30 and 60 degrees, are the single-axis style used by architects to create multisided perspective drawings, called axonometric projections. The geometry brings the purple thunderstorm back to the subject of architecture.

For these two projects, the essay page spreads and the poster, the designers have pushed the skeletal structure of each informational system while adding expressive power specific to the information being conveyed. Such thinking applies to all sorts of design projects. For example, the logotype for Saks Fifth Avenue by Pentagram used the overlay of a grid to reveal beautiful juxtapositions of the familiar Saks Fifth Avenue script (Figure 8.29). The language of graphic design itself advances when new associations are made, in this case between grids and logos.

8.29 MICHAEL BIERUT/PENTAGRAM.
Saks logo redesign subdividing
the square into a 64 component
grid system.

8.30 LEONARDO DA VINCI.
Vitruvian Man. c. 1490.

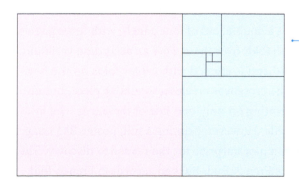

8.31 The golden rectangle
is constructed by creating an
arc from a square.

The Golden Ratio

Ancient architecture such as the Egyptian pyramids and the Greek Parthenon used what is considered a divine proportion, the **golden ratio** of geometry, to create a harmonious relationship within buildings. In this ratio, if you lay line *a* next to line *b* and then lay a line equal to *a* plus *b* next to *a*, the two pairs of lines would have the same proportion. This ratio is expressed as an irrational number (1.6180339887) and is also known as the golden section or golden mean. The mathematical relationship is found in many aspects of nature, including the human body, as demonstrated in *Vitruvian Man* by Leonardo da Vinci (1451–1519) (Figure 8.30).

Similarly, if a rectangle has a ratio of length to width that is the golden ratio, it is called a **golden rectangle**. To create a golden rectangle, begin with a perfect square and draw a line from the midpoint of one side of the square to an opposite corner. Then use that diagonal line as the radius to create an arc that defines the long dimension of the rectangle (Figure 8.31). Once created, each square added to its longest dimension produces another golden rectangle (Figure 8.32).

This unique mathematic ratio has had a significant presence in architecture, in the scale and chords of classical music, in painting and sculpture, and in the book arts, where the system was used to create harmonious page layouts beginning in the Renaissance and continuing through today. Figure 8.33 shows this relationship in a medical book printed in 1545. The 500-year-old page can still inspire a contemporary layout because the elements that make it so beautiful haven't changed. For example, designing a functional margin—on the bottom for ease in reading and on the right for turning pages—also creates compositional tension on the page.

8.32 The square (magenta),
when added to an existing
golden rectangle (cyan),
produces another golden
rectangle.

8.33 C. ESTIENNE & RIVERIUS.
*De Dissectione Corporis
Hunani. S.* de Colines. 1545.

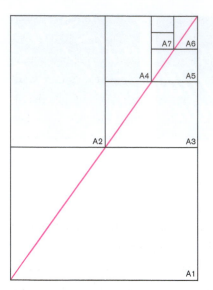

8.34 International standard paper system (ISO 216) charting the A Series of sizes.

8.35 Two A4 pages put together create an A3 size.

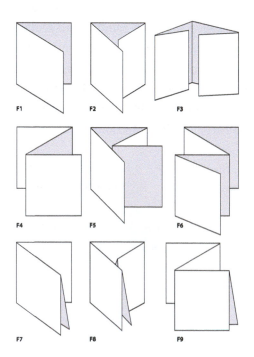

8.36 Typical and atypical paper folds for commercial printing and binding.

Paper Formats

The common-sized letterhead paper used in the United States is 8.5" × 11" (216 mm × 279 mm). One explanation for the 11" length is that the paper maker could pull four uncut sheets from the vat—a full arm's length. A common alternate size in the United States is ledger paper, 8.5" × 14". In Europe, and in most countries outside of the United States, a standardized paper format was developed to save on cost and resources by creating a coherent system of metric measurements for the printing industry (Figure 8.34). The letterhead size, called an A4, 8.3" × 11.7" (210 mm × 297 mm), is narrower and longer than letterhead in the United States (210 mm × 297 mm). A4 is part of the A Series of paper sizes, as you can see in the diagram. There is also a B Series of alternate sizes, and a C Series for envelopes.

The paper was designed so two pages placed side by side result in the next larger size in the system, referred to as the **silver ratio** (Figure 8.35). The smaller side to the longer side equals the ratio of half the longer side to the smaller side, and the height-to-width ratio is the square root of 2. Starting with the largest size of A0, every time the paper number gets smaller, the paper size is halved.

Paper-Fold Formats

The paper folds shown in Figure 8.36 are all possible within a commercial printing paper's maximum size, generally either 25" × 38" or 28" × 40" (U.S.-based) for text and cover weights. Some folds are typical, some atypical, and choosing a format depends on how you want the information to literally unfold.

As marked, F1 is a simple four-page fold. Its proportion can grow in width or height to compensate for letter-sized pages of information, or shrink to hold the information of a small invitation. F2 is called a **gate fold,** which acts as a cover that, when opened, reveals a second panel underneath. When completely opened, it presents a full, three-panel spread. The only hidden panel is the back. F3 is a variation, a double-gate fold. Once opened, a double-gate reveals two inside panels. Unfolded once more, it creates a full, four-panel spread. F4 is an accordion fold, which has a **zigzag** appearance. Accordion folds can contain as many panels as a given commercial sheet allows. The only concern is that when unfolded, half the panels are in the back. F5 is a double fold of four panels, with three panels in accordion, and the fourth folds over them. F6 is an accordion variation. F7 is called the **French fold** and is created with center folds on the horizontal and vertical axis. The crossover creates a weightier piece, but also allows the possibility of printing on only one side of the paper. The fold-over hides the unprinted side. However, printing a full, poster-like image on the hidden side creates a nice surprise for the reader to discover. The same is true for F8 as a gate French fold. F9 is an accordion French fold.

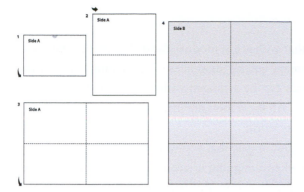

8.37 Format for a possible mailer that doubles as a full poster (on the back side).

8.38 A grid showing how the rule of thirds can help frame an image.

Creating the dual function of folded pages and full poster is also possible in a more complicated series of cross folds (Figure 8.37). In this case, a mailed piece with a wafer seal first attracts the recipient's attention. The mailer unfolds vertically into a two-panel spread with its overall message taking form. Unfolded again, the piece reveals four panels; all panels up to this point are on one side of the form. Unfolding one last time reveals the inside, unseen, set of panels, which could present a full poster covering eight panels.

The Rule of Thirds

Chapter 6 briefly discussed the useful cropping tool that can bring tension or contrast to the framed image. This cropping approach is most effectively carried out through a system known as the **rule of thirds,** dividing an image into nine equal parts using two horizontal and vertical lines, with important elements placed along the lines or their intersections. The idea is to avoid centering an image within a frame. The overlapping lines create points of interest. In the sample shown here, the child's face is in the top-left intersect rather than in the static center (Figure 8.38). If the face were centered, the rest of the photograph wouldn't be visually activated. The off-center quality creates tension and energy.

If we used an ocean image, then the horizon line might sit out of center, with more sky above or below that center. A seagull would offer another layer of contrast in the picture. Rather than show it floating in the center, the bird might be placed in one of the overlapping areas of the grid to activate the entire composition. The rule of thirds should become an automatic guide for you when photographing and cropping images. With it, you can add energy and interest through asymmetry and contrast in your composition. With experience, you will come to understand all its advantages and possibilities, and you will also learn that you can break the rules and do something completely unexpected.

In the opening spread for the magazine *Pastoral,* Glenn Suokko used the rule of thirds to find an alignment structure for a comfortable balance of text, image, and white space (Figure 8.39). Through the horizontal placement, he has evoked a landscape image, as the publication's title suggests. The typographic line is also seen as a field's horizon for the foreground of idyllic images, set in place like a row of houses.

8.39 GLENN SUOKKO. Opening spread of pages from the magazine *Pastoral.*

In Perspective

Once you become familiar with grids, modules, and alignments, the mystery of proportion systems quickly dissipates. Even compositions that contain only a few words can be arranged within a structure that gives them logic and intention. All these tools are inspired by what you see and experience in the everyday world.

The building, window, or gate that you walk by are all made of patterns that you can use when designing a layout. Try to find a rationale or connection between the structure and your subject. For example, a repeating modular pattern from a building façade might inspire an idea for organizing a series of photographs on a web page. The concrete wall with a small window could inspire a design that has one solid block of text in the center of a page with wide surrounding margins. Once you get used to it, you will begin to see grids and modules everywhere, and their inspiration for your work will be limitless.

Typographic columns are the most obvious examples of the grid because type and grids work so well together. For a small block of type, the grid gives the designer something to push against—rules that the designer can establish and then break. For large quantities of type, the same playful freedom can add interest and create visual and conceptual connections between pages.

Finally, this chapter explores a grid as something that can be exploited. Don't let the grid confine you or set limits on your creativity. See it as a foundation for you to take advantage of and to challenge. In this spirit, being influenced by something peculiar or personally idiosyncratic can be as valid as any divine proportions used through the ages. The magical golden ratio is a valuable way to structure information, but it is certainly not the only way. Use it if it works well for your concept, but feel free to overcome the mathematics and try something completely different. What works *best* should be determined by your viewer's intellectual and emotional reactions. It is quite valuable to learn the traditional means of creating proportions, but equally valuable to then question and exploit them. Your overriding concept will drive you to think creatively and to discover new directions for your work.

EXERCISES AND PROJECTS

Review additional Exercises and Projects on myartslab.com

Exercise 1 (Grids in the Everyday World): Find examples of existing grids, including objects, buildings, spaces, nature, geometries, and patterns. Record them (using digital scans or photos), and then notate each system found in the image by simplifying it into line and shape. Position each on the left page of two 11" × 17" sheets. Repeat the image on the right sheet, but reduce the density to 30 percent. Over the ghosted image, draw eight vertical or horizontal 1 pt rules in solid cyan to break the image into a series of lines and shapes.

Exercise 1 SCHUYLER HIGGINS. Personal photograph with notational grid overlay.

Exercise 2 (Grid Systems in Graphic Design): Repeat the instructions from Exercise 1, but instead of finding objects or buildings, find a single, complex page design that uses both text and one or more images. Mark the predominant grid system or modular structure, as well as patterns or alignments in the design.

Project 1 (Compositional Construction): Create an 8" × 8" page with a 1-pica perimeter margin. Use guidelines within the margin to create 25 modules, each with a 1 pica gutter space. Enter the words "Graphic Design 1, Steuben Hall, Room 418, Course Number x36.9011.1101." Use the grid as your guide to construct five compositions, one for each of the following specifications (export with guides both on and off):

1) Typeset the text in 20 pt Helvetica Regular, using black type. Dynamically arrange the words using only direction and position, aligning with the grid. Include hierarchy in your decisions.

2) Now use type scale in a new design. You may bleed the letters, change their scale, and edit the text.

3) In addition to all the previous elements, in this composition, make font changes (light, regular, bold, black), as well as lines or rules, tints, and reversals of type.

4) Add semantic interpretation of the subject to the specs already in this composition. Consider effects, line-art graphics, and geometric shapes.

5) Use all the previous elements, but also include an additional color and a monotone photograph. The image should have something to do with the subject.

● **Things to Consider:** *Think of the page as a room and the elements within it as furniture. Your arrangement can tell a story using surprise, energy, emphasis, unity, depth, and motion to lead the eye through the space and create poetry on the page.*

Project 2 (Text Columns): Find an online article of at least 300 words, one headline, two subheadlines, and one color image. Create a vertical 8.5" × 11" page with a 3-pica perimeter margin. Set five text columns (flush left, rag right) inside the margin and pull horizontal guides to establish the location of text and images.

Choose the typeface (based on the material you find), fonts, type size, leading, and hierarchy to move the eye through the layout. Include additional elements (rules, arrows, bullets, etc.) to add interest to the page, but keep it clean and uncluttered. Reference Chapter 1 and the Bibliography to find past studies for reference and inspiration. Your objective is to prove visually how the composition can be improved by starting with a grid structure.

Alternative: Take the same text and redesign it for an online publication.

Project 1 MAY PARSEY (LEFT) AND RACHEL SALIERNO (RIGHT). Steps in the compositional construction project.

● **Things to Consider:** *Play with scale, contrast, and emphasis to create tension and energy.*

9

Concepts in Action

→ CHAPTER OBJECTIVES

AFTER READING THIS CHAPTER, YOU SHOULD BE ABLE TO:

- Identify and explain the major concepts presented in the essays.
- Discuss how the major concepts presented in this text were used in the case studies.
- Compare the processes among the designers and describe how they vary.
- **Exercises and Projects**

Research the work of a contemporary graphic designer; develop a concept for a graphic design around a public service announcement; invent a project and package it; create a visual identity for a place.

The bicycle mechanics Orville and Wilbur Wright wanted to solve a most innovative problem: they wanted to build and fly the world's first self-propelled airplane. They brought what they knew to the equation, using bicycle chains to drive the propeller and the idea of balance for controlling the plane. They tested more than 200 designs in a wind tunnel and, most important, they built their own prototype.

One big piece of advice that I have for a young designer is to go out on a limb...and to be prepared to do the things that you feel strongly about that maybe other people don't.
—Hillman Curtis

Watch the Video on **myartslab.com**

Opposite page: COMA AMSTERDAM/ NEW YORK. Back cover (detail) from the Vitra catalog *Workspirit 10: Nest 'n' Nest* (full image, see Figure 9.14).

In this hands-on process, each idea they developed sparked the next idea. The final result of all their experimentation was flight.

Whether designing a plane or a logo, you need to start with an idea. The Wright brothers were mechanics, but their innovative thinking turned them into engineers. Every designer presented in this chapter is a graphic designer and, in a sense, an engineer. They all resolved their client's design problems, but they did it by transforming their ideas to a physical state.

When learning how to confront design problems, look to these designers to understand how they approached theirs. In each of these essays, you will find they have a focused, yet flexible spirit; are committed to testing and refining their work along the way; make an effort to access historical facts and explore the location or situation; and bring their own personal experience to every problem. They push a little harder and make their designs go further—enough to fly. In every sense, they have used action to make their concepts a reality.

Michael Bierut is a partner in the New York office of Pentagram, an international design consultancy. He is a recipient of the AIGA Medal and a Senior Critic at the Yale School of Art. His most recent book is Seventy-Nine Short Essays on Design *(Princeton Architectural Press, 2007).*

The advantage of the program, deployed in black and white, is that it creates recognizable consistency without sameness.

Does any project stand out for you in terms of developing a design concept?

A good example is a project my team did for Saks Fifth Avenue. They approached us about designing a new identity for their stores, seeking a graphic program that would encompass signage, advertising, direct mail, online presence, and, most importantly, packaging. (See the previous discussion of this project in Chapter 8).

We understood quickly that this was more than a logo design project. The current Saks logo had been in use since the mid 1990s, but had done little to create a profile for the brand, particularly as part of a gray-on-gray packaging program that was recessive, to say the least. Saks wanted something that could be immediately identifiable when glimpsed across a busy street. The store had used literally dozens of logos since its founding, but no signature color or pattern, just variations on the same theme: cursive writing, sometimes casual, sometimes Spencerian (Vignette 9.1).

Of these, one stood out—the logo drawn in 1973 by Tom Carnese, adapted from a signature introduced almost twenty years before. In many people's minds, this still was the Saks logo. But simply reinstating a thirty-year-old logo wouldn't be enough—Saks wanted to signal that it was looking to the future.

What was the working process?

In our early creative sessions at Saks, we'd gathered a lot of visual inspiration. The team kept coming back to the boldness of artists like Franz Kline and Barnett Newman. Was there a way to get that kind of dramatic scale and energy into the program?

We were excited when we finally hit on the solution. We took the cursive logo, redrew it with the help of font designer Joe Finocchiaro, and placed it in a black square (Vignette 9.2). Then we subdivided that square into a grid of sixty-four smaller squares (Vignette 9.3).

The sixty-four tiles can then be shuffled and rotated to form an almost infinite number of variations (Vignette 9.4). Most of the individual logo tiles are quite lovely in their own right, and within the system can be used in various combinations to form still more abstract compositions. Each of these suggests, within its details, the graphic character of the new logo. Enlarged, they have a kind of energy and drama that contrasts nicely with the original mark from which they were derived.

Was the application difficult, especially when having only one color to use?

The advantage of the program, deployed in black and white, is that it creates recognizable consistency without sameness. The logo

Vignette 9.2 Saks Fifth Avenue logo redesign by Pentagram.

Vignette 9.3 Logo subdivided into a sixty-four-square grid system.

Vignette 9.4 Variations on the grid system.

elements will be used in signage, direct mail, and advertising. There are more than forty different packages in the program, from jewelry boxes to hat boxes, and four sizes of shopping bags, and no two of these will be alike, yet will all go together (Vignette 9.5). Our hope is that they will all become associated in the minds of shoppers with the style and élan of Saks Fifth Avenue.

Vignette 9.1 Historic cursive logotype identities.

1940	*Saks Fifth Avenue*
1946	*Saks Fifth Avenue*
1955	*Saks·Fifth Avenue*
1955	*Saks Fifth Avenue*
1973	*Saks Fifth Avenue*
1997 (Previous logo in use.)	**SAKS FIFTH AVENUE**

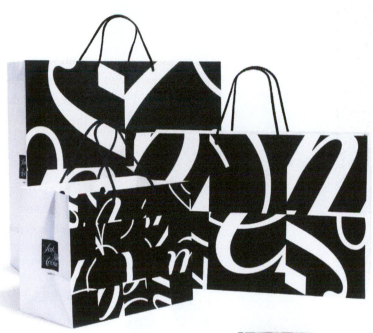

Vignette 9.5 Application of the logo reconfiguration to shopping bags (above) and specialty boxes (below).

DESIGNER VIGNETTE: MICHAEL BIERUT

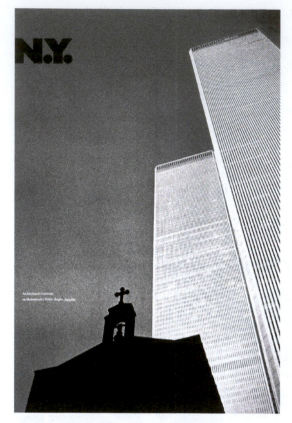

CONCEPTS INSPIRED BY A SUBJECT'S LOCATION

Poster for Monadnock Paper by George Tscherny, George Tscherny, Inc.

Rarely do I recall the Eureka moment when the birth of an idea appeared full blown. It is more likely that I would recall the process or steps taken to arrive at a final design solution.

A case in point: when photographing New York architecture for a paper promotion, I shot, among other sites, the World Trade Center in downtown New York. After circling the towers, and exhausting the usual (cliché) views, I made a wider circle coming upon the little church located a block south of the towers—a study in architectural contrasts. It is interesting how, by means of composition, cropping, light and shadow, a small and architecturally insignificant building can visually dominate a vastly larger structure. This led to the notion of isolating the church by folding the poster so that the first impression is that of an adobe church in New Mexico. When the poster is unfolded, the viewer gets the full impact of this incongruous and surreal scene in Manhattan (Figure 9.1).

Needless to say, neither building survived the events of 9/11.

▶ *In Practice: The graphic design created an archive of a site that once was. Here, the designer charted his approach in photographing the towers and found the church along the way. The idea of using compositional principles and elements such as dominance and shape, along with a folding technique, resulted in a design concept that endures.*

9.1 GEORGE TSCHERNY (DESIGN AND PHOTOGRAPHY). N.Y.; Poster; 1975; unfolded (top) and folded (bottom), for Monadnock Paper Inc., with a view showing the context of the church within the setting.

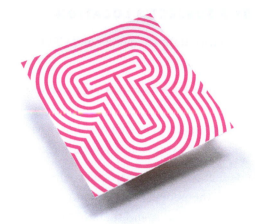

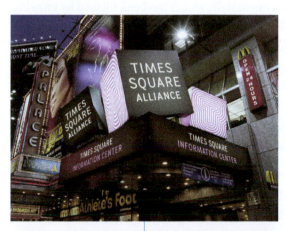

9.2 ALAN DYE, OGILVY BRAND INTEGRATION GROUP. Visual identity for the Times Square Alliance NYC (above), and applied to business card and signage for the organization (below).

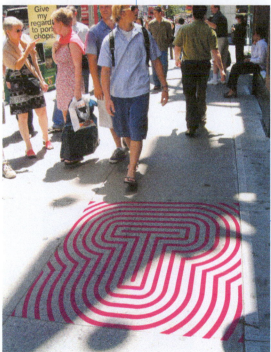

Times Square Alliance Identity by Alan Dye

In the spring of 2002, the Brand Integration Group at Ogilvy was asked to design a logo for the Times Square Alliance. Like any other project, we began by doing our research. We looked into the history of Times Square, walked its streets, explored its subway stations, smelled its smells, ate its food, fought its crowds, and tried our best to soak it all in. It wasn't an easy task—Times Square is a dizzying blur of energy. Our initial ideas focused on trying to break through the visual clutter of the frenetic place. We tried simple bold marks, a signature color, and a number of logos that were based on an "x" (since the streets that make up the square create an x … and triple x's have a history in Times Square as well—we couldn't help ourselves). All of our efforts fell short.

In the end, rather than trying to fight it, we embraced the chaos. The final mark hopes to capture the energy of the area, referencing its flashing neon lights and bright color. I have always been a fan of Victor Vasarely (I wrote a report on him in eighth grade), so I was eager to reference op-art. This was a rare opportunity to create a mark where I could push the boundaries of legibility. The repeating lines and vivid magenta color evoke the feeling of what it is like to be in the midst of the Square. Also, we drew a signature typeface for Times Square based on vernacular New York typography, most specifically, elevator typography. In the end, we were quite pleased with the results, as the mark captured the spirit of Times Square perfectly: bright, bold, colorful, and full of energy (Figure 9.2).

▶ *In Practice: Going to the location for onsite research helped this concept immeasurably. The sights and sounds may trigger a connection to other creative works that can be used for further inspiration.. In this case, Victor Vasarely and the op-art movement inspired the designer to broaden the range of possible forms the logo could take.*

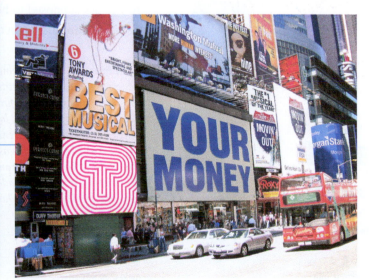

9.3 Store interior of Bond No. 9.

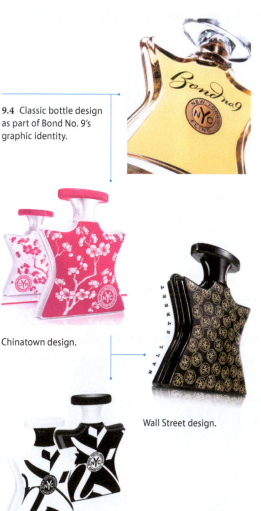

9.4 Classic bottle design as part of Bond No. 9's graphic identity.

Chinatown design.

Wall Street design.

Saks Fifth Avenue design using their new, fragmented logo.

CONCEPTS INSPIRED BY A SUBJECT'S LOCATION

Bond No. 9 New York by Laurice Rahmé, founder and CEO of Bond No. 9

In Paris, where I was born, perfumers have been making neighborhood scents for centuries—but no one had done it here. I decided Bond No. 9 would be the perfect combination of the art of French perfumery with the dynamics of New York City. After all, everyone wants a piece of New York!

The idea was to develop scents that convey the particular vibrancy and sensibility of each neighborhood, the people who live and spend time there, and the people who want to live and spend time there. There had to be a quintessential New York element to every aspect of the Bond No. 9 "package." I adopted (and trademarked) the NYC subway token, which has been modified as our logo. It's on every bottle and every box, and it even covers the "Bond mobile," our vintage English taxicab.

For the stores, I relied on my own style, which has been formed by growing up in Europe, living in the Middle East, and then here in New York (Figure 9.3). It's an eclectic mix of color and design—and there is nothing more "New York" than a fusion of globally oriented elements! I approach the music I play in the stores with the same global-New York point of view (with a downtown edge). Everything—from the music to the welcoming attitude of the sales staff—is a critical part of Bond No. 9 packaging. I created places where people want to spend time (the "in-and-out" customers are few).

Because every single client is different, I have to incorporate elements that are essentially human. My bottle design shadows the human form—you can see the head, shoulders, waist, and legs. With every new fragrance, I'm also dressing it up in a complete ensemble, from the bottle design to the box design (Figure 9.4). And my clients create fragrance wardrobes. I've never been afraid to take the designs and the colors to the next level. People respond to vibrancy, and I respond to vibrancy; and this is perfume—it's supposed to be fun! What maintains the element of luxury is never compromising on quality.

▶ *In Practice: The packaging of an entire store—from bottles to the shop's interior design to music and the attitude of the sales staff—reaches beyond the scope of most design projects. This project was all encompassing. New York City neighborhoods, and even the brand logos of other stores (Saks Fifth Avenue, see Figure 9.4), are brought in as subjects. And yet, the Bond No. 9 brand is maintained, thanks to an adaptable logo and bottle shape that hold their own definable identity.*

Candle packaging using Bond No. 9's logo as the main graphic device.

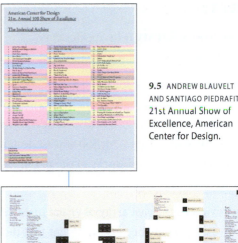

9.5 ANDREW BLAUVELT AND SANTIAGO PIEDRAFITA. **21st Annual Show of Excellence, American Center for Design.**

▶ *In Practice: Bringing an analytic framework to this project was perfectly matched with the function of presenting competition winners. It asked the viewers to look at every design from a different angle. The idea drove the form of the catalog, but still let the individual works shine on their own merits.*

ANALYTIC-BASED CONCEPTS

Creating a Framework by Andrew Blauvelt, design director and curator, Walker Art Center, Minneapolis, Minnesota

In 1967, the artist Sol LeWitt wrote: "The idea becomes the machine that makes the art." LeWitt was describing his own artistic process while also defining a new, more conceptually oriented realm of art making that gained prominence in the 1960s and 1970s. What began as a simple statement about one artist's procedural approach to art became a broader indictment about the art world's preoccupation with authorship and formalism.

Nearly thirty years later, and in another context, I embraced LeWitt's statement and the purpose behind it. I was interested in the search for ideas more than a search for new forms, just as I was eager to take the notion of what constituted the radical in design and shift it away from formalism and into conceptualism. Just as LeWitt rejected "the arbitrary, the capricious, and subjective," I too sought to sublimate graphic design's dependence on formalism, expressionism, and subjectivity, and embrace an approach that emphasized design's intrinsic love of constraints.

In many projects, but not all of them, I try to create a framework for "things to happen"—a set of rules or constraints, a sequential procedure—a "machine that makes the design," to paraphrase LeWitt. This generative approach to designing should not be confused with attempts to eliminate the designer from the equation—for instance, through automated computing, although the computer can be a helpful tool in the creation of such systems.

The emphasis on the conceptual should not be confused with a refusal of form, since any design must have form to exist. An early project that adopted this approach came in the form of a commission to design a book documenting an annual design competition for the now-defunct American Center for Design (Figure 9.5). The genre of this kind of publication had become ossified into a predictable image-caption, picture-book presentation. Instead of simply following this formula and submitting the usual essay about what trends and styles could be discerned in the winning year's work, we instead created a series of twenty-six appendices that would analyze the work in different ways. One analysis, taking the form of a map, located the geographic dispersal of the winning designers. Another charted the size of each winning piece, from the smallest (a business card) to the largest (a billboard). Others classified each winning work by genre: posters, books, logos, and so on. Still others grouped the work by the juror(s) who selected it. Each analysis examined the same content, illuminating a different part of the whole. The concept was to reframe how designers look at works in a design competition using all of the available and objective information to point out what is, in the end, an essentially subjective exercise in an individual juror's taste.

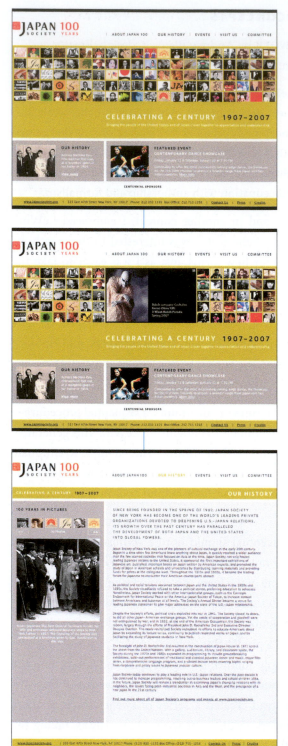

9.6 Web pages of the Japan Society 100 years website.

ANALYTIC-BASED CONCEPTS

Japan Society 100 Years Website Design by Agnieszka Gasparska, founder, Kiss Me I'm Polish, LLC

The year 2007 marked the centennial anniversary for the Japan Society in New York, an organization founded to foster and strengthen the cultural exchange between the United States and Japan. One of the largest of its kind, the institution has a rich and diverse history. Our job was to design a website that would allow for the many voices and works of the organization to shine.

The design process began with a review of the vast array of visual material compiled from the society's archives. It quickly became apparent that one image, no matter how powerful, could not fully convey the life of such a vibrant institution. We therefore limited our selection to 100 of the greatest hits, presenting them in what we referred to as a "democratic grid." The order rearranges itself every time a user comes to that page. What's nice is that, when combined, all of these little images read as one whole picture, bringing a distinctive character to the site.

It would have been easy to get carried away with clichéd visual elements in the site's graphics. Instead, we took a path that tried to evoke the Japanese sensibility of simplicity. All of the pages are built on the same clean layout of stacked panels and soft grays, so as not to overpower the imagery and information. Even the color red was used only as a hint, especially since the organization wanted to distance itself from layers of political and monarchial connotations of old Japan. The result was sparingly elegant, yet fresh and informative (Figure 9.6).

▶ *In Practice: Abstracting the traditional sensibilities of Japanese culture was a good approach to take for the design of this site. Simplicity of color, layout, and type eliminated the usual cultural clichés and resulted in a site that has a fresh, contemporary look, but still embraces the aesthetics of Japanese culture.*

9.7 Brown University's Sciences Library building in Providence, Rhode Island.

9.8 Original library signs from 1971.

9.9 Retro-futuristic directional signage to coordinate with the remaining signs from 1971.

9.10 Cataloged text and images silkscreened onto walls in unexpected areas throughout the library.

Brown University Friedman Study Center Signage System by Scott Stowell, Open™

The Sciences Library at Brown University, built in 1971, is the kind of building you see at many colleges: big, bold, and modern, but not warm or comfortable, and not well loved by many people on campus (Figure 9.7). In 2006, Brown decided to convert the first three levels of the building into the Susan P. and Richard A. Friedman Study Center. The center, which is open 24 hours a day, offers a variety of spaces where students can work, gather, and collaborate. Architecture Research Office designed the center and we at Open were asked to design its signage. After seeing that many of the original signs from 1971 (Figure 9.8) were still there (and looked great), we used similar forms and typography to create retro-futuristic directional signage, incorporating new materials that conform to current accessibility guidelines (Figure 9.9).

But while working on the project, we discovered something surprising. We were thinking about a nickname for the center that could be used as a logo or identity system and suggested "Brown Study." As it turns out, the phrase "brown study" is in the dictionary—it means a kind of absent-mindedness that comes from being lost in thought. Inspired by this, we found words and images from books within the Brown library system and had them silkscreened directly onto the walls of the center. We also included their card catalog numbers so that students could look them up (Figure 9.10). Some are serious and some are funny, and the more time you spend there, the more of them you discover. And we were happy because through our design, we were able both to help people find their way around the center and to make the time they spend there a little more unexpected and exciting.

▶ *In Practice: The design idea for the study center at Brown University went beyond the directional signage system that was originally commissioned. The addition of silkscreened words and images on otherwise bare walls created a playful connection to the library's books and celebrated the whole notion of studying and learning.*

USING RESEARCH AS A CONCEPTUAL APPROACH

Throwing Apples at the Sun by Elliot Peter Earls, artist in residence, 2-D Design, Cranbrook Academy of Art

On its most basic level *Throwing Apples at the Sun* was conceived as an exploration to understand narrative. Through it, I was also attempting to deal with wide-ranging issues, including greed, race, and sex. There wasn't any traditional process that I went through in creating the work—no linear, step-by-step storytelling. Instead, I wanted the viewer to interact with thirty minutes of music and spoken word tracks, an interactive multimedia composition, and four printed posters (Figures 9.11 and 9.12). All of the elements were orchestrated: bass beats and pop song fragments co-mingled with original typography, drawings, spoken-word poetry, and robotic musical instruments. The concept was to reveal the human condition through this rumination, but in a blended and interactive way.

▶ *In Practice: Through personal search, the designer can become his own source material, exploring universal questions. This personal approach to public issues helps graphic design break into areas such as painting and sculpture that are traditionally explored by the fine arts. The typefaces created by Elliot Peter Earls are artworks unto themselves. They border on being illegible, yet the nonlinear sequence somehow maintains a translatable narrative. This piece challenges the established notions of design's role in the world and challenges the viewer to understand design in a whole new way.*

9.11 Logo and video stills for *Throwing Apples at the Sun* interactive video. 1995.

🔍—[**View** a Closer Look for the Earls poster on **myartslab.com**]

9.12 Poster as part of a set packaged with the CD.

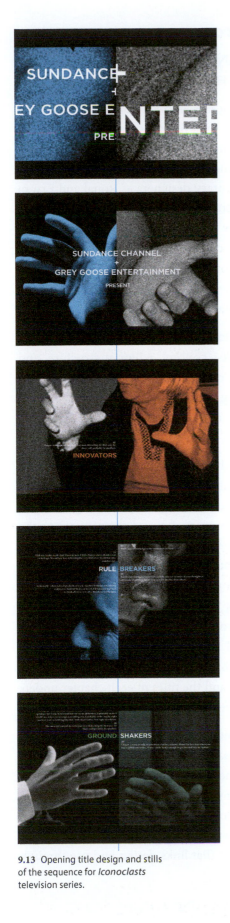

Iconoclasts Title Design by Greg Hahn, Gretel

Iconoclasts was a television series for the Sundance Channel produced by @Radical Media. The show had a simple premise: put two great talents together for a couple of days, have one guest interview the other, and see what happens. Our job was to create a main title sequence that gave the viewer a sense of what it was all about.

Our plan from the outset was to play off the idea of dialogue and juxtaposition. Our initial exploration used actual transcripts from the show to create something completely type based. We split the frame of the screen and had type reading out from the center to give the feeling of a back-and-forth conversation. The results were great, giving us an elegant execution with potential for animation, but something seemed to be missing.

Because the show is so personality driven, we decided to add photography. It brought even more life to the idea (Figure 9.13). A focus on gestures, along with close crops of hands and expressive eyes and mouths, captured the lively discussion. And the split frame created strange, yet striking compositions that reflected the odd intersection of two minds meeting. Ultimately we tried to create something that felt at once classical and avant-garde—fitting for a show about people who had often gone against the grain to make their mark.

▶ *In Practice: This motion design uses the device of a split screen, coupled with close-ups of human gestures, to convey the idea of two guests interviewing each other. The supportive elements, including muted colors and classic typography, help push the feeling of a serious, intellectual show.*

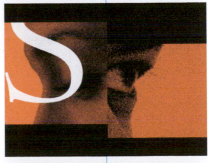

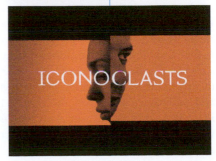

9.13 Opening title design and stills of the sequence for *Iconoclasts* television series.

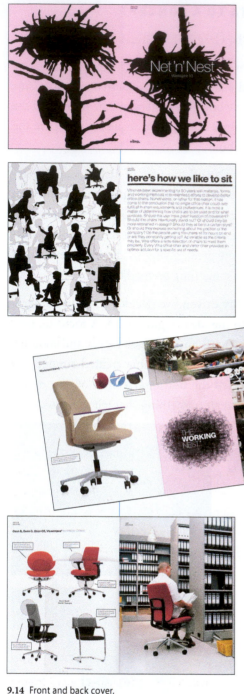

9.14 Front and back cover, and subsequent spreads from the Vitra catalog *Workspirit 10: Net 'n' Nest.*

▶ *In Practice: This catalog goes beyond being simply about furniture. The bigger idea brought to it, that of nesting, makes sense in the context of a functional office environment. The whole notion of understanding that workers need both private and public space is intriguing. Workspirit 10 shows this idea so clearly, and the catalog is visually beautiful, making the innovative concept even more exciting.*

BRINGING A BIGGER IDEA TO A CONCEPT

Vitra Workspirit 10: Net 'n' Nest by COMA Amsterdam/ New York (Cornelia Blatter, Marcel Hermans, and Billy Nolan)

For over half a century, Vitra has been a leading name in the world of furniture and interiors. Its mission is to develop furniture and furnishing systems that stimulate, inspire, and motivate. From its early patronage of such influential figures as Charles and Ray Eames and Jean Prouvé to its support of such renowned contemporary designers as Ronal and Erwan Bouroullec and Jasper Morrison, Vitra has always experimented with new ideas and is always tackling the new challenges of the field of work. The theme behind the most recent collection of office furniture is based on what Vitra calls the Net 'n' Nest theory: we go to the office to communicate with others (net) but we also need the option of withdrawing from the communal environment for solitary productivity (nest).

The role of COMA in the Vitra catalog *Workspirit 10: Net 'n' Nest* extends beyond graphic design to encompass concept, editorial structure, and art direction of photo shoots. As a result, the entire book is tailored to reinforce the central theme—netting and nesting—right from the cover, which depicts a solitary individual at work while ensconced in a nest (Figure 9.14).

The human need to nest is expressed by smaller pages that "nest" within the larger pages. These inserts feature scenes in which Vitra furniture becomes the defining props in the nests of imaginary working individuals. The human aspect—both the counterpoint *and* complement to the net-driven world of work—is further emphasized in different ways. Key designers are introduced by their first names and speak to the reader. Old masters are brought to life through portraits and eulogies from today's top designers. Individuals seated on Vitra chairs are pictured at work in archives, laboratories, and other workspaces. Leading figures in other fields are pictured in their favored surroundings with Vitra products. Chairs are even presented as a cast of characters bearing traces of users. Even the headers that top the pages and the titles of each chapter underline the human, the individual, the personal.

The alternation between complementary pairs (larger and smaller pages, formal and informal imagery, personal and impersonal insights) communicates the key Vitra message, that netting and nesting form a dialectical pair that do not simply complement each other but mutually promote each other. The entire book can be understood as a structure that brings together a host of designers and users. The Vitra catalog *Workspirit 10: Net 'n' Nest,* therefore, forms a device that links design and use through designers and users.

9.15 Process students follow for the assignment.

▶ *In Practice: Reducing a complex idea, image, or object to its simplest form is a dynamic way to get to the essence of something you are trying to communicate. And this effort can produce new insights about the same idea, image, or object each time you do it.*

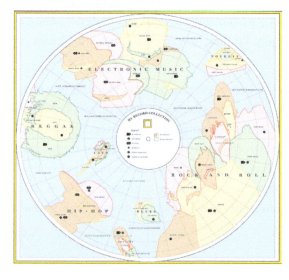

9.16 DMITRI SIEGEL. Student project charting his record collection through the image of a world atlas.

BRINGING A BIGGER IDEA TO A CONCEPT

On Student Assignments, with Barbara Glauber, principal of Heavy Meta; faculty, Yale Graduate Graphic Design Department

What is your favorite student assignment?

There is one that I love to give in which I ask students to choose a personal obsession and then create six separate icons that categorize the obsession. The icons must appear to belong to the same family by sharing a formal vocabulary, but each must symbolize a different aspect of the subject (Figure 9.15).

Is there an ultimate objective with the project?

The challenge for the student is in finding a way to express the depth of their obsession through the reductive language of icons. I want students to understand that a system of symbols doesn't only have to mean the kind you see at an airport. The spectrum of graphic vocabularies is much wider than that. The language students reference when rendering their icons might draw on vernacular languages, pop culture, digital bit maps, spray painting, even the stamping on a plastic coffeemaker button. In the process, we discuss strategies for boiling forms down to their essence in order to make a successful translation, and how the nuances of each gesture carry their own meaning.

In crafting these forms, students are forced to look at other icon systems to observe a number of things: to see how line weights and corner treatments are considered in order to achieve optical uniformity; how similar ratios of positive and negative space can balance each icon; and how borrowing from other visual languages can expand their own imagery. For example, a human figure can be appropriated from a conventional bathroom icon, or the use of collage across a system can unify the set of icons. Drawing skills also come into play throughout the process as students create laser prints and work on them with felt-tip markers to discover possible refinements.

The students are also asked to invent an application for their icon systems. It might be a book or a poster or an installation. This aspect gives them a context to design within and helps determine the scale at which the icons need to be read.

What student solutions stand out for you?

Dmitri Siegel managed to chart his entire record collection on one National Geographic-like atlas. Layers of information overlap—continents double as silhouettes of recording artists that categorize the genres of music while inside each region, tiny record-based icons provide his take on the album's usage for being a DJ, sampling, and frequency of play (Figure 9.16).

The limitations of communication itself can be addressed through the project. For instance, Julie Cho created a book pairing the texts of instant-

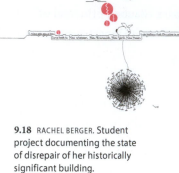

9.17 JULIE CHO. Student project pairing the texts of instant-message conversations with icons describing the subtext of the dialogue.

9.18 RACHEL BERGER. Student project documenting the state of disrepair of her historically significant building.

🔍—View a Closer Look for the embellishments on **myartslab.com**

message conversations she had with her father with icons that described the subtext of the dialogue—lonely, confused, homesick, or worried (Figure 9.17). Another project, by Amanda Bowers, modified the assembly instructions for an Ikea Billy bookcase by including icons for her personal belongings that showed their quantity and exact placement on the shelves each time the bookcase was moved to a new location, thereby highlighting her peripatetic existence.

Some students choose to explore the relationship between ornamentation and representation. Rachel Berger documented the state of disrepair of her historically significant apartment building by framing images of frozen pipes and broken light bulbs with beautiful Arts and Crafts-style embellishments, hiding the building's defects behind decoration (Figure 9.18).

☯ SPEAKOUT: **Conceptual Healing** by Louise Sandhaus, professor, School of Art, California Institute of the Arts

Crammed among my many graphic design books are personal scrapbooks brimming with stuff that I've torn from magazines and newspapers (and occasionally printed from the web). This hodgepodge, which I often share with my students, has become the butt of several jokes because the pages seem to reflect a crazy-brained lack of collecting logic. An example of "good design" sits next to a bird photograph, which is next to a science fiction story, which is nestled between a comic article called "Abstract Thought Is a Warm Puppy" and a graph showing how the brain works. Everything seems miscellaneous.

But for me, connecting the dots of miscellany reveals fresh insights and new possibilities. The way that I use my imagination to make sense of the world is what makes my work as a designer personal. In other words, I approach graphic design conceptually. Finding new associations is what keeps my work alive. And besides, it's what's fun about design for me.

So what does it mean to approach design conceptually? I do an exercise with my students in which I give them a pile of small objects, say fifty or so things about the size of a spool of thread. I ask them to collectively categorize these things as logically as possible. Usually everything gets organized into color, then size, then material, then shape, and so on. In other words, all the clichéd or typical ways we organize our world. But once all the boring approaches are exhausted, then the creative brain kicks in. Objects are organized by the times of day they might be used or by their ability to float, or perhaps their usefulness as a tool. Imaginative connections between all the seeming randomness reveals how new perspectives can create fresh ideas.

EXCERPT: Paragraphs on Conceptual Art by Sol LeWitt, *Artforum* (June 1967)

I will refer to the kind of art in which I am involved as conceptual art. In conceptual art the idea or concept is the most important aspect of the work. When an artist uses a conceptual form of art, it means that all of the planning and decisions are made beforehand and the execution is a perfunctory affair. The idea becomes a machine that makes the art.

In Perspective

In this chapter, you've had the opportunity to learn about the design process from a selection of graphic designers, each of whom has a very different outlook on his or her art. Every working designer has a unique story to tell about how he or she approaches design work. These observations are valuable lessons for students who are learning about not only the practical aspects of design but also design as a lifestyle that embraces problem solving. You will develop your own working system over time, but never overlook the value of learning from others, even after your own design practice matures. The learning process always continues, and you will come to see yourself as a perpetual student.

In the next chapter, you will be challenged to look deeper into the concept of loading your form with visual codes that carry meaning. Knowing and understanding these visual codes can move your work beyond the ordinary and into the realm of truly significant, groundbreaking design.

EXERCISES AND PROJECTS

✓ Review additional Exercises and Projects on **myartslab.com**

Exercise 1 (Contemporary Designer Profile): Research the work of a contemporary graphic designer and write a short essay (approximately 300 words) about the importance of concept in their work. Read your essay aloud to the class for feedback and discussion.

Exercise 2 (Design for Public Service): Develop a idea for using graphic design to help promote a public service dealing with community, education, health and safety, or the environment. Identify the ideas you would like to explore and sketches for finished designs, focusing on a full concept as a driving force.

Project 1 CHANG HOOK PARK. Liter-sized energy drink called BOOM UP.

Project 1 (Product Packaging): Invent a product and package it. Research any competition and target an audience you want to reach. Name the product, design a logo, and create the package shape for the product. In other words, create a complete concept for it. Your presentation should include whatever visuals you need to present your ideas—drawing or prototype of the object, actual packaging, representation of research, and so forth.

Things to Consider: The product doesn't necessarily have to work—don't let the mechanics get in the way of your creativity and final solution.

Project 2 (Visual Identity): Take (or find) a photograph of a place that you feel ought to be visually branded. This place can be a well-known public site or it can be an obscure location. Create a visual identity for your place and apply that identity to any medium (website, poster, motion design).

Things to Consider: Use your imagination with this project by choosing a place that is unusual or something blatantly obvious. Be just as creative with your presentation of the final project, choosing whatever medium suits it best.

Visual Coding: Loading Form with Meaning

10

→ **CHAPTER OBJECTIVES**

AFTER READING THIS CHAPTER, YOU SHOULD BE ABLE TO:

- Interpret the visual codes inherent in a design's medium, format, and treatment.
- Recognize the codes that are carried through typography, color, and context.
- Explain the theory of gestalt perception.
- Apply the principles of gestalt perception to your work.
- Describe semiotics and distinguish its three categories.
- Compare the differences between icon, index, and symbol.
- Explain the use of a logo as a visually coded identity.
- Discuss why it is important to create meaning with a design.

Exercises and Projects

Find examples of linguistic principles in existing designs; create compositions that have semantic meaning; visually represent the meaning of specific words; redesign a take-out menu; create an ad using visual codes.

If a graphic designer had only to organize information into pleasing arrangements, then the aesthetic use of form, devoid of any meaning, would be all that's required of our job. Graphic design would be more about decorating than communicating. However, as you have already seen, graphic design is much more than form. In this chapter, you will see how visual codes help make it so.

We're really invested in how style communicates, not only in terms of form but also in terms of content or process.
—Michael Greenblatt and
Jessica Wexler

👁 Watch the Video on **myartslab.com**

Opposite page: YOONSEUK SHIM. Proposed poster (detail) for the International Trademark Association (full image, **see** Figure 10.8).

A **visual code** sets a tone, narrates with a particular voice, and brings a perspective through which the viewer can understand the work. Every image we use or create is imbued with nonverbal messages that come from the cultural context in which the image exists. These nonverbal messages function a bit like a picture frame, setting a context that adds to the meaning. Imagine a contemporary, minimalist painting mounted in an ornate Baroque picture frame—what messages are being sent by the unusual combination? The style and treatment of both the painting and the frame are imbued with visual codes that can be read by the viewer, assuming the viewer has even a rudimentary knowledge of art history. If you were to bring a Baroque style to a brochure for a contemporary museum, the juxtaposition would set up an odd and most probably confusing perspective for the reader, which the creator would need to clarify in some way to explain the message.

Graphic designers need to keep these inherent messages in mind when choosing or creating images; it needs to be a conscious part of the

design process. In a sense, you are taking a step back from a design to really see it—to consider not only what it looks like but also what underlying messages it sends.

For example, if you were to design a booklet for a scientific research center, you might begin by simply organizing and studying the content information. Certainly the imagery and chart material are going to carry scientific information, but typeface, grid, colors, and other graphic elements also relay visual codes that can help the reader get fuller meaning. In managing these inherent codes, you can push the communication further, reinforcing the messages. To understand exactly what you are designing, you will need to review articles and books that cover the same field of science. You will need to explore elemental charts and structures to learn commonly used mechanisms of communication in the particular field. This knowledge will enable you to make conscious decisions with a better understanding of how your design will be perceived within the context of similar publications. You then will have much better control of the design and of the visual codes that are conveyed through the design.

The research required to successfully design the scientific booklet points to an important requirement for the transmittal of visual codes in general: you need to know your audience and the context in which your work will be received. Every field, every culture, and every geographic region will recognize different infused information. A specific color, typeface, or image may be filled with coded information for one particular audience, yet carry no associations at all for another. It is your responsibility as a designer to understand the subject matter of your design, no matter how simple or complex, and to know its targeted viewers. Without that background, your messages may be muddled or completely misread.

Visual Codes Do Send Messages

Communication is really an assembly of parts. Each part of the whole is recognized, or read, as something meaningful. Generally, designers factor in three levels of reading as they create designs: medium, format, and treatment. For example, a mass-market paperback novel is typically considered as a print medium—industrially produced with paper and ink—that conveys a kind of nostalgia, a familiar comfort. The same novel viewed on a handheld digital reader might convey a different message— might seem to be more modern, perhaps even unemotional inside its container of plastic, glass, and steel. A graphic designer has to take both of those messages into account.

Format is the next level of reading. The physical format of a paperback (usually created with low cost as a defining factor), is, most often, interpreted visually as a *novel*. Viewers expect to see a cover indicating the book's title and author, with the inside pages numbered and text divided into chapters. E-book audiences generally expect some sort of enriched

The medium is the message.

—Marshall McLuhan

▶ *In Practice: The book design for* Forgotten War *(discussed in Chapter 5, Figure 5.26) is a good example of how the format of the book can be visually coded to connect to the subject, which in this case is the organization Doctors Without Borders. It is bound with cardboard and a rubber band, reflecting the raw and makeshift conditions in which the doctors operate. It feels serious, yet adventurous; bold, yet fragile.*

reading experience involving an audio file of the spoken text, linked keywords, or other search features.

Medium and format apply to most design projects and are generally determined before the project is begun. The publisher knows the finished product will be a book. A firm requesting a website design is most probably looking to relay information and provide an interactive experience, with its format incorporating a home page and navigation to second- and third-level pages. A firm requiring a design for an advertisement is looking to tell a story about a product or service, with its format sized to include a headline, image, supporting text, and sign-off or tagline. Designers rely on the fact that the general public understands the basic purpose of these different formats, and that understanding itself becomes an element in the message of the design. It is also the groundwork for the next level of visual coding—the design's treatment.

Treatment is the third level of visual coding. A treatment can be thought of as an adjective modifying a noun. For example, you don't simply use a line but, instead, might use a soft line or a jagged line. The same goes for a clean letterform or a flexible grid. Treatments bring another level of complexity to your design, pushing your thinking further when using a compositional element, a bit of typography, or a proportional system.

For example, suppose you've been asked to design a poster for a hotel that wants to promote its proximity to a popular art museum. You begin by recognizing the poster as a medium, produced in multiples, that is meant to announce something publicly. Its format includes its size, which is probably determined by standard paper stock available. A smart treatment will bring meaning to its form, increasing the chances that it gets hung, that people will stop to look at it, and that it will send a message that resonates with those people.

The first step in beginning the design might be to choose adjectives that describe the poster. Is the museum's collection historic, modern, or contemporary? What about the hotel? Is it a chain or independent? Is it's architecture modern or traditional? And what sort of adjectives might both the museum and the hotel evoke—traditional, controversial, academic, family-friendly, or sophisticated? The designer's job, in conjunction with the hotel as the client, is to choose adjectives on which to base the direction of the design. Using just one adjective might be too simplistic, but using too many adjectives might lead to an inconsistent final result.

Your next step would be to determine visual elements to help the poster connect the hotel to the museum. These visual devices can make direct and recognizable connections for the reader, for example, a canvas texture, an image of people looking at art, or a reproduction of artwork from the museum's collection combined in some way with key aspects of the hotel. When combining medium, format, and descriptive visual adjectives in this way, your end result should be a design that is deliberate in its form and effective in its communication.

Tools for Visual Coding

An important consideration in the design process is what your design looks like through the eyes of your audience. One way to locate the visual codes you will use might begin by stopping for a moment and actually pulling back from a work. Does your design read clearly? Is it saying something you didn't intend or that will confuse or repel your audience? How could it read better? You should ask yourself these questions at all stages of the design process—from the early exploratory stages to the finished product.

The proposed redesign of New York Metropolitan Transit Authority (MTA) evacuation instructions is an example in which the designer felt the need to reenergize the existing design, especially in aftermath of the attack on the World Trade Center (Figure 10.2). The existing design uses a frame-by-frame sequence explaining how to exit a subway car. It has the visual code of authority and instructions, but its familiarity in the context of subway cars meant it was generally ignored. The designer, Chakaras Johnson, wanted to create an alternative design—in fact, he designed two versions, each connecting with its rider audience in a different way.

The first uses a visual code that imitates the instructions that went before, but more as a **parody,** a satirical imitation of something serious (Figure 10.3). The disassembled form requires visual reassembly, as if it were a puzzle. The second design uses a solid blue background typical of police departments to add weight to the design (Figure 10.4). Badge-like shapes and typography are visually coded elements that push the design even more heavily toward the message of authority.

Both redesigns use visual codes that are energized and fun. Most of all, they're noticeable in the context of what came before. The train and need for rules have not changed, but the treatment of the information has changed the way subway riders read the message—as someone speaking *with* them instead of speaking *at* them.

10.2 MTA evacuation instructions in New York City subway cars.

10.3 + 10.4 CHAKARAS JOHNSON. Proposed subway train evacuation instructions, vertical format (left) and horizontal format (right).

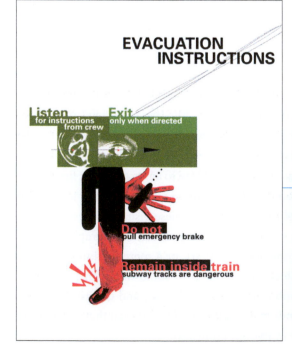

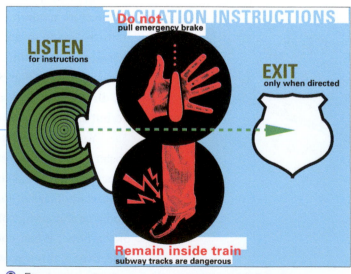

View a Closer Look for the evacuation instructions on **myartslab.com**

View a Closer Look for the CalArts dance poster on **myartslab.com**

CALARTS SCHOOL OF DANCE PRESENTS

CalArts
Dance Ensemble
10th
Anniversary

Cristyne Lawson *Artistic Director/Choreographer*
Larry A.Attaway *Producer*
Dancers:
Rebecca Bobele
Laurence Blake
Clare Duncan
Kurt Weinheimer
Tina Yuan
Lance Fuller Erin White
Costume Design: Martha Ferrara
Mod Scenographer :
COMPOSERS:
LARRY A. ATTAWAY
JOHN CAGE
ORNETTE COLEMAN Toshiro Ogawa: *Light Design*
FEATURING: DAVID ROITSTEIN
AND THE *CALARTS JAZZ ENSEMBLE*
AND THE *BRAZILIAN PERCUSSION ENSEMBLE*
CONCERTS: NOVEMBER 30, DECEMBER 1,2, 8, 9 (1989)
AT 8:00PM CALARTS MODULAR THEATRE AND MAIN GALLERY
TICKETS ARE $6 GENERAL ADMISSION AND $3 FOR STUDENTS AND SENIOR CITIZENS
CALL (818) 362-2315 OR (805) 253-7800 FOR RESERVATIONS

10.5 ED FELLA. CalArts Dance Ensemble 10th Anniversary. Irregular letter spacing creates visual movement.

Typographic Coding

If the text that you're reading now was set in a novelty typeface such as Hobo (**and here is an example of Hobo**), it would produce an Art Nouveau-inspired nostalgia or might remind one of a 1960s television comedy. Knowing that the typeface was designed in 1910 and revived in the psychedelic 1960s helps to ground its associations. (Psychedelic poster artists claim that the popular floral and plant motifs were often inspired by drug-induced hallucinations.) But could Hobo ever be appropriate to use as book text? Possibly—it depends on whether the typeface coordinated with the main message of the book. For example, if the subject were about 1960s advertising design, then the Hobo typeface might convey a more appropriate feeling than any other typeface could. Its use would be taken seriously, not ironically. But would the reader understand the association? The questions, and the coding decisions, must all start with the designer.

Ed Fella's poster for a dance ensemble (Figure 10.5) shows a creative use of typography and visual coding. The poster has a light and airy feel about it, and much of the text rests at the bottom of the page, leaving more air at the top. In doing so, it reflects the act of freeing oneself momentarily, but ultimately being gravity bound. The most inventive aspect of this poster is the kinetic quality of its letterforms. Where the typical dance poster might animate words and letters leaping off the page, something more unusual is happening here. Fella made the letters hold steady to the baseline, but he used great freedom in spacing those letters, shifting them irregularly to the left and right, and thus conveying the idea of movement, of dancing and shuffling feet. Two levels of coding are taking place here—the general public sees the letters moving like dancers; the graphic design community sees how the poster pushes the possibilities of kerning.

Color Coding

Color is a useful way to convey emotion or simply help information stand out. The color red may imply passion or anger, but red also helps a word stand out from the rest of the page—an optical effect (see the Worklist on Meaningful Color, page 260). In addition, blue might convey the cold of winter or signify technology because of the association with IBM's three blue letters. Designers rely on these cultural associations of color to convey meaning without being explicit.

It's also true that colors mean different things to different people. Cultures hold very different associations with colors; therefore, unless the designer can specifically identify the audience, he or she should not depend on color to convey too much. Color can be an underlying suggestion, but it should not be the message itself (see more on the cultural association of color in Chapter 6).

10.6 PAUL SAHRE, design; JOHN GALL, photography; GROVE/ATLANTIC, publisher. Cover design for *Stripper Lessons*.

10.7 Identical composition as above (Figure 10.6), but with colors changed to shades of green, which dilute the charged visual code that the color red conveys.

The book cover (Figure 10.6), designed by Paul Sahre, uses color to convey images of night life and neon signs. The cover's actual die-cut hole reinforces the idea of peaking from a dark room, with the black background suggesting mystery. The second version of the cover, using yellow and green, has less impact because those colors don't convey the same sense of passion, taboo, and excitement that yellow and red do (Figure 10.7).

 All perceiving is also thinking, all reasoning is also intuition, all observation is also invention. —Rudolf Arnheim

W O R K L I S T

Meaningful Color

Color can be psychologically contradictory. For example, just imagine hearing someone say, "I hate the bright purple shirt that you love so much." In this case, color is eliciting a subjective and personal response. But there are some general agreements: cool colors (blue, green, and purple) tend to be considered calming; warm colors (red, yellow, and orange) are considered exciting. The following breakdowns get a bit more specific (note that all examples given here are from an American perspective):

- **Black**—mysterious, authoritative, powerful, and elegant—associated with religion (priests), with death, with rogues (Darth Vader), and with fashion (designers, artists, sophisticates)

- **White**—innocence and purity, positive and spiritual, clean—associated with brides, nuns, doctors, and nurses

- **Gray**—neutral, conservative, sophisticated, smart, and old—associated with serenity, boredom, being hard and cold, expertise, wisdom, elderly beings, worn-out items

- **Red**—intense and emotional—represents love, but also energy, anger, power, danger, and blood

- **Blue**—tranquil and peaceful—symbolizes loyalty and wisdom, but can also connote coldness or sadness

- **Yellow**—active and cheerful, spontaneous and childlike, dangerous—softer shades can symbolize hope; stronger shades can indicate joy, but also cowardice or caution

- **Purple**—royal and luxurious, spiritual and romantic—considered artificial because of its rarity in nature

- **Green**—nature and growth, ambition and greed, Earth friendly—used by hospitals as it is easy on the eye and relaxes the psyche

- **Orange**—fun and energetic, provocative and challenging—connotes citrus and harvest, youth and sports

Codes and Contexts

The MTA evacuation instructions mentioned earlier were designed in relation to where the poster would be installed—on the interior wall of a subway car (Figures 10.3–10.4). Context can also be used within the confines of a design itself, as seen in a promotion for the International Trademark Association by Yoonseuk Shim (Figure 10.8). Shim used barbed wire as a visual metaphor for securing and protecting trademark usage for its membership. In the context of a brightly lit page, viewed from above, with the "No Trespassing" sign at the bottom, it sends a clear message to stay away from trademark infraction.

However, if the photograph of barbed wire were made with a darkened background (as if shot at night) and from a bird's eye view, the inherent message might have taken on a more dangerous and sinister code that would have taken the meaning beyond the parameters of what the organization, or the average viewer, would find acceptable. The context of the photograph sets the tone.

James Victore's poster protesting the "Disneyfication" of New York City's Times Square uses context both inside and outside the work (Figure 10.9). The idea begins with a decapitated mouse head, clearly a reference to Disney's Mickey Mouse. The gritty texture of the lines adds a code or message to the image—reading as intense, spontaneous, and angry. The tongue sticking out of its head suggests the decapitated mouse is either dead or gagging, not the usual message to come from cheerful Mickey Mouse. The printed words "Just Say No," (from a popular antidrug campaign in the United States) are powerful here: "Just say no to Disney and all it represents." But perhaps the locations where it was posted made an even more powerful statement—in the shadows of the Times Square tourist neighborhood.

Context can also be abstracted for use, as in the chart design accompanying a *GOOD Magazine* article (Figure 10.10). The design documents the no-smoking policy for each of the fifty states in the United States. The treatment of the data is clean and succinct, with each state represented by a cigarette, its size determined by the state's population and percentage of smokers. Overall, however, it sends a more profound message because its general appearance is that of a cigarette warning label. The piece takes on a dual function: it informs with clear data, but it also carries a coded message, making the connection to the deadly consequences of smoking.

10.8 YOONSEUK SHIM. Proposed poster for the International Trademark Association.

10.9 JAMES VICTORE. *Just Say No* poster protesting the "Disneyfication" of New York City's Times Square.

10.10 CASEY CAPLOWE, creative director; MATT OWENS, VOLUMEONE LLC, design. Chart for the social activist publication *GOOD Magazine*.

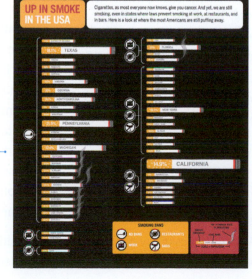

Kim Kiser teaches Psychology of Visual Perception in the graduate Communications/Packaging Design department at Pratt Institute, where she earned a masters degree. She holds a bachelor of journalism degree from the University of Texas at Austin and has worked as both a copywriter and art director for advertising and design studios. Kim is also vice president, global creative director for Morgan Stanley, where she oversees creative design, strategy, brand consistency, and brand governance for print, web, and multimedia. She lives and works in New York City. • Based on the writings and teaching of Rudolf Arnheim, art theorist and perceptual psychologist, Kim's classes explore physiology, symbolism, and the visual and verbal tools needed for creative problem solving.

▶ What is the value of learning about visual codes and perception techniques?

People have emotional and often highly personal reactions to visual stimuli. I am always amused at how a design's success can hinge on whether we've used one of the client's favorite colors. Studying perception helps designers understand how people respond to what they see, so they choose colors, typefaces, and imagery that are appropriate to the message, not to their personal tastes. Breaking down a design into its parts also gives designers a visual vocabulary to explain why something works or doesn't work. "I like it" isn't enough.

In the example (Vignette 10.1), a student redesigned the cover for Albert Camus's classic novel *The Stranger*. The choice of black and white fits perfectly with the existentialist themes in the book. The disappearing lines on top of the bent-over figure convey both a lightness and heaviness—an apt expression for the main character in the story. The design is as simple as it needs to be to capture the mood. All the elements on the page work together to build the whole.

Can these codes and techniques be a starting point for generating design ideas?

Definitely. All designs should begin with the question, "What is my design trying to accomplish?" Clearly defining the design's end goal will fuel your approach. One question I like to ask myself, and my clients, is "If your company/product/service were a car, what kind of car would it be? A BMW or a VW? How about a celebrity? Are you Tom Hanks, Tom Cruise, or Tom Selleck?" Writing down a list of adjectives that describes the desired look and feel is a good way to spark ideas. Then, throughout your design process, ask yourself if each decision is supporting the message.

How do you apply them in your work environment?

In a large corporation, the marketing needs vary widely. Yet everything we produce has to speak with one overall voice and brand. A challenging project we do each year is the firm's holiday card. We have offices in forty-two countries, so the card needs to reflect the diversity of our employees and our clients. This year we partnered with a worldwide children's charity. The message we wanted to convey was "feel good," without being too cute or too cliché, which meant no kids' drawings. The card also needed to be sensitive to cultural, religious, and environmental concerns, so red and green combinations and flashy printing techniques were off the table. Many concepts fit part of the equation, either communicating the right message or the right tone of voice, but not the total gestalt.

One solution (Vignette 10.2) solved the problem nicely. Reminiscent of children's paper dolls

One question I like to ask myself, and my clients, is "If your company/product/service were a car, what kind of car would it be? A BMW or a VW? How about a celebrity? Are you Tom Hanks, Tom Cruise, or Tom Selleck?"

and the universal symbols for man and woman, the multicolored figures join hands to form a snowflake and star in one. The idea and execution were elegant and understated, but, most importantly, it felt like us.

Vignette 10.2 Proposed holiday card design for Morgan Stanley.

by albert camus

Vignette 10.1 CHRISTINE AHN. Student project to redesign the cover of *The Stranger*.

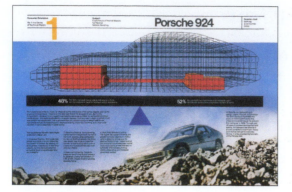

10.11 HELMUT KRONE, DOYLE DANE BERNBACH. Print advertisement for Porsche where the treatment is the concept. 1979.

10.12 Halftone dot screen (enlarged). As the viewer pulls back from the image, the total picture comes into sharper view. The forming of dots into a face is the Gestalt effect—visual recognition from something that might be otherwise completely abstract.

10.13 ROCCO PISCATELLO. Poster for the Visiting Artist Program at the Fashion Institute of Technology.

Coded Treatments in Advertising

In the late 1970s, Bill Bernbach noticed a shift in the way his agency, Doyle Dane Bernbach, was handling a particular advertising campaign for the Porsche car manufacturer. Instead of a traditional concept based on a headline, the ad relied on a clean typographic grid and precise handling of information to sell the product. In fact, the campaign's art director, Helmut Krone, used the visual code of scientific data to create a treatment that read to the audience as "technologically cutting edge." As Krone put it, "It's the styling, the presentational concept, that's important."

Each design in the campaign included an image of the car itself in rugged terrain, but there was also a high-tech schematic of the car's anatomy (Figure 10.11). What Bernbach noticed was, in fact, the ad's overall visual coding. The language it spoke was the underpinning of what the manufacturer wanted to convey—that the car was built to perfection using the latest technology.

Gestalt Perception

Gestalt is a school of psychology founded in the 1920s that deals with the mind's self-organizing tendencies. The basic premise of **gestalt** is that an assembly of elements is perceived as more than the sum of its parts. An overall pattern takes precedence over the individual elements that make up that pattern. The primary principles of Gestalt psychology were far reaching—from the way psychologists observed patients to techniques used for military camouflage to use of design elements.

When you see individual halftone dots together, your eyes form them into a complete picture (Figure 10.12). This phenomenon would be considered a visual form of gestalt, seeing a whole that is made of individual parts. On a broader level, a design is built of many layers—idea, form, image, and context—but with a total graphic design concept in mind. The gestalt, the goal, unifies the parts, forming a complete and unified message.

You can see an example of this packaging of elements in an event poster by Rocco Piscatello for the Fashion Institute of Technology (Figure 10.13). Bars of type create a pattern of stripes. They call out for attention, vibrating against their black background. They impart the necessary information in a simple and elegant way. The names and dates manage to fit effortlessly into the white stripes, creating an energetic pattern and rhythm across the page.

And yet there is another visual element happening here—a gestalt—for the viewer. The stripes can also be seen as tiers of amphitheater seats. What at first appears to be negative space in the top half of the page—in contrast to the type below—seems to have a more significant role. It represents the back wall and high ceiling of the amphitheater as seen from the stage. The viewer just has to stand back a bit from the poster to visualize the unified whole.

10.14 TURNER DUCKWORTH, LONDON + SAN FRANCISCO. Royal mail stamps celebrating British airplane designers.

The Speakout by Kim Kiser gives a summary of the gestalt perception, explaining it as a simple human response to abstract the process into pure shapes (Figures 10.16–10.19). The reductive process causes the mind to discern groups and patterns more easily.

Design Using Gestalt Perception

You will find an interesting application of gestalt in a special range of Royal Mail stamps celebrating the anniversary of the British airplane, the Spitfire (Figure 10.14). The camouflaging technique that the plane uses is built into the stamp design itself. The objective of the design brief was to show famous British aircraft and its designers. According to Bruce Duckworth of Turner Duckworth, the designers came up with a solution purely by accident. "At regular intervals, we'd receive faxes of archive pictures of one of the plane's designers. Late one evening, a heavily distorted fax of R.J. Mitchell tumbled out of the machine. Barely distinguishable, it resembled a cloud formation. I knew it was the answer." The closer you look, the more you can see the designer there, in the background, composed of the clouds themselves.

The Canadian design firm Wax used another method of camouflaging for a poster series for the Calgary Farmers' Market (Figure 10.15). In each poster, the skin on a piece of fruit is cut away. What's left is meant to resemble an accessory worn during the summer months when the fruit is eaten. The peel is so expertly done that, for a moment, the eye is tricked into believing the fruit have on real overalls, bathing suits, or sunglasses. The foreground color and simple text enhance the impact of each image. This kind of advertising design uses humor, craft, the context of summer, and an ingenious gestalt effect to create an effective concept.

10.15 WAX, CALGARY, AB, CANADA. Farmers' Market summer posters.

SPEAKOUT: **A Summary of Gestalt Concepts** by Kim Kiser

Gestalt psychology's premise is that the whole is greater than its parts. We apply this premise to visual perception when looking at graphic design or any visual medium. The question we ask is, "Does it work?" There is an immediate, intuitive "yes" or "no" reaction to this from everyone. But not everyone can evaluate why. As designers, our job is to break down the parts (shape, line, color, texture, weight, direction) to evaluate what role each plays in the success of the whole, and, of course, to do the reverse and build a design part by part so that the whole works.

With perception, the mind is trying to solve a puzzle—to interpret what the arrangements of shapes and colors mean. This interpretation depends on many factors, from the viewer's memories, culture, and mood to the design's context, form, and style. A designer must, therefore, carefully consider every element he chooses, so the viewer can translate the design's code properly.

For example, in looking for patterns, the brain will naturally group together objects of a similar size, shape, color, or location. If the designer did not create these pairings deliberately to clue in the viewer to what the design is saying, the form and function are at odds. Author and perceptual psychologist Rudolf Arnheim calls this the Law of Grouping by Similarity, one of four laws of organization that shape our visual perception (Figure 10.16).

A second law, the Law of Simplicity, describes how the simplest conclusion will prevail when interpreting visual media (Figure 10.17). To that end, a designer should not go beyond what is needed for his purpose. For instance, when a composition is cluttered or unbalanced, we feel the urge to eliminate extraneous details and move tense objects away from one another. Arbitrary elements in a design only serve to confuse and distract people from the overall message.

Tied in with simplicity is the Law of Constancy. This law allows us to recognize representations of three-dimensional objects on a two-dimensional page from any number of projections or angles, because we see objects as being of a constant size and shape (Figure 10.18). We see past the distortions of perspective and foreshortening and perceive the object as it is physically. Simplicity plays a part, as we'll see a parallelogram as a square tilted in space, because a square is a simpler shape.

Lastly, the Law of Closure describes our tendency to complete incomplete shapes when they are missing information, cut off or covered up by another form (Figure 10.19). This allows us to recognize objects easily despite gaps or partial contour lines. The phenomenon is also useful for seeing depth. For instance, it is simpler to see an overlap as one figure in front of another than as one deformed figure on a flat plane.

10.16 Law of Grouping by Similarity. These dots are associated because they share a common characteristic in the form of a line, which becomes an associative link.

10.17 Law of Simplicity. The process of elimination or reduction. The one block is simpler than the many, but in that perception, the functionality of the many is also removed.

10.18 Law of Constancy. Because the square is a simpler shape, the viewer will still read the distorted perspective as a square.

10.19 Law of Closure. The eye tends to complete a contour and ignore gaps. The triangle can be perceived here, even though there are large gaps in its contour.

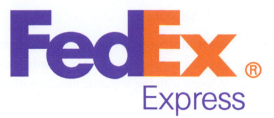

Gestalt can also unify a logo design into an ingenious mark. The Federal Express logo is perhaps one of the best (and well-known) examples (Figure 10.20). The letters bleed into one another and form a bold, memorable image, but the white arrow formed by the negative space within the counters of the E and x letterforms is surprising in its cleverness and simplicity. It subtly reinforces the idea of movement and speed of the company's delivery service. The flip of letter and arrow is so perfectly natural that you like it simply because its presence tricked you.

> ▶ *In Practice: During the design process, stand back and try to discern any gestalt-based effects. Any visual pairings, groupings, reductions, or distortions that you can get the viewer to participate in or complete will make your design more memorable.*

> **"** *What a picture means to the viewer is strongly dependent on past experience and knowledge. In this respect the visual image is not a mere representation of "reality" but a symbolic system.*
>
> —E. H. Gombrich, *Art and Illusion*

Semiotics

One could argue that graphic designers actually create signs, not pictures. **Semiotics** is the study of signs and how these signs are used in everyday communication, taking shape as logos, book covers, packages, exhibits, web pages, and motion designs. Knowing the terminology is important because it differentiates the kinds of signs with which designers work.

Swiss linguist Ferdinand de Saussure (1857–1913) studied and discussed semiology, a theory based on the notion that a sign is a representation of something not present. American philosopher Charles Sanders Peirce (1839–1914) furthered the study, coining the term "semiotics," and breaking the subject down into three components: (1) the sign itself, (2) the thing the sign refers to, and (3) the interpreter of the sign. Later, the philosopher Charles Morris (1901–1979), in his monograph *Foundations of the Theory of Signs* (1938), proposed another division of semiotics, creating three distinct categories—syntactics, semantics, and pragmatics—each a subcategory with its own independence. The synthesis of all three forms the basis of how an audience perceives a sign (Figure 10.21).

10.21 KATHERINE MCCOY.
High Ground seminar and workshop. Semiotics chart—the science of signs.

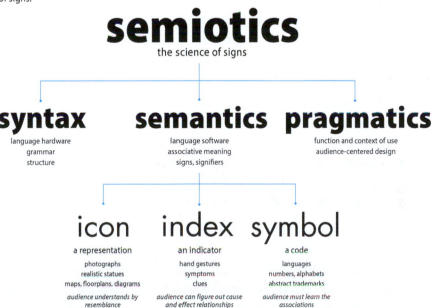

semiotics
the science of signs

syntax
language hardware
grammar
structure

semantics
language software
associative meaning
signs, signifiers

pragmatics
function and context of use
audience-centered design

icon
a representation
photographs
realistic statues
maps, floorplans, diagrams
audience understands by resemblance

index
an indicator
hand gestures
symptoms
clues
audience can figure out cause and effect relationships

symbol
a code
languages
numbers, alphabets
abstract trademarks
audience must learn the associations

Syntactics

Syntactics is a way to understand formal parts of a sign. For example, the syntactic study of a gray sky doesn't concern itself with what it means. Instead, the image is understood in terms of its structure, line, color, hierarchy, and so on—its actual form. An analytic-based concept will tend to begin by understanding the syntax of the content before any meaning is assigned.

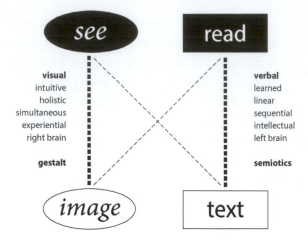

10.22 KATHERINE MCCOY. High Ground seminar and workshop. *See, read, text, image:* chart describing some of the visual and verbal tools and strategies. From High Ground's seminar workshops.

I just wondered how things were put together. —Claude E. Shannon

10.23 KATHERINE MCCOY. Graphic explaining the universal communication system originally proposed by Claude E. Shannon (1916–2001) in his influential 1948 paper *The Mathematical Theory of Communication.* Shannon is known as the father of information theory. His mathematical formulas—to reduce communication processes for Bell Telephone Laboratories—led to his digitizing of information known as bits, short for binary digits.

10.24 STUDIO NAJBRT. Visual identity and application for the city of Prague.

Semantics

Semantics considers the associative meaning behind a sign. Here, a gray sky suggests a rainy day or sadness. Metaphoric concepts tend to begin with the semantic meaning of signs being used. For example, a montage of two images results in not only the interpretation of each of the two images used but also a third interpretation—that of the message created by the blend. Just as syntactics can be visually layered and complex, semantics can also be layered with meaning. As the chart by Katherine McCoy explains, the activities of seeing and reading—of both images and text—are unavoidably interconnected (Figure 10.22).

Pragmatics

Pragmatics determines how a sign is actually understood by the user, and context plays an important role. If we think of the gray sky pragmatically, we will consider how others will interpret it as a sign whose meaning shifts dramatically based on the particular audience and their beliefs, the place, time, or situation. For example, how will a child see gray skies during a birthday party; how will a farmer confronting a field of dry crops see those same gray skies?

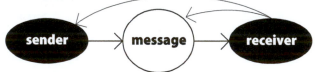

These pragmatic considerations incorporate feedback. As Figure 10.23 shows, a sign is going to have a sender, a message, and a receiver. The receiver responds to the message, but that information is also sent back to the sender for possible readjustment and further refinement. The visual identity for the city of Prague in the Czech Republic (Figure 10.24) is an example of how syntactics and pragmatics operate. A red square is vertically bisected by a white line splitting the name Prague, which appears in four languages. The structural approach creates an understandable and memorable logo.

Semiotics may seem complex and academic, but its basic principle is to provide the vocabulary for understanding purposeful mark-making. Every communication carries some kind of meaning; even when something is deliberately void of any meaning, it takes on the code of voided meaning.

Icon, Index, and Symbol

Within the subcategory of semantics, three terms define how a sign is literally visualized—as an icon, index, or symbol. Take, for example, the semantic interpretation of a file folder. A folder is used to hold and organize papers, but in the virtual world, it holds computer files. Figures 10.25–10.27 show how a folder would be categorized semantically.

Icon

10.25 The folder as an icon, literally mimicking the shape.

An **icon** is a sign that has a direct resemblance to the thing it represents. For example, the image of a folder on a computer's desktop is considered an icon because it actually looks like a real file folder (Figure 10.25). Even if it were a photograph, it would still be called an icon because of its direct relationship to the thing it represents.

Index

10.26 The folder as an index, referring to the physical location of it.

An **index** is a sign that refers to its object, either through physical location or strong clues. An index signifying the idea of a folder might be an arrow pointing to the list of files held within the folder or to a file cabinet (Figure 10.26). There isn't any resemblance to the actual object—the folder. The index is simply an indication.

Symbol

10.27 The folder as a symbol using the capital letter F inside of a rectangle as an abstract association.

A **symbol** is a sign that functions more abstractly: the object being referred to is represented by an association to a general idea. In this case, the symbol for folder might be a rectangular shape with the letter F reversed out of it (Figure 10.27). With symbols, the image can look far different from the actual object so long as the user still understands the association. Under this condition, Christianity is symbolized with a cross, the United States with a particular flag that has thirteen stripes and fifty stars, and a heart shape symbolizes love. If the connection being made is vague, then repetition will reinforce the association until it is clear and automatic in the reader's mind.

Visually Coded Identities

Logos have a language all their own and are a good example of visual coding. A logo is first perceived as an identifier of something more complex. It must be able to be read easily at a half-inch size and at a size scaled for the side of a truck. To be effective in this range of sizes, it must have great impact and be self-contained, unique, and spirited.

HUMAN RIGHTS CANADIAN MUSEUM FOR

10.28 MATTHEW MCNERNEY. Proposed logotype for The Canadian Museum for Human Rights.

With these criteria in mind, take a look at the proposed logo for the Canadian Museum for Human Rights designed by Matthew McNerney (Figure 10.28). First, it plays with the idea of syntactics, breaking the order in which one would typically read it. The words "HUMAN RIGHTS" come first—the shift made more apparent with an emphatic color change from stately black to urgent red. The logo also uses a sturdy typeface that reads as strength; namely, it is willing to stand up for something important. These treatments lead to a gestalt perception of power in the face of crisis. The design is both unique and memorable because the viewer takes part in assembling the communication.

SPEAKOUT: CARE Logo by Michael Thibodeau, managing partner, Verse Group

One of the most useful skills a graphic designer can acquire is the mastery of language. In the broadest sense, our design language includes everything that is seen, heard, felt, smelled, and tasted. This is because anything that engages the senses can have associative and symbolic meaning.

Design relies on the interplay of language to engage, inform, and motivate. In order to convey more than what is simply written, we use not only words, but pictures, forms, textures, scents, sounds, and movement. They all indicate things as subtle as status, purpose, character, and value.

Take, for example, a handwritten sign promoting "homemade pies." Besides what it says, the handwriting suggests spontaneity, freshness, a personal touch, even uniqueness. This is because the associations people have with handwriting evoke an image that is enticing and appropriate for a person selling homemade pies. Now imagine a handwritten sign for an oral surgeon down the street. The idea of a spontaneous oral surgeon might be enough to repel even the most brave-hearted patient.

Sometimes design language is local, and other times, universal. A lion's roar typically evokes the quality of courage. A circle typically evokes a sense of completeness. But the meaning behind the color red changes from culture to culture. In China, red is associated with strength, in the United States it is associated with passion, and in South Africa it is associated with mourning.

When creating the logo for Care International (a global relief organization dedicated to the elimination of poverty through the creation of sustainable communities), it was imperative that the identity spoke a universal language (Figure 10.29). During the exploration phase of the project, the designers only considered imagery, color, and form that were truly global. The circle of hands reinforced the idea of a healthy community. Its bright, earthen tones implied optimism and honesty. They did research to ensure that these colors did not reflect that of any one nation or religion. Furthermore, the lowercase typography suggested the approachable, humble nature of the organization. Through this interplay of appropriate language, the Care International logo could tell a rich and compelling story.

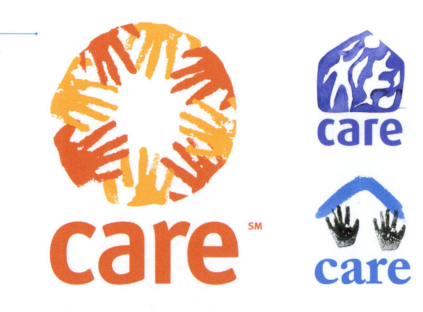

10.29 MICHAEL THIBODEAU, MARCO ACEVEDO, AND MARINA BINNS. Logo for Care International and the exploration made toward the final design (small/right).

10.30 BRIAN COLLINS. Logotype and its application for we, a nonprofit, nonpartisan effort founded by Nobel laureate and former Vice President Al Gore.

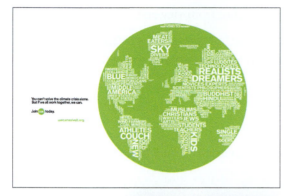

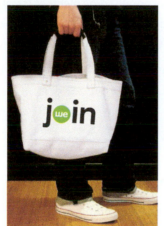

In another logo example, this one for the "we" campaign, a part of The Alliance for Climate Protection, Brian Collins used a syntactic assembly process to engage the reader (Figure 10.30). We see the letter m flipped to change the word me to we, a simple switch that embodies the notion of changing one's mindset from self-centered to globally oriented. The green circle framing the word helps stabilize its connection to the earth and its climate crisis.

The visual code for this word play draws from two adjectives—*friendly* and *simple,* which work well together for an organization whose job is to motivate the public. There is also a consistent application as shown in a print advertisement and tote bag design. This unified system of designed parts is, in fact, a gestalt that creates the perception of an organized whole—a branded image for the organization.

Logo Application

Logos have a long tradition. Early monograms for royalty were designs that went beyond their single-letter composition toward signifying authority; heraldic shields and coats of arms became symbols that signified social identity; stonemason and printer's marks became a source of pride; and branding irons showed ownership for domesticated animals, literally burnt into the flesh of the animal. In each case, a logo carried the code that declared, in essence, "I am this," "I made this," or "I belong to this."

Today, logos are part of brand images that are burnt into the mind of the general public (Figure 10.31). To help create a memorable image, you should ask yourself a number of pointed questions during your research and sketching phase (see the Worklist on Visual Identity on page 272).

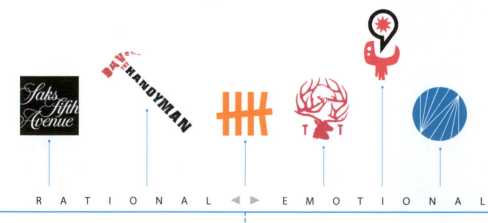

R A T I O N A L ◄ ► E M O T I O N A L

Logotype	**Wordmark**		**Pictorial Mark**	**Abstract Mark**
Word-based and literal, logotypes create a simple and direct visual identity.	Typographic in its composition but with the added help of an image to signify meaning.		An idea represented through a picture that makes conceptual sense when used with the name of a business' name.	Includes signs, symbols, and icons as part of an agreed on meaning by a specific audience. A lockup with a name is required.

10.31 The range of logos can be charted along a scale, from words to pictures and abstractions. Shown from left to right: Saks Fifth Avenue (MICHAEL BEIRUT, design) see Chapter 8; Dave the Handyman (DESIGN: JASON LEE) see Chapter 7; HK Restaurant (DESIGN: ALEXANDER GELMAN AND DAVID HEARTY) see Chapter 4; Tall Tales Restaurant (DESIGN: DUFFY & PARTNERS) see Chapter 1; Poetry Slam, Inc. (DESIGN: TRAVIS OLSON, CARMICHAEL LYNCH THORBURN) see Chapter 1; NYC Alliance (DESIGN: WORKSIGHT) see Chapter 3.

A trademark is a symbol of a corporation. It is not a sign of quality…. It is a sign of the quality. —Paul Rand

Visual Identity

Ask the following questions when beginning a project:

- Is the spirit of the company or service being conveyed?

- Is there an emotional component to the message of the design or to the anticipated response from viewers?

- What words would you use to express the personality of the logo (for example, fun, active, friendly, serious, elegant)?

- Are there formal categories that could be used to create the logo: typographic word marks (for example, Fedex), pictorial images (Shell Oil), abstract symbols (Nike)?

- Can you montage or combine two elements to create a unique symbol?

- Does the logo incorporate some element (treatment or shape) that can be extended into a complete design package (stationary, brochure, website)?

- Is there a unique quality about the logo that will make it stand out from its competition?

The Psychedelic Language

Psychedelic, meaning mind-expanding, is an excellent example of a visually coded style that became a cultural movement in the 1960s and early 1970s. Psychedelic's main form was the poster, which announced the performances of the folk-and-blues rock bands. The posters borrowed heavily from other movements and time periods, especially Art Nouveau, but their main determinate was the economy of funds and time. The poster designers relied on hand-drawn letterforms rather than costly typesetting, and the finished designs were silkscreened within a day or two as small runs because of the last-minute schedules of local bands.

These circumstances set the creative tone for a visual language to develop. In fact, the posters were nearly illegible to anyone outside of its core audience. Yet this feature was consistent with the counterculture attitude the posters represented, contrasting the clear, clever advertising of the day. The idea was that anyone over the age of thirty wouldn't bother with the camouflaged announcement (Figure 10.32). The form and the information are indistinguishable from each other. The posters read like

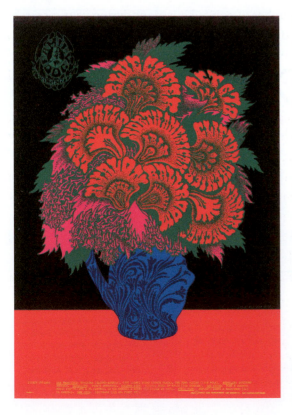

10.32 VICTOR MOSCOSO. *Flower Pot.* Music poster for the band Blue Cheer, at the Avalon Ballroom. 1967.

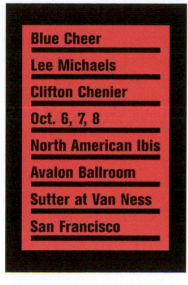

10.33 A presentation of the same information used in *Flower Pot* (Figure 10.32), but with a very different visual code.

signs—visually coded to amplify their meaning to their intended audience. They became symbols of their time and culture as well as of the sense of mind expansion and experimentation that was essential to that culture.

As an experiment, the information on the poster was reorganized into a clean and bold layout (Figure 10.33). The same information is presented, but without the psychedelic underpinnings. The poster now uses another code to connect, perhaps a neutral Swiss International Style code, or a distanced punk rock message. In any event, the visual code now conveys something completely different—becoming part of the content of the communication itself.

Why Create Meaning in a Design

There are practical reasons why designers bother to create meaning in their work. Meaning completes the sentence, solves the puzzle, brings order to the mind, and, quite simply, resonates with the viewer. Without meaning, a message is not memorable.

For the audience to realize meaning, the designer must make a considered effort. You must push your idea, and the form it takes, a bit further than you might want—until all the parts support each other. When this approach really works, your design will convey its message with confidence; it declares to the viewer that it is sure of itself.

The advertising design for an environmental organization is a good example of meaning built into a design with the help of visual coding (Figure 10.34). The goal of the poster is to get people to support nature and to see it flourish in the city. The poster expresses confidence by using the most simple and obvious elements to their best advantage—signs. The designer, Terrence McCarthy, chose a leaf as an icon for nature. He used loosely scrawled type to suggest a grass-roots organization. There is a painterly aspect to this work; the rough, hand-drawn typography and leaf shapes seem as if they were created with playfulness and passion.

The rough texture also has a unifying aspect: the elements integrate under a photographic collage of leaves and trees. The result is a poster with visual integrity. An intellectual idea is still the core of the piece, but the idea wouldn't work as well without supportive form and treatments. McCarthy's poster uses visual coding to provide a clear, consistent message.

10.34 TERRENCE MCCARTHY. Proposed logo and advertisement for Natural City, a nonprofit organization that promotes nature in urban settings.

In Perspective

Visual coding provides a means for designers to build visual integrity into their work by enabling them to determine deliberate reasons for the way a design looks and reads. In fact, when readers respond to a design, they are unconsciously decoding the visual language designers have embedded. The cohesive links that exist between what is being stated (content), how it's being stated (form and treatment), and where it's being stated (context), unify a design into something beyond the sum of its parts. A printed train schedule can be much more enjoyable when it is not just organized but also fun; a party invitation becomes more interesting when it is both inviting and smart. With the intelligent use of visual codes, your designs will embody a complexity that offers a strong message to the audience.

⚙ EXERCISES AND PROJECTS

✔ ●─Review additional Exercises and Projects on **myartslab.com**

Exercise 1 (The Study of Signs): Find one example used in an existing design for each of the following linguistic principles: syntactics, semantics, pragmatics, icon, symbol, and index. Look for these examples in magazines, books, design catalogs, and websites.

Exercise 2 (Gestalt Language): Within a 10" × 10" format, create five compositions, each of which uses five geometric elements (same or different) to describe a different adjective: tender, strong, funny, expert, and distanced. The main point is to transform otherwise abstract shapes into compositions that have semantic meaning.

Exercise 3 (Typographic Semantics): Work with a partner and choose two words from the list below. Visually represent the meaning of each of the two words using only the letters and some effect. Size, cropping, color are permitted, but no images should be included in the solutions. Words to choose from: anger, blast, cheer, chilly, crash, dance, dry, echo, erase, flake, float, giant, hot, juicy, laughter, magnify, mix, nest, pinch, sleep, skip, point, cloudy, fluffy, rain, sharp, sunny, quake, feather, scratch, snip, sparkle, spring, swim, tears, trap, wish, yell, zoom.

Project 1 (Visually Coded Menu Design): Take all of the information from what you think is the worst take-out menu you can find and redesign it into a 7" × 10" vertical page. Your new menu can include photographs and illustrations, but it must be driven by one of the following nouns to use as a visual code: science, dictionary, street, pop, classical, nostalgia, or diagrammatic.

⊘ **Things to Consider:** *Keep in mind the cuisine and the audience for your menu. Find some relevance in the visual code you use.*

Project 2 (Merging Visual Codes): PART 1: Find a Yellow Pages ad for a specific subject and use a visual code that represents the subject in a redesign. For example, for a flower shop ad, use all the visual codes you know that read as "flower shop"—vase shapes, tissue paper, floral forms—or for a gym ad, use codes that read as "gym"—the weights and measurements, horizontal bars, treadmills, or other exercise equipment.

PART 2: Create a second ad, but use an unrelated visual code. For example, keep the subject and content for a flower shop, but change the visual code by using something unrelated such as boxing (tough, simple posters with woodblock type) or science (elemental chart, academic typeface), or keep the subject and content for a gym's ad, but using the visual code of something unrelated such as a construction company (building materials, tools, instructions).

Things to Consider: *Look for contrast in the montage of visual codes—the more outlandish, the more noticeable.*

Project 2 (Part 2) NICOLE RODRIQUEZ-LEWIS. Yellow Pages advertisement for a construction supplies company redesigned with a child-like visual code using popsicle sticks and glue.

Interaction and Motion Design

11

➜ CHAPTER OBJECTIVES

AFTER READING THIS CHAPTER, YOU SHOULD BE ABLE TO:

- Summarize the ways that interaction and motion design blend time and sound with typography and composition.

- Explain the thinking behind interaction and motion design, particularly how they can be considered in analytic and metaphoric terms.

- Explain the logic and intricacies of website structure and navigation.

- Build a narrative structure for the creation of an interaction or motion design, using storyboarding as a method of design layout.

- Discuss how to use sound as another layer of graphic communication.

- Describe new technologies and trends in the field of graphic design.

The boundaries of graphic design are broader than ever before, with new categories including interaction design and motion design. Both fall under the larger umbrella of graphic design, and for good reason. Designing a website that merely functions and holds information simply isn't enough. Animating type around the screen isn't enough either.

Exercises and Projects

Critically examine websites; redesign a six-sided package as a website; design a website for a nonprofit organization; evaluate motion designs; create motion designs; brand yourself with sound or music; change a sound track for a film; do an environmental inspection of a retail environment; illustrate an audio with type and imagery.

Design is all around us but everything that is designed is an answer to a question or a problem or some sort of a puzzle that is being solved.
—Agnieszka Gasparska

👁 ▷ **Watch** the Video on **myartslab.com**

Opposite page: LAB AT ROCKWELL GROUP. Public projection (detail) of *Plug-in-Play* (full image, see Figure 11.33).

Interaction design and motion design need the same amount of design consideration as traditional print projects. Whether the medium is print or digital, the job for a designer is the same—to convey ideas with bold gestures, deliberate form, and a clear message.

This chapter discusses interaction design and motion design together because they are very closely integrated. Most websites now include some form of motion, and it is rare to see a motion design broadcast that isn't supported by an online presence. Both are capable of creating an intense user experience in a virtual space. The designer's goal is to create a virtual space that someone wants to enter.

11.1 BUILT® AND THE STUDIO FOR INTERACTIVE MEDIA. Website design for Built. The strong functionality of the site ties to the product itself.

SPEAKOUT: **Website Principles** by Justin Bakse, principal, The Studio for Interactive Media

Website design combines both graphic and interaction design. The traditional elements of graphic design—composition, typography, color, and form—must be addressed, and if a design wouldn't work well in print, it probably won't work online either. Not everything that would work in print will work on a website, however; online and print media exist in fundamentally different contexts and technical considerations can make some designs impractical.

Interaction design also informs us when we use a website, play a game, or experience any interactive media. The choices that we are given (or that are withheld from us), the decisions we make, and the way the media reacts all contribute to our understanding and contextualization of content much in the same way that graphic design does. Interaction demands an investment from the viewer and creates a more personal relationship between the viewer and the content, even allowing the viewer to contribute to and shape it.

Designing for a Virtual Space

Interaction and motion designs incorporate time and sound into the mix of typography and composition. The user becomes part of a virtual space, whether that space is a website, a kiosk as part of a museum exhibit, or handheld apparatus with a screen no wider than an inch. In all cases, users will click and search, follow paths, and watch stories, all of which have been created by the designer.

Interaction Design

Interaction design is a category of graphic design that prioritizes the user's interaction with the information that is accessed. And yet, if creating links and navigation was the entire task of the interaction designer, it could be more easily left to a programmer. Interaction design is much, much more than simply creating links.

Designing navigable links is an important part of the process, but providing context, personality, and message is equally important. Context adds comfort, accessibility, and memorability to an otherwise cold site. The medium is completely different from print, and yet the intellectual and emotional connections that designers create hold true with the Web just as they do for print, and require the same interpretive skill set (see the Speakout: Website Principles by Justin Bakse).

The site design for Built® is an example of how design concepts are developing within the interactive dialect (Figure 11.1). The site promotes a product—protective neoprene totes—and presents information in a way

11.2 CHACON JOHNSON AND CHAKARAS JOHNSON, HELEN MARIE CREATIVE PARTNERS. Website design for *BlackPublicMedia.org*.

11.3 MICHAELA PAVLATOVÁ, motion; TOMAS PAKOSTA, design; ALAN ZARUBA, art direction. Interaction design for the European Union presenting the Czech Republic as the year's council host.

11.4 TOMAS PAKOSTA, design; ALAN ZARUBA, art direction. Website design for the European Union using type as a graphic motif to create a connection between media.

that reinforces the spirit of the company. Like the product, the site has a strong sense of functionality. Those who visit the site in the first place would be most interested in finding items that solve utilitarian problems. Driven by a custom content management system, the staff is able to create content quickly for uploading. The result is a marriage of form, content, and technology.

The use of new materials on which Built bases its product is reflected in the site, too. The photographs and rollover navigation have an unexpected quality about them. When clicked, they surprise the user, linking him or her to an online game, a company manifesto, and even X-rays of the product with objects inside.

The website for BlackPublicMedia.org shows how important motion has become in interaction design (Figure 11.2). The site defines itself as "a destination for free video streaming and distribution of new media related to the global black experience." The site's home page reflects this mission by providing the visual code associated with a theater. The visitor is presented with front-row seats to documentary clips.

Each clip is a mini-documentary, and each has a short title sequence to introduce the piece, for example, the introductory title sequence for a campaign called the *Masculinity Project*. As the user moves deeper into the site, more video clips are offered, along with interactive blogs. Yet one thing remains consistent—the visual language that has the visual code of a public forum.

Motion Design

Motion design is a category of graphic design that can be traced back to mid-twentieth-century film titles and broadcast animations. At that time, typography and graphics were limited by technology. Today, any planned movement of elements is possible.

For a typographic animation presenting the 2009 host country for European Union (EU) council affairs, abbreviations for each of the EU countries swirl and flow as if they were pulled directly from conception in the designer's mind (Figure 11.3). Through the thirty-second television spot, created by Alan Zaruba, letter pairs vie for position until a sugar cube (a Czech invention) appears, revealing the Czech Republic (CZ) as the selected country. The abbreviations settle into their proper locations within the map of Europe and finally string together in unison to create a web address linking to more extensive information. And for the website, the map and letters are used as a graphic motif, creating a visual connection between the two mediums (Figure 11.4).

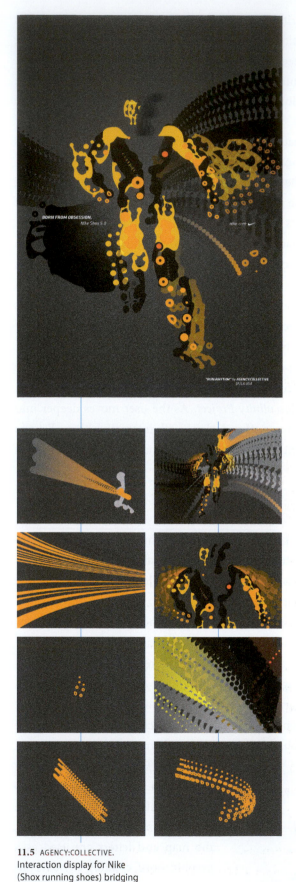

11.5 AGENCY:COLLECTIVE.
Interaction display for Nike
(Shox running shoes) bridging
motion design and the body.

The more you look around, the more you will see the most amazing motion designs—on the screen of a mobile phone or a child's electronic toy. These creations are works that couldn't have been either imagined thirty years ago or even technologically possible. The medium has evolved quickly to the point where our entire bodies are involved—as anyone who's played a Nintendo Wii or an Xbox virtual game can attest.

A project for Nike, by agency:collective, bridges motion design and the body in an abstract and engaging way (Figure 11.5). The idea behind the piece is to create a one-minute journey for users who must run on a Shox platform to activate the display in front of them. The motions of the body are mimicked as an alternate self is created in the form of abstract graphics. The piece also bridges the gap between motion and interaction design by including a set of navigational instructions that users must follow. The result is a flowing rhythm that is beautiful to look at, listen to, and engage with—a total experience for the user.

The Overlap of Electronic Media

Interaction and motion are just two of the many categories of graphic design that overlap as technology develops. Even paper is now being designed to hold an electric charge, with each printed ink dot containing an RGB ratio. It seems that every year a designer must acquire more and more knowledge because understanding the integration of technology and creativity has become crucial to the field of graphic design. Consider the possibility that in the near future a grocery store might have package labels that change or move the moment they're touched. To create these labels, a designer must have a general understanding of interaction and motion as well as their relationship to time—in addition to the knowledge of typography and composition. And, of course, all this knowledge is used with the essential knowledge of how to develop creative ideas.

Figure 11.6 is an example of how student Ryan Meis solved an assigned project that blends packaging with web interaction. The project brief requested students to rework each side of a product's packaging to create an interactive web page. In this case, the student transcribed six sides of information from a roach bait station package and transformed a mundane set of instructions into a warlike editorialization that is also a navigable set of linked pages. Typography, structure, textures, and images all helped dramatize this deadly product, with the design becoming an experimental testing ground for how old and new media can meet.

❝❞ *As technology advances, it reverses the characteristics of every situation again and again. The age of automation is going to be the age of "do it yourself."*
—Marshall McLuhan

11.6 RYAN MEIS with instructor JEFF BLEITZ, RINGLING COLLEGE OF ART. Student assignment to rework each side of a retail package into a series of website pages.

11.7 MEGAN MCGLYNN. Student motion design project using pins, paper clips, and thread.

11.8 MEGAN MCGLYNN. Student motion design project translating the word *suspect*.

The spirit of experimentation is also seen in a set of motion designs. In Figure 11.7, Megan McGlynn animated a set of everyday items (pins, paper clips, and thread) to create a rhythmic flow involving time, motion, and sound. They playfully move and interact in an engaging, if not surreal, motion clip. In another of her pieces, a sequence of transforming images, from branch to spider's web to dripping blood, finish with the word *suspect* (Figure 11.8). According to McGlynn, both projects required complicated software, but she managed to get past the fear of the software and just play with it to make her engaging designs.

The fear of technology melts away when you can think of software applications simply as playful tools. That mindset leaves you to focus on the essential task of engaging and informing an audience. Your goals remain the same no matter what tools or vehicles the technology provides. The tools that designers use have changed dramatically in the past ten years or so, but the need for solid design thinking is a constant. If you know how to think creatively, you will be successful; you can always learn the new technologies as you need them.

11.9 AGNIESZKA GASPARSKA, KISS ME I'M POLISH, LLC. Website design for Jazz at Lincoln Center (Hall of Fame).

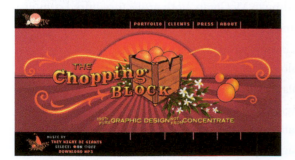

11.10 MATTHEW RICHMOND, CHOPPINGBLOCK.COM. Website design for the musical group They Might Be Giants.

11.11 MATTHEW RICHMOND, CHOPPINGBLOCK.COM. Website home page for the designer's own studio.

Interaction and Motion Concepts

Both interaction and motion design projects can be thought of in analytic or metaphoric terms. Ideas are still required to drive directions. For example, an interactive kiosk as part of a science exhibit will be filled with data-driven facts that might need an analytic approach more than a metaphoric one—in other words, an approach without any interpretive expression.

Yet if the kiosk is designed for young children, a metaphoric approach (one that interprets with imagery) might be necessary to help make sense of the information. You need to know your audience to make such determinations about your approach.

The process of sketching, testing, and revising for both interaction and motion design projects is especially valuable because of the intricate (and potentially expensive) production levels of the two mediums. Design problems that can be worked out at the front end will eliminate costly changes in later stages of the process. In the excerpt from Charles Eames's Norton Lectures (page 286), the idea of getting something wrong when modeling a design should not be something to worry about; experimenting and "feeling out" a design are part of the process.

Interaction Concepts

The website by Agnieszka Gasparska for a Jazz Hall of Fame is an example of an analytic concept (Figure 11.9). Serving as a section within a larger jazz site, the Hall of Fame creates a system that accommodates an expansive list of jazz artists. The site is crisp, functional, and informative, with immediate access to recordings, biography, and time line for more than thirty inductees. In addition, there are animated graphic shapes that slowly grow within each page, each specific to the artist's style, subject, or time period: for Billie Holiday's page, they are flower petals; for Charlie Parker, a Jackson Pollock-like paint drip. The audience can understand the organizational system and visual language without the use of heavy metaphors that might have seemed intrusive.

In contrast, for the band They Might Be Giants, Mathew Richmond used an overall metaphoric approach when creating their website (Figure 11.10). The visitor is confronted with moving targets which, when clicked, activate sounds and pop up new pages. The site is like a carnival's shooting gallery, a perfect metaphor for the band's absurdly funny and ironic music.

The design studio, choppingblock.com, which created the site for They Might Be Giants, also used a metaphor to define their working process on their own website (Figure 11.11). The image of a heavy-duty worktable, coupled with the tag line "100% graphic design, not from concentrate," emphasizes their approach to hard work, pure form, and nothing unessential.

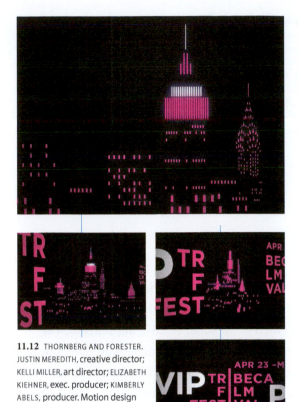

11.12 THORNBERG AND FORESTER. JUSTIN MEREDITH, creative director; KELLI MILLER, art director; ELIZABETH KIEHNER, exec. producer; KIMBERLY ABELS, producer. Motion design sequence for the Tribeca Film Festival.

Motion Design Concepts

An analytic concept is created in the motion sequence announcing the Tribeca Film Festival by Thornberg and Forester (Figure 11.12). It begins with the idea that the logo's extended capital I, moving through each of the words in the title, is reminiscent of the verticality of the Manhattan skyline. The sequence dramatizes this comparison by transforming the skyline into the logo itself. The implied meaning is that the festival is a vital part of the culture of the city. The typography and treatment convey the design's meaning without a heavy use of an interpretive metaphor.

For the title sequence for the television series *Mad Men*, the studio Imaginary Forces used metaphor in a way that is quite compelling, conveying the idea of someone's world collapsing around him (Figure 11.13). The title begins with a silhouetted character walking into an office setting and setting his briefcase on the floor. This action initiates the process of everything in the room falling straight down as if the walls and floor turned into a cloud. In this dreamlike scene, the character falls past classic 1960s ads that are enlarged to the size of billboards. The scale creates a powerful contrast against a now tiny image of the man. The sequence finishes with that same character sitting on a sofa, his arm outstretched as if nothing happened. The scene is compelling because one is forced to reconsider the beginning and middle again, and to wonder about this character's adventures in life.

Aesthetics are your problem and mine. Nobody else's. The fact of the matter is I want everything we do, that I do personally, that our office does, to be beautiful. I don't give a damn whether the client understands that that's worth anything or the client thinks it's worth anything or whether it is worth anything. It's worth it to me. It's the way I want to live my life. —Saul Bass

11.13 IMAGINARY FORCES. Motion design title sequence for the broadcast television series *Mad Men*.

Hillman Curtis (1961–2012) was a designer, filmmaker, and author whose company, hillmancurtis, inc., designed sites for Yahoo, Adobe, the Metropolitan Opera, Aquent, the American Institute of Design, Paramount, and Fox Searchlight Pictures, among others. His film work includes the popular documentary Artist Series, as well as award-winning short films. His commercial film work includes spots for Rolling Stone, Adobe, Sprint, Blackberry, *and* BMW. *His three books on design and film have sold close to 150,000 copies and have been translated into fourteen languages. Hillman's work has been featured in design publications worldwide and has been honored with the One Show, Gold, Silver, and Bronze; The Webby;* Communication Arts *Award of Excellence; and the South by Southwest Best of Show. Hillman lectured extensively on design and film throughout Europe, Asia, and the United States.*

▶ **In what ways do interaction and motion design converge?**

Even the simplest Flash or JavaScript rollover is motion. And all motion has the potential to communicate a theme or emotion. It is part and parcel with the job of engaging the viewer through technological mediums, but how you use motion is tricky. For a website, motion can butt heads with interactivity. In other words, just because you can doesn't mean you should. The idea is to be thoughtful as well as mindful of it. For Nike, spinning text might be perfectly in line with the brand. But for a bank that wants to promote a brand image of stability and security, any motion would need to settle down quickly. And for a retail site, motion could actually get in the way of people placing orders. That said, motion is evocative and its power can't be denied in any setting. It simply ought to blend well with design. My rule of thumb is to ask why something should move before it is made to move. Once you've answered that question you're pretty much good to go.

Are interaction and motion design predominantly about function and technology or is there a level of self-expression that designers can call their own?

It's difficult to maintain your vision with complex projects that involve interaction and motion. What I've found is that if you keep focused on the purpose and function of what you want to achieve, and balance it with the concept that you want to communicate, then all the other creative decisions such as structure, type, color, and motion will express the *you* in your design. These projects have many limitations—in bandwidth, screen size, or plain-old budget—but they can enable you to focus your vision more tightly, to the point where seeming limitations actually become a blessing. You are forced to find opportunities in the limitations—it's what I find especially cool about design.

Will the designers always have to follow the technology as it develops, or can the designers lead the way?

For large and complex projects the first decisions tend to be based on technologies that exist—server structure, content management, databases, and so on. If you want something more, the tech's answer is usually "You can't do that." The way around this is to learn the technology—not the nitty-gritty—just the basics so that you have an idea of what—and how—to ask. I can't code any of the stuff, but I understand the logic just enough to ask in specific ways. For example, the phrase "object-oriented coding" shouldn't sound scary—it's not overly complex logic to grasp. When we're informed, the knowledge allows us to interact with developers better. Innovations become

...learn the technology—not the nitty-gritty—just the basics so that you have an idea of what—and how—to ask.

standards—blogs are a good example. Push what you want, but do so with knowledge of the technology, and you will begin to see openings and possibilities.

Vignette 11.1 Website design for The Metropolitan Opera, America's largest classical music organization, annually presenting some 220 opera performances.

Vignette 11.2 Website design for PlayIndies, a community site for indie musicians and filmmakers where artists can connect, post, and promote their creative works.

Vignette 11.3 *Cityscape.* Animation design project for Adobe demonstrating Flash as a communication tool. Created just after the 9/11 attacks, a central character travels through the city confused in a world turned upside down.

The Internet is not just one thing, it's a collection of things—of numerous communications networks that all speak the same digital language. —Jim Clark

Interactive Architecture: Website Anatomy

One way to envision a website as an interactive entity is to think of it as a house. You go to a virtual web address and arrive at the front of the house, the **home page**—the entry point, a site's first-level page, where you get a sense of what you will find inside.

As you enter through the doorway of a site, the home page, you are given choices on which direction to take. The home page is where you see the primary design features of the website, just as you would get an inkling of the ambience of a house when in the entryway. The site map of pages explains how all the links connect (Figure 11.14). The links placed on every page are like the main rooms of the house from which you have the choice to head up the stairs, go down the hall to other rooms, enter the kitchen and dining room, or go down the stairs to the basement.

Website Navigation

Navigation, the linked access to all the pages within a site, is a significant design element because it is used consistently throughout an entire website. Navigation works well when it remains in the same location on every page, just as a keyhole and handle are usually in the same place on every door. A door handle on the upper-left corner of a door might be not only disconcerting but also difficult to use. There is an intuitive quality to a link's location and function—one shouldn't have to hunt for it, jiggle it, or turn it an opposite way than the rest of the links. The goal is to help users find their way to other pages with ease. No matter how far your user has traveled into a site, it should always be easy for him or her to find the way back to the home page or to any other page. A rule of thumb for navigation is that no page should ever be more than three or four clicks away from any other page.

Sometimes people create links that open whole new sites with a different web address. There can be good reasons for creating these links, but make sure those links are needed because after using them, it is more difficult to return to the home page on the original site. Think of it as leaving the house to go to the hardware store for a tool. If you can find what you need in the house, you don't have to leave. And if you are collecting data on page hits and click-throughs for your site, you will have just lost some hits when your user moves on to a different site.

First-Level—Home Page

Websites must have a high degree of utility and function. Audiences depend on specific visual codes to understand a website's purpose. For example, information-based sites take on a clean and informational aesthetic whereas entertainment-based sites may be more playful and active. The Webby Awards competition lists nearly seventy website categories, including Art, Community, Education, Humor, Nonprofits, Radio,

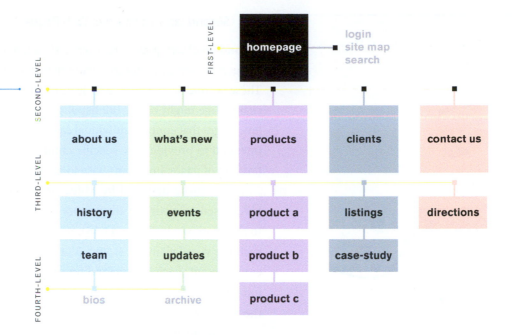

11.14 A site map visualizes the breadth of page and links.

Restaurants, Religion, Sports, Tourism, and Youth; related categories include Interaction Advertising, Online Film & Video, and Mobile Web.

The home page is the starting point, or first level, as you can see in the many creative examples by Rowland Holmes pictured in Figure 11.15. His approaches range from graphic to illustrative to editorial. Some are quite simple, others visually complex and active, yet all reflect important aspects of the businesses they represent.

The navigational links are the driving, expressive force of these many examples. Some buttons are static, others move into position on the page, and still others grow organically into a full set of links. But within each is a navigational structure that is based on content and matched with visual codes and images to build personality and help the user gain a better understanding of the site.

11.15 ROWLAND HOLMES, web developer. RivertoRiverNYC.com, Jeff Scher Gallery, and CindyChupack.com web design by NUMBER17.COM; ChocolateBarNYC.com web design by AGNIESZKA GASPARSKA, KISSMEIMPOLISH.COM; Carpenternyc.com web design by CARPENTER GROUP; PaulaHayes.com web design by JOHN GRAY; Las Venus web design by ARTURAN; ChildrensShakespeare.org web design by BRIGHTGREENDESIGN.COM.

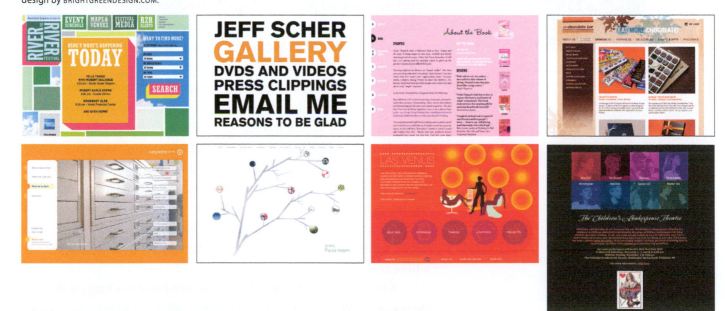

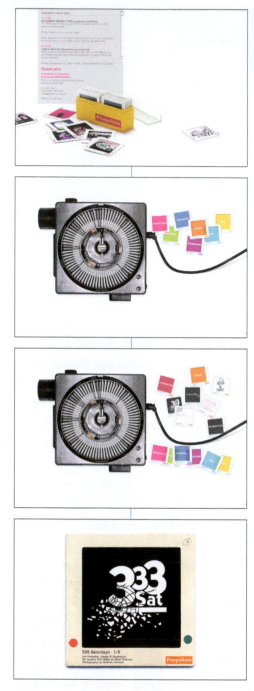

11.16 MILES DONOVAN and SPENCER WILSON / MATT RICE and HEGE AABY for SENNEP.COM. Web design for the portfolio site peepshow.org.uk.

Second- and Third-Level Web Pages

Second-level web pages are where a site's main content is located. Typical categories include *about us, what's new, products, clients,* and *contact us.* These second-level pages then lead to third-level pages. For example, a *clients* page might be the full list of clients with individual links to third-level pages that contain individual case studies. **Third-level web pages** are intended to provide very specific content. You may even need a fourth-level set of pages, but it isn't wise to go beyond that.

A website designed by Miles Donovan and Spencer Wilson for a U.K.-based collective of illustrators uses an ironic twist of technologies to showcase work (Figure 11.16). Its first-, second-, and third-level pages each use visual elements from a 35 mm slide projector to create a virtual environment. Each corresponding slide is a navigable link. It creates an interesting historical connection to use an anachronistic technology as the basis for the design of a contemporary website.

You can plan in advance how the site's navigation will work by creating a map of all the pages and levels. Simply surfing the web is probably your most valuable research tool here. Each site you explore can inspire how your own pages and levels could be structured and how a consistent visual message might flow throughout. Look at the sites of designers and businesses you respect. You will find an amazing level of creativity and unbridled imagination in a website's structure.

Wireframing a Website

Sketching out ideas for the structure of a site is called **wireframing.** Whereas a site map determines the structure for a complete website, a wireframe establishes the layout of the individual pages. A wireframe is meant to be easily modifiable; only simple lines are used to create the structure. It is good practice to begin by wireframing the home page first. That effort allows you to establish framed areas that indicate the prominence of navigational elements and categorized sections. Second- and third-level pages follow the home page's lead.

The advantage of treating a site's design so abstractly is that it helps keep the study focused on how the content should be organized rather than what the site should feel like or look like. Engaging in a discussion concerning the wireframe with clients and fellow programmers will help make the rest of the design process much smoother. For example, a website for a nonprofit will need key elements such as a donate button, mailing list sign-up, news feed, featured story, and so forth. You should get a full consensus from all the parties involved in the organization when creating this initial wireframe. They all should have a say in how the site will be constructed.

After developing the wireframe, you can begin working on the aesthetics of the site. This stage of the process will begin a continual balanc-

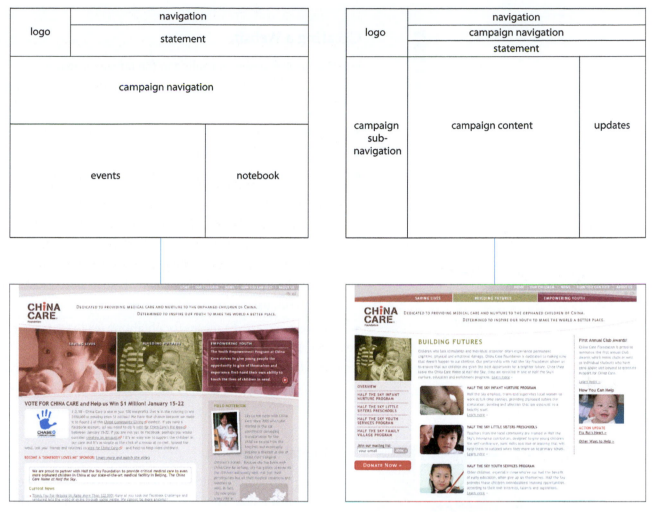

11.17 CLEVER NAME HERE, INC.
Wireframe and final home page
design for Chinacare.org.

▶ *In Practice: A good thing to keep in mind when designing the main navigation for a site is to leave space for links to additional second-level pages as the site grows and develops. As the example in Figure 11.17 shows, the top, flush-right navigation has been given enough room for more sections to be added if needed.*

ing between structure and visuals as you modify each to maintain the overall integrity of the site. You will probably find that you have to make adjustments to type size, images, and placement to fit everything comfortably in the screen and have it function as you wish. You have to take into account the viewer's patience in looking at a screen and the amount of information you need to display. There are different theories about how far a user should be able to scroll down before moving on to a new page. All these decisions will influence the structure and aesthetics of the site.

As the examples in Figure 11.17 show, Sam Nelson created an initial wireframe for chinacare.org to establish the position of all the necessary elements—the navigation bar, logo, events listing, and so on. But for the final implementation of the design, he changed many of the frame proportions. For example, he reduced the height of the navigation area because the typography didn't need the amount of space allotted. He changed some straight lines to curves to separate sections because the imagery, color, and the content seemed to call for a gentler handling. The end result is a website with a clean structural hierarchy and a personality that reflects the nature of the nonprofit organization (see the Worklist on Creating a Website).

Creating a Website

- Is the site's design appealing to the target audience?
- Does the home page establish a personality and visual code for the rest of the site?
- Is there enough contrast between text and background?
- Do all hyperlinks and Javascripts function properly?
- Have you established an underlying grid structure (or wireframe) to be used as a template for all of the secondary and tertiary pages? And does it reflect the home page?
- Does the navigation help to convey the spirit of the site?
- Is the text as succinct as possible for ease of reading?
- Have you considered formal elements such as contrast, emphasis, balance, and white space?
- Have you created a means for obtaining feedback from the site's users?
- Do you want users to be able to add content of their own to the site?

▶ *In Practice: Keep in mind that not all monitors are the same dimensions. What balances perfectly on your machine may look completely different on another machine. Check out all the possibilities on different monitor sizes and different web browsers before considering your design finished.*

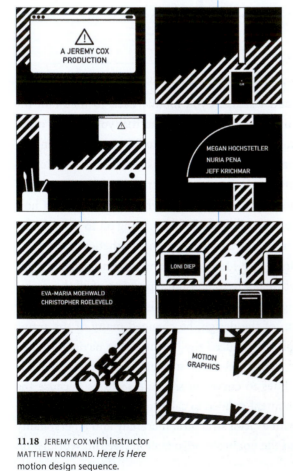

11.18 JEREMY COX with instructor MATTHEW NORMAND. *Here Is Here* motion design sequence.

Digital Storytelling

Storytelling can educate and entertain simultaneously. The traditional narrative construction has a beginning, middle, and end. This structure exists in most stories, no matter if they are ten seconds or ten hours long. A story is meant to engage an audience on an emotional or intellectual level, offering the reader a chance to see through someone else's eyes. Because of the linear quality of a story, you should first set the premise. The beginning of a narrative can present the cast of characters and location; it tells the audience who, what, when, and where. The middle is where the plot unfolds, often revealing a conflict. In the end, that conflict is resolved and all the details are wrapped up.

Endings usually have a *why* component built in, which relates in some way why the story was told. The ending enables the audience to understand the point, after which the path back to the beginning of the story is made clear. The whole experience has to hold together as a unified narrative. Jokes are a condensed version of this mechanism. A subject is introduced, and as we are led along on a seemingly uncharted path, we are quickly brought to a conclusion with the punch line.

For a motion design assignment asking students to recount the act of getting to their class, student Jeremy Cox created a narrative that runs its course in thirty-nine seconds (Figure 11.18). The plot depicts Cox as a generic character making his way to the classroom. The patterned diagonal lines around him become a leitmotif, a dominant recurring theme,

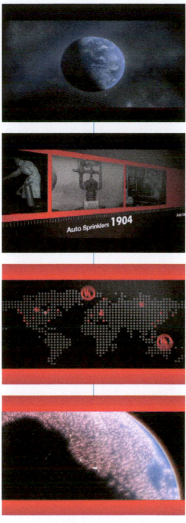

11.19 G2 BRANDING AND DESIGN. Motion sequence for Underwriters Laboratories (UL).

threading the frames together. The piece has clean and crisp personality, as if it were seen through the eyes of a graphic designer, where everything looks like signage. Images move toward the viewer, creating depth within the frame. Other compositional elements such as unity (in the line weight), and contrast (in the black and white forms) all add to the overall unity of the story. By the end, the plot is complete: the character finds his classroom and his teacher, each composed of the same graphic lines as he is, reinforcing the notion that he will fit in well in the classroom.

The narrative structure is also applied to a three-minute branding video for Underwriters Laboratories that was shown to the company's 6,000 employees worldwide (Figure 11.19). The piece is interesting to watch because it accomplishes three goals. First, it presents the company's history, complete with time line and archived images. Second, the logo—as a kind of stamp of approval—is used as a device to pinpoint not only testing facilities but also electrical appliances that benefit from the service. And third, it carries a dramatic, almost epic, tone in the narration. It is informative, entertaining, and effective.

Even a series of five-second movies, one created each day for three weeks, can contain the ingredients for a narrative, as you can see with the string of clips by Jason Jones (Figure 11.20). The sequence becomes a fast-paced bombardment of tiny stories or the beginnings of larger ones. As the designer says, they are "mixed in a soup." But they are also inspiration for his future motion designs that montage and integrate text and image.

Storyboarding a Motion Design

Designers rely on structural maps to plan the flow of links for interface-based interaction designs such as those for websites, but they use a **storyboard** when planning a motion design. Storyboards are a refined version of thumbnail sketches, except they are roughed into actual frames

11.20 JASON JONES, LIFELONG FRIENDSHIP SOCIETY. A series of five-second clips as part of a self-initiated motion sequence.

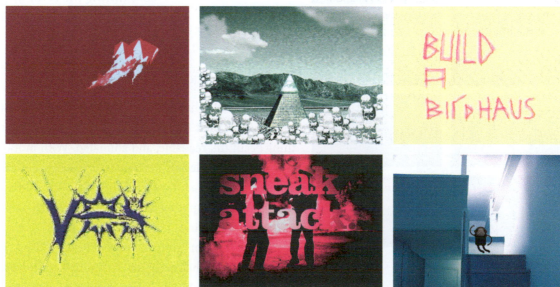

11.21 JEREMY COX. Working sketches and art for *Delicate Balance* (below).

View a Closer Look for *Delicate Balance* on **myartslab.com**

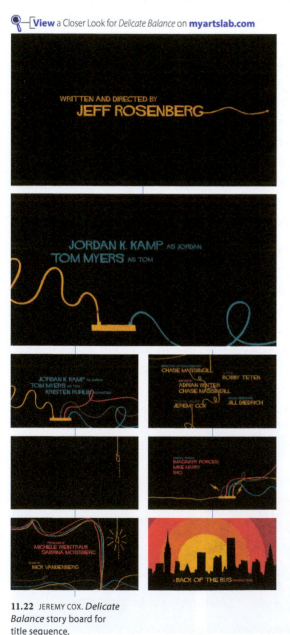

11.22 JEREMY COX. *Delicate Balance* story board for title sequence.

(usually eight to twelve) and placed in a certain order to fully visualize a motion-based idea. Elements such as sequence, rhythm, and timing are more fully grasped through storyboarding, allowing the designer to focus on how the parts flow together.

In storyboarding, a **keyframe** marks the beginning or end of a significant plot point or action, particularly of an animated movement. The process or period of time that smoothly connects these points of action is called a **transition.** A transition can include dissolves, cuts, and wipes, and this element becomes extremely important when creating a fluid, consistent, time-based design.

Storyboards can be drawn by hand or created on a computer. The purpose is to work in a format that can be easily changed and refined until the idea of a sequence is captured. You can observe how an idea begins to take form in sketches for the title design of the short film *Delicate Balance* by Jeremy Cox (Figure 11.21). Bits of type, combined with electric cords and switches, present the titles and simultaneously describe the film's situation in which the main character acquires super abilities when accidentally receiving an electric shock.

When the sketches are moved to a storyboard, it is easy to visualize the transition from keyframe to keyframe (Figure 11.22). In this form, the concept is ready for presentation. When continuing the project, Cox will fill in the frames with animated motion and sound (see the Speakout by Kelli Miller on storyboarding pointers).

▶ *In Practice: A motion sequence has the power to distort our perception of time and space, treating them as malleable elements. One scene, for example, can be recorded from three angles at the same time, melded together like a Cubist painting.*

> 66 *Storytelling reveals meaning without committing the error of defining it.*
> —Hannah Arendt (1906–1975)

Type in Motion

When motion is brought to type, the viewer becomes an instantaneous reader. It's almost impossible to look away when presented with something beautiful, readable, and animated. With motion-based typography, it is possible to design keyframes that are beautiful in their own right. They would be great posters if they were static images. When animated, the viewer is set up for a narrative to take place—a physiological reaction of the eyes and mind.

In a student project for the Peace Corps, Jarratt Moody's idea revolves around the metaphor of the organization being a "helping hand" for others (Figure 11.23). Through the sequence, a hand stacks individual

Important Moments in Time: Concentrate on key movements and plot points in the narrative. How will you show the big explosion scene? Not how will the bomb get onto the screen when the guy is walking across the parking lot. That is not as important.

Transitions: An important element that will come back to haunt you when you're animating transitions. How do you get from one scene to the next? It's a good practice to figure this out when you're storyboarding. Will it cut? Will there be some sweet graphic transition? Don't ask how something will move. Instead, storyboard it to get the point across.

Form! Form! Form! This is the time in the process to really work out your formal idea. How is this thing going to look, literally! All the standard design criteria stand. The frames should be well composed and have a hierarchy; the shapes should be well drawn; the type should be beautiful. Remember all those fundamental design challenges and keep practicing them.

Write Treatments: It can be hard to illustrate how something will move. How do you make a shape look "fast" in a jpeg? Well, you can apply a motion blur or you can simply write, "This shape will be fast." Or both. Treatments help describe the actual movement in the frame and story. They are an important element in communicating how your piece will behave once it's animated.

Don't Worry about Technicalities, Yet: Try not to get caught up in the technicalities, like "How will I do this?!" This will trip you up, frustrate you, and strangle your ideation process. Those questions will be easier to answer when you start animating. This is a time to generate IDEAS and FORM. Don't worry about how to do it yet. Figure that out later.

blocks of words together into a paragraph. Alongside are images of far-off places that grow and change.

Semantic puns help the viewer along, too. For example, the hand keeps a word from falling over or spins another around. The story's message is conveyed when the organization behind it is revealed. Then the meaning of the helping hand becomes clear and the story is complete.

11.23 JARRATT MOODY. Proposed motion design for the Peace Corps.

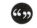 *Design must seduce, shape, and perhaps more importantly, evoke an emotional response.* —April Greiman

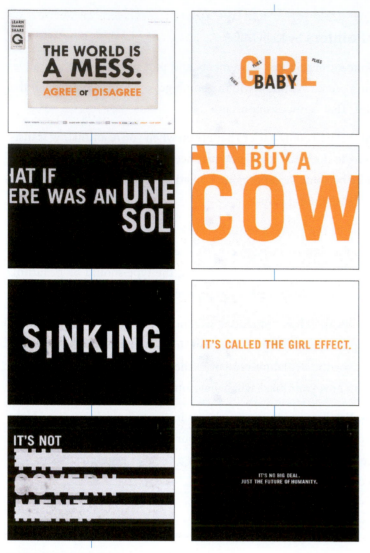

11.24 THE GIRL EFFECT: NIKE FOUNDATION. Typographic motion design sequence for Girleffect.org, a nonprofit organization empowering adolescent girls in the developing world.

▶ *In Practice: A radio commercial promoting the New York Water Taxi visualized two images in the minds of its listeners. One was the sound of beeping horns (chaotic traffic jam) and the other, the caw of seagulls (relaxation at the water's edge). The montage of the two created the message that an annoying situation could be averted.*

In another project, a typographic animation prefaces the website girleffect.org (Figure 11.24). The artists combined interaction and motion along with color, scale, and sound not only to engage but also to educate. The piece begins with the statement "The World Is a Mess. Agree or Disagree." If you click on "Agree," you are taken through a video narrative that prepares you for entry to the main site. You can't help but read along. In fact, the graphic interpretation of the words help educate you to the mission of the foundation: that with access to a healthy environment, education, and financial power, among other things, adolescent girls in the developing world can have a positive impact and can make their country and the world a better place. If you click on "Disagree," you get a story about the terrible lives of girls who have grown up in poverty and what the alternatives can be. With either click, a story is told with words and images. The piece is effective, functional, and beautiful. It is an example of motion and interaction working together to send a powerful message.

Words also create a strong and emotive response in an opening title sequence for a conference called Pop-Tech (Figure 11.25). In the piece, created by Trollbäck + Company, the dynamic qualities of flowing ink and magnetized fluids (ferrofluids) morph with typography to create a rhythmic interplay. The piece is a complex production, with many people involved in its making. Yet the idea itself is quite simple: a visual interpretation of two very controversial words, *scarcity* and *abundance,* especially when set in opposition to each other. The sequence literally pops off the screen as the symbiotic state changes from light and delicate to dense and explosive.

It sets a controversial tone for the conference and establishes a dichotomy that speaks to PopTech's diverse group of attendees—visionary thinkers in the sciences, technology, business, design, the arts, education, government, and culture.

The Design of Sound

In the visually oriented field of graphic design, it can be difficult to understand the significant role that sound can play; however, used effectively, sound can bring a richness to communication projects. Think of it as just another of layer of graphic communication.

For a brand identity, sound can be crucial. For example, the chime of three tonal bars for the National Broadcast Company (NBC) is perhaps the most recognized little melody. It was the first audio trademark and serves to

11.25 TROLLBÄCK+COMPANY. JAKOB TROLLBÄCK, creative director; CHRISTINA RÜEGG, senior designer; STINA CARLBERG, designer; LEARAN KAHANOV, director of photography; WHITNEY GREEN, producer; MARISA FIECHTER, exec. producer. Opening title sequence for PopTech.

11.26 THORNBERG AND FORESTER. JUSTIN MEREDITH, creative director/designer; SCOTT MATZ, creative director; ELIZABETH KIEHNER, exec. producer; JOE RUSS, art director/senior animator; GUILLAUME ALIX, designer; KIMBERLY ABELS, producer. Planet Green television channel promotion.

define NBC without the use of color, typeface, or motion. Even if heard from another room, you know what channel is on.

Sound can also be a malleable tool with which you can create meaning, just as you do with words and images. For example, if you were to turn off the volume of a sports event and substitute opera or ballet music, it would shift the viewer's perception of the event toward something cultural and artistic. Using any sound in an unconventional manner—montaging one type of sound with the image of something seemingly unrelated—adds a metaphoric dimension not normally associated with traditional design projects.

For sound-branding expert Audrey Arbeeny (partner at audiobrain.com), sound becomes a property that is described in three-dimensional terms. The company created an audio signature for Xbox 360 that finishes with an inhaled breath. As Audrey explains, "The metaphor of a breath expressed human energy and a sense of wonderment and surprise for this global brand." Here, sound enriched the communication by reflecting the brand attribute of a living entertainment system.

Three aspects of sound will help your interactive or motion design piece come alive. As discussed below, the use of sound effects, music, and voice-over narration will engage the user and activate what might otherwise be a flat communication.

Sound Effects

Sound effects are extremely useful for interactive projects such as a website. A simple rollover link with sound reinforces that the link is active. For a motion design, a sound effect might be something dubbed into a sequence to bump up the personality of a scene. Sound technicians, or **Foley artists,** study the craft of sound effects, for example, emphasizing the sound of footsteps or imitating the sound of a cricket by clicking teeth of a plastic comb. The sounds you think you hear are actually something else, but the source doesn't matter if the sound generates a positive response from its audience.

Sound effects are a major component for a motion design spot by Thornberg and Forester promoting the Planet Green channel. The piece begins with the company's trademark, a green globe, used as the head of a person (Figure 11.26). As the scenes progress, the green globe sits atop a horse, on a bicycle, and inside of a car, all examples of evolutionary modes of travel. Individual sound effects (a horse galloping, a car's engine, etc.) are emphasized, helping to tell the story. As the sequence concludes, the globe sits next to the trademark's type, thus completing the story.

Music

11.27 MATT OWENS. *Meridians* motion design as part of a Volumeone.com series of self-initiated projects.

Many graphic designers listen to music during the layout phase of a project. There's an easy connection between the layout composition of the page and the abstract flow of sound. Some designers find inspiration in the music they listen to while working through their ideas. As part of their work, graphic designers often visualize music in the form of covers, posters, and other promotional materials for the music industry. The power that music has on our field also works in reverse. Whether vocal, instrumental, or a blend of both, music has the power to draw an audience into a communication, and its use has become almost a necessity for contemporary motion design projects.

In a motion design experiment by volumeone.com, synthesized music and sound effects add to the dreamlike assemblage of pieces in a design reminiscent of the artist Joseph Cornell and his shadowbox constructions (Figure 11.27). Designer Matt Owens explains, "The idea was to create a piece that talked about time and space and finding your way; hence the use of the lighthouse, pyramids, flags, and other items. I made stickers and a booklet to go with the piece as well—to translate the idea from motion to print." In the excerpt from *Silence: Lectures and Writings,* John Cage takes this process one step further, to control sounds as musical instruments.

Integrating music into an interaction design, however, can be more challenging, especially if there isn't a solid connection to the site's subject. In this case, designers should refrain from simply playing music in the background unless there is a real connection. For example, if a company's brand uses music, as in a television or radio campaign, the site might do the same. A type of music for a specific audience is another way to make a meaningful connection. For the most part, music as part of a site is not yet being fully realized.

▶ *In Practice: Performing a web search for "music+sound design" will result in a long list of sites loaded with interesting examples of sound design, for example: spankmusic.com, humit.com, and epicsound.com.*

EXCERPT: Silence: Lectures and Writings, "The Future of Music: Credo," by John Cage, Wesleyan University Press, 1961

Wherever we are, what we hear is mostly noise. When we ignore it, it disturbs us. When we listen to it, we find it fascinating. The sound of a truck at fifty miles per hour. Static between the stations. Rain. We want to capture and control these sounds, to use them not as sound effects but as musical instruments.

11.28 AGENCY:COLLECTIVE. Livescribe's *Pulse Smartpen* motion design spot portraying the pen's ability to record, store, and share notes.

11.29 STUDIO TORD BOONTJE FOR TARGET. *Bright Nights* responsive footpath project at Union Square Park.

Voice-Over Narration

The third aspect of sound design is **voice-over** narration, which usually takes the form of someone actually explaining a product, service, or company to the viewer. And a voice-over doesn't necessarily have to be introduced as a particular person. The sound of a human voice itself is effective as a means of connecting on a more personal level—either with a real person guiding you through a communication or telling you how he or she feels. When you have a minute or two to make a connection, as is often the case in motion design, the sound of a human voice can work very effectively.

An interaction design with a specific message to convey might include a voice-over introduction. For example, a kiosk or website for a medical facility might include voice-over testimonials about the quality of care. The voice carries an authenticity that can't be captured in a block of text, and it engages the audience on a more personal level.

Motion designs have a linear progression. Just like stories, they usually have a beginning, middle, and end. In this sense, a motion design can easily incorporate a voice-over narration through the entire sequence. With the help of narration, a motion design can exist as a stand-alone piece, for example, as a broadcast-ready commercial that you might see on television or as part of an interactive website.

The motion design campaign by agency:collective for the Pulse Smartpen is a good example of this narrative use of voice-over (Figure 11.28). Intended to function mainly as a clip on the company's website, it also serves as a short commercial at trade shows. A voice-over takes us through the pen's functions, with sound effects emphasizing key features and background music holding it all together. In fact, the piece was written, directed, animated, and produced by one design studio, which is rather unusual in the business. You notice the coordination—the pen functions with all the elements working together in a dramatic and graphic way. Clean icons pinpoint key features of this high-tech object, and the very clever tagline completes the message: the pen "Never misses a word."

The Expanding Realm of Graphic Design

Every so often, you see a work of design that makes you realize there is so much more to this field than you have experienced thus far. The possibilities are always expanding, especially with advancements in technology. *Bright Nights* is a case in point (Figure 11.29). Sponsored by Target department stores, the piece combined physical interaction with virtual

11.30 GEOFF KAPLAN/GENERAL WORKING GROUP. Channel identification for the Digital Entertainment Network (DEN).

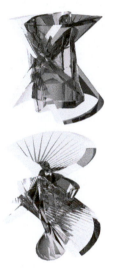
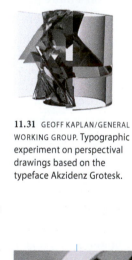

11.31 GEOFF KAPLAN/GENERAL WORKING GROUP. Typographic experiment on perspectival drawings based on the typeface Akzidenz Grotesk.

11.32 JOEL STILLMAN. A motion design assignment to document an invisible event using everyday white masking tape.

simulation for an unexpected outdoor experience. The project was actually created by Tord Boontje for the Christmas holiday season in New York City's Union Square Park. It created a stir in the design community because it was so well executed and so public. Along the footpath of the park were eight stations that each projected sets of snowflakes, stars, and forest creatures in the shape of Target's bull's-eye logo.

As visitors walked through these radiating puddles of light, the clustered images responded to their movements. Using infrared lights controlled by a sophisticated computer program, the designers created images that would burst apart like ripples of water. The graphic images were kicked around by children and adults alike, causing the surfaces in the park to dazzle with projected color and movement. Visitors chased, and were chased by, these moving light forms. The entire experience was fluid, natural, and seamless—a design that truly took advantage of interactive technology in an imaginative way and, furthermore, bridged the gap between graphic design and fine art.

The channel identification for the Digital Entertainment Network (DEN) by Geoff Kaplan is another peek into the future, this time using one of graphic design's favorite elements—the letterform (Figure 11.30). The notion of type as a flat and printed item is fairly well set in our heads, which may explain why we are so entertained when we see letters animated in space. The DEN animation completely flips this notion. Letters are transformed into motion sequences, free from the constraints of two-dimensionality.

In another typographic experiment by Geoff Kaplan, letterforms literally flip inside themselves (Figure 11.31). The letters (in the typeface Akzidenz Grotesk) unfold into the third dimension through a process called **splining,** in which computer-generated mathematical formulas help to automatically present a two- or three-dimensional object in proportion as it is repositioned or rotated. Kaplan's process splines each letter with a circle and then rotates it on a vertical axis. The motion transforms otherwise static letters into something completely new and filled with energy.

In a student assignment to visualize an invisible process—one that occurs outside the visual field—student Joel Stillman took an everyday roll of white masking tape and made it appear strange and unfamiliar as it moved through virtual space (Figure 11.32). Stillman describes his thought process: "Technically, I arranged moving planar surfaces from multiple time-signatures to allow a spilling into, and splitting apart, within the same clip."

The assignment and its description reveal something significant about the field of graphic design—that the technology itself will eventually become invisible. As clunky monitors and hard drives become obsolete, as

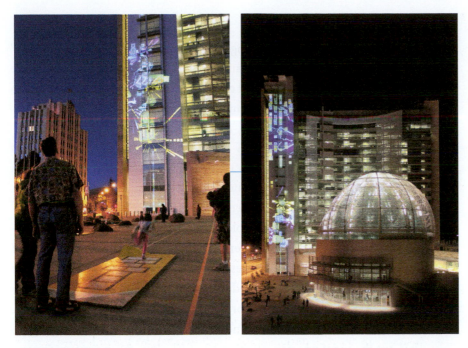

11.33 COURTESY OF LAB AT ROCKWELL GROUP. *Plug-in-Play* public projection.

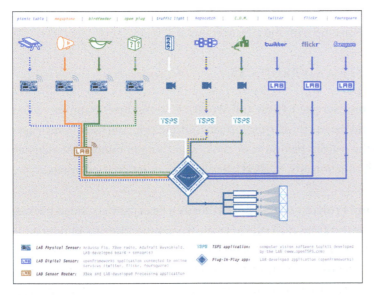

11.34 COURTESY OF LAB AT ROCKWELL GROUP. Diagram of how the user connected to the projection.

people move toward mobile devices and cloud computing where data is stored virtually and is accessible from a variety of places, and as motion sequences become effortlessly seamless, the main focus will return to the designer's ideas and concepts, used to solve complex problems with intelligence and imagination.

The line between the physical and the virtual continues to blur in a project titled *Plug-in-Play* (Figure 11.33). Graphic designers, architects, as well as software and hardware engineers at LAB (a digital interaction design team at Rockwell Group architecture firm) came together to create a public installation, designed by Richard Meier, at the San Jose City Hall building and the surrounding plaza. The project was based on the notion that individuals can provide creative solutions for public engagement. It was intended to be a celebration of city life and activity.

LAB connected a number of outdoor objects, some existing and some staged, onto the building facade using oversized theatrical plugs. Visitors jumped on a hopscotch court, shouted into a megaphone, and used digital services such as Twitter or Flickr to create new content (Figure 11.34). Each of these interactions registered as a projection of an abstracted urban landscape onto the City Hall facade. It suggested a new type of environment where the vitality and complexity with which people engage with their urban environments was reflected dynamically in an ever-changing display. This installation revisited that futuristic, urban infrastructure concept in seeking to demonstrate the interconnectedness of the people and things through play, social media, and human interaction.

The possibilities for what graphic design can be are changing constantly. Graphic designers who embrace technology find that their field is growing dynamically. The opportunities to engage with the public are becoming more and more intriguing as designers create projects based on wiki applications, where participants contribute to the content of the piece. Furthermore, with the use of the web, the community of one's audience has broadened to include the whole world. All of these changes add to the potential of design to have an impact on the world and, thus, adds to the responsibility of the designer to send a strong and significant message. It is an exciting time to be a graphic designer.

In Perspective

The old proverb "The more things change, the more they stay the same" applies perfectly to interaction and motion design. The tools people use to tell stories keep changing and developing, but the goal is the same—to make connection to another human being on an intellectual and emotional level.

The projects presented in this chapter fall under the banner of graphic design. They require a unique and concrete relationship with technology, yet share similar principles and elements that graphic designers have always put to use. Whereas traditional print projects have prepress concerns of resolution, color, and line screen, a motion or interaction project will shift its concerns to browser compatibility, download time, hyperlinks, and screen sizes. For a motion design, the principles of contrast and unity can be created through time or sound just as potently as they might be through color or texture.

Sound may be the most nontraditional element for designers to use, yet the more you pay attention to audio clips, the more familiar you will become with how ideas can be expressed through sound. Graphic designers have a heritage of incorporating each breakthrough technology into their own design language as they try to communicate better, even as technology moves ahead at warp speed. As cutting-edge designers, it is our job to keep up with the advancements.

EXERCISES AND PROJECTS

Review additional Exercises and Projects on **myartslab.com**

Interaction Exercise 1 (Best and Worst): Choose three examples each of the best and the worst websites you can find and print out their home pages. Explain the reasons behind your choices, keeping in mind three elements of design: functionality, intellectual value, and emotional experience.

Interaction Project 1 (Package as Website): Select any six-sided package and use the text from each side to create a corresponding set of interactive Portable Document Format (PDF) pages (one page for each side).

The Rules: (1) Each page must be directly accessible from every other page; (2) Navigation must remain in the same location on every page UNLESS you have a good reason to move it; (3) No text may be added or removed; (4) All package text must be present in the site.

Process/Considerations: You may choose to use the existing color scheme, typefaces, photographic, and graphic elements, but you also have the freedom to apply your own. You may want to remain true to the spirit of "the brand" for the product in the box, or you may create a visual system that readdresses or parodies the intention of the original package.

Format: Your design should be prepared as a multipage Adobe InDesign file (six single pages), with navigational hyperlinks to the other pages in the document (in the top menu items, see Window > Interactive

> Hyperlinks). Images should be at a minimum resolution of 300 dpi, with page size set at a 4:3 standard ratio (for example, 10" × 7.5"); viewable as a full-screen projection, but also printable for a comfortable portfolio size. Export your multipage PDF at press quality, with an sRGB destination profile and with hyperlinks turned on.

 Time frame: Two weeks. Week 1—rough mockups; week 2—finish for individual LCD projection. —*Based on a project provided by Jeff Bleitz, instructor, Ringling College of Art and Design*

Things to Consider: *Find a package whose subject matter you can expand into a bigger idea. When designing your pages, use proportion, structure, modular systems, and grids, to help organize your material (see thegridsystem.org).*

Interaction Project 2
Wireframe.

Interaction Project 2 (Design a Website for a Nonprofit Organization): Choose an existing website for a nonprofit organization and learn everything you can about its subject, specific audience, and competition. Create a web map that visualizes how pages link to one another; create a wireframe for your ideas on structure and hierarchy; and consider the use of interpretive metaphor and/or analytic structure as your main concept. Design a new home page with navigation, one second-level page, and one third-level page to illustrate how the complete site would work.

Things to Consider: *Choose an organization that you care about. Consider ways to approach the information from both a functional and emotional point of view.*

Motion Design Exercise 1 (Best and Worst): Locate and print out eight frames each of the best and the worst motion design you can find. Explain the reasons behind your choices, keeping in mind three elements of design: functionality, intellectual value, and emotional experience.

Motion Design Project 1 (Digital Flipbook): Choose one type of transformative movement from the following options: metamorphosis (changing from one form into another); degeneration/decay (reverting to a simpler form or falling apart); growth/progression (developing or maturing); or position (moving from one point to another). Create a five-second animation (120 frames) with sound.

Motion Design Project 1
ESTHER LI. Transformation of a signature to a skyline, shown top to bottom, left to right.

 Begin by brainstorming for creative ideas. Write a brief paragraph describing three of your best ideas in terms of the sequence of events. Format 360 × 216 pixels, exported from Photoshop as a Quicktime movie. Import into GarageBand for adding sound. —*Provided by Kelli Miller*

Things to Consider: *Whether you choose to draw images by hand or create them on a computer, you should make images that unfold some type of narrative. Consider the pacing, transitions, and how the overall rhythmic structure can help unify the design.*

Motion Design Project 2 (Kinetic Type): Select a quotation, a song lyric, an excerpt from a conversation, dialogue from a movie, or any source of verbalized word, and visually illustrate the segment with motion. Enhance

the meaning and capture the viewer's attention by making your piece expressive, interpretive, and emotive. The final sequence animation should be twenty seconds long.

 Things to Consider: *Create a storyboard first, locating the key moments. Use compositional elements such as scale, rotation, transparency, and repetition to help animate your words. Pay close attention to intonation and attitude.*

Motion Design Project 3 (News Narrative/Spatial Movement): Pick a headline from a newspaper to become the inspiration for a short narrative. The headline is the jumping-off point, not a literal translation or recounting of the actual story. Your narrative can be fantastical, surreal, lyrical, poetic, or other style. Write three to five sentences that will guide a storyboard of eight keyframes in the sequence. Make notes for each frame, describing the movement and sound ideas. Incorporate at least three types of image in your piece (photograph, digital, drawing, found, texture, or pattern). —*Provided by Kelli Miller*

Things to Consider: *Ask how the decisions you make about imagery will inform your narrative by adding meaning or helping to transition movement. How will ambient noise, sound effects, a song, or soundtrack create a sense of setting?*

Motion Design Project 4
CLAIRE KWON. Stills from Geoff Kaplan's Invisible Event project visualizing a type of micro-organism known to inhabit drinking fountains.

Motion Design Project 4 (Document an Invisible Event): Shoot and edit a movie that documents an invisible event—one that occurs outside the visual field. Visually represent the invisible. Shoot a digital video of commonplace objects set up in the studio; then bring the footage onto the computer where you can manipulate the appearance and time lapse (what is the "lived time" of the event?) to create an imagined event.

Suggested readings that relate to this project: *The Third Policeman* by Flann O'Brien; *Jay's Journal of Anomalies* by Ricky Jay; *On Longing: Narratives of the Miniature, the Gigantic, the Souvenir, the Collection* by Susan Stewart; *Dust: A History of the Small and the Invisible* by Joseph Amato; online articles on nanotechnology. —*Provided by Geoff Kaplan*

Things to Consider: *Solutions to this project are wide open. Any process, whether biological or conceptual, can be abstracted and presented. Start by making, interpret as you go along.*

Motion Design Project 5 (Five-Second Movie): The idea for this project is quite simple. Think about something, anything. It can be a funny thing you saw today, a line from a book that was inspirational, a song that reminds you of your childhood, a plate of eggs that look like the inside of a cloud—anything that may lend itself well to animation. You can also animate a design that you already made—it's all very open. Get into the application and start tooling around. Good things can happen when you explore with an open mind.

Create three five-second animations using any illustration, photograph, texture, sound, and so on that fits with your idea. Keep the execution minimal. Render using these specifications: low-resolution previews

for Web: 400 × 300, H.264; low-resolution previews for critique: 720 × 540, photo jpeg; full-resolution files: 720 × 540 animation compression.
—*Provided by Jason Jones, lifelongfriendshipsociety.com*

 Things to Consider: *Familiarize yourself with Adobe After Effects and build your improvisational skills. Try conceptualizing while you are executing, making, and thinking simultaneously.*

Sound Design Exercise 1 (From Print to Web): What do you sound like? Brand yourself! Select three songs, music, or sounds that reflect your personality. Consider how the music inspired you to do something, reflects your personality, or made an impact on your life. Explain how this music or sound supports and articulates your personality.
—*Provided by Audrey Arbeeny*

Sound Design Project 1 (Changing Perception with Sound): Record or capture a scene from a movie or television show and discuss its emotional impact. Now select a music track that is quite different from the original and assess how it alters the interpretation of the visuals and action simply by changing the sound. Share the before and after versions with others and have them write down what they think is happening in the scene.
—*Provided by Audrey Arbeeny*

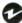 ***Things to Consider:*** *Think of the music track in terms of what it brings to mind and how it will contrast with what one expects.*

Sound Design Project 2 (Sound Touch Points): Carry out an environmental inspection of a retail department. Observe and listen. How do the voices of the salespeople, the music being played, the on-hold music of the customer service center, and the sounds coming in from other locations affect the environment? Compile your findings and present them with both audio and visual recordings. —*Provided by Audrey Arbeeny*

Things to Consider: *Sound is a reflection of a brand image just as visuals are. Consider how sound might communicate something about a brand's personality, especially when heard continually in a specific setting.*

Sound Design Project 3 (Audio Illustration): Capture a ten-second audio and illustrate it with type and imagery in motion. The sound can be a literal conversation or an abstract set of notes—generated organically by an animal or as the result of an industrial tool. The sequence can use still images, recorded footage, or typography. Synchronize your visual with your audio.

Things to Consider: *Consider the use of contrast, rhythm, repetition, metaphor, and interpretation.*

Becoming a Designer

12

→ **CHAPTER OBJECTIVES**

AFTER READING THIS CHAPTER, YOU SHOULD BE ABLE TO:

- Apply the essential steps for starting a career in graphic design.
- Build a personal website and write a blog as a means of self-promotion.
- Summarize guidelines for effective job interviewing.
- Discuss the primary issues of running a graphic design business.
- Summarize how to make your graphic design work a reflection of who you are.
- Explain why graphic designers will always need to be on the cutting edge of technology.
- Discuss how the relationship between graphic design and the fine arts has implications for your own work.

Exercises and Projects

Evaluate an existing logo; create signage for a museum; rework a bad advertisement; create a poster that reflects how your past work experiences relate to graphic design.

The preceding chapters have explained how to speak the language of design and how to think like a designer. This final chapter focuses on going out into the world as a practicing design professional. Your general life experiences will continue to contribute to your growth and development, but there are many practical considerations in finding a job or setting up your own studio practice.

If you have the boring stuff figured out then you have the space to do the fun stuff.
—Scott Stowell

👁—**Watch** the Video on **myartslab.com**

Opposite page: RICK VALICENTI. Portrait (detail) for *See Thru Me* (full image, see Vignette 12.7).

Now is the time to take all that you've learned thus far and use it to begin building your career.

For many graphic designers, the art of designing is not simply a way to make a living; it is a calling. Whether you work on staff at a company or are self-employed, people will depend on you to be creative and expressive. So few occupations ask that of you. You have chosen a very exciting field; now you have to figure out how to make it work for you.

As you start to speak from your own individual point of view, you will begin to clarify what design means to you. You will need to develop your own voice, a learning process that will continue throughout your career. Part of that process will involve regularly reading design magazines *and* newspapers. You need to know what's happening in the world and understand how you fit into it. The broader your knowledge of both the design culture and the general culture, the more fluent your design interpretation and expression will be. Your awareness of current events, other cultures, and the world will make you a better designer.

Always do what you are afraid to do.

—Ralph Waldo Emerson

▶ *In Practice: Your cover letter should never explain how the job you are after will help you grow or learn. Instead, explain how you can contribute to the firm where you want to get hired.*

Actively searching for new perspectives will also help you to develop as a designer. First, look inward for inspiration from your own experiences. Second, look through the eyes of fellow designers to understand new approaches and solutions. And third, look outward to find inspiration from related fields. Keep these three points of view in mind as you're working on new projects and as you make your way through the world. If you follow these three practices, your design education will continue throughout your entire career.

Getting a Job in Graphic Design

Your first design job is important. It may not be a high-profile position or offer much money, but it will be valuable because you will be learning the ropes, particularly in terms of process and presentation—a large part of being a professional graphic designer. You will also learn good work habits that will support your design work for your whole career.

Search for studios and agencies whose work you admire. Good studios regularly look for promising designers. Learning is the criteria by which you measure progress at first. Fulfill your responsibilities, but also push yourself to learn. When you stop learning at one job, move on. Your search for your next position will be much easier because you will know better what you want or don't want, and you will have some experience.

Cover Letter and Résumé

A **cover letter** is a strong and succinct way to introduce yourself to a potential client or employer. It also helps convince employers to review your résumé by focusing attention on specific résumé information, for example, credentials, skills, or specific projects in your portfolio of design work. The letter should be concise and well written, with no grammar or spelling mistakes. The cover letter is your first point of contact, so craft one that makes an excellent impression.

A **résumé,** which summarizes your training and experience, is absolutely necessary when searching for a job, especially because employers will usually want to review all résumés and portfolios before seeing any applicants. Employers often have to sort through large numbers of résumés, so make yours informative, easy to read, and concise. It should list your education, experience, and skills but should never exceed two pages. As a designer, think of a résumé as an informational project, an opportunity to show how you can bring a typographic treatment to pure information (see the example by Milo Kowalski, Figure 12.1). The goal is to make your résumé stand out from the rest in a professional way.

A résumé can be printed on paper or presented in virtual form on a website or as a PDF. If it is digital, it should be designed so it can be printed for distributing during an interview or incorporated as part of your portfolio.

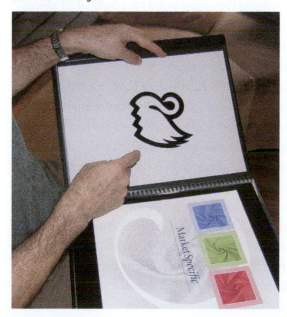

12.1 MILO KOWALSKI. Résumé design using a smart and simple layout of information.

12.2 Portfolio of bound acetate pages, each with an opening at the top for designs to be slipped in and out, or their order rearranged.

Try to follow some general best practices when creating your résumé. For example, don't mention reasons for leaving a previous job; the focus should be on strengths and skills. Don't list salaries—neither what you are earning now nor what you hope to earn. Discussing money before being hired is considered bad form, and it limits your negotiations later. Don't include a personal photograph; it gives only a superficial impression of you, and it can cause others to make judgments before ever meeting you.

Do include a list of schools you attended, degrees you obtained, **internships** in which you got experience in design, paid design jobs, and related volunteer experiences. Also include concise information about responsibilities you have had and skills you have acquired—what abilities you can bring to the company. Include specific (yet brief) information that not only summarizes who you are professionally but also presents you as qualified for the advertised position. Just as you have learned to do research for a design client, plan to research potential employers so you can decide what to emphasize in your résumé and cover letter. Also, plan to customize your résumé and cover letter for each position to present yourself in the strongest way.

Creating a Graphic Design Portfolio

Your design **portfolio** is a visual autobiography. The work it contains reflects who you are, what you are interested in, and what you can do creatively and technically as a graphic designer. Once you enter the professional field, your portfolio will be much more important to a potential employer or client than the schools you have attended or degrees you have received. It's a good idea to keep your portfolio updated with your latest work so you can respond to opportunities quickly.

A good portfolio is a design project itself. The crafting of the pages in your portfolio case, the pacing, and overall quality of the presentation will influence the reviewer's perception of your attention to detail and will reveal your skills and creativity in a very concrete way (see the example in Figures 12.2 and 12.3).

Each piece inside your portfolio is significant to your presentation, and when all are considered together, they should prove your range and ability as a designer. To exemplify the full reach of your design thinking, your portfolio should include analytic and metaphoric concepts in pieces ranging from print-based solutions to interactive and motion designs. The selection of the projects you present should represent just who you are and what you are capable of achieving, so make your selections wisely. Don't include every project you did in school.

Ideally, at least one project should cross over from one media to another. For example, to demonstrate a complete visual identity, you can show a crafted logo design plus its application to a printed item (a business card, brochure, or advertisement), a three-dimensional object

Graphic Design Portfolio Presentation

All of the work in your portfolio should be your best effort. Each piece, typically about fifteen, should represent a successful design solution. Here are a few things to remember:

- Small books or portfolio cases are more easily transported and handled than large ones.

- Begin with a few of your best designs.

- Finish with what you consider to be your very best work.

- Keep booklets and fold-outs in a side pocket.

- If your designs are on boards, have just two sizes for easier handling—one for smaller pieces, one for larger pieces. Both sizes should share one dimension for consistency.

- Don't turn pages for reviewers; let reviewers look through the portfolio at their own pace.

- Don't defend your pieces. Allow them to stand on their own merits.

- After your interview, send an e-mail message or short note to the reviewer, thanking the person for his or her time. Include an image of your best piece to serve as a reminder of who you are.

12.3 ABBY HIRSH. Wire-O® bound portfolio of pages.

(a package, truck, or piece of clothing), and a digital solution (a web page or motion design).

If there are gaps in your portfolio, fill them. Invent projects if necessary. Create a new logo, rework an existing website, or develop a new interactive element. The process of observing, identifying, and solving problems out in the world helps to validate your qualifications to an employer or client (see the Worklist on Graphic Design Portfolio Projects for categories that might serve as departure points for individual pieces). If you are just finishing school, a potential employer will not assume that you have a vast amount of work experience, but he or she might be impressed by your initiative to pursue design projects on your own.

When economic times are difficult, you may have trouble finding a job anywhere, but don't get discouraged. It is important at such times to just keep on working, so continue to come up with self-initiated projects or volunteer to do design work for a nonprofit organization. Keeping the creative side of your brain active and keeping up with the latest computer technology will serve you well when the economic climate eases. You will be even more qualified to pursue work when it becomes available.

While still a student, Calla Henkel designed the introductory wall of a gallery exhibit with a project titled *Free to Dry,* which questioned the wisdom of suburban communities banning outdoor clothes drying—a policy that would only add to the problem of global climate change. Calla clipped clothing and a block of type onto the clothesline and created a

FREE TO DRY

12.4 CALLA HENKEL. Design for a wall graphic introducing a gallery exhibit titled *Free to Dry* that questions the banning of outdoor clothes lines.

12.5 JOHN LEPAK. Illustrated quote poster. "Time is dead as long as it is being clicked off by little wheels; only when the clock stops does time come to life."—William Faulkner

ONE WEEK LATER

unified and powerful composition. The piece not only served to make viewers aware of an unusual issue, it also expanded the breadth of the student's meaningful work (Figure 12.4).

As you discovered in Chapter 6, form can communicate inner meaning, at times in a deeper way than words can express. Shifting and adjusting elements in a design to the point where you can sense that the composition is right reflects that you cared about something enough to give it attention. The projects you choose reveal something about your interests and concerns. See, for example, the typographic illustration by John Lepak illustrating a quote by the writer William Faulkner, "Time is dead as long as it is being clicked off by little wheels; only when the clock stops does time come to life" (Figure 12.5).

Lepak hung letterforms on the empty limbs of a tree and photographed them a day later to show the effect time had on the hand-cut letters. In this public installation, the tree seemed as if it had been brought back to life. As a piece in his portfolio, it shows how the designer is able to think beyond the usual computer-driven solutions to a project made by hand that included three-dimensional physicality.

Something as innocuous as a coffee spill can become a portfolio project, too. Max Pitegoff created an informational design that charted how many coffee spills occurred within one day, he being a self-proclaimed spiller (Figure 12.6). The treatment also adds to the information: the coffee-colored splash against a black circle creates a vigorous contrast that grabs attention, and the shape has a sense of urgency about it in the way it spills outward. The information is innocuous, but it shows how much further a design can be taken—in this case, beyond the typical pie charts—where the form itself becomes part of the information.

Creating a graphic design portfolio requires careful effort in both its content and presentation, but in the end, it is your best opportunity

12.6 MAX PITEGOFF. Chart illustrating the amount of coffee spills made over the course of eight days.

to showcase your skills and professional qualities. The Worklist on the Graphic Design Portfolio Presentation (page 308), which includes pointers on personal etiquette, project sizing, and pacing, will help you to put finishing touches on the design of your own portfolio.

Personal Website and Design Blog

Graphic designers today really need to have their own website and design blog. A website serves as an online portfolio, with each navigable section offering a categorized view of your work. For example, there might be a section for visual identities, print, motion, web design, and so on. If your

Graphic Design Portfolio Projects

Advertising design: Consumer (food, clothing, transportation), institutional (health, foundations, political, religious, professional associations); billboards, print (ad campaigns), radio (spots), television (storyboards)

Cover design: Annual reports, paperback or hardcover book jackets, magazine covers, music CDs, video DVDs

Display design: Institutional (banks, hospitals, museums, libraries), retail (stores, sales offices); banners, point-of-purchase, shop windows

Environmental design: Construction (barricades, sidewalk shelters), corporate (factories, offices, hotels, terminals), institutional (churches, hospitals, libraries, museums, schools, zoos), residential (apartment buildings, houses); kiosks, maps, signage (architectural, events, fairs, transportation), wall murals

Information design: Editorial, institutional; charts, forms, maps (indexing, directional signs)

Interaction design: Corporate, entertainment, informational, or institutional; websites, kiosks, mobile devices

Motion design: Film and television broadcasts; film title sequences; station identifications; web page banners

Packaging systems: Consumer food and products, industrial, pharmaceutical; containers (boxes, bottles, bags, jars, tubes), labels

Posters: Corporate (conventions, products, services); institutional (museums, botanical gardens, hospitals); partisan (political, religious), entertainment (film, theater, circuses, fairs)

Publication design: Annual reports (two-year summary, president's letter, public relations, financials); catalogs; book interiors (full titles, table of contents, chapter openers, main text, index/credits); magazines, (mastheads/covers, contents pages, article openings, subsequent spreads); newsletters

Typographic design: Typefaces; type manuals and alphabet books

Visual identities: Packaging (shopping bags, menus), signage (storefronts, windows, vehicles), stationery (business cards, envelopes, letterhead), style manuals; corporate entities (products, services), institutional entities (museums, foundations, nonprofits), events (fairs, film festivals); product lines (food, software); small businesses (restaurants, florists, bookstores)

Miscellaneous pieces: Calendars, invitations, menus, self-promotions, shopping bags, stamp series, T-shirts, wrapping paper

12.7 CAITLIN FOLCHMAN-WAGNER. Personal design blog.

> 66 99 *You can't depend on your eyes when your imagination is out of focus.*
> —Mark Twain (1835–1910)

To present yourself well, identify what you do best, and emphasize those strengths to the interviewer with specific examples that support your claims.

physical portfolio is not available for someone, your website will always be accessible.

Maintaining a current website indicates that you are serious about what you do. Many of the projects you will work on involve an online component, and your personal website is the perfect place to demonstrate your skills as a web designer. Keep it current with your latest projects, and make sure the functionality is flawless. You might lose a job opportunity if a client discovers that one of your links is broken or a page doesn't load properly.

Writing a design blog can be a very handy tool for promoting yourself. It keeps your clients and colleagues informed about what you're working on, and it can increase traffic to your site. It's a great way to establish yourself as an active member of the community of graphic designers. A design blog forces you to practice structuring your thoughts about design into clearly written text. The blog example "Mélange: A Miscellaneous Medley" is a depository of weird and interesting images and links (Figure 12.7). You will find yourself following the blogs of designers you respect, and hopefully those same designers will follow your blog. The secret to keeping your audience is to write well, be creative, and write regularly. If you drop off for two months, people will forget your blog and stop following you at all. Graphic designers are, of course, known to be primarily visual people, but writing is another way to let your voice be heard. You can have an impact on the field and market as a designer who thinks clearly and manages information in an organized fashion. And, best of all, it will simply remind people that you exist. When they need a designer, they might think of you first.

Interviewing

The main goal of an interview is to obtain the job you want; however, you can learn a lot from interviews, even if you're not sure the job is right for you. Interviews enable you to make contacts, learn about a firm, and see how other designers work. Even the interview questions can reveal how a firm functions and what its priorities are. Be sure to ask your own questions, too; they can help you decide whether the job is the right fit (while also showing that you know enough to ask about relevant things). You can ask better questions if you research the firm beforehand. With each interview, evaluate how you think you did, and your skills will improve.

The interview is a prime opportunity for you to market yourself. To present yourself well, identify what you do best, and emphasize those strengths to the interviewer with specific examples that support your claims. Also, show that you have an open mind—that you can debate and question appropriately while working cooperatively as part of a team. By engaging in a lively and positive conversation during the interview, you will demonstrate that you can add vitality to the organization. Tell the

EXCERPT: The Cheese Monkeys, A Novel in Two Semesters (P.S.), by Chip Kidd, *Simon and Schuster,* 2001

"The Cookie Cutters can't think about anything beyond selling cookies, so they would have you believe this class is the Introduction to Commercial Art. It is not. Should that give you cause to leave this room, do so now—without the threat of being scorned, or having to think."

Nobody did. Leave, I mean.

"But I've been put in charge of the store here, and I say it's Introduction to Graphic Design. The difference is as crucial as it is enormous— as important as the difference between pre- and postwar America. Uncle Sam … is Commercial Art. The American Flag is Graphic Design. Commercial Art tries to make you *buy* things. Graphic Design *gives* you ideas. One natters on and on, the other actually has something to say. They use the same tools—words, pictures, colors. The difference, as you'll be seeing, and as you'll be showing me, is *how.*"

interviewer what you can contribute to the organization, not what you hope the organization will do for you—a subtle, but very important difference.

As you consider jobs, keep an open mind about what sort of studio would be your ideal workplace. You may have expectations that are unrealistic. After all, every work environment is different. Don't make any rash judgments about a work situation until you have had a chance to get to know what it's all about.

The strongest impressions are made within the first thirty seconds, and are usually based on manners, dress, and etiquette, which an interviewer interprets as signs of respect. Always be on time—even early— for your interviews, but never late. No matter how employees dress, you should dress professionally and neatly for your interview. Interviews are not the time for exotic appearances. Never discuss previous employers or colleagues in a derogatory way or divulge confidential information about other people or firms. If you do, you show that you might do the same anywhere you work. Your interviewer might also have a relationship with someone you mention, so discuss everyone with the utmost respect. Some people think that the rules are different for artists, that they can present themselves in eccentric ways because they are creative people. That idea simply is not true during an interview. Be professional and mature at all times.

When going to an interview, always bring a sample of your work that you can leave behind. It will remind the interviewer of you and your capabilities; he or she might also want to show the work to others who were not at the interview. This sample can be printed reproductions of several key pieces of your work, reduced in size and neatly packaged with a business card attached, or it can consist of digital samples and contact information on a CD or DVD. Keep it short and sweet—just a summary of highlights (see Figure 12.8).

You can also use this work sample to try to get an interview. It can serve as an introduction or miniature portfolio. The point is to give a taste of your entire portfolio, show your talents and creativity, and get your contact information into the hands of a possible employer or client.

Some firms discuss salaries during an interview, but most leave that discussion until making an actual offer. You shouldn't be the one to bring it up. If your interviewer discusses salary, be flexible, especially if the offer is less than expected, but don't commit to anything right away. You will make better decisions when you are not in such a high-pressure situation. It's perfectly appropriate to say you would like time to consider the information. Later, you might try to negotiate before deciding anything, particularly if you have other interviews around the same time. Make sure you get details about the offer, including hours, salary, benefits, and vacation, so you know exactly what you are accepting or rejecting. If you are interviewing at a firm that you think fits your sense of design and career

12.8 WORKSIGHT. Mini portfolio sampler with tiny tools attached to create a gift-like feeling.

goals, seriously consider accepting an offer that might be below your ideal. The learning experience alone could be worth the low salary, and you might be surprised at how quickly you are given more responsibilities and compensation.

Always, always follow up with a thank-you note, either by e-mail or regular post. Thank the interviewer for his or her time, and summarize your qualifications as well as what you could bring to the company. A thank-you note may seem old fashioned, but it shows you are a mature, respectful individual who would be a responsible and reliable employee. It also keeps you in the employer's mind. Send a note even to a company that rejected you at the interview or a company where you don't think you want to work. Someone might come back to you with a better offer or remember you when another job becomes available. A thank-you note is a small courtesy that can reap huge benefits.

The Business of Design

Create your own visual style….
Let it be unique for yourself
and yet identifiable for others.
—Orson Welles (1915–1985)

There is a practicality to graphic design: ads must sell, books must be readable, and websites must function smoothly. In addition, design projects will need to be completed in a limited amount of time or within a limited budget, will most likely need to be approved by someone besides you, and will require revisions that can drive one mad. These practicalities reflect the business side of design. It is less glamorous than pure aesthetic expression, but just as important in the process of completing work.

SPEAKOUT: Trust Your Instincts by Connie Birdsall, creative director and senior partner, Lippincott

Before you apply for employment at a particular firm, you'll want to do your homework. Make sure the firm has people you admire and can learn from and opportunities for growth. Understand what a day in the life is like. Know who its clients are.

After you've drawn up your list of pros and cons, how do you decide? Think about the work environment. Is this the kind of place where you'll be able to grow creatively? When you interviewed, did you see yourself fitting in and thriving there? A common theme I've heard from candidates about their previous jobs is that they didn't thrive in the work environment. And the truth is, not every studio will be a right fit for you.

Once you feel good about a workplace, then you need to tune in to your gut. This is the time to listen to that voice in your head and not censor it. Did you have a visceral reaction to your potential boss or coworker? How did you feel after the interview, when you were on the street walking away? What was the first thing that came into your mind? Remember, great designers have great creative and intuitive instinct. Use yours and cultivate it when you interview. The ability to trust your instincts and know yourself is a skill that will benefit you on interview day and throughout your career.

Sean Adams is a partner at AdamsMorioka. He has been recognized by every major competition and publication, including, Step, Communication Arts, Graphis, AIGA, the Type Directors Club, the British Art Director's Club, and the New York Art Director's Club. A solo exhibition on AdamsMorioka was held at the San Francisco Museum of Modern Art, and Adams has been cited as one of the forty most important people shaping design internationally in the ID40. He has served as the national president and national board member of the AIGA and as president of AIGA Los Angeles. He is a fellow of the Aspen Design Conference and an AIGA fellow. He teaches at Art Center College of Design and is a frequent lecturer and international competition judge. Adams is the coauthor of Logo Design Workbook, Color Design Workbook, *and author of* Masters of Design: Logos & Identity: A Collection of the Most Inspiring Logo Designers in the World *and* Masters of Design: Corporate Brochures: A Collection of the Most Inspiring Corporate Communications Designers in the World. *AdamsMorioka's clients include ABC, Adobe, Gap, Frank Gehry Partners, Nickelodeon, Sundance, Target, USC, and The Walt Disney Company.*

▶ Is your design approach influenced by personal experiences?

I'm not so crazy about chaos. I've never been interested in drama or unnecessary conflict. I'm not interested in being oblique or cryptic. Since founding AdamsMorioka, we've maintained a philosophy of speaking in plain and pragmatic terms with our clients. I've seen too many abused clients who have been beaten into submission by a tyrannical designer to continue the cycle of abuse. I treat our clients with the respect I would expect to be given. This may be a product of relentless etiquette training as a child, but it probably has more to do with just good common courtesy.

How do you maintain your point of view in a large-scale project?

This attitude of clarity is at the core of every project. The concept of courtesy and respect transfers, not just to the client, but to the audience also. We've been accused of doing work that is too accessible, but why shouldn't it be? Making work that is purposefully oblique not only tends to sink under the weight of its own importance, it has a clear subtext of exclusionary elitism. "The client needed to be educated" is a phrase that drives me to drink. Respect and true collaboration is critical to maintain a personal vision on any project, large or small. Like the saying, "Don't worry about people liking you, just try liking them," if I treat

my client with respect and as an equal, 90 percent of the time, the same is returned to me.

What advice do you have for someone interested in making design their occupation?

When making a career choice, follow the three Q's: quality, quality, and quality. Do the best work possible. Work with the best people you can find. In my experience, good work gets you more good work. Bad work will always attract more bad work. The best people know other good people. In the end, your future will be determined by the quality of your design work. Money may be tempting, but the work is your future.

CENSORSHIP
+
SILENCING

PRACTICES OF CULTURAL REGULATION

Vignette 12.4
Sundance Film Festival
book jacket design.

Vignette 12.5 Adobe
Creative Suite package
design.

Vignette 12.1 (above)
University of California
poster announcing a series
of week-long seminars on
the issue of censorship.

Vignette 12.2 (opposite)
Poster design for the
University of California
announcing the start of its
winter quarter classes.

Vignette 12.3 (right)
Logotype for Oh! Oxygen
cable television network.

Design also requires an ability to express abstract data concretely, to make strange information more familiar so the viewer will feel comfortable with it (for example, complex numbers simplified into a pie chart). At other times, familiar information needs to be made a bit strange to create interest (for example, an event poster announcing dates that need to stand out).

None of these business circumstances diminish the potential for a design to express and enlighten. This double duty that design performs helps define it as unique profession, one with an objective to communicate ideas. Furthermore, graphic design opportunities can be realized through studios established by others or through your own enterprise. Either way, design work involves personal and professional ethics as well as the maintenance of a sustainable environment.

Starting Your Own Practice

Graphic design programs don't offer many courses on the business aspect of design. The assumption is that you will learn the ropes while working for a firm, for example, how to correspond with clients, how to take a project from start to finish, and how to use good phone etiquette such as stating the name of the studio when answering a call.

Whether you are just entering the professional field or have worked for years in a studio, starting your own practice means pushing aside the fear you may have about actually doing it, and there will be many reasons to hesitate, including the financial insecurity of not having a full-time job or the potential loneliness of working by yourself. Your survival will rely on finding work and keeping clients, including getting work from larger studios and agencies. There are four basic working relationships you should establish:

- An accountant to help you with bookkeeping practices and government tax requirements. An accountant will be able to recommend whether you should start your business as a **sole proprietorship** (a business owned by one person), as a **partnership** (each partner being liable to the other), or as a **corporation** (the business as a separate entity from the individuals who compose it).

- A lawyer whom you can turn to for legal advice on leases, overdue invoices, and the basics on liability. A lawyer's hourly fee will be much higher than yours, but it will be worth it.

- A bank specialist to help you create a business checking account and suggest ways to handle day-to-day transactions.

- A professional printer or programmer who can guide you through production processes such as file preparation and **finishing techniques** (trimming, folding, binding, or programming languages). Nurture loyal relationships with your collaborators who will be there for you as you grow your business.

A lot can be used. —Rick Vermeulen

► **In Practice:** *The AIGA website offers a thorough set of documents concerning the design business and its ethics. The AIGA has its own Standards of Professional Practice available at aiga.org/standards-professional-practice.*

View a Closer Look for the manifesto on **myartslab.com**

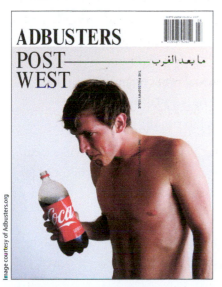

12.9 "First Things First Manifesto 2000," was simultaneously published in *Adbusters* (Canada), *Emigre* and the *AIGA Journal of Graphic Design* (United States), *Eye* magazine and *Blueprint* (Britain), and *Items* (Netherlands).

12.10 *Adbusters* magazine cover design *(the philosophy issue).*

Design Ethics

Over the years, graphic design has honed its own set of ethics on professional behavior, including policies toward plagiarism; speculative work; contracts; and the property rights of software, typefaces, and images. The fields of contract law and intellectual property rights have become quite complex, but you will need some basic understanding of them to run a professional design business.

The field of graphic design includes the creation of ethically minded design projects, ones with a sense of social responsibility, or what we might understand as design for the greater good of society. Lester Beall's Rural Electrification poster from 1937 is an early example (see Chapter 2, Figure 2.58). Beall's powerful reductivist approach helped Americans understand why bringing electricity to people living in rural areas was a moral obligation. Beall used design as a means to create positive change. Just four years after Beall's project, Nazis in Germany began to use design as a propaganda tool, creating messages promoting the Nazi dictatorship that used graphic design for a very different purpose.

Design ethics can operate at both a personal and public level. Personal ethics can help designers create a better profession for themselves. For example, refusing a project or client that you know is misleading will add to your own integrity and to the overall positive perception of your profession, but agreeing to do such work can damage your reputation and hurt your design career. In choosing to do only work that you think will positively affect the world, you will help the general public make better, more informed decisions about their own lives.

This approach to a more humanist concern took shape in 1964 with the publishing of the paper "First Things First," by British graphic designer Ken Garland. Backed by more than 400 graphic designers, the manifesto challenged the profession's growing consumerist culture and presented an appeal for the pursuit of "more useful and more lasting forms of communication." Designers began to realize that they were on the front lines in handling information with ethics and integrity. Thirty-six years later (in 2000), *Adbusters* magazine updated the manifesto, proposing "a reversal of priorities in favor of more useful, lasting, and democratic forms of communication—a mind shift away from product marketing and toward the exploration and production of a new kind of meaning" (Figures 12.9 and 12.10).

The Internet has increased the speed at which ethical issues arise as the profession evolves. For example, design projects are now posted with a call for submissions from worldwide participants, with only one design to be chosen. This form of crowd sourcing, requesting designed work that is specially created (usually without compensation) and submitted from many competing finalists, is open to ethical debate because of the harm it does to the profession when unchosen designs are then used for other purposes. As the profession evolves, it will continue to nurture values that affect the society in which it operates and to whom it communicates.

Environmental Sustainability

Environmental sustainability refers to the responsible maintenance of the environment, and the design community has become especially conscious of its role in how energy and resources are used in producing printed materials and in its use of energy resources. Concerned designers have influenced the printing and paper industry which, in turn, has responded quite admirably. Today, most printers use nontoxic inks and varnishes in their process. Paper companies are finding better ways to recycle paper fiber and have become part of stewardships that offer responsible management and protection of forests, which prevent damages from logging such as habitat destruction, water pollution, and displacement of indigenous peoples.

The job of educating others to the value of a healthy, sustainable environment continues today with the understanding that sustainability's goal is not to eliminate paper, but to use it in sensible ways. The Worklist on Sustainability by Noble Cumming helps designers to realize this vision by providing questions every one of them should ask themselves with each new project.

The *You* in Your Work

When other people recognize your work, it is a great compliment. They may recognize your humorous attitude coming through the work or see a visual treatment that you have brought to many of your solutions in the past. These distinguishing characteristics reflect your style, which can come through you unconsciously. In fact, your style *is* you.

> **""** *What works good is better than what looks good, because what works good lasts.*
>
> —Ray Eames (1912–1988)

▶ *In Practice: There's a difference between personal style and general style. A general style usually begins as the style of one person. Once adopted by an increasingly larger group, it can eventually be labeled as trendy or stylish. The problem with adopting a trendy style in your own work is that trends usually peak and then subside. The originators of those trends progress onward, but the designers who simply copied the trend are left with work that looks dated.*

WORKLIST

Sustainability by Noble Cumming

- Consider the materials you are using.

- Are the inks the printer uses environmentally friendly?

- How much ink are you using for your piece? Can you use less in areas?

- Are you using standard paper sizes? If not, can your press sheet hold more pages by a slight adjustment in proportion? Can multiple jobs be run on the same sheet?

- Is the printer using green energy?

- How much electricity are you using while designing? Do you shut down your computer at night? Is your studio energy efficient?

- Is an actual proof required from the printer or is a PDF acceptable for approval to run the job?

- How far away is the printer? Will a local printer cut down on the cost of travel for the finished product?

- Can the finished product be reused—is there a way for the design to expand the life span of the piece?

12.11 MARIA UROOS. Series on the positive and negative effects of the Iraq war.

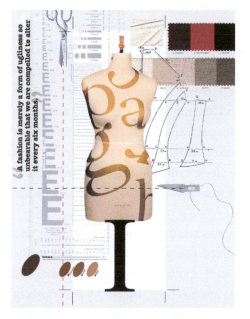

12.12 JANET LEE. Personal myth project.

12.13 RICK VALICENTI, THIRST. Vancouver Lecture Poster.

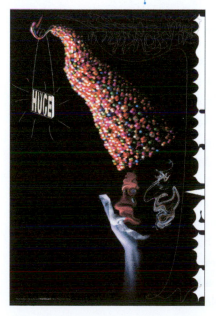

The places we've been and things we've seen, felt, or heard all broaden our vision as designers. They also define us. For example, a trip to Vermont to see the foliage could add to your color pallet; an unfortunate visit to a hospital's emergency room could shock you into realizing how efficient people can be under pressure. In either case, both experiences will be internalized: you will realize that a recent design has a color you never thought about using before, or it has an energized immediacy about it. These influences can come from everywhere. Can you trace them back?

The fact that some place or thing might feed your work is, in effect, acknowledging connections with your larger culture, community, and environment. A good example of this dynamic is a visual series on the impact of the Iraq war by Maria Uroos (Figure 12.11). She grew up in the Middle East and felt a need to create a visual dialogue about the changes in life, culture, and religion that she saw there. Her tools include text and image, metaphors and analogies, elements and principles. All convey thoughts about the region where she lived, fleshed out into a form that is meant to extend conversations. Each piece begins with her.

In a design experiment by Janet Lee, whose family is in retail fashion, two activities are merged into one composition (Figure 12.12). She created a montage of typography with a dress form, color chips with fabric swatches, and single-edge cutting blades with scissors. The art historian E. H. Gombrich (1909–2001) wrote, "Anyone who can handle a needle convincingly can make us see a thread which is not there." The connection this designer makes to retail fashion isn't necessarily there either, but is more a myth that forges a connection to something more personal and perhaps more meaningful to her. She uses that same ability to tell stories and making connections when creating works for her clients.

In another piece, Rick Valicenti examines his own future role as a graphic designer (Figure 12.13). The poster's purpose is to announce a design lecture in Vancouver, Canada, and the character pictured—a jester that is full of remorse—is a portrait of Valicenti himself. Hanging off his hat is a flickering sign that reads "HUGE." The ghostlike, wispy image of an old man beside his own face hints at his later life. Together, the images make a social comment about whether this effort is all there is in Valicenti's future, and for that matter, in the profession as a whole. In other words, designers can be practical problem-solvers (such as finding a way to announce an event), but also passionate artists whose work also matters in terms of making a positive difference in the world. See the Designer Vignette with Rick Valicenti on pages 322–323.

Designing within a Group Environment

Pablo Picasso is quoted as saying, "Good artists copy. Great artists steal." In other words, whereas bad artists can only copy what they see, great artists understand the whole concept behind a work, and they steal the whole work—ideas, visuals, and all. They then can take that work, develop it further, and make it their own. Design works the same way, especially in a group environment. Design teams are created to effectively complete large projects, especially ones with many components. Instead of being solely responsible for an idea and its execution, you are just one of a group of designers. You may think this arrangement would stifle your creativity, but many designers find that they work better within a group. The exchange of ideas and collaborative effort can foster creativity in ways you may have never considered. You learn to build off of one another, and the results can be quite amazing.

Expressing your own voice may be difficult when you are part of a team, but it is a skill you can learn. Social skills are important to maintain in these group environments. Getting along, being a good listener, contributing to the discussion, and staying focused through a meeting and project can result in a positive work experience. Pay attention to the main ideas that your client and fellow designers want to get across. Ask your own questions to determine design directions to take from those ideas, which is the best way to figure out just what your role will be in the project.

When you take the time to understand the points being made and ask questions specific to those points, you effectively contribute to the research process. Your team will want you to be the creative individual you normally are as you collaborate and become inspired by the efforts of your colleagues. Your particular approach in developing ideas will add to the successful output of the whole group.

Your Voice in Advertising Design

The groundbreaking work of art directors such as Bill Bernbach, Helmut Krone, and George Lois established a strong relationship between what an ad says and how it looks (see Chapter 2). They formed the basis for advertising design—the form brought to words and images to help convey a message. Advertising is a very competitive environment. Ads need to sell products or services, and their daily barrage on the public makes traditional design projects seem relatively tame. Book covers, logos, and websites are competitive, too, but not at the level that advertisements are.

Breaking rules creatively is a most valuable asset in an advertising agency. Before an ad can have the chance to resonate, it must first get noticed. The designer must create graphic excitement that is backed up with an idea. Think of a memorable ad. What made it memorable? Was it funny, smart, or compositionally pleasing? Usually it's all of these, with

CONTINUED FROM PREVIOUS PAGE

taking what a client says, transforming it, and giving it back to them in a way that's exciting, creative, and even magical—yet, in their eyes, still a product of their imagination.

The second is an "air comp," spontaneously creating a new concept, but only through word and gesture after a client looks unimpressed at a presentation. This usually wins back their faith and buys you enough time to get some sleep and present a new design.

Design Collaboration

by Rick Griffith, Matter; instructor, University of Denver

The future of graphic design will rely on its collaboration with people who don't fit its current definition. By encouraging interests outside its border, design will breathe new life into areas of communication that haven't been considered before (Figure 12.14).

the designer's voice completing the human connection and perhaps providing an unexpected twist.

Design and Technology

We may, in fact, be transitioning out of our incunabular period of the digital realm. The word, from the Latin word cuna (cradle), refers to the first stages of something and is typically used in reference to books created before 1501—during the infancy of printing. Our digital incunabula applies to graphic design from 1984 to the current time. As we enter our digital "toddler" phase, we are seeing the mouse and hard drive disappear, monitors are becoming invisibly thin, separate design applications now blend into one, and our bodies integrate into the design process.

This toddler phase is foreshadowed in the Web's increasingly interactive nature through which consumers build their own content. As technology evolves—as the machines and software get better and better—our ability to focus on pure ideas will grow. The resurgence of letterpress printing and bookbinding techniques increasingly value the craft and care given to information you can hold as being older art forms.

12.14 RICK GRIFFITH. Chart design notating the theory and practice of critical visual communication.

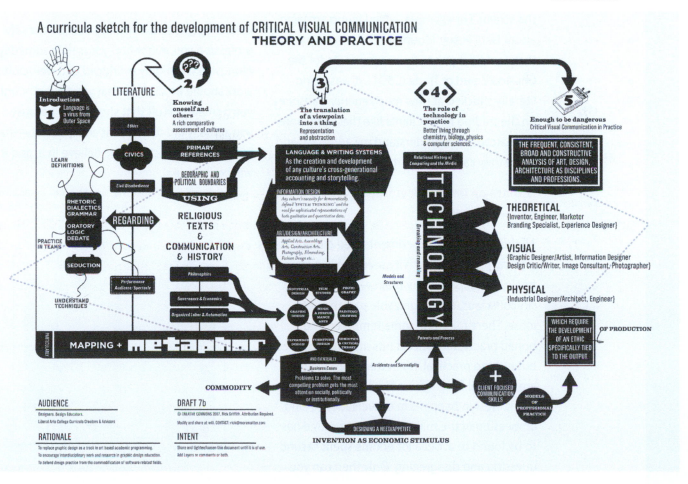

Rick Valicenti has a BFA from Bowling Green State University, and an MA and MFA in photography from the University of Iowa. He has lectured extensively on six continents, exhibited his work internationally, and juried countless design awards, including the Presidential Design Awards/ National Endowment for the Arts. He received the 2011 National Design Award for Communication Design from The Cooper-Hewitt, National Design Museum, the AIGA Medal for his sustained contribution to design excellence and development of the profession, and the AIGA Chicago Fellow for his steadfast commitment to the education of design's future generations. Valicenti has been a member of the Alliance Graphique Internationale (AGI) since 1999 and has served as president of the Society of Typographic Arts. His work has garnered awards from the Type Directors Club, Tokyo Art Directors Club, AIGA, ACD100, Graphis and ID Magazine, among others, and has been included in the permanent collections of the Smithsonian Cooper-Hewitt National Design Museum, the Art Institute of Chicago, and Library of The Museum of Modern Art.

▶ Your personal style doesn't just sweat out of you, it bleeds. How do you convince clients that their communications aren't going to be overwhelmed by your finished design?

Let's just say that I'm a curious fellow who gets very excited about the subject matter I work with. I simply translate my raw expression about those subjects onto paper or in digital bits on the screen. For example, what I found amazing about Gary Fisher Mountain Bikes was a product that could get you to fly on wheels. As for the Chicago Board of Trade (CBOT), it was being literally shocked at how much energy transpires on the trading floor. Clients like these are more like patrons; they understand my approach and know they can take it to market.

Is there an impractical side to your experimentation?

All the impractical experiments feed directly into my practice. Creativity seems to live more freely in that part of my brain—the messy, subconscious, unrecognizable part that lets loose. There might be some tempered and honed practicality once it hits my consciousness, but not too practical. It's better when the two are on equal footing, just like a designer and a client. Design happens in conversation, a kind of meeting of the minds. Common ground has to be found to avoid a lot of time spent second guessing and disagreeing. Only then can you

"get away with it," if you know what I mean. But the honest truth is that fresh, innovative work develops early in the process, where everyone is personally as well as emotionally engaged. The moment that stops happening, you start to see formulaic design being applied to design problems.

Do you have any advice for design students entering the field?

Invest in yourself by working outside the safe profession you might find yourself in someday. Alongside the highly produced and well-crafted work should be designs that you never thought you'd create—stuff that shocks you because you actually did it. Feel that chill you get—that's passion that you can't fake. Believe in it, and it will become real.

Vignette 12.6 Chicago Board of Trade annual report spread using semi-transparent paper.

Vignette 12.7 Portrait, *See Thru Me.* Gilbert Paper promotion.

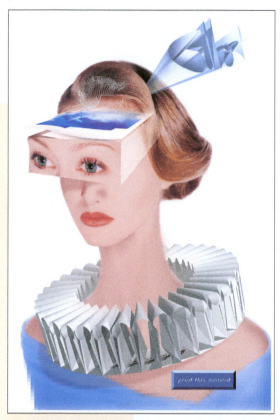

Vignette 12.8 Chicago Board of Trade annual report cover and page spreads.

Vignette 12.9 Gary Fisher Bicycle Corporation page spread from the brochure titled *Change is Good*.

Advertising Design Parameters

- What is the background of the project or service (its history, competition, future prospects)?

- How does it compare to a similar product or service?

- What makes the product or service different?

- Is it an often misunderstood product or service?

- What are the negative aspects of its use?

- Are the points you're making about the benefits believable?

- What is most honest in the communication you're creating?

- Does the ad's composition have stopping power (ability to grab attention)?

- Does the design have a distinctive feeling, personality, attitude, and so on?

- Can readers see themselves in the picture?

- What is the payoff for the audience? Does the ad appeal both to the head (intellect) by which they learn something and to the gut (emotions) by which they are moved or entertained?

> *I just say I'm an artist who works with pictures and words.*
>
> —Barbara Kruger

12.15 ANDY WARHOL. *Campbell's Soup Cans.* Installation of 32 canvases at the The Museum of Modern Art, New York. 1962.

Design and the Fine Arts

The debate as to whether design is considered an art seems to have become irrelevant as the two fields have converged in so many ways. Yet the issue is worth contemplating as our culture morphs and changes because designers keep pushing the boundaries of what defines their field.

Presumably, for a fine artist, a client doesn't exist. Even commissioned work allows for a certain amount of freedom to create original work without burdensome limitations. Designers aren't so lucky. Their work must reach out from the wall and grab the audience's attention. Ideas and meaning are constructed mostly from content provided by the client and in response to a client's request.

If this challenge weren't difficult enough, designers also have had to live under the mantra "form follows function" for decades. Form is not subservient to information; it is information itself, but the mantra translated for many into a kind of neutralized, "authorless" design approach. The result was a commercial art that was ever more relegated to the bottom rung in the hierarchy of artistic expression.

In many ways, Andy Warhol (1928–1987) changed that mindset (Figure 12.15). Originally a working graphic designer and illustrator himself, Warhol became a painter and printmaker, creating prints in multiple quantities. Through his artwork, he continually examined the commercialization of the fine arts, using pop culture icons that included images of movie stars and packaging found on store shelves. His groundbreaking work seriously questioned the distinction between the fine arts and advertising.

Other artists such as Ed Ruscha and Barbara Kruger have expanded the idea of incorporating the commercial world into their work. Ruscha

12.16 ED RUSCHA. *Standard Station*. Screenprint. 1966.

12.17 BARBARA KRUGER. *You Are a Captive Audience*. 1983.

treats corporate brands as cultural symbols and creates paintings of these brands (Figure 12.16). He is particularly well known for his paintings of signs and billboards. Barbara Kruger blends stock photography with confrontational writing, creating very bold graphic statements about our culture (Figure 12.17).

Designers can learn much from this work that crosses boundaries into territories previously unexplored by the design community. For example, in the exhibition *Thoughts on Democracy,* sixty leading contemporary artists and designers were invited to create works inspired by American illustrator Norman Rockwell's *Four Freedoms* paintings of 1943. In a piece for the show titled *Liberty Weeps* (Figure 12.18), designer Elliott Earls cross-references yet another artist's work from 1830, *Liberty Leading the People* by Eugène Delacroix (1798–1863). Rather than show a grown woman leading the charge, as Delacroix portrayed, Earls's allegory, or symbolical narrative, depicts a young child who seems to beg us to take responsibility for our actions as an equally young nation.

Earls's poster also signifies graphic design's evolution. The facial expression of Henri de Toulouse-Lautrec's dancer (*La Goulue,* Chapter 2) quietly reflected the miserable social conditions in which the dancer lived. Over one hundred years later, Earls's *Liberty Weeps* presents an unabashedly prominent expression of sadness. Whereas Lautrec's sad smile was subtle, Earls's is not. The role of design as a means to comment on our society has evolved to become part of a larger cultural conversation.

12.18 ELLIOTT EARLS. *Liberty Weeps,* as part of the Wolfsonian-Florida International University's exhibit *Thoughts on Democracy.*

EXCERPT: Never Give Up. Never Give In by Charles Goslin (1932–2007), design professor, Pratt Institute and the School of Visual Arts (SVA)

That small child with the scissors and colored paper, sitting in the middle of the parental living room rug, making shapes out of beautiful colors, for his or her own joy, not for money, not for critical acclaim, that child is you. You have the opportunity to create what never was. Forget about revolutionizing the world. Work for the joy of working, and without intending to, you will help to change your corner of the world.

> " Everything needs redesigning
> today, from the laws we live by
> to the institutions we believe in.
> In addition to a degree in graphic
> design, get a degree also in
> another field so you can extend
> your reach and transform the
> human condition. —Barry Deck

In Perspective

This chapter has covered three main points that will guide you in your future career. The first point is that you must be willing to put yourself out there, to be assertive both personally and through your work. Graphic design is a field for extroverts, not introverts. Just as designs have to reach out to the viewer, designers also have to reach out.

The second point is that in promoting yourself, you should handle it just as you would a design project, considering you and your work as a total package. Creating a cover letter and résumé, professional portfolio, blog, and website translate as meaningful acts that indicate you care about design and that you have a distinctive point of view. Make them look as professional and creative as you would any design project. They are the tools you use to present yourself to the world.

The third point is to remember that, although your design work speaks for your client, it also speaks for you. In other words, define yourself through the designs you make. Design can be as deep and expressive as you want it to be. You can include a full spectrum of design projects in your portfolio, but also make sure to include projects that use type and image to break boundaries into more personal, cultural, and social areas. Certainly you have to make work that pleases your clients, but it has to be your work—designs that say something about who you are and what is important to you.

EXERCISES AND PROJECTS

✓ Review additional Exercises and Projects on myartslab.com

Exercise 1 (Real World Practicalities): Find an existing logo that you think is very poorly designed. Make a copy of it and construct a worklist of points to consider if you were to redesign it. Base your decisions on the perceived audience, what you believe their response should be to such a mark, and whether the final design should be typographic, pictorial, or abstract.

Exercise 2 (Working in Groups): Break into groups of three and find a website for an unusual museum (for example, toiletmuseum.com). Think about a directional signage system for this museum. You will be designing three signs (elevators, bathroom, and parking). Your design can be iconographic, photographic, or typographic, and the directions can be humorous or serious, but your design must integrate with the subject of the museum itself. Full color. Format/Material: Open.

Project 1 (Rework an Existing Design): Find what you consider to be a really bad advertisement and rethink it, reframe it, bring new meaning to it—completely redesign it. Your design should integrate the existing text from the ad, but if you need to edit it, do so. Your job will be to bring craft

and thinking to the form and content of the design. Create new imagery using either a photo or illustration. Try to engage the viewer's mind and please the eye.

 Things to Consider: *Ads tend to show scenes. Make your scene more like a meaningful sign.*

Project 2 (Personal Myth): Compile a list of professions or activities that you know well and have participated in. The list can include, for example, your family's business, your first job, another subject you studied, or a sport at which you have excelled. Choose one and write a paragraph on the basic tenets of the profession or activity and how it is similar to graphic design. Explain it in terms of how it relates formally, psychologically, physically, socially, etc. Don't be afraid to abstract it to make a connection. Examples: (1) If you studied linguistics, you might consider the similarity between your understanding of language structures and what you know about structures in design; (2) If you have been a part of a swimming team, discuss how pacing and breathing relate to aspects of sequence and page layout in design. Begin with a subject you know well and see where it takes you in terms of branding and identity, form-making, storytelling, structural metaphors, and conceptualization.

Review your research and consider how it might guide the structure of your graphic design work. If you're having trouble coming up with a field that relates, just make one up. Create a poster as a document of your research. Full color. Size: 18" × 24".

 Things to Consider: *The value of this assignment is to learn that by pairing two seemingly unrelated things, each becomes better defined. Graphic design tends to be so oriented toward the public; when comparing it with a more personal activity, you are exercising your skill of finding analogies between subjects.*

View a Closer Look for the myth project on **myartslab.com**

Project 2 TOP TO BOTTOM, LEFT TO RIGHT: GENELLE SALAZAR, NICOLE RODRIQUEZ-LEWIS, MIKE CARSTEN, ANNE CHIANG, GERALDINE TRY, SUNGHYUN PARK, DAVID CIMOROSI, AND JAMES MOFFITT.

Key Terms

Abstraction
The process of distilling an image or information down to its basic elements or qualities while moving away from pictorial representation. (p. 44)

Aestheticism
A late nineteenth-century literary-based art movement whose goal focused on a search for ideal beauty. (p. 42)

Analogous colors
Colors that sit next to one another on the color wheel. (p. 164)

Analogy
A comparison between two things as a way to increase meaning. (p. 76)

Analytic concept
A concept that relies primarily on the audience recognizing treatments and relationships where the use of form, line, color, and texture have a considerable role. (p. 90)

Anti-aliasing
A method of fooling the eye into believing that a jagged edge is actually smooth, used in digital type to make curved letterforms. (p. 229)

Art Deco
An art and design movement initiated as a decorative style during the 1925 Paris Exposition. Its sleek lines and geometry offered an exciting alternative to the floral patterns of Art Nouveau. (p. 56)

Art movement
The manifestation of visual concepts in the art world, also expressed in the graphic design of historical periods. (p. 42)

Art Nouveau
Late nineteenth- and early twentieth-century art and design movement inspired by both the Arts and Crafts and Aestheticism movements. Its high contrast shapes, patterns, and plant motifs broke away from traditional dependence on history and the classics for its subject matter. (p. 42)

Arts and Crafts movement
A late nineteenth- and early twentieth-century art movement, based on the theories of John Ruskin and William Morris, that advocated traditional craftsmanship using simple forms and that looked to medieval decorations as inspiration. (p. 42)

Balance
The distribution of items in a composition that achieves visual equality symmetrically or asymmetrically. (p. 167)

Baseline
Horizontal base alignment of the feet of capital letters and bottoms

of nondescending lowercase letters. (p. 184)

Bauhaus
An early twentieth-century school of design established in Weimar, Germany, that promoted a blending of the applied arts with technology and functionally based aesthetics. (p. 53)

Bleed
Type, image, or color that extends beyond the trimmed edge of a page. (p. 200)

Brainstorming
A problem-solving session where creative thoughts are allowed to flow freely and spontaneously. (p. 129)

Brand
An identity for a product or service to show ownership, especially as it pertains to the personality projected to the public. (p. 13)

Cascading Style Sheets (CSS)
A style sheet language used to create the layout, colors, and fonts of a web page that then cascades onto subsequent web pages, allowing them to share the same formatting. (p. 220)

CMYK
An abbreviation for the four process colors—cyan (C), magenta (M), yellow (Y), and black (K). (p. 164)

Cold type
The setting of type using a photographic exposure process. (p. 183)

Color
The appearance of light reflected by an object, defined in terms of hue, value, and saturation. (p. 164)

Complementary colors
Pairs of colors that sit opposite each other on the color wheel. (p. 164)

Comprehensives (comps)
The polished and finished versions of roughs. (p. 30)

Constructivism
An art movement that existed from 1919 until the beginning of World War II. Inspired by the early politics of Soviet Russia, it favored art as a practice for social reform and was concerned primarily with machines, space, materials, and motion. (p. 50)

Contrast
The juxtaposition of forms, treatments, or ideas to create visual or intellectual tension, resulting in an enhanced perception of differences between the elements. (p. 169)

Copywriting
The art of writing headlines and body text for advertisements, brochures, websites, and other

published material. (p. 14)

Corporation
A business that is a separate entity from the individuals who own it. (p. 316)

Cover letter
A letter that serves as an introduction to one's resume or portfolio, used to present one's work to a potential client or employer. (p. 306)

Critique
An evaluation or review of work, usually done in a group setting. (p. 29)

Cropping
Removing the area outside of what is determined to be the desired image or frame. (p. 174)

Cubism
Early twentieth-century art movement that made use of abstract form and space, creating a fragmented perspective both visually and conceptually. It made a complete break from the past in terms of image and concept. (p. 46)

Dada
Twentieth-century art movement that rejected all traditions and standards in art. Its nonsensical spirit established footholds in America, Germany, France, and The Netherlands. (p. 48)

De Stijl
Meaning "The Style," a Dutch abstract-art movement of the early twentieth century that was known for its straight lines, right angles, and primary colors. (p. 52)

Deconstruction
A philosophical movement that began in the 1960s when the term was coined by French philosopher Jacques Derrida. It critically scrutinized literature, power structures, and cultural values, while making extensive use of irony, puns, and word play, with the goal of destabilizing defined meaning and eliminating assumptions. (p. 118)

Depth
The perception of physical space. Also the complexity of meaning within a design. (p. 160)

Design brief
A written document establishing a project's parameters, including what needs to be achieved, by whom, when, and why. (p. 29)

Digital age
Also called the computer age or information age, identified by the ability to access, manipulate, and distribute information freely and quickly using a computer. (p. 69)

Direction
The orientation of elements within a design composition. (p. 170)

Dominance
A compositional principle based on how the emphasis of an element on the page creates visual hierarchy, determining what is seen first, second, and so on. (p. 172)

Egyptian serifs
Also known as slab serifs, typefaces that have thick rectangular finishes to their vertical strokes. (p. 184)

Em
A unit of measurement used in letter spacing, which is proportioned to the width of a capital M. (p. 195)

En
A unit of measurement used in letter spacing (generally proportioned to the width of a capital N) that is one-half the width of an em. (p. 195)

Environmental sustainability
Responsible maintenance of the environment so it can endure and thrive. (p. 318)

Finishing techniques
Trimming, folding, binding, and other post-production processes of printing. (p. 316)

Flow
A stream of connections that help move the eye to specific focal points. (p. 170)

Flow lines
A grid's horizontal lines. (p. 221)

Flush
Alignment of text or other elements on the margin. (p.199)

Focus group
Field or primary research that involves group meetings in person or online and that makes use of phone surveys. Participants are selected based on how they might typify a consumer and are observed for their attitudes, reactions, and choices toward a product or service. (p. 116)

Foley artist
Sound technician, replicating everyday sounds and background noises for filmmaking. (p. 295)

Font
The complete set of characters, figures, punctuation marks, and symbols within the specific style of a typeface family, for example, Helvetica Bold. (p. 192)

Footer
Text, usually containing the title or author of the publication, that runs along the lower portion of a page type, beyond the field of the regular body of text, that repeats on every page (see also Header). (p. 226)

Form
Color, line, shape, or manner. (p. 76)

Four-color process
The reproduction of text or images in four colors (CMYK), made up of cyan (c), magenta (m), yellow (y), and black (k). (p. 164)

Frame
A structural format that puts the meaning of something into a specific context. (p. 118)

French fold
Paper with center folds on the horizontal and vertical axes, resulting in a weightier object that limits printing to only one side of the paper. (p. 234)

Futurism
An art movement originating in Italy in 1910 that tried to convey the experiences of speed, technology, time, light, and emotion. (p. 47)

Gate fold
A fold in paper in which a panel acts as a cover that, when opened, reveals a second panel underneath. (p. 234)

Gestalt
A perception of the whole as being greater than the sum of its parts. (p. 264)

Golden ratio
Expressed as an irrational number (1.6180339887), the Golden Ratio is also known as the Golden Section or Golden Mean. The mathematical relationship is thought of as the divine proportion and is found in many aspects of nature, including the human body, taking form in Leonardo DaVinci's *Vitruvian Man (ca. 1487)*. In this ratio, if you lay line *a* next to line *b* and then lay a line equal to *a* + *b* next to *a*, the two pairs of lines would have the same proportion. (p. 233)

Golden rectangle
A rectangle that has a ratio of length to width that is the golden ratio. (p. 233)

Gothic revival
A style in the late-nineteenth and early twentieth centuries based on the Gothic style of the Middle Ages, which included the pointed arch, the ribbed vault, and the flying buttress. The revival of this handcrafted style was a response attempting to offset the mechanical banality of modern mass production. (p. 39)

Graphic design
An umbrella term to describe the process of bringing form to intellectual ideas with the goal of organizing information into communicable messages. (p. 6)

Graphic design concept
Intellectual and formal ideas integrated into the overall framework of a design to form a complete assertion. (p. 75)

Grid
A framework of horizontal and vertical lines that cross each other at regular intervals. (p. 216)

Grid system
An underlying system of horizontal and perpendicular coordinates to aid in the alignment of text and image as part of a layout. (p. 216)

Gutter width
A small distance between each column of text, built into a typographic grid. (p. 220)

Halftones
A technique that simulates continuous tone imagery (color or black and white) through the use of various-sized dots. (p. 164)

Header
Text, usually containing the title or author of the publication, that runs along the upper portion of a page type, beyond the field of the regular body of text, that repeats on every page (see also Footer). (p. 226)

Home page
A website's opening page that introduces the site's subject matter and provides navigation to the next level of web pages. (p. 286)

Hot type
Type created by molten hot lead injected into a mold to create a cast of letters. (p. 183)

Hue
Attributes of color that allow it to be classed as red, yellow, blue, or any combination of those. (p. 164)

Icon
A sign that has a direct resemblance to the thing it represents. (p. 269)

Idea
A creative spark, often the result of bringing together two separate thoughts in an attempt to solve a problem. (p.75)

Illustration
The blend of intellectual ideas and stylistic techniques (including but not limited to drawing, painting, and digital mediums) to create pictorial interpretations for use in print, interaction, and motion design. (p. 14)

Index
A sign that refers to its object, either through physical location or strong clues. (p. 269)

Interaction design
A category of graphic design that allows the user to interact with the design to access information from computer-driven formats, including websites, exhibit kiosks, and handheld devices. (p. 278)

Internship
Beginner-level practical experience in a specific field, sometimes unpaid. (p. 307)

Justified
Simultaneous left and right alignment of type, resulting in a rectangular block of text. (p. 199)

Kerning
The manual adjustment of space between pairs of letters. (p. 195)

Keyframe
A significant plot point or action within a motion design. (p. 292)

Keyword
A word that represents an essential part of an idea. (p. 136)

Leading
The vertical measurement of distance from the baseline of one letterform or line of type to the next. (p. 198)

Line
A narrow, elongated mark, as in a drawn line; a horizontal or vertical row of characters or type; a boundary. (p. 153)

Logo
A graphic representation or symbol for a company. (p. 13)

Logotype
A graphic representation of a company made predominantly with type. (p. 188)

Meta concept
A concept that relies on the reader's understanding of the self-referential and/or parodying aspect of the design. (p. 92)

Metaphor
An visual or verbal image used to explain one thing in terms of another, creating an analogy between two seemingly unrelated things or ideas. (p. 82)

Metaphoric concept
A concept that relies on the use of metaphor to interpret a design's subject. The integration of form and typography complete a metaphoric concept. (p. 87)

Mockup
A draft version of a design. (p. 143)

Modern typefaces
Late eighteenth-century typefaces with high contrast between strokes, a uniform and mechanically balanced shape, and relatively abstract, horizontal serifs. (p. 184)

Modernism
A cultural movement from the mid-nineteenth to mid-twentieth centuries, in which a conscious break was made with the aesthetics and sensibilities of the past. Its main tenet was a revolt against realism as well as cumulative progress in literature, philosophy, art, and architecture. (p. 44)

Modular grid
A structural pattern of repeating shapes or lines that helps guide the organization of typography or images. (p. 217)

Module
A repeating shape used to create a structure or system. (p. 216)

Montage
The technique of creating one image from two or more images, or parts of images, resulting in the illusion that the new composition is naturally whole. (p. 87)

Mood boards
A collection of visual material used to help explain references, provide inspiration, and build consensus. (p. 121)

Motion design
Any planned movement generally displayed on electronic media that incorporates animated graphics (imagery and/or typography), often combined with sound. (p. 279)

Navigation
The linked access to other pages within a website. Usually designed in the form of a horizontal or vertical bar, navigation is a key design element because it is used on every page of a site. (p. 286)

Negative space
Also known as white space, the space around an object, and between more than one object, including the background of a page. (p. 158)

New Typography
An asymmetric approach to typography and layout based on *Die Neue Typographie* by Jan Tschichold. (p. 54)

New York School
An advertising design method that integrates text and image in a harmonious and humorous way, with its epicenter being New York City's Madison Avenue. (p. 64)

Observational research
Research conducted in the actual context of the thing being studied—in the home, on the street, in nature—including surveys and observations. (p. 114)

Offset printing
A commercial printing technique in which ink on lithograph plates transfer to a rubber blanket, which then transfers the image onto paper. (p. 165)

Old Style typefaces
Pen-based mechanical letterforms whose strokes have a right-leaning inclination. (p. 184)

One-point perspective
A view typically in a drawing or painting in which one vanishing point exists for two axes—for example, as in a railroad track going off into the distance. (p. 160)

Parody
Satirical imitation of something serious. (p. 258)

Partnership
A business in which each partner is liable to the others. (p. 316)

Pattern
An element that repeats in a predictable and decorative manner. (p. 155)

Pica
A typographic measurement system for print design. There are approximately six picas in an inch. (p. 192)

Point
The measurement system for type characters (abbreviated as pt.), based on the distance from the top of the highest point in a letter (ascender), to the bottom of the lowest point in a letter (descender). There are 12 points in a pica, and approximately 72 points in an inch. (p. 192)

Portfolio
A collection of work that showcases one's talent and creativity. Portfolios can exist in both print and digital formats, the goal being to show a breadth of work that favors quality over quantity. (p. 307)

Positioning Chart
A visualizing research technique in which adjectives or other descriptors are entered along x and y axes to describe the personality of a product, service, and so forth. (p. 121)

Posterized
An effect in which the grayscale quality of a photograph is removed or replaced by a limited number of tones. (p. 142)

Postmodernism
A wide-ranging term describing a condition that exists after Modernism (1945–present) and applied to literature, philosophy, art, and architecture. Postmodernism generally rejects the pursuit of perfectionism and timelessness as notions based on sociocultural constructs. (p. 68)

Pragmatics
The study of how a sign is understood by the user. (p. 268)

Presentation
The stage in which the finished comp is accompanied by words and thoughts about the project as a full concept. (p. 30)

Primary colors
In pigment, the primary colors are red, blue, and yellow, defined as

such because no two colors can be combined to produce them. In light, the primary colors are red, green, and blue. (p. 164)

Production
The creation of a design for printing, uploading, or broadcasting. (p. 30)

Psychedelic
A genre based on the 1960s counterculture, making use of vibrant colors and patterns, experimental electronic music, and hallucinogenic drugs. (p. 63)

Rag
Unaligned vertical margin in a typeset column of text. (p. 199)

Random word technique
A technique in which a word is chosen randomly and its principle meaning is then applied to a design problem as a way to generate new ideas. (p. 136)

Recontextualization
Elements, signs, and meaning introduced within a new context. (p. 205)

Repetition
A design element using recurring lines or forms that brings visual energy and motion to a composition. (p. 175)

Research
Building a body of knowledge about a client-assigned project, including the company's history, target audience, and competitors. (p. 29)

Resume
A summary of one's training and experience. (p. 306)

RGB
Abbreviation for red, green, blue. (p. 164)

Rhythm
A pattern effect that relies on the repeat of a line, shape, or thing to create unity and energy in a visual design. (p. 175)

Roughs
Quick compositions that give a full-sized but raw visualization of ideas as they pertain to layouts. (p. 29)

Rule of thirds
The compositional division of an image into nine equal parts (made from two horizontal and two vertical lines), with important elements placed along the lines or their intersections. (p. 235)

Sans serif
Typeface where the main stroke of a letter is not finished off with a much shorter perpendicular stroke. (p. 182)

Saturation
Level of intensity in a color. (p. 164)

Scale
The distinctive relative size, extent, or degree of elements within a design composition. (p. 161)

Secondary colors
Purple, orange, and green; each made by mixing two primary colors. (p. 164)

Second-level web pages
Area on a website where a site's main content is located. (p. 288)

Semantics
The meaning behind a sign and behind that to which it refers. (p. 268)

Semiotics
The study of signs and how they are used in everyday communication. Three specific categories of semiotics are syntactics, semantics, and pragmatics. (p. 267)

Serif
Typeface where the main stroke of a letter is finished off with a much shorter perpendicular stroke. (p. 182)

Shape
A two-dimensional space, created by joining the two ends of a line. (p. 154)

Signage
The design of navigational information as it pertains to direction and identification, for interior and exterior architectural spaces. (p. 12)

Silver ratio
Proportion of paper sizes used in Europe in which two pages together result in the next largest size of paper. (p. 234)

Slab serif
Also known as Egyptian serifs, typefaces that have thick rectangular finishes to their vertical strokes. (p. 184)

Sole proprietorship
A business owned by one person. (p. 316)

Splining
A process in which computer-generated mathematical formulas help to automatically present a two- or three-dimensional object in proportion as it is repositioned or rotated. (p. 298)

Storyboard
A refined version of thumbnail sketches that are roughed into actual frames (eight to twelve) to visualize a motion-based idea. (p. 292)

Suprematism
Russian-based art movement founded in 1915 that completely eliminated objects and representation and reduced elements to geometric forms. (p. 48)

Surrealism
An early twentieth-century art movement, developed out of Dadaism, that grounded its investigations on unexpected juxtapositions and non sequiturs, with psychologically based images that caused shock and surprise. (p. 49)

Swiss International Style
A mid twentieth-century international movement that reflected a philosophy of refined type and image use. The approach was largely initiated in Swiss design schools and was based in large part on the mathematical organization of the page. (p. 62)

Symbol
A sign that operates abstractly, where the object being referred to is made by association into a broader general idea, for example, the cross used as a symbol of Christianity. (p. 269)

Syntactics
The relationship of form between signs without regard to specific meaning. (p. 267)

Tension
The visual strain based on an imbalanced relationship of contrasting elements—big/small, rough/smooth, clean/messy—that create energy within a composition. (p. 169)

Texture
The two- or three-dimensional tactile quality of a surface, either real or perceived, that has the potential to cause an emotion or sensation from the viewer. (p. 155)

Third-level web pages
Area of a website that is intended to provide very specific content, typically that expands on information in the second-level web pages. (p. 288)

Thought starter
Any method or technique that helps to activate one's creative process. (p. 127)

Thumbnails
Small preliminary sketches, generally no bigger than a business card, that quickly capture the essence of an idea. (p. 29)

Tracking
Creation of consistent spacing to a group of letters within a word, paragraph, or entire column of type. (p. 195)

Transition
The process or interval of time smoothly connecting two different elements in a motion design. (p. 292)

Transitional typefaces
Typefaces that bridged the gap between Old Style and Modern,

with less right-leaning inclination than Old Style and medium contrast between thick and thin strokes. (p. 184)

Two-point perspective
A way to create the illusion of depth by using two vanishing points instead of one, creating an image that is a little closer to the way we actually perceive distance on the curved earth. (p. 160)

Typeface
A design of a particular set of letterforms, numerals, and signs that share consistent characteristics. (p. 181)

Typeface family
A single typeface design, for example Helvetica, comprising the full alphabet, numerals, and signs as well as all the corresponding font weights such as regular, italic, bold, and bold italic. (p. 191)

Typogram
A miniature visual poem, made of letterforms, that can be understood both as text and image. (p. 66)

Typographic grid
A column-based system used to organize text. (p. 220)

Typography
The arranging of type (including typeface, font, size, and leading) to create a deliberate appearance, hierarchy of reading, or structure. (p. 182)

Unique selling proposition
A way to differentiate product brands by proposing specific benefits consumers would get if they used the item being sold. (p. 118)

Unity
A design principle in which elements work together in harmony. (p. 176)

Value
The brightness of a color based on shades of light and dark, ranging from white to black. (p. 165)

Vernacular
Unorthodox, local language. (p. 203)

Visual code
A nonverbal message that sets a tone, narrates with a particular voice, and brings a perspective through which the viewer can understand a graphic design communication. For example, a boxing poster has a visual code that reads as "tough." (p. 255)

Voice-over
An audio narration as part of a motion design. (p. 297)

White space
The area between elements on a page, including the background;

also known as negative space. (p. 158)

Wireframing
The sketching of ideas for the structure of a website using line-framed areas to notate navigation and content sections. (p. 288)

Word mapping
The mapping of words into a diagram-based sketch as part of a research technique for linking ideas. (p. 122)

Ades, Dawn. *The 20th-Century Poster.* New York: Abbeville Press, 1984.

——. Arnheim, Rudolf. *Art and Visual Perception.* Berkeley: University of California Press, 1954.

Visual Thinking. Berkeley: University of California Press, 1969.

Arnston, Amy. *Graphic Design Basics.* Belmont, CA: Wadsworth Thomson Learning, 2003.

Berger, John. *Ways of Seeing.* London: British Broadcasting System and Penguin Books, 1972.

Blackwell, Lewis. *20th-Century Type Remix.* Corte Madera, CA: Gingko Press, 1998.

Booth-Clibborn, Edward. *The Language of Graphics.* New York: Abrams, 1980.

Bruno, Michael, ed. *Pocket Pal.* New York: International Paper Company, 1986.

Carter, Rob, Ben Day, and Phillip Meggs. *Typographic Design.* New York: Van Nostrand Reinhold, 1985.

Challis, Clive. *Helmut Krone. The Book.* Cambridge: The Cambridge Enchorial Press, 2005.

Constantine, Mildred, and M. Alan Fern. *Word and Image.* New York: The Museum of Modern Art, 1968.

Darton, Mike. *Art Deco.* London: Tiger Books International, 1990.

Davies, Penelope J. E., Walter B. Denny, Frima Fox Hofrichter, Joseph Jacobs, Ann M. Roberts, and David L. Simon. *Janson's History of Art.* Upper Saddle River, NJ: Pearson Prentice Hall, 2007.

de Bono, Edward. *Lateral Thinking.* New York: Harper & Row, 1970.

Foster, Jack. *How to Get Ideas.* San Francisco: Berrett-Koehler, 1996.

Gombrich, E. H. *Art and Illusion.* Princeton: Princeton University Press, 1960.

Heller, Steven. *Paul Rand.* London: Phaidon Press, 1999.

Hochul, Jost, and Robin Kinross. *Designing Books.* London: Hyphen Press, 1996.

Hurlburt, Allen. *Layout.* New York: Watson Guptill Publications, 1977.

——. *The Design Concept.* New York: Watson Guptill Publications, 1981.

Jacobs, Marvin. *Graphic Design Concepts … Plus!* North Olmsted, OH: Words and Pictures, 2007.

Jefferson, Michael. *Breaking into Graphic Design.* New York: Allworth Press, 2005.

Kince, Eli. *Visual Puns in Design.* New York: Watson Guptill Publications, 1982.

Kunz, Willi. *Typography: Macro + Microaesthetics.* Sulgen, Switzerland: Verlag Niggli AG, 2000.

Landa, Robin. *Graphic Design Solutions.* Albany, NY: Delmar, 2001.

Lauer, David A., and Stephen Pentak. *Design Basics.* Belmont, CA: Wadsworth Thomson Learning, 2003.

Leborg, Christian. *Visual Grammar.* New York: Princeton Architectural Press, 2006.

Lupton, Ellen. *Thinking with Type.* New York: Princeton Architectural Press, 2004.

Meggs, Philip B., and Alston W. Purvis. *Meggs History of Graphic Design.* Hoboken, NJ: John Wiley, 2006.

Moggridge, Bill. *Designing Interactions.* Cambridge, MA: Massachusetts Institute of Technology Press, 2007.

Mollerup, Per. *Marks of Excellence.* London: Phaidon Press, 1997.

Müller-Brockmann, Josef. *Grid Systems in Graphic Design.* Niederteufen, Switzerland: Arthur Niggli, 1981.

Noble, Ian, and Russell Bestley. *Visual Research.* Lausanne, Switzerland: AVA Publishing, 2005.

Ocvirk, Otto G., Robert E. Stinson, Philip R. Wigg, Robert O. Bone, and David L. Cayton. *Art Fundamentals.* New York: McGraw-Hill, 1998.

Oldach, Mark. *Creativity for Graphic Designers.* Cincinnati, OH: North Light Books, 1995.

Poyner, Rick. *No More Rules.* New Haven: Yale University Press, 2003.

Rand, Paul. *Thoughts on Design.* New York: Wittenborn, 1947.

Remington, R. Roger. *American Modernism.* London: Laurence King Publishing, 2003.

Resnick, Elizabeth. *Design for Communication.* Hoboken, NJ: John Wiley, 2003.

Rosentswieg, Gerry, ed. *The New American Logo.* New York: Madison Square Press, 1994.

Roukes, Nicholas. *Design Synectics.* Worcester, MA: Davis Publications, 1988.

Samara, Timothy. *Typography Workbook.* Gloucester, MA: Rockport Publishers, 2004.

Shaughnessy, Adrian. *How to Be a Graphic Designer, without Losing Your Soul.* New York: Princeton Architectural Press, 2005.

Stewart, Mary. *Launching the Imagination.* New York: McGraw-Hill, 2002.

Stokstad, Marilyn. *Art History.* Upper Saddle River, NJ: Pearson Prentice Hall, 2005

Sutnar, Ladislav. *Visual Design in Action.* New York: Hastings House, 1961.

——. *Catalog Design Progress.* New York: F. W. Dodge, 1950.

Wheeler, Alina. *Designing Brand Identity.* Hoboken, NJ: John Wiley, 2003.

White, Alex. *The Elements of Graphic Design.* New York: Allworth Press, 2002.

Wilde, Judith, and Richard Wilde. *Visual Literacy.* New York: Watson-Guptill Publications, 2000.

Young, Doyald; *The Art of the Letter.* Hamilton, OH: SMART Papers, 2003.

Zeldman, Jeffrey. *Taking Your Talent to the Web.* Indianapolis: New Riders Publishing, 2001.

Index

D

E

F

Text Credits

CHAPTER 1

Page 7: Excerpt from Michael Worthington, "The Name Game" *AIGA Journal*, Vol. 16, No. 2: Page 10: Reprinted by permission of Barry Deck, Barry Deck Design LLC; Page 18: Reprinted by permission of Kali Nikitas, Graphic Design for Love; Page 20: Reprinted by permission of Katherine McCoy; Page 22: Reprinted by permission of Maya Drozdz, partner, VisuaLingual Limited; Page 26: Warren Lehrer, 'Emptying the Spoon, Enlarging the Plate: Some Thoughts on Graphic Design Education" from *The Education of a Graphic Designer*, 2/e Copyright (c) 2005, Allworth Press. Reprinted by permission of Skyhorse Publishing, Inc.; Page 31: Reprinted by permission of Randall E. Hoyt, Mark Zurolo.

CHAPTER 2

Page 40: Reprinted by permission of Steven Heller; Page 56: Reprinted by permission of Jan Uretsky; Page 62: Willi Kunz, New York; Page 66: Reprinted by permission of Peter Wong, professor of Graphic Design, Savannah College of Art and Design, Atlanta Georgia; Page 72: (c) Tamar Cohen. Reprinted by permission of the author.

CHAPTER 3

Page 76: Reprinted by permission of Doug Kisor, department chair, Graphic Studies Department, College for Creative Studies; Page 80: Reprinted by permission of Joseph Roberts, professor of Communication Design, Pratt Institute; Page 84: Reprinted by permission of Jacek Mrowczyk; Page 85: Martin Woodtli, martin@woodt.li; Page 89: Reprinted by permission of Xu Guiying; Page 96: Reprinted by permission of Katherine McCoy; Page 97: Reprinted by permission of Saki Mafundikwa, founder/director, Zimbabwe Institute of Vigital Arts (ZIVA), Harare, Zimbabwe; Page 98: Reprinted by permission of Inyoung Choi, PhD, Department of Graphic ad Package Design, Hanyang University, South Korea; Page 100: Anita Merk, Flyleaf Creative, Inc.

CHAPTER 4

Page 104: Seth Godlin; Page 107: Design Strategist and Writer Michele Y. Washington; Page 108: Reprinted by permission of Somi Kim, senior partner, creative director, Ogilvy & Mather, Los Angeles; Page 112: The Far Side (r) by Gary Larson; Page 114: Reprinted by permission of Jeff Zack; Page 115: Reprinted by permission of Katherine McCoy; Page 116: Reprinted by permission of Tina Park; Page 117 Figures 4.19 and 4.20: Reprinted by permission of Helen Marie Creative Partners, LLC; Page 118: Reprinted by permission of Anna Gerber; Page 119: Reprinted by permission of Kareem Collie, Dimitrous II, Inc.; Page 120 Figure 4.21: Charles Eames; Page 123: Reprinted by permission of Kali Nikitas, Graphic Design for Love.

CHAPTER 5

Page 134: Reprinted by permission of Luba Lukova; Page 139: Reprinted by permission of Charles Goslin; Page 146: Stephen Banham and Samantha Neumann; Page 148–149: Based on a presentation by Geoffry Fried, professor, The Art Institute of Boston, at Lesley University (see revolution-philadelphia.aiga.org/content27c8.html?Alias=rp_presentations).

CHAPTER 6

Page 156: Reprinted by permission of April Greiman, Made in Space; Page 158: Reprinted by permission of Andrew McCall Photography/design by Worksight; Page161: Reprinted by permission of Gusty Lange, professor Graduate Communications Design, Pratt University; Page 171: Reprinted by permission of Matthias Brendler, Brazil-based U.S. expat multidisciplinary artist, designer, researcher, writer, and educator; Page 179: Reprinted by permission of Paul Shaw.

CHAPTER 7

Page 189: (c) Philippe Apeliog. Reprinted by permission of Philippe Apeliog; Page 194: Reprinted by permission of Joshua Ray Stevens; Page 197: Reprinted by permission of Paul Shaw; Page 206: Hoefler & Frere-Jones, *Specimen of Types*, 8th ed. Designed by Jonathan Hoefler, 2004.

CHAPTER 8

Page 222: Willi Kunz; Page 229 Figure 8.23: Reprinted by permission of Randall E. Hoyt and Mark Zurolo; Page 230 Figure 8.24: Reprinted by permission of Object Collective; Page 231: Reprinted by permission of Khoi Vinh.

CHAPTER 9

Page 240: Reprinted by permission of Michael Bierut; Page 242: George Tscherny, *NY Poster*. Reprinted by permission of George Tscherny; Page 243: Reprinted by permission of Alan Dye; Page 244: Reprinted by permission of Laurice Rahme; Page 245: Reprinted by permission of Andrew Blauvelt; Page 246: Reprinted by permission of Kiss Me I'm Polish, LLC; Page 247: Reprinted by permission of Elliot P. Earls; Page 248: Reprinted by permission of Elliot P. Earls; Page 249: Reprinted by permission of Greg Hahn, owner, Gretel; Page 250: Reprinted by permission of COMA Amsterdam/New York (Cornelia Blatter, Marcel Herman, and Billy Nolan); Page 251: Barbara Glauber, designer; Page 252: Reprinted by permission of Louise Sandhaus, professor, School of Art, California Institute of Arts.

CHAPTER 10

Page 258 Figures 10.3 and 10.4: Reprinted by permission of Helen Marie Creative Partners, LLC; Page 262: Reprinted by permission of Kim Kiser; Page 266: Reprinted by permission of Kim Kiser; Page 267 Figure 10.21: Reprinted by permission of Katherine McCoy; Page 268 Figures 10.22 and 10.23: Reprinted by permission of Katherine McCoy; Page 270: Reprinted by permission of Michael Thibodeau.

CHAPTER 11

Page 278: Reprinted by permission of the author, Justin Bakse; Page 279 Figure 11.2: Reprinted by permission of Helen Marie Creative Partners, LLC; Page 279 Figure 11.4: Reprinted by permission of Alan Zaruba; Page 279 Figure 11.6: Reprinted by permission of Ryan Meis, instructor Jeff Bleitz; Page 282 Figure 11.9: Courtesy of Jazz at Lincoln Center, Nesuhi Ertegun Jazz Hall of Fame; Page 282 Figures 11.10 and 11.11: Reprinted by permission of The Chopping Block, Inc.; Page 284: Reprinted by permission of David Hillman Curtis, principal/director, Hillman Curtis, Inc.; Page 286: Courtesy of the Eames office; Page 287 Figure 11.16: Reprinted by permission of Peepshow Collective, Ltd.; Page 288: Reprinted by permission of Clever Name Here, Inc.; Page 292 Figure 11.21: Reprinted by permission of Jeremy Cox; Page 293: Reprinted by permission of Kelli Miller; Page 296: John Cage, "The Future of Music: Credo" in *Silence: Lectures and Writing* Copyright (c) 1961 Wesleyan University Press. Adapted by permission.

CHAPTER 12

Page 311: Reprinted by permission of Caitlin Folchman-Wagner; Page 312: Reprinted by permission of Scribner, a Division of Simon & Schuster, Inc., from The Cheese Monkeys: A Novel in Two Semesters by Chip Kidd. Copyright (c) 2001 by Charles Kidd. All rights reserved; Page 313: Connie Birdsall, senior partner, creative director, Lippincoh; Page 314: Reprinted by permission of Sean Adams, Partner, AdamsMorioka, Inc.; Page 318: Noble Cumming, design director; Page 322: Designer Rick Valicenti and Thirst; Page 325: Reprinted by permission of Charles Goslin.

Image Credits

FRONT MATTER

Page XII: rvlsoft/Shutterstock

CHAPTER 1

Page 6: akg-images/Newscom; Page 6: MasPix/Alamy; Page 6: Courtesy of Library of Congress; Page 8: TurnAround, Inc.; Page 8: FedEx service marks used by permission; Page 9: Broadway Video Enterprises; Page 11: Paper Magazine; Page 12: "Jacket Cover" copyright ©2004 by Anchor Books, a division of Random House, Inc., from *The Bug* by Ellen Ullman. Used by permission of Doubleday, a division of Random House, Inc.; Page 13: Tall Tales Restaurant; Page 13: Automatic Data Processing (ADP); Page 13: Le Saucier Frozen Foods; Page 14: Morningstar, Inc.; Page 16: Poetry Slam, Inc.; Page 17: Louis Boston; Page 20: Cranbrook Educational Community; Page 21: Collection of Cranbrook Art Museum, Bloomfield Hills, Michigan, Gift of Katherine and Michael McCoy (c) Katherine McCoy and Cranbrook Art Museum; Page 24: Contra-Composition of Dissonances, XVI, 1925, Doesburg, Theo van (1883–1931)/Haags Gemeentemuseum, The Hague, Netherlands/The Bridgeman Art Library.

CHAPTER 2

Page 35: mountainpix/Shutterstock; Page 36: M.S. Barth. 42, folio 110v. Universitätsbibliothek Johann Christian Senckenberg. Frankfurt am Main; Page 37: The Art Archive/Alamy; Page 37: Stapleton Historical Collection/Heritage-Images; Page 38: Courtesy of Library of Congress; Page 38: 1836 Poster from the Theatre-Royal, Norwich; Courtesy of Library of Congress; Page 39: Courtesy of Library of Congress; Page 40: Steven Heller; Page 41: School of Visual Arts; Page 42: Fotomas/TopFoto/The Image Works; Page 42: The Pierpont Morgan Library/Art Resource, NY; Page 42: "J'ai baise ta bouche, Jokanaan (I kissed your mouth, John)", illustration from 'Salome' by Oscar Wilde, pub. 1894 (line block print), Beardsley, Aubrey (1872–1898)/Private Collection/The Stapleton Collection/The Bridgeman Art Library International; Page 43: Victor Horta/SOFAM-Belgium; Page 43: General Electric; Page 43: Fine Art Images/Glow Images; Page 44: Velde, Henry van de (1863–1957) Tropon Poster (Plakat: Tropon) (plate, facing page 62) from the periodical Pan, vol. IV, no. 1 (Apr–May–Jun 1898). Lithograph, composition (irreg.): 12 1/4 x 7 13/16" (31.1 x 19.9 cm); Page 44: sheet: 14 5/16 x 10 7/8" (36.4 x 27.7 cm). Publisher: Genossenschaft Pan GmbH, Berlin. Printer: Leutert & Schneidewind, Dresden. Edition: 1213 (artist's edition: 38, numbered, on Imperial Japan paper; deluxe edition: 75, numbered, on copper-plate printing paper; general edition: 1100 on copper-plate printing paper [this ex.]). Gift of Peter H. Deitsch. The Museum of Modern Art, New York, NY, U.S.A. Digital Image ©The Museum of Modern Art/Licensed by SCALA/Art Resource, NY. ©2012 Artists Rights Society (ARS), New York/SABAM, Brussels; Page 45: TopFoto/The Image Works; Page 45: Wright, Frank Lloyd (1867–1959) Living room from the Little House, Wayzata, Minnesota. 1912–1915. H. 13 ft. 8 in. (4.17 m), L. 46 ft. (14 m), W. 28 ft. (8 53 m). Purchase, Emily Crane Chadbourne Bequest, 1972 (1972.60.1); Location:The Metropolitan Museum of Art, New York, NY, U.S.A. Image copyright ©The Metropolitan Museum of Art/Art Resource, NY. ©2012 Frank Lloyd Wright Foundation, Scottsdale, AZ/Artists Rights Society (ARS), NY; Page 45: Public Domain, Peter Behrens; Page 45: bpk, Berlin/Kunstbibliothek, Staatliche Museen, Berlin, Germany/Art Resource, NY. ©2012 Artists Rights Society (ARS), New York/SIAE, Rome; Page 46: Historical Picture Archive/CORBIS; Picasso, Pablo (1881–1973). *Les Demoiselles d'Avignon*. Paris, June–July 1907. Oil on canvas, 8' x 7' 8" (243.9 x 233.7 cm). Acquired through the Lillie P. Bliss Bequest. The Museum of Modern Art, New York, NY, U.S.A. Digital Image ©The Museum of Modern Art/Licensed by SCALA/Art Resource, NY. ©2012 Estate of Pablo Picasso/Artists Rights Society (ARS), New York; Page 47: Marinetti, Filippo Tommaso (1876–1944); *In the Evening, Lying on Her Bed, She Reread the Letter from Her Artilleryman at the Front.* 1919. Letterpress, 13 3/8 x 9 1/4". Jan Tschichold Collection, Gift of Philip Johnson. (598.19771). The Museum of Modern Art, New York, NY, U.S.A. Digital Image ©The Museum of Modern Art/Licensed by SCALA/Art Resource, NY. ©2012 Artists Rights Society (ARS), New York/SIAE, Rome; V&A Images, London/Art Resource, NY; Page 48: Art Resource, NY; Page 48: The Philadelphia Museum of Art/Art Resource, NY. ©2012 Artists Rights Society (ARS), New York/ADAGP, Paris/Succession Marcel Duchamp; bpk/Nationalgalerie, Staatliche Museen, Berlin, Germany/Jörg P. Anders/Art Resource, NY. ©2012 Artists Rights Society (ARS), New York/VG Bild-Kunst, Bonn; Page 49: Photo ©Oasis/Photos 12/Alamy. ©2012 Artists Rights Society (ARS), New York/VG Bild-Kunst, Bonn; Page 50: CNAC/MNAM/Dist. Réunion des Musées Nationaux/Art Resource, NY. ©2012 Man Ray Trust/Artists Rights Society (ARS), NY/ADAGP, Paris; Page 50: Man Ray (1890–1976) ©ARS, NY. Keeps London Going. 1932. Offset lithograph, 39 5/8 x 24 1/4" (100.6 x 61.6 cm). Gift of Bernard Davis. The Museum of Modern Art, New York, NY, U.S.A. Digital Image ©The Museum of Modern Art/Licensed by SCALA /Art Resource, NY. ©2012 Man Ray Trust/Artists Rights Society (ARS), NY/ADAGP, Paris; Page 50: Tatlin, Vladimir (1895–1956). Model of the Monument to the Third International. 1920; Page 51: The Museum of Modern Art, New York, NY, U.S.A. Digital Image ©The Museum of Modern Art/Licensed by SCALA/Art Resource, NY; Page 51: Lissitzky, El (Eleazar) (1890–1941) *Die Kunstismen/Les ismes de l'art/The Isms of Art/Kunstismus*, 1914–1924. by Jean (Hans) Arp, El Lissitzky. 1925. Letterpress, page: 10 1/8 x 7 11/16" (25.7 x 19.5 cm). Publisher: Eugen Rentsch, Zurich, Munich, and Leipzig. Edition: unknown. Gift of The Judith Rothschild Foundation. The Museum of Modern Art, New York, NY, U.S.A. Digital Image ©The Museum of Modern Art/Licensed by SCALA/Art Resource, NY. ©2012 Artists Rights Society (ARS), New York; Page 51: Lissitzky, El (Eleazar) (1890–1941) *USSR Russische Ausstellung.* 1929. Gravure, 49 x 35 1/4". Jan Tschichold Collection, Gift of Philip Johnson. (376.1950). Digital Image ©The Museum of Modern Art/Licensed by SCALA/Art Resource, NY. ©2012 Artists Rights Society (ARS), New York; Page 52: Doesburg, Theo van (1883–1931). *Simultaneous Composition.* 1929. Oil on canvas. 50.2 x 50.4 cm (19 3/4 x 19 13/16"). Gift of Katherine S. Dreier to Collection Société Anonyme. 1948.209. Yale University Art Gallery, New Haven, CT, USA. Yale University Art Gallery/Art Resource, NY; Page 52: ©Bildarchiv Monheim GmbH/Alamy. Gerrit Rietveld. ©2012 Artists Rights Society (ARS), New York; Page 52: Theo van Doesburg; Page 52: Anonymous, 20th century. De Stijl NB 73/74. 1926. Letterpress, 8 5/8 x 10 7/8". Jan Tschichold Collection, Gift of Philip Johnson. (674.1999). The Museum of Modern Art, New York, NY, U.S.A. Digital Image ©The Museum of Modern Art/Licensed by SCALA/Art Resource, NY; Page 53: Foto Marburg/Art Resource, NY. ©2012 Artists Rights Society (ARS), New York/VG Bild-Kunst, Bonn; Page 53: Moholy-Nagy, Laszlo (1895–1946) ©ARS, NY. 14 Bauhausbücher. 1928. Letterpress, 7/8 x 8 1/4" (14.9 x 21 cm). Jan Tschichold. Collection, Gift of Philip Johnson.The Museum of Modern Art, New York, NY, U.S.A. Digital Image ©The Museum of Modern Art/Licensed by SCALA/Art Resource, NY. ©2012 Artists Rights Society (ARS), New York/VG Bild-Kunst, Bonn; Page 53: Bayer, Herbert (1900–1985) 10 Banknotes, designed for the State Bank of Thuringia. Printer: State Government of Thuringia and Thuringia State Finance Board. 1923. Letterpress, each: 2 11/16 x 5 1/2" (6.8 x 14 cm). Gift of Manfred Ludewig. The Museum of Modern Art, New York, NY, U.S.A. Digital Image ©The Museum of Modern Art/Licensed by SCALA/Art Resource, NY. ©2012 Artists Rights Society (ARS), New York/VG Bild-Kunst, Bonn; Page 54: ©2012 Artists Rights Society (ARS), New York/VG Bild-Kunst, Bonn; Page 54: Deutsche Nationalbibliothek (German National Library), Jan Tschichold; Page 54: Deutsche Nationalbibliothek (German National Library), Jan Tschichold; Page 55: ©2012 Artists Rights Society (ARS), New York/c/o Pictoright Amsterdam; Page 55: Piet Zwart (1885–1977). *Een Kleine Keuze Uit Onze Lettercollectie* (A Small Selection of Type Face). 1932. 11 x 7 3/4" (28.3 x 19.7 cm). Peter Stone Poster Fund. 1928. The Museum of Modern Art, New York, NY, U.S.A. Digital Image ©The Museum of Modern Art/Art Resource, NY. ©2012 Artists Rights Society (ARS), New York/c/o Pictoright Amsterdam; Page 55: Digital Image ©The Museum of Modern Art/Art Resource, NY/Herbert Matter Estate/Department of Special Collections, Stanford University Libraries; Page 55: The William Andrews Clark Memorial Library, University of California, Los Angeles; Page 56: Nathan Benn/Alamy; Page 57: Image Courtesy of the Advertising Archives/Herbert Bayer. ©2012 Artists Rights Society (ARS), New York/VG Bild-Kunst, Bonn; Page 58: Image Courtesy of the Advertising Archives/Department of Special Collections, Green Library, Stanford University; Page 58: Image Courtesy of the Advertising Archives/Department of Special Collections, Green Library, Stanford University; Page 59: Digital Image: Museum of Decorative Arts/Copyright The Ladislav Sutnar Family; Page 60: Courtesy Wittenborn Art Books. www.live-work.us; "Book Cover" copyright 1958 by Vintage Books, a division of Random House, Inc., from *Prejudices: A Selection* by H.L. Mencken. Used by permission of Vintage Books, a division of Random House, Inc. For online information about other Random House, Inc. books and authors, see the Internet Web Site at www.randomhouse.com; Page 60: Paul Rand. Courtesy of Westinghouse Yale University, Sterling Memorial Library; Image Courtesy of the Advertising Archives/Alvin Lustig/Elaine Lustig Cohen; Page 61: Brad-

bury Thompson/Copyright MeadWestvaco Corporation; Page 62: Josef Müller-Brockmann (b. 1914). Musica Viva. Printer: City-Druck, AG, Zürich. 1958. Linocut and letterpress, 50 3/8 x 35 5/8" (128 x 90.5 cm). Gift of the designer. The Museum of Modern Art, New York, NY, U.S.A. Digital Image ©The Museum of Modern Art/Art Resource, NY. ©2012 Artists Rights Society (ARS), New York/ProLitteris, Zurich; Page 63: Hofmann, Armin (b. 1920) Wilhelm Tell. Printer: Wassermann A.G., Basel. 1963. Offset lithograph, 50 3/16 x 35 1/2" (127.4 x 90.2 cm). Gift of the designer. The Museum of Modern Art, New York, NY, U.S.A. Digital Image ©The Museum of Modern Art/Licensed by SCALA/Art Resource, NY; Advertising Archives; Page 64: Wilson, Wes (Robert Wesley Wilson) (b. 1937). The Association, Along Comes Mary, Quicksilver Messenger Service. 1966. Offset lithograph, 19 11/16 x 13 3/4" (50.0 x 43.9 cm). Purchase. The Museum of Modern Art, New York, NY, U.S.A./Digital Image ©The Museum of Modern Art/Licensed by SCALA /Art Resource, NY. Art ©Wes Wilson; Page 64: Moscoso, Victor (b. 1936). The Chambers Brothers. 1967. Offset lithograph, 20 x 14 1/4" (50.8 x 36.8 cm). Gift of Jack Banning. The Museum of Modern Art, New York, NY, U.S.A. Digital Image ©The Museum of Modern Art/Art Resource, NY. Art ©1967 Neon Rose, www.victormoscoso.com; Page 64: Milton Glaser; Page 65: Image courtesy of The Advertising Archives/Trademarks and advertisement are used with permission of Volkswagen Group of America, Inc.; Page 65: George Lois, Art Director. Carl Fischer, Photographer; Ivan Chermayeff/Chermayeff & Geismar; Page 66: Courtesy of the Herb Lubalin Study Center of Design and Typography; Page 66: Courtesy of the Herb Lubalin Study Center of Design and Typography; Page 67: Trepkowzki, Tadeuz (1914–1954) Nie! 1952. Lithograph, 39 3/8 x 27 5/8". Gift of the Lauder Foundation, Leonard and Evelyn Lauder Fund. (626.1990); Location: The Museum of Modern Art, New York, NY, U.S.A.; Page 67: Digital Image. The Museum of Modern Art/Licensed by SCALA/Art Resource, NY; Page 67: Courtesy of Jerzy Janiszewski; Page 67: Courtesy of Shigeo Fukuda; Page 67: Image Courtesy of the Advertising Archives/Rambow Lienemeget van de Sand 1988; Page 69: Emigre Inc. (American, founded 1987), Rudy VanderLans (Dutch, b. 1955) and Zuzana Licko (Slovakian, b. 1961). Emigre 10, Cranbrook. 1988. Lithograph, Various dimensions. Agnes Gund Purchase Fund. ©Rudy VanderLans & Zuzana Licko. The Museum of Modern Art, New York, NY, U.S.A. Digital Image ©The Museum of Modern Art/Licensed by SCALA/Art Resource, NY; Emigre, Inc.; Page 70: Design Quarterly #133 "Does it Make Sense?" Walker Art Center MIT Press.

CHAPTER 3

Page 77: Robert HM Voors/Shutterstock; Page 77: Hein Nouwens/Shutterstock; Page 82: National Audobon Society; Page 82: National Audobon Society; Page 83: Chronicle Books; Page 84: Moore. 1959. Lithograph, 27 1/4 x 39" (69.3 x 99.1 cm). Gift of the designer. The Museum of Modern Art, New York, NY, U.S.A. Digital Image ©The Museum of Modern Art/Licensed by SCALA/Art Resource, NY. Art Courtesy Filip Pagowski; Page 84: Zamek Cieszyn; Page 85: Photograph by Jason Fulford; Page 85: Logicaland/www.logicaland.net; Page 87: Arthur S. Aubry/Getty Images; ilker canikligil/Shutterstock; Picturehouse; Page 88: Created for Immigrants' Theatre Project's 4th New Immigrant Theatre Festival, 1997; Page 88: Mohawk Fine Papers Inc.; Page 88: New York Times; Page 88: New York Times; Page 90: New York Times; Page 91: Columbia University, Graduate School of Architecture; Page 91: NYC Alliance Against Sexual Assault; Page 94: Ashley Gilbertson/VII /University of Chicago Press.

CHAPTER 4

Page 105: San Francisco Jewish Film Festival—www.sfjff.org; Page 105: San Francisco Jewish Film Festival—www.sfjff.org; Page 106: Hells Kitchen NYC; Page 109: Motorola; Page 113: ©2012 The Hain Celestial Group, Inc.; Page 113: ©2012 The Hain Celestial Group, Inc.; Page 115: Chrysler Corporation; Chrysler Corporation; Page 120: San Francisco Museum of Modern Art.

CHAPTER 5

Page 133: Columbia University, Graduate School of Architecture; Page 135: Company: SAY IT LOUD! an advertising agency in Orlando, Florida. Date the logo was created: 2003 Creative Team: Julio Lima/Creative Director/Owner of SAY IT LOUD! Luba Lukova/Illustrator/Designer; Page 140: Public Domain, Wikipedia; Page 144: de.MO/Giorgio Baravalle.

CHAPTER 6

Page 150: Victoria Symphony Society/Illustration ©The Heads of State; Page 153: Time Warner; Page 154: NattJazz; Page 155: Victoria Symphony Society/Illustration ©The Heads of State; Kimberly-Clark; Page 157: RoTo Architects; Page 159: Canterbury Printing company; Page 160: Cannes Film Festiv; Calvary of Albuquerque; Page 161: CNAC/MNAM/Dist. Réunion des Musées Nationaux/Art Resource, NY. ©2012 Kate Rothko Prizel & Christopher Rothko/Artists Rights Society (ARS), New York; Page 162: ©Richard Haughton/International Festival of Arts & Ideas; Page 162: National Institute for Play;Page 165: Photo courtesy of Pantone. Pantone® and other Pantone trademarks are the property of Pantone, LLC. Pantone, LLC is a wholly owned subsidiary of X-Rite, Inc.; Page 168: Yale University Press; Page 169: Beacon Press; Page 170: United For Peace and Justice; Page 176: Teas' Tea.

CHAPTER 7

Page 183: Otis Lab Press; akg-images/Newscom; bpk, Berlin/Staatsbibliothek zu Berlin/Art Resource, NY; Page 186: DK Images; Page 186: Public Domain from A Source Book of Advertising Art, ©1964 Bonanza Books; Page 189: Courtesy of Amazon.com; Page 191: Agence Française de Développement; Page 200: Abbeville Press; Page 208: ©Woodruff/Brown Architectural Photography; Page 209: Reproduced by permission of the University of Connecticut.

CHAPTER 8

Page 218: Absecon Mills, Inc.; Page 219: Columbia University–Graduate School of Architecture; Page 222: Merit Energy Company; Page 223: copyright ©1987 Typogram; Page 224: Orange Management Inc. ESKQ/Mike Klausmeier/NGOC MINH NGO; Page 224: Chronicle Books; Page 225: American Apparel; Page 227: Scully, Vincent; Modern Architecture and Other Essays. Princeton University Press Reprinted by permission of Princeton University Press; Page 228: PricewaterhouseCoopers LLP; Page 230: Orange Management Inc. /ESKQ/Mike Klausmeier/NGOC MINH NGO; Page 232: Southern California Institute of Architecture (SCI-Arc). www.sciarc.edu. Weston Bingham, Offramp, A student journal of architecture; Page 233: Saks Fifth Avenue Page 233: Google Books; Page 233: Jakub Krechowicz/Shutterstock.

CHAPTER 9

Page 238: Vitra; Page 241: Saks Fifth Avenue; Page 242: Monadnock Paper Mills, Inc.; Page 245: American Center for Design; Page 249: Sundance Channel; Page 250: Vitra.

CHAPTER 10

Page 259: Courtesy of CalArts; Page 260: Cover artwork from Stripper Lessons by John O'Brien. Used by permission of Grove/Atlantic, Inc.; Page 264: Dr. Ing. h.c. F. Porsche AG is the owner of numerous trademarks, both registered and unregistered, including without limitation the Porsche Crest®, Porsche® and the model numbers and distinctive shapes of Porsche automobiles States. Used with permission of Porsche Cars North America, Inc. and Dr. Ing. h.c.F. Porsche AG; Page 265: Calgary Farmers' Market; Page 265: Royal Mail; Page 267: FedEx service marks used by permission; Page 269: Morgan Lane Photography/Shutterstock; Page 270: Care International; Page 271:; Page 271:; Page 271: Hells Kitchen NYC; Page 271: Tall Tales Restaurant; Page 271: Poetry Slam, Inc.; Page 271: The Alliance for Climate Protection, WE Campaign; Page 271: NYC Alliance Against Sexual Assault; Page 272: Moscoso, Victor (b. 1936). Blue Cheer. 1967. Offset lithograph, 20 x 14" (51 x 35.6 cm). Gift of the designer. 799.1983. The Museum of Modern Art, New York, NY, U.S.A. Digital Image ©The Museum of Modern Art/Art Resource, NY. Art ©Family Dog 1967–©Rhino Entertainment 2008, artist Victor Moscoso, www.victormoscoso.com/©1967 Rhino Entertainment Company. Used with permission. All rights reserved.

CHAPTER 11

Page 280: Nike, Inc.; Page 283: Lions Gate Films; Page 283: Tribeca Film Festival; Page 285: Adobe Systems Inc.; Page 291: Courtesy of Underwriters Laboratories (c) 2008; Page 294: The Nike Foundation; Page 295: Images courtesy of PopTech; Page 295: Discovery Communications, LLC; Page 297: LiveScribe; Page 298: Digital Entertainment Network (DEN.)

Page 304: Neenah Paper; Page 315: Image use courtesy of UCLA Extension and Sean Adams; Page 315: AdamsMorioka and Sundance Institute; Page 315: Oxygen Network; Page 315: Adobe product box shot(s) reprinted with permission from Adobe Systems Inc.; Page 317: Courtesy of adbusters.org; Page 317: Courtesy of adbusters.org and of the artist Alex Da Corte; Page 322: With Permission, CME Group Inc., 2012; Page 323:; Page 323: Neenah Paper; Page 323: Trek Bicycle; Page 325: Warhol, Andy (1928–1987). *Campbell's Soup Cans*. 1962. Synthetic polymer paint on 32 canvases, each 20 x 16". Gift of Irving Blum; Nelson A. Rockefeller Bequest, gift of Mr. and Mrs. William A.M. Burden, Abby Aldrich Rockefeller Fund, gift of Nina and Gordon Bunshaft in honor of Henry Moore, Lillie P. Bliss Bequest, Philip Johnson Fund, Frances Keech Bequest, gift of Mrs. Bliss Parkinson, and Florence B. Wesley Bequest (all by exchange). (476.1996.1-32). Digital Image ©The Museum of Modern Art/Licensed by SCALA/Art Resource, NY. ©2012 The Andy Warhol Foundation for the Visual Arts, Inc./Artists Rights Society (ARS), New York; Page 325: Ruscha, Ed (1937–). *Standard Station*. 1966. Screenprint, composition: 19 5/8 x 36 15/16" (49.6 x 93.8 cm); sheet: 25 5/8 x 39 15/16" (65.1 x 101.5 cm). Publisher: Audrey Sabol, Villanova, Penn. Printer: Art Krebs Screen Studio, Los Angeles. Edition: 50. John B. Turner Fund. The Museum of Modern Art, New York, NY, U.S.A. Digital Image ©The Museum of Modern Art/Licensed by SCALA/Art Resource, NY. Art Copyright Ed Ruscha; Page 325: Copyright © Barbara Kruger. Courtesy: Mary Boone Gallery, New York; Page 325: The Wolfsonian–Florida International University, Miami Beach, Florida.

Whew! —s.w.s.